Clement Greenberg

THE COLLECTED ESSAYS AND CRITICISM

Clement Greenberg, 1955. © Hans Namuth 1986.

23 August 1944

Dear Bill:

Thanks for your card. Glad to hear that you're getting lots of work done, and very curious to see it. Myself, I haven't seen any painting since June, and I haven't written about since then either. My piece on Surrealism was the last thing. I want to know what you frankly think of it. Don't pull any punches. It appeared last week and the week before in The Nation. I'm now waiting for lightning to descend, or hoping rather that it will descend, for it may not at all. The Surrealists have probably got too tired.

Regards to your wife.

Clement Greenberg

Letter from Clement Greenberg to William Baziotes, 23 August 1944. William Baziotes Papers, Archives of American Art, Smithsonian Institution. Gift of Ethel Baziotes.

Clement Greenberg

THE COLLECTED ESSAYS AND CRITICISM

Volume 2
Arrogant Purpose

1945 – 1949

Edited by John O'Brian

The University of Chicago Press CHICAGO AND LONDON

CLEMENT GREENBERG, a dominant figure in
American cultural criticism since the 1940s, has
been an editor for *The Partisan Review*, an art critic
for *The Nation*, and a book reviewer for the *New York
Times*. John O'Brian is a teaching fellow in the
Department of Fine Arts at Harvard University.

The University of Chicago Press, Chicago 60637
The University of Chicago Press, Ltd., London
© 1986 by Clement Greenberg and John O'Brian
All rights reserved. Published 1986
Printed in the United States of America
95 94 93 92 91 90 89 88 87 86 54321

Library of Congress Cataloging-in-Publication Data

Greenberg, Clement, 1909–
 The collected essays and criticism.

 Includes bibliographies and indexes.
 Contents: v. 1. Perceptions and judgments, 1939–
1944—v. 2. Arrogant purpose, 1945–1949.
 1. Art—Addresses, essays, lectures. I. O'Brian,
John. II. Title.
N7445.2.G74 1986 700 85-29045
ISBN 0-226-30617-8 (v. 1)
 0-226-30618-6 (v. 2)

Contents

Acknowledgments

I would like to thank T. J. Clark for first encouraging me to track down, read, and compile the uncollected writings of Clement Greenberg; Anne M. Wagner for arming me with an excellent bibliography that greatly facilitated my work in the early stages; S. J. Freedberg, Oleg Grabar, Serge Guilbaut, Michael Kimmelman, and Henri Zerner for offering advice on publishing matters; the staffs of the New York Public Library, the Widener and Fine Arts libraries at Harvard University, and the Robarts Library at the University of Toronto for responding, always patiently, to inquiries; and Whitney Davis, Friedel Dzubas, Caroline Jones, and Michael Leja for bringing my attention to articles I had overlooked. I must also thank Robert F. Brown, at the Archives of American Art, for helping to locate stray material; Jim and Susan Worts for offering their house in Toronto as a place to work one summer; and Roger Hecht for typing, and Eileen M. McHugh and Jennifer Riley for reading, the manuscript.

Finally, I thank Clement Greenberg himself. He responded favorably to the idea of a "Collected Works," and encouraged the endeavor throughout.

John O'Brian

Editorial Note

The essays and criticism in this volume consist of published writings only and are arranged chronologically in the order of their first appearance. Each article concludes with a reference stating when and in what publication it first appeared. Reprints are also indicated. The abbreviation A&C is used for the book *Art and Culture: Critical Essays*, the collection of Greenberg's writings published in 1961. Most of the articles in the book were revised or substantially changed by Greenberg for republication. This volume, however, reprints the articles as they appeared originally. Reprintings of revised or changed articles from *Art and Culture* are not cited.

All titles are either Greenberg's own or those of the editors of the publications for which he wrote. In most cases the titles for the essays were supplied by Greenberg himself and the titles for book reviews were supplied by others. Greenberg's column for *The Nation*, which appeared from 1942 to 1949, was written under the generic heading "Art" (sometimes "Art Note" for shorter pieces). In order to indicate the contents of each column, I have supplied descriptive headings in place of the generic ones.

The text has been taken from articles as they appeared in print. Unless otherwise indicated, articles were signed Clement Greenberg or C.G. Some short reviews that appeared in *The Nation* were unsigned and these have been so designated. One article published in *Commentary* in 1946 was signed K. Hardesh; this too has been indicated. Throughout, the titles of books, poems, periodicals, and works of art have been put in italics. Spelling and punctuation have, with some exceptions, been regularized to coincide with the usage in *The Nation* column. All ellipsis points in the text are Greenberg's.

Greenberg used a minimum of footnotes in his writing, and for this edition I have followed his practice in my own footnoting. The text is footnoted only where there is a reference to a topic about which the reader could not be expected to find infor-

mation in another source. The majority of Greenberg's articles were written as one or another kind of journalism and the edition attempts to preserve the sense of occasion for which they were written. The articles, then as now, were unaccompanied by illustrations.

The Bibliography lists other writings by Greenberg, including books, translations from the German, and articles which have not been collected. It also provides a selected bibliography of secondary sources on Greenberg's work. The Chronology offers a brief summary of events to 1949 to give some background to the criticism.

Foreword

In 1948 Clement Greenberg wrote of Matisse that he was "cold, undistracted, and full of arrogant purpose." The title of this second volume of Greenberg's collected essays and criticism borrows from that measured description, for it conjures up something of Greenberg's own critical purpose in the period from 1945 to 1949. Convinced that the decade and its art demanded unusual candor, he attempted to provide it in his own writing. "To define the exact status of contemporary American art in relation to the history of art past and present," he wrote in *Partisan Review* in 1948, "demands a certain amount of mercilessness and pessimism. Without these we shall not know where we are at. There is no use in deceiving ourselves with hope. Our most effective course is to confront the situation as it is, and if it is still bad, to acknowledge the badness, trusting in the truth as the premise of any improvement, and feeling a new security because of the very fact that we have met and verified the worst." Mercilessness and pessimism, of one kind or another, underlie a good deal of Greenberg's criticism from the second half of the 1940s.

The format and organization of this volume is identical to that of the first volume, *Perceptions and Judgments*, which covers the years from 1939 to 1944. The apparatus—listing Greenberg's uncollected writings and selected secondary sources on his work, and providing a chronology—is also identical. The introduction, however, though it serves to introduce the contents of both volumes, appears only in *Perceptions and Judgments*.

<div align="right">John O'Brian</div>

Clement Greenberg

THE COLLECTED ESSAYS AND CRITICISM

1945

1. Trail Blazer: Review of *William Sidney Mount* by
 Bartlett Cowdrey and Hermann Warner Williams, Jr.

It may be said some day that a signal achievement of plain, ordi-
nary scholarship was to have discovered an American tradition
of middle-class art. An instance is provided by *William Sidney
Mount*, a book composed of a catalogue, an essay, and notes, by
Bartlett Cowdrey and Hermann Warner Williams, Jr. Mount
founded the American school of genre painting, borne on the
wave of Jacksonian populism; and he drove one of the nails into
the coffin of the historical school and the grand manner. Dutch
models inhibited as well as encouraged his naturalism; yet his
example and style, whether known directly or through in-
fluences, must have nourished Eakins and Homer in their
beginnings.

The Nation, 13 January 1945

2. Obituary and Review of an Exhibition of Kandinsky

There are two sorts of provincialism in art. The exponent of one
is the artist, academic or otherwise, who works in an outmoded
style or in a vein disregarded by the metropolitan center—
Paris, Rome, or Athens. The other sort of provincialism is that
of the artist—generally from an outlying country—who in all
earnestness and admiration devotes himself to the style being
currently developed in the metropolitan center, yet fails in one
way or another really to understand what it is about.

The late Marsden Hartley, about whom I wrote several weeks
ago,[1] was a provincial of this latter sort. And so was the Russian,

1. *The Nation*, 30 December 1944. [Editor's note]

Wassily Kandinsky, who died two weeks ago in Paris at the age of seventy-eight. They were quite different as painters but both were alike in being provincial. Hartley failed to understand the School of Paris because he really lacked culture. Kandinsky was learned and at ease in his learning, and was one of the first, if not the first, to get an intellectual purchase on post-cubist painting, yet he failed in the end to understand it in practice. (Kandinsky and Hartley were further alike in that they both came to post-impressionist painting through German expressionism, which seemed to make post-impressionism more accessible to non-Latin outsiders.)

Kandinsky began as a disciple of the *Jugendstil*, then joined the *Blaue Reiter*, and finally developed a species of impressionism-cum-fauvism which under the indirect influence of cubism and the experiments of Malevich dissolved into outright abstract art. It was during these movements of transition and search that Kandinsky's painting reached its heights, to decline almost steadily thereafter. His best work remains those paintings in fluid contour and gauzy color that he executed between 1909 or so and the early twenties (the heroic period of the flowering of cubism which also saw such non-cubists at Matisse and Chagall at their best.)

The abstract or—as Kandinsky himself called them—"concrete" paintings he turned out from the middle twenties represent a misconception, not only of cubism and its antecedents, but of the very art of putting paint on canvas to make a picture. Like many a newcomer to a situation, seeing it from the outside and thus more completely, Kandinsky was very quick to perceive one of the most basic implications of the revolution cubism had effected in Western painting. Pictorial art was at last able to free itself completely from the object—the eidetic image—and take for its sole positive matter the sensuous facts of its own medium, reducing itself to a question—purely on canvas, not in the observer's consciousness—of non-figurative shapes and colors. Painting could become like music, an art contained in its own form and thus capable of infinitely more variety than before—at least in theory. But Kandinsky erred in assuming that this newly won freedom exhausted the meaning of the cubist revolution and that it permitted the artist to make a clean break with the past and start all over again from scratch—something which no art can do without losing all sense of style.

4

In point of practice Kandinsky merely exchanged one past for another: that of Renaissance-Paris painting for the woefully meager one of the *art nouveau* of his youth and peasant decoration (already once joined in the *Jugendstil*). He rejected what to my mind is a prior and perhaps even more essential achievement of avant-garde art than its deliverance of painting from representation: its recapture of the literal realization of the physical limitations and conditions of the medium and of the positive advantages to be gained from the exploitation of these very limitations.

Kandinsky, in principle, seems to have paid ample homage to the new awareness that easel-painting takes place on a *flat, continuous*, finitely bounded surface, but he lacked an intuitive grasp of the consequences of these facts in actual practice. As if in reaction against his earlier liquescent style, he came to conceive of the picture *überhaupt* as an aggregate of discrete shapes; the color, size, and spacing of these he related so insensitively to the space surrounding them—that which Hans Hofmann calls "negative space"—that this remained inactive and meaningless; the sense of a continuous surface was lost, and the picture plane became pocked with "holes." At the same time, having begun by accepting the absolute flatness of the picture surface, Kandinsky would go on to allude to illusionistic depth by a use of color, line, and perspective that were plastically irrelevant. Last but not least, the consistency of his paint surface and the geometrical exactness of his line seem more appropriate to stone or metal than to the porous fabric of canvas—this stricture also applies to Mondrian. But it is not so much that Kandinsky's methods led him to paint bad pictures as the fact that academic reminiscences crept into them at almost every point other than that of what they "represented." And only a sense of style acquired from closer contact with the School of Paris would have insured him against such reminiscences, or at least against their discordant quality.

As a result of his failure to acquire a modern sense of style, Kandinsky remained an insecure painter. A somewhat similar insecurity operated in Hartley's case, which drove him, too, to eclecticism. The stylistic and thematic ingredients of Kandinsky's later work are as diverse as the colors of Joseph's coat: peasant, ancient, and Oriental art, much Klee, some Picasso, surrealist protoplasma, maps, blueprints, musical notation, etc., etc. If Kandinsky's later painting has a certain uniformity,

that is owed mostly to its faults; where they are absent we are likely to take a Kandinsky for a Klee. A real high style would have imposed harmony upon materials even more diverse, but Kandinsky could have developed such a style, as I have said, only by going to the School of Paris for inspiration. It remains the necessary source of the only high styles of painting our age is capable of, even as Italy remained the only such source during the sixteenth century.

The exhibition at Nierendorf's illustrating Kandinsky's life work, even though incompletely, makes this quite clear. For a relatively short time Kandinsky was a great painter; he was and will remain a large and revolutionary phenomenon—he must be taken into account always; yet he stays apart from the main stream and in the last analysis remains a provincial. The example of his work is dangerous to younger painters. Let them be warned by the decorations that make vacuous the halls of the Art of Tomorrow museum.

The Nation, 13 January 1945; A&C (substantially changed).

3. Review of Exhibitions of Edgar Degas and Richard Pousette-Dart

A superb exhibition of Degas's bronzes, drawings, and pastels at the Buchholz Gallery asserts him to have been a great sculptor. However that may be, the charcoals and pastels surrounding his bronze pieces show that he was an incomparably greater drafts-man. His marvelous line, not sharp but deep, cuts volumes out of flat picture space instead of out of gathering shadows; yet at the same time it cuts back into the infinity into which all the possible contours of a volume can be multiplied. His bronzes, on the other hand, depend just a little too much on the spectator's finding the right point of vantage—in other words, his sculpture reveals fewer contours than his drawings.

Richard Pousette-Dart, a young painter being shown at the Willard Gallery, displays considerable promise. Working away from an ornamental, too heavily elaborated style, pushed along by the kindred influence of Jackson Pollock and that—strangely enough—of Mark Tobey, he tries for boldness, breadth, and the

6

monumental. He has not attained them yet; he is still too grace-
ful, but he is traveling in the right direction. American painting
is much in need of all three qualities, and it is significant that
Pollock, who manifests all three, has already begun to exert an
influence, though he has been before the public hardly more
than a year.

The Nation, 20 January 1945

4. Review of an Exhibition of Morris Graves

It has been my feeling that the basis of Morris Graves's art would
not be sufficient to carry it beyond its first impulse. In the first
place, nature worship can furnish but scanty and rather irrele-
vant material in these times—when the main and inescapable
problem is urban life; in the second place gouache on thin paper
can do only so much in any one artist's hands; in the third place,
the tradition in which Graves works—Chinese painting and
Klee—is too narrow and too far removed from the main stream.
It was large enough for him to demonstrate that he was talented
and original to begin with; but once the demonstration was
made there was no place left to go.

Graves's art already began to hesitate several years ago as it
eked out its first substance with a strong dosage of Klee. In his
latest show at the Willard Gallery it manifests what is almost a
collapse. His new *kakemonos*, which are paintings vertical in de-
sign and "mounted on scrolls," either are too derivative of Ori-
ental art or waver awkwardly between decoration and easel-
painting. Not enough plastic material is present to indicate,
much less fulfil, his intentions—not enough tone, not enough
compositional elements. The same poverty weakens his framed
gouaches. Graves is subtle—he has to be within the narrow lim-
its set for himself—but subtlety is of no avail when it has to deal
with matter so evanescent as hardly to attain the status of the
visible. Something very spontaneous, very valid, moves at the
bottom of his art, but for the present it does not materialize as
anything much more than an impulse, an initial impulse—
sometimes only the demi-semi-quaver of an impulse.

Modern experience sets the bounds within which modern art

must be practiced. These bounds are considerably wider than those of Graves's painting, but wide as they may be, relatively, they have, since the death of Klee, excluded birds, fishes, and trees. For all its emphasis on inwardness, Graves's eye is not really inward enough; if it were, it would be a *positive* eye that saw through and beyond pantheism.

The Nation, 17 February 1945

5. Review of an Exhibition of Dutch Painting

As time passes, the break between modern and Renaissance-naturalistic painting seems to become less sharp, though remaining definite nevertheless. Ultimately a picture by Picasso has to satisfy the same demands—demands involved by the nature of easel-painting—as does a Rembrandt. A continuity, historical and social as well as technical, is to be discerned even when modern painting is confronted with that of the seventeenth-century Dutch, which is in one sense its direct antithesis. For the Dutch school—if anything so various can be called a school—explored more consistently and thoroughly than any other the possibilities of contriving the illusion of deep space and of light in deep space on a two-dimensional surface. It did the most to annihilate the spectator's consciousness of the flatness of the picture plane—that flatness which the moderns have so literally and drastically reasserted.

The seventeenth century in Western Europe was inspired by a new perception of the infinity, intangibility, and continuity of space. What its painters explored pictorially—and Milton poetically, with his exotic place names and allusions and his vision of Satan soaring and diving between infinite height and infinite depth—was investigated practically and theoretically by the square-rigged ship, discoverers, geometers, and philosophers. But nowhere was this new sense of space, and of light as the description of space, bodied forth so consummately as in Dutch painting. Space and light are the themes not only of Dutch landscape but also of Dutch genre and interior painting, with its dramatic intervention of light amid enveloping, limitless shad-

ows—or as in the cases of Vermeer and de Hooch, with the recession of flat planes according to the modulation of light.

Modern taste has charged the Dutch—save for Vermeer and de Hooch—with lack of design; but twentieth-century taste, under the influence of Cézanne and the Oriental example and in reaction against the presumed amorphousness of the impressionists, has conceived of design too exclusively in terms of solidity and line, the ultimately decorative arrangement of mass, volume, and opaque plane—in all of which the Dutch were largely uninterested, even as they were uninterested in sculptural effects and the nude. What caught them was the play of light on surfaces and in atmosphere, and out of that play of light, registered in the varying densities of neutral tones—grays and browns—they created design as firm as any in pictorial art.

Two landscapes at the very good show of Dutch painting now at Knoedler's—one a river scene with boats by Salomon van Ruysdael, the other a view of Arnhem by Jan van Goyen, both of them almost identical in size—achieve the perfection of this type of design—framed on gradations of dark and light against which delicate, restrained color beats an obbligato as subtle as any in music itself.

And yet the charge of neglect of design is to some extent borne out: particularly by Rembrandt, who sometimes paid for his most striking effects precisely by sacrificing design. His remarkable portrait of Gérard de Lairesse has too much space at the bottom—not to mention its overpowering directness of psychological vision, which, being far in excess of the capacities of physical vision, renders the unhappy subject a monster of physiognomic nakedness; his otherwise excellent *Young Girl Standing in a Room* shows too much space around the figure, while his *Still Life with Dead Game* is put out of joint by the clumsily handled empty space on the left-hand side. Rembrandt's concentration on the highlights and his habit of surrounding them with great areas of "brown sauce" proved a hypnotic example to his followers, and a destructive one, for it was a style much too risky for anyone but a genius. It was dangerous enough to Rembrandt himself, whose true masterpieces come relatively few and far between.

Dutch still-life painting, too, sacrificed design, at least in

the decorative sense, but in such a marvelously executed still life as Willem Kalf's the eye discovers its delight as it goes from one detail to another. Were it to draw back to take in the picture at a single glance, everything would collapse. The picture has to be read chronologically, its points of paint examined one at a time. The dexterity of Kalf's brush and the richness and juice of his *pâte* overcome the eye's resentment at the absence of decorative design. And it is characteristic of the Dutch school that the very workmanship of the artist, the good quality and permanence of his pigments, glazes, and varnishes, the skill, patience, and conscientiousness with which he has applied them—all these contribute somehow to the pleasure.

Other good works at this exhibition are by de Hooch, Metsu, Victors, and Ochtervelt. There is a second, and almost equally successful, river scene by Salomon van Ruysdael, a fair seascape with ships by Willem van de Velde, and an interior by ter Borch and a genre scene by Steen that just barely manage to come off.

Aelbert Cuyp's two landscapes are clumsy and lifeless, though well-painted in spots; while a self portrait by Barent Fabritius, a disciple of Rembrandt, falls into monotony and over-smoothness in its browns, for all the charm of its high-lighted parts. Frans van Mieris, who excelled in "silks and satins, luster, plate, and jewels," is represented by the small *Lady with a Parrot* whose shortcomings demonstrate why Kalf's still life succeeds so well. Each object in Kalf's still life is painted almost perfectly within the naturalistic terms Kalf set himself; within the same terms Mieris has superlatively rendered the satin and velvet of his lady's clothes, but her head and the parrot are handled with a weakness the rest of the canvas cannot make good.

The Nation, 24 February 1945

6. Steig's Cartoons: Review of *All Embarrassed* by William Steig

The mating of drawing with caption has produced a new but very dependent and transitory pictorial genre. The future will be more informed than delighted by it. We can still relish the

brush-drawing on a Greek vase for its own sake as a drawing—whether fitted happily or unhappily to the shape of the vessel. But to appreciate William Steig's cartoons you have to get their point, and to get their point you have to be intimately acquainted with the contemporary American literate middle classes. And yet in spite of all this, Steig's cartoons push and strain against the social and psychological limitations of the cartoon form and strive to become self-sufficient, time-transcending art. The quasi-abstract drawings in *All Embarrassed* are, though not necessarily the best, those which most visibly embody Steig's aesthetic yearning. A good deal of automatism has gone into them as well as a full acquaintance with Klee, Picasso, and particularly Miró, yet they do not manage to escape the neatness and the formu-larization of the cartoon—nor will they until Steig forces himself to leave his forms more open and to take into greater account the shape of the page. It is no accident that the cartoon called *Organism and Environment* is the best in the book as a matter of drawing and picture composition.

Once in a while Steig's wit makes all the above irrelevant. I submit the cartoons called *The Conversation Lags 1, Misunderstanding*, and *Intrusion*. If, however, Steig were somewhat more susceptible himself to those dangers of middle-class existence he too triumphantly points out, he would score much more frequently.

The Nation, 3 March 1945

7. Review of an Exhibition of Arnold Friedman

Four or five pictures at Arnold Friedman's show at the Marquié Gallery establish him as one of the strongest and most original landscapists we have. A member chronologically of John Sloan's generation, Friedman has had trouble finding himself—he earned his living as a post-office clerk—and only lately, being able to devote all his time to painting, has he discovered his true vein—the atmospheric landscape. Perhaps this delay accounts for the unevenness of his work, which even today, like faulted strata that have broken through to the surface, exhibits simulta-

neously almost every phase of his past. Thus his genre scenes remind one poignantly of the American impressionist-realist school of the early century: Sloan, Glackens, and their fellows—who produced what in my opinion still remains the best American painting of our time. Details in other pictures are reminiscent of later developments. Only in his landscapes does Friedman arrive at himself.

Like most contemporary landscape painters of any merit, Friedman works with the inheritance left by impressionism and Cézanne, eschewing values of frank color and controlling space by warms and cools rather than by darks and lights. His preference for the simple, rectilinear composition is offset, as was the case with Pissarro too, by his success in intensifying surface and texture. He paints best with the palette knife, scumbling colors one over the other, and using very little medium. The result is complex, ripe, wistful, atmospheric, and at the same time solid and monumental.

None of this gives any idea of Friedman's originality. He is possibly the only really original landscapist left in this country after Marin. His originality is the expression of a pure, honest, serious, and independent personality rather than of a method. A character to which all chic and facility are foreign yields an absolute contribution—which is even greater than most of those who admire his art realize. Friedman has managed to make the landscape—hardly the typical genre of our age—express something of this age's abiding emotions: the sad remoteness of nature, the anonymity of cities, and the permanence of art. Here for the first time the real pessimism of suburban life comes through in painting.

Friedman will paint even better in the future, ironing out inconsistencies in quality and receiving, I feel sure, a recognition delayed so far only by the current tendency to identify art with chichi. The irony in the note which he himself wrote for his catalogue is justified, but not its humility.

The Nation, 17 March 1945

8. Review of an Exhibition of Arshile Gorky

Although to my knowledge Arshile Gorky is having his first one-man show (at Julien Levy's), he is by no means a fledgling painter. Examples of his work have in recent years appeared in many group exhibitions. From the first there has been no question about the level of his art, regardless of the varying quality of individual pictures; his painting early won a central position in the main stream flowing out of cubism and until recently stayed close to the most important problems of contemporary painting in the high style.

The critical issue in Gorky's case was how much of the value of his work was intrinsic and how much symptomatic, evidential, educational. He has had trouble freeing himself from influences and asserting his own personality. Until a short while ago he struggled under the influences of Picasso and Miró. That he fell under such influence was ten years ago enough proof of his seriousness and alertness—but that he remained under them so long was disheartening. He became one of those artists who awaken perpetual hope the fulfilment of which is indefinitely postponed. Because Gorky remained so long a promising painter, the suspicion arose that he lacked independence and masculinity of character.

Last year his painting took a radically new turn that seems to bear this suspicion out. He broke his explicit allegiance to Picasso and Miró and replaced them with the earlier Kandinsky and—that prince of comic-strippers, Matta. Formerly he had adhered to the cubist and post-cubist convention of flat, profiled forms and flat textures—the convention within which the main current more or less of high painting since Seurat and Cézanne has flowed. But now he changed suddenly to the prismatic, iridescent color and open forms of abstract, "biomorphic" surrealist painting. And these lately he has begun to cover with the liquid design and blurred, faintly three-dimensional shapes of Kandinsky's earlier abstract paintings.

This new turn does not of itself make Gorky's painting necessarily better or worse. But coming at this moment in the development of painting, it does make his work less serious and less powerful and emphasizes the dependent nature of his inspiration. For the problems involved in Kandinsky's earlier abstract

paintings were solved by Kandinsky himself, while the problems of "biomorphism" were never really problems for modern painting, having been dealt with before impressionism and consigned since Odilon Redon to the academic basement. What this means is that Gorky has at last taken the easy way out—corrupted perhaps by the example of the worldly success of the imported surrealists and such neo-romantics as Tchelitchew. Certainly, his paintings register success within their own terms more consistently than before, but those terms are lower than they used to be. And certainly his art radiates more charm and has become much easier for the initiated to take. But it all goes hand in hand with the renunciation of ambition.

Yet perhaps Gorky was meant to be charming all along; perhaps this is his true self and true level; perhaps he should have pastured his imagination in the surrealist meadow long before this; perhaps his "corruption" was inevitable.

And yet again, it is not quite that simple. For one thing: whether or not he is a first-rate artist, Gorky is definitely a first-rate painter, a master of the mechanics and cuisine. He does far, far more with the "biomorphism" of Matta *et al*. than they themselves can do. For another thing: Gorky still continues to show promise! The most recently executed picture at his show, called *They Will Take My Island*—black looping lines and transparent washes on a white ground—indicates a partial return to serious painting and shows Gorky for the first time as almost completely original. It is not a strong picture and still makes concessions to charm, but it is a genuine contemporary work of art.

The Nation, 24 March 1945

9. Review of Exhibitions of Mondrian, Kandinsky, and Pollock; of the Annual Exhibition of the American Abstract Artists; and of the Exhibition *European Artists in America*

Academicism shows itself nowhere more nakedly than in painting and sculpture, being much more immediately depressing

there than in literature. One brief glance at the recent annual exhibition of the National Academy of Design was enough to fill the visitor with gloom. Van Wyck Brooks's resentment of advanced literature's lack of "affirmation" would find greater justification if it were directed to backward art. These painters of purple and emerald landscapes of glazed figurines and wax flowers, these nigglers, these picklers of nudes and bakers of mud pies plumb depths of negation and pessimism T. S. Eliot or Joyce, much less Picasso, could never remotely reach. But it is in the very nature of academicism to be pessimistic, for it believes history to be a repetitious and monotonous decline from a former golden age. The avant-garde, on the other hand, believes that history is creative, always evolving novelty out of itself. And where there is novelty there is hope.

The hope shining from Piet Mondrian's white canvases with their criss-crossed bands of black has little to do with his platonizing theories except in so far as they express an almost naive faith in the future. Rationalized décor—rectilinear lines and bright, clear colors—means the conviviality and concord of an urban tomorrow stripped of the Gothic brambles and rural particularities that retarded life in the past. Mondrian's pictures are an attempt to create conditions of existence and stabilize life itself. They are not "interesting" the way Titians are; you are supposed to go on with life in their presence. Aside from the fact that he was a pioneer who pushed the implications of modern art to their last consequences, Mondrian was one of the greatest painters of our time. Unfortunately, the memorial show at the Museum of Modern Art includes too few of his works to give a really adequate notion of the scale of his art and the heights it reached in his best periods. (I realize that Mondrian's paintings need lots of empty wall around them, but then the show should have received more gallery space.) It is also unfortunate that the white areas in many of his pictures have by now become discolored or dirty. The artist himself should have foreseen that; and while his art is inseparable from the qualities induced by canvas and oil, he might have done more wisely and equally beautifully had he used tempera on board or gesso panel. Perhaps the fact that he made many changes and over-paintings during execution kept him away from the relative inflexibility of tempera. In any case it suffices that he put together pictures that

are completely at rest—solid, unshakable—and at the same time tense and dramatic.

Along with the memorial exhibition a sixty-four-page book containing six of Mondrian's essays on art has appeared, edited by Robert Motherwell and Harry Holtzman. (The assistance of Charmion von Wiegand, who practically put one of the essays into English, is for some reason or other not acknowledged.) Acquaintance with Mondrian's theories may expand one's idea but will hardly deepen one's experience of his work. They are real feats of speculative imagination but seem to have been more a rationalization of his practice than a spur to it. Theories were perhaps felt necessary to justify such revolutionary innovations. But Mondrian committed the unforgivable error of asserting that one mode of art, that of pure, abstract relations, would be absolutely superior to all others in the future.

The late Kandinsky, Mondrian's only true compeer, whose life work is reviewed in a splendid exhibition at the Museum of Non-Objective Painting, fell somewhat short of Mondrian in practice but maintained a better concept of what was going on. His chief mistake was to draw too close an analogy between painting and music. And while he did not give "non-objective" art the absolute primacy, he did hold that only through the non-objective could "absolute" works of art be approximated. Like Mondrian he spoke of "liberation"—from the past, from nature—and was optimistic, anticipating a future of inner certainty and the "growing realization of the spiritual." (As far as I can make out, Kandinsky's "spiritual" means simply intensity and seriousness and has no religious connotations.)

Kandinsky was more a landscape painter at heart than anything else. Even before developing his abstract "lyrical" style he seems, according to the evidence, to have proved himself the best of all the *Blaue Reiter* artists in Germany. His parti-colored expressionist landscapes are better than we, who have been brought up on the School of Paris, may rightly realize.

Jackson Pollock's second one-man show at Art of This Century establishes him, in my opinion, as the strongest painter of his generation and perhaps the greatest one to appear since Miró. The only optimism in his smoky, turbulent painting comes from his own manifest faith in the efficacy, for him personally, of art. There has been a certain amount of self-deception

in School of Paris art since the exit of cubism. In Pollock there is absolutely none, and he is not afraid to look ugly—all profoundly original art looks ugly at first. Those who find his oils overpowering are advised to approach him through his gouaches, which in trying less to wring every possible ounce of intensity from every square inch of surface achieve greater clarity and are less suffocatingly packed than the oils. Among the latter, however, are two—both called *Totem Lesson*—for which I cannot find strong enough words of praise. Pollock's single fault is not that he crowds his canvases too evenly but that he sometimes juxtaposes colors and values so abruptly that gaping holes are created.

The ninth annual exhibition of the American Abstract Artists at Riverside Museum suffers from a lack, not of optimism, but of strong personalities. The rules laid down by the epigones of cubism are a little too carefully observed. Some of the animation that comes with surrealism is needed. Three women painters, however, show a good deal of promise: Nell Blaine—whose large white picture struck me as the best in the show—Fannie Hillsmith, and Eleanor de Laittre. There is one colorist present, Giorgio Cavallon, who may come to more than anyone else once he controls his design.

The large *European Artists in America* show at the Whitney Museum represents international, *ipso facto* School of Paris, art. All the works were executed in this country except those of a single artist. The mood is one of resigned optimism—everybody is glad to be here and alive—coupled with that kind of liveliness, not necessarily identical with vitality, which skilled performers create in their effort to attract attention. The exhibition abounds in finished performances, but very little in it goes deep. More than half the painters on hand show surrealist or neo-romantic affects—which is another way of being lively. Surprisingly enough, the sculpture section makes a better impression, on the whole, than the painting. Lipchitz's granite *Return of the Child* deserves to be called great, while Max Ernst shows himself to be an immeasurably better sculptor than painter—there is almost no organic relation between his abstract sculpture and his diabetic, prematurely worm-eaten pictures. Also present are a good Mondrian and a hopeful picture called *Unfolding Stratum*, by Herbert Bayer. Léger's oils are stronger than

they have usually been of late; Léger always knows how to put a picture together, but he repeats his design to the point of stereotype—and his little touches of shading create volumes that are overinflated with respect to every other element.

The Nation, 7 April 1945

10. Review of an Exhibition of Hans Hofmann and a Reconsideration of Mondrian's Theories

Hans Hofmann is in all probability the most important art teacher of our time. Not only has his school sent out good painters; the insights into modern art of the man himself have gone deeper than those of any other contemporary. He has, at least in my opinion, grasped the issues at stake better than did Roger Fry and better than Mondrian, Kandinsky, Lhote, Ozenfant, and all the others who have tried to "explicate" the recent revolution in painting. Hoffman has not yet published his views, but they have already directly and indirectly influenced many, including this writer—who owes more to the initial illumination received from Hofmann's lectures than to any other source. (Whether this redounds to Hofmann's credit or not I leave to others to decide.) Hofmann practices what he teaches, and his second one-man show of painting in this country—his first was held only last year—is now running at 67 Gallery. It would be unfair of me to pretend to critical detachment with regard to it. I find the same quality in Hofmann's painting that I find in his words—both are completely relevant. His painting is all painting; none of it is publicity, mode, or literature. It deals with the crucial problems of contemporary painting on its highest level in the most radical and uncompromising way, asserting that painting exists first of all in its medium and must there resolve itself before going on to do anything else. Perhaps Hofmann surrenders himself too unreservedly to the medium—that is, to spontaneity—and lets color dictate too much: his pictures sometimes fly apart because they are organized almost exclusively on the basis of color relations. Perhaps he insists too little on the resistances of his own temperament—in every artist

18

there must be something that fights against being set down in art and yet whose setting-down constitutes part of the triumph of art. Be that as it may, the works of the teacher do not betray his teachings. Hofmann has become a force to be reckoned with in the practice as well as in the interpretation of modern art.

I may have seemed high-handed in my disposal two weeks back of Mondrian's theories. The irritation caused by any sort of dogmatic prescription in art was most likely responsible. Mondrian attempted to elevate as the goal of the total historical development of art what is after all only a time-circumscribed style. That style may be—I myself believe it is—the direction in which high art now tends and will continue to tend in the forseeable future. But in art a historical tendency cannot be presented as an end in itself. Anything can be art now or in the future—if it works—and there are no hierarchies of styles except on the basis of past performances. And these are powerless to govern the future. What may have been the high style of one period becomes the kitsch of another. All this is elementary; yet it needs to be repeated in Mondrian's case. These reservations made, one can proceed to value Mondrian's theories—which are logical deductions from the results of his own practice and from the evidence of the world around him as to the aesthetic and social implications of abstract art—for the brilliant insights they are. With Marx, he anticipated the disappearance of works of art—pictures, sculpture—when the material décor of life and life itself had become beautiful. With Marx, he saw the true end of human striving as complete deliverance from the oppression of nature, both inside and outside the human being. With Marx, he saw that man has to *denaturalize* himself and the things he deals with in order to realize his own true nature. He saw that what is wrong at present is that man only partly denaturalizes his own nature and his environment, and through this partial denaturalization—that is, capitalism, the suburbs of Chicago, radio, movies, vicarious experience, popular taste—attains precisely the opposite of what he really wants. Mondrian's art was not "inhuman"; it did not aim at "perfection"; it aimed at nothing beyond itself. But it was guided by an ideal, as all human action in or out of art should be.

The Nation, 21 April 1945

Review of an Exhibition of Claude Monet

A reaction against what was called the "formlessness" of impressionist painting cast a pall for a time over the reputations of Claude Monet, Pissarro, and Sisley. There now seems to be a reaction against that reaction. We have discovered more "form" than had been supposed in their pictures.

Cézanne detected a lack of three-dimensional structure in their painting, but this lack became really compromising only in the work Monet turned out in his last period, when he went off in a direction tangential to that of all art. His ambition to note, record, and make permanent the most transitory aspects of nature was an extra-aesthetic one that had more to do with science than with painting. It meant an unwillingness to consider the work of art as a complete event in itself. The picture became only one notation in a series, with the artist hurrying on to the next. In the poem that furnishes the epigraph to the catalogue of the spectacular Monet show now running at Wildenstein's, Henri de Régnier says with much insight:

> Et pour vous, ô Monet, le plus beau paysage
> Sera toujours celui que vous peindrez demain.

Coincident with the notational fallacy was the equally serious if more aesthetically relevant one of chromaticism. As Debussy would often present the mere texture of sound as the form itself of music, so Monet in his last period offered the mere texture of color as adequate form in painting. Monet, logical nineteenth-century materialist, forgot that art is relations, not matter, and that it exists primarily by virtue of relations, while all that matter can do is repeat itself: thus clusters of lily pads, masses of foliage, gray mists, and watery reflections—the canvases on which Monet painted them look like segments cut from much larger pictures.

But the earlier Monet is something quite different. Brought up as a painter under Boudin's tutelage, but with Manet's the decisive influence, he was already producing first-rate painting in his middle twenties in a somewhat eclectic style that betrayed the influences of Corot and Courbet as well. The broad, heavy earth tones of the latter, the gray lighting of the former, and Manet's sharp value contrast alternated or were combined. Pur-

suing naturalism and the effects of light, Monet worked into the photographic impressionism of atmospheric darks and lights and summary definitions that Manet was the first to devise; and then, along with Renoir and the other impressionists, he arrived at the divided tone and the colored shadows which became the hallmarks of high impressionism—that is, the fusion of colors optically by juxtaposition on the canvas instead of by mixture on the palette and the recognition of the fact that objects cast shadows in colors complementary to those of their lighted surfaces. Gone for good were the gray and brown half-tones that had been the glory of painting since the Venetians. The style of the divided tone reached its full blossom in the eighteen-eighties in Monet's landscapes (some of the best of these, though now in this country, were for some reason not included in the otherwise so comprehensive show at Wildenstein's). Their yellow luminosity, feathery definitions, delicate surfaces, and solid, simple design make a perfection the painter did not attain before or after that time.

It is the pictures Monet turned out between 1870 and 1890 that earn him greatness. The strongest item in the present show, the still life *Vase de Capucines*, was painted in 1880 at the exact middle of this period. He produced an occasional strong painting after 1890—a startling *Haystack*, for instance, at this show, which anticipates Vlaminck—but on the whole his design disintegrated progressively and his color thinned out and lost its juice. His pictures became exercises in his particular technique of notation—mere instances of his style but not works of art. There may still be something to savor in these things, but to do so one has to work oneself up to a very high and unendurable pitch of sensitivity.

Monet followed the impressionist logic in too straight a line and too tenaciously. Pissarro, on the other hand, swerved away for a time to pursue Seurat's pointillist technique, and after he abandoned that he felt refreshed and went on to paint some of the best pictures of his career—even though his color, too, had begun to lose itself in atmosphere and turn gray. (Incidentally, Monet and Pissarro, the two painters who more than any others relied on their sheer eyesight, both suffered from cataracts in old age.)

Monet was a *flat* painter, and the first concern of his *métier*—a

concern that leads from him straight to Mondrian—was to maintain plastically the equilibrium that the surface of the canvas already possesses physically. Impressionism meant naturalism as understood in the terms proper to painting rather than to literature. The impressionist painter, once he found his "motif," took care to slice it out naively, without posing it and without differentiating his interest in its various parts. There could be no highlighting or dramatic centering; the corners of the picture were to show with the same clarity and come as close to the eye as the middle, and the projected field of vision was not permitted to blur toward its horizontal and vertical limits (in this respect impressionism violated its own naturalistic tenets and introduced, before cubism itself, the multiple point of view). Thus the impressionists brought back into painting a flatness not seen since the Italian primitives. Monet's style after the seventies shows such consistency and continuity because he stays so willingly inside this flatness. Renoir and Cézanne struggle in each picture to transform it as much as possible before surrendering to it, whence the drama and complexity. Monet surrenders almost in advance. Thus his pictures stay in their places on the wall much more quietly, even as their creator stayed within his style.

But at the same time light moves inside them, dissolving objects and attacking identities. Monet saw the world as sadly reconciled to itself, with all its conflicts eliminated by the inevitable working out of atomic mergers. The uniform surfaces and texture of his paintings, built up—atomically—with small touches of pigment, and inhering in and creating the objects depicted, make everything finally one—in contrast to the strata of varnish under which the Renaissance painter usually protected his objects and their separateness, and in contrast, too, to the impastoed surfaces of Courbet which emphasize the corporeal identity of things. But Courbet was an earlier and more optimistic materialist than Monet, who had begun to feel the pathos of such a point of view. Like another late materialist, Mallarmé, he knew that the flesh was sad in the end.

The Wildenstein show, said to be the largest or most representative Monet exhibition ever assembled, contains eighty oils and three drawings. It is being held for the benefit of the children of Giverny in France, the town on the Seine in which

Monet spent the last half of his long life—dying there in 1926; and there is an admission charge of fifty cents.

The Nation, 5 May 1945

12. Review of an Exhibition of Georges Rouault

Art lovers yearn now for the Terrible. If any art is going to be allowed to take such liberties with nature as modern art does, then it ought to repay us with emotion—shake and scare us the way titans like Michelangelo do. What is involved is really the Sublime, but the term is a little ashamed of itself by now and is excluded from the useful cant of contemporary writing on art and literature. Nevertheless, the Terrible of our time (it is even better form to call it the "disquieting") proves just as hollow in the end as the Sublime of the romantics.

The same taste that feels the cubists to have sacrificed "emotional content" to "intellectualism" and "technique" discovers a latter-day titan in Rouault and is overcome by his "volcanic force." No one who visits Rouault's large show at the Museum of Modern Art can fail to discern a remarkable painter, see several very effective pictures, and recognize a quantity of genius. Yet that remarkable painter is not a great or a major artist. The quietness that unfailingly characterizes great painting does not enter here as it enters into some of the most agitated of Tintoretto's and Delacroix's works—artist's triumph over the medium, and the medium's final acquiescence.

The fault with Rouault does not lie precisely in the extruded emotion or in the bombast, but rather in a lack of deference. He refuses to let his intentions be shaped by the etiquette and physical conditions of his art; histrionic impatience, the anxiety to express, makes him try to rape the medium and anticipate the spectator's emotions by presenting a *fait accompli* before the fact—there the spectator's emotion is in the picture before he has had time to feel it. He gets a portrait of the way he ought to feel. And so many of us feel guilty about emotional impotence that we hurry to assent.

Rouault cultivates a style that seems the essence of spon-

taneity, yet whose repetitiousness stamps it as almost a formula. He takes few chances with color and invariably plays one complementary tone against another; his main reliance is black—or raw umber—to which he relates every other color, and this, as most painters know, is one of the safest tricks in the game. His design tends usually to be dead-centered and, too frequently, symmetrical. At the same time his control of three-dimensional depth is unsure; here and there in his earlier works highlights pop out or spots of shadow retreat too far or submerge too much. In one and the same picture he will handle space now in the modern way, as a question primarily of surface, and now in the Renaissance way, as a question of fictive depth. The influence of Daumier, one of the last great painters to conform to the Renaissance conception of pictorial space, struggles with that of the post-impressionists—and maybe that of Munich too. Daumier's precept gets the upper hand in Rouault's black-and-white work, however, and the result is an increase of calm and also the revelation of how much more conventional his art is than it at first seems to be.

Rouault did not embrace his expressionism until he was over thirty and had undergone a religious conversion. For the first six or seven years thereafter he appears to have restricted himself largely to water color, oil on paper, and similarly direct media, which best registered his *fougue* without forcing him to abandon certain vestiges of academicism. (One must remember that though Matisse, who was taught by Gustave Moreau, began as an impressionist, Rouault remained a *disciple* of Moreau until he was thirty.) In the beginning he organized his pictures chiefly by darks and lights in depths and paid little heed to surface design. Some of the nudes Rouault executed at this time are quite strong, especially when they stay close to nature, but lack a certain incisiveness. Unlike Degas, whose influence may have touched him just then, Rouault could not integrate the two-dimensional pattern of the literal surface with the illusion of the third dimension underneath.

Some time around 1913 Rouault began to devote more attention to oil proper. With this came a greater interest in surface and texture, while his color range widened considerably and he ceased to rely mainly on values. As James Thrall Soby—who seems to have an obsessional affinity with "morbid" mod-

ern art—points out in his very informative catalogue note, Rouault's heavy contour lines first appeared now, sectioning off the human figure into anatomical compartments—perhaps in answer, as Mr. Soby suggests, to the then all-persuasive influence of cubism.

It is as if, conscious of the faulty integration of his painting, he tried to resolve the problem by draining everything off into immediate sensuous effect. But a separateness, a disparity between the literal surface and the picture "within," persists. Rouault turned out some remarkable paintings from 1916 on— especially the *Three Clowns* (1917), the *Portrait of Henri Lebasque*, the *Crucifixion* (1918), *Self Portrait* (1929), the *Last Romantic*, the *Wounded Clown*, and also the tapestry of the *Wounded Clown*— but all, except perhaps the tapestry, reveal on repeated view a curious fissure between technique and the whole picture—as if the *Ding an sich* had failed to manifest the appropriate phenomenal evidence. The style runs off by itself; we come away remembering colors and textures but not complete works of art. Whence it dawns on us that this passionate religious painter is really a kind of narrow virtuoso, maintaining content in order to exploit a style—unlike Matisse and Picasso, who work at and change style in order to achieve content. And the content of Rouault's art has to be explicit and emphatic in order to support a style whose intensity does not compensate its limited range, and which down at bottom lies sick with academicism.

It is ironic that Rouault, the up-to-date exponent of pornographic, sadomasochistic, avant-garde Catholicism, should be set forth as the only great religious artist of our time. A painter with real gifts, he fails to fulfil them because among other things, he goes precisely to religion to find a pretext and justification for venting his abhorrence, not only of the epoch, but of humanity and himself. Perhaps this hatred and this desire to suffer lie profoundly at the heart of our epoch. But as the German philosopher Husserl said, profundity is chaos.

The Nation, 19 May 1945; A&C (substantially changed).

13. The Missing Link: Review of *An Essay on Man* by Ernst Cassirer

Ernst Cassirer ranks among the outstanding philosophers of this century. His sudden death in April robbed us of one of the broadest and most cultivated minds it has been the fortune of our times to produce. Professor Cassirer devoted much study to the problem of the way man's mind functions, and in this short book he condensed without the sacrifice of clarity or elegance the results of years of work contained in much larger and still untranslated books. One may differ with him as to particulars— as I do in this review—but for the whole one can feel nothing but admiration and gratitude.

More vainly than elsewhere the natural sciences dash themselves against the problem of man. Like surf, they have gradually worn something of the problem away, yet its core remains seemingly more remote than ever. The present age as much as any in history lacks an operative notion, a viable concept of the human being—a lack that is one of the "still centers" around which the crisis of our times revolves. The more we learn about man and the more contexts we discover him to exist or function in, the less able are we to make up our minds about him. The great theoretical, social and psychological need of our age is a means of centralizing the various separate departments of human activity to which the wholeness of life and the collective interests of humanity are not being immolated.

Professor Cassirer's focus is professional and methodological, his point of departure Kantian. After an extremely informative review of the various directions in which attempts to define man have been made, he concludes that for a critical philosophy the proper study of what man *is* is the study of what he *does*. Man can be distinguished from the rest of the animal kingdom only functionally, not substantially. And what man does constitutes culture.

The second part of Professor Cassirer's book becomes a historical and descriptive survey of the results of the *Geisteswissenschaften*—those departments of study that attempt to characterize man's more intellectual or spiritual activities. Chapters are devoted respectively to myth and religion, language, art, his-

tory and science. These summations are the fruit of a personal culture of a depth and breadth rare in our time, and deal so concisely, clearly and yet thoroughly with their subject matter as to form an up-to-date report for the specialist as well as a textbook for the layman.

Seeking some factor that would conclusively differentiate man from the rest of the animals, Professor Cassirer alights on the symbol. "Man has, as it were, discovered a new method of adapting himself to his environment. Between the receptor system and the effector system, which are to be found in all animal species, we find in man a third link which we may describe as the *symbolic system*. . . . There is an unmistakable difference between organic reactions and human responses. In the first case a direct and immediate answer is given to an outward stimulus; in the second case the answer is delayed. It is interrupted and retarded by a slow and complicated process of thought." The symbol is to be differentiated from the sign or signal in that the latter has "a sort of physical or substantial being; symbols have only a functional value." In other words, as an instrumental notion the symbol approaches the Kantian concept of the faculties of the mind.

The society in which man lives, says Professor Cassirer, is not only "a society of action but also a society of thought and feeling. Language, myth, art, religion, science are the elements and the constitutive conditions of this higher form of society. They are the means by which the forms of social life that we find in organic nature develop into a new state, that of social consciousness." Thought then accounts for the origins of politics. By seizing upon this to obviate the need for any more detailed consideration of politics as a specific and characteristic human activity, Professor Cassirer falls into the genetic fallacy. There is much more to politics than its origin and the mental instrument by which man carries it on. The uniqueness of human social and political relations needs fuller explanation than that. Is it not Durkheim's contention—which the author himself admits to have been substantiated—that the fundamentals of myth are projections of man's social relations? How then can myth, which is one of the primary symbolical activities, be anterior to these relations? Is it not conceivable that the beginnings of human

social life were coeval with the beginnings of thought, that nei-
ther preceded the other and that thought with its symbols arose
out of social life even as the latter rose out of thought?

Professor Cassirer seeks to establish the *functional*, not the
substantial, unity of the various fields of specifically human en-
deavor: ". . . not a unity of effects but a unity of action; not a
unity of products but a unity of the creative *process*." I am still
not clear as to what sort of unity the professor had in mind, but I
suspect that he conceived it in scholastic terms as a unity or uni-
formity of logical method. If so, Professor Cassirer's undertaking
is forever hopeless. Had not his own mentor, Kant, shown how
unamenable the methods of art, for one, are to logical analysis?
By this time it would have been better to manipulate the raw
material of the problem with the tools of psychoanalysis—to
the findings of which Professor Cassirer pays scant heed.

Even so, the nature of the problem is stated far better and far
more simply than was to be expected in so short a space, and the
author's scrupulous description of the difficulties inevitably to be
met with in any attempt to establish a unity of method between
religion, myth, art, language, history and science is a real con-
tribution in itself.

Contemporary Jewish Record, June 1945

14. Review of the Exhibition *A Problem for Critics*

The exhibition *A Problem for Critics*, now running at 67 Gallery,
is pointed up by Howard Putzel's catalogue note, which singles
out and attempts to define a recent and most important tendency
in American avant-garde painting. It is illustrated somewhat
inconsistently by a show composed of works by artists as dis-
parate as Masson, Miró, Arp, Hofmann, Pollock, Picasso, Gott-
lieb, Gorky, Matta, Rothko, Tamayo, Pousette-Dart, Krasner,
and Seliger. Mr. Putzel ventures to call the trend a "new meta-
morphosism" whose "real forerunners were Arp and Miró."
(James Johnson Sweeney, in the spring *Partisan Review*, refers
to it as "an expressionist direction.") There is no question that

Mr. Putzel has hold of something here. Until recently abstract painting in this country and elsewhere was governed by the structural or formal or "physical" preoccupations that are supposed to exhaust the intentions of cubism and its inheritors. Now there has come a swing back toward "poetry" and "imagination," the signs of which are the return of elements of representation, smudged contour lines, and the third dimension. Images, no longer locked to the surface in flat profile, reappear against indeterminate, atmospheric depths. Exhibited emotions give the spectator something to hang his interest on.

Aware of the dominant direction of art since the mid-nineteenth century—which, compelled by the social, psychological, and philosophical necessities of our late bourgeois age, takes painting farther and farther from illusion—one is liable to pronounce Mr. Putzel's new "ism" a step backward. But the judgment of taste does not quite agree. The aridity of orthodox abstract art—the fault belongs to the practitioners rather than to the mode—has of late been such that relief from almost any quarter seems welcome. Yet a great danger is involved in this new quasi-literary turn.

For one thing, I disagree with Mr. Putzel that the inspiration of the new tendency came from Arp and Miró—both of whom, despite their desire to restore "poetry" to modern painting, continue the flattening-out, abstracting, "purifying" process of cubism. And their influence, moreover, was strong in abstract painting long before the new turn came. No, that owes its impulse to surrealist "biomorphism." Whereas the cubists and post-cubists, including Arp and Miró, had either ended with the inanimate still life or made the animate inanimate by reducing it to pure silhouette, "biomorphism," restoring the third dimension, gave the elements of abstract painting the look of organic substances.

There is nothing aesthetically wrong in this per se, but it does at this moment entail a certain return to the human-all-too-human, too obvious emotion, and academic subterfuges. The novelty and apparent importance of his subject tend to keep the artist from realizing the conventionality of his methods. Instead of exploring the means of his art in order to produce his subject matter, he will hunt about for new "ideas" under which to cover

29

up the failure to develop his means. These new "ideas" may make a sensation for a day, but they shortly begin to look woefully faded.

Many of the painters at 67 Gallery do not really belong to the new trend. Most of those who do have succumbed to its dangers. One or two, however, have accepted just enough of surrealist cross-fertilization to free themselves from the strangling personal influence of the cubist and post-cubist masters. Yet they have not abandoned the direction these masters charted. They advance their art by painterly means without relaxing the concentration and high impassiveness of true modern style.

The Nation, 9 June 1945

15. The Flemish Masters: Review of *The Last Flowering of the Middle Ages* by Joseph van der Elst

The easel picture was prefigured in manuscript illustration and in the panels of the altarpiece. The cathedrals north of the Alps, with their skeletal structures and great windows, could not accommodate murals, only isolated great pictures or sets of pictures in ornate frames. The magnates and clerical bureaucrats of Flanders found in the framed picture a proper means by which to celebrate themselves publicly in their character as individuals, for the framed picture spoke for itself and was not to be subordinated to its architectural surroundings in the role of mere decoration.

The presence of a tradition of book illumination developed in the courts of France and Burgundy also conditioned Flemish painting. By this, as well as by the general influence of Gothic style, the Flemish picture was determined as a matter more of detail and compression than of broad spatial design. The picture was arrived at by the exclusion rather than the organization of space, and aimed at retaining and fixing attention instead of catching it in flight as Italian painting did. The latter remained closer to the mural and accomplished the transition to the three-dimensional much more slowly—given that this transition be-

gan with Giotto. Derived so intimately from missal art—and to some extent, in my opinion, from the very naturalistic late medieval sculpture—the painting of Flanders in the fifteenth century remains late Gothic in its crowded, angular design, its profusion of anecdotal and other detail, and its ornamental emphasis, reminiscent of metal work.

Paying relatively scant heed to rhythm and unifying design, the Flemish painter distributed his accents with little modulation over the entire surface of his picture. This would have been fitting enough had the painter kept his handling somewhat flat, but having just discovered the ways of rendering depth and mass, he insisted on modeling all volumes boldly and with almost equal prominence. Thus the effect was one of turgidity. It was a mode more appropriate to the illustration of books than to pictures to be seen at a distance, and it constitutes a defect of the Flemish style which all its excellences cannot make us overlook.

This stricture does not apply, however, to the portraits executed by these same painters, which through clarity of design and coolness of handling acquire a monumentality their larger and more strident religious-anecdotal pictures generally lack. The psychological naturalism and impersonal intimacy of these portraits put them on a level that in some respects no later work has approached (except Goya's portraits). Here the Flemings were at their most modern—and only by anticipating the modern did they produce their greatest work.

Straddled between the Middle Ages and the Renaissance, between the aristocratic court and the bourgeois town, Flemish naturalism underwent a premature development—chiefly at the hands of Jan van Eyck, who, the first and greatest genius of all the Flemish painters, managed best at the same time to redeem this prematurity. (Van Eyck was once credited with having invented painting in oil, but it seems that he only developed it to a new point.) Van Eyck transferred to the wooden panel and expanded with amazing suddenness the naturalism that Franco-Flemish manuscript illustration had incubated, and he posed and nearly succeeded in solving problems that almost none of his successors were equal to. How to order the rich variety of visual phenomena the artist was cast upon once he abandoned the prescriptions of the church? How to discipline the peculiarly

Flemish appetite for the texture and grain of objects? It remains one of the charms and yet one of the shortcomings of van Eyck's art that it overpowers by a wealth of minutiae thrown into lapidarian relief. But toward the end of his career he seems to have discovered atmosphere as a selective agent that, in the absence of iconographical prescriptions, decided what was to be emphasized and what subordinated. Van Eyck, however, was too far in advance of his times, and of his lineal successors only Hugo van der Goes retrieved anything of the uses of atmosphere. Memlinc, thirty years after van Eyck, faced with the still unsolved problem of organizing the anecdotal picture, made a great if sudden retreat to the principles of book illustration in designing the pictures for the famous St. Ursula shrine in Bruges.

Only when the center of Lowlands trade shifted from the comparatively provincial Bruges, Louvain, Ghent, to the world port of Antwerp did Flemish painting begin to lose its peculiarly gawky character—that blending of regional Gothic with naive naturalism and brilliant physical finish. Quinten Massys is still a Fleming but one softened by cosmopolitanism. Hieronymus Bosch is still Gothic, but worldly Gothic, and some of his plastic means show a modernity out of all relation to the painting then around him. Brueghel, his continuator, was even farther ahead of his times than van Eyck had been; he combined a summary and far from naive naturalism with a painterly sense of the decorative and two-dimensional in a way only to be approached again by Courbet three hundred years later. (Courbet, like Bosch and Brueghel, was a peasant by origin and, also like them, hostile to the ways of the high bourgeoisie. Never elsewhere did the petty bourgeoisie express themselves in as great and as enlightened a way as in the art of these three.)

Baron van der Elst's *The Last Flowering of the Middle Ages*, attempting to evoke the milieu in which they lived, describes, explains, and evaluates the work of the principal Flemish masters of the fifteenth century, including Bosch and Brueghel. Despite the fact that it very often hovers on the edge of banality, the book provides as good an introduction to its subject as I know of in English, and it does succeed in bodying forth some of the reality of the things it treats. In addition, it is well illustrated.

As Meyer Schapiro pointed out in his review of the book in

View, the Baron gives too idyllic a picture of the fifteenth century in Flanders. (I would recommend Jan Huizinga's *The Waning of the Middle Ages* as an indispensable corrective.) There was something over-ripe and slightly vicious about the period, of which the noble author gives little hint. And yet the art he considers provides unmistakable evidence. A certain malaise is to be detected in van der Weyden, under and above the intense emotionalism that is restrained by the lingering decorum of Gothic gesture. That marvelous painter van der Goes was a psychotic who suffered from delusions of guilt. Van Eyck, for his part, gained his insight as a portraitist from a rather profane detachment. Commissioned chiefly by cosmopolitan courts, he expressed a worldliness that the high bourgeoisie, upon whose patronage his successors were dependent, were not yet ready to accept. Yet they were on their way to it, and the closer they came, the more their painters had to force religious feeling. It is this forcing that tells. And the need to do so also tells. The worldliness did not come easy, and the fifteenth-century crisis in Catholic belief was also a crisis of premature skepticism—for the middle classes had not the psychological resources to come to terms with the skepticism generated in aristocratic and intellectual circles.

There is still another aspect to the historical ambiguity of Flemish painting. The painters of Flanders, like all other trades of the time, were organized in guilds whose members constituted a sort of petty bourgeoisie. The guilds were hostile to the developing capitalism, and this made their mood, in a historical sense, reactionary. At the same time the control they exercised over their members tended to discourage innovation or experiment. In so far as painting was an intellectual pursuit—which it always is in part—it went in advance of the times; but in so far as it was a guild trade, it hung back. As rapid as seems the progress of Flemish painting in the fifteenth century, one has only to compare it with what was going on in Italy at the same time to see that it actually did little more than fill in the outlines already sketched by van Eyck. Again and again during its course it suddenly faces about toward the past as it comes up against the problems of naturalism that van Eyck failed to solve. And it only leaps forward once more with Bosch and Brueghel at a time

when the great commercial expansion signalized by the ascendancy of Antwerp was giving the guild system—and with it the "primitive" tradition of Flemish painting—its quietus.

The Nation, 11 August 1945

16.　On Looking at Pictures: Review of *Painting and Painters: How to Look at a Picture: From Giotto to Chagall* by Lionello Venturi

Most books that propose to tell you how to look at pictures turn—usually very early—into expositions of how pictures get to look the way they do. Lionello Venturi's *Painting and Painters: How to Look at a Picture: From Giotto to Chagall* is no exception.

Professor Venturi's conclusion states: "The first impression of a picture is quite vague, and it is only after an analysis of all its components that we may really understand the meaning of each of them and of the picture as a whole." This statement seems to me highly misleading if not completely wrong. The process of looking at a picture is infinitely more complex in scheme than that; it cannot be analyzed into discrete, sequential moments but only, if at all, into logical moments (though logic as such has very little to do with the experience of art). Doesn't one find so many times that the "full meaning" of a picture—i.e., its aesthetic fact—is, at any given visit to it, most fully revealed at the first fresh glance? And that this "meaning" fades progressively as continued examination destroys the unity of impression? With many paintings and pieces of sculpture it is as if you had to catch them by surprise in order to grasp them as wholes—their maximum being packed into the instantaneous shock of sight. Whereas if you plant yourself too firmly before looking at a picture and then gaze at it too long you are likely to end by having it merely gaze blankly back at you.

Professor Venturi is one of the few competent living art critics, and his book gives an expert and philosophical, if sketchy, account of the development of Western painting until the present. Yet books telling you how to look at pictures should gen-

erally be read only after you have already learned how by patient experience.

The keystone of Professor Venturi's aesthetics is the somewhat Crocean axiom that "the only standard for . . . appreciation is the personality of the artist"—which is correct but open to serious misinterpretation. The chief difficulty of this book is that it constantly announces the truth in misleading or incomplete terms. There is an inability to round out expression that makes for a certain haziness and incoherence which do not, perhaps, characterize the professor's thought itself.

The Nation, 8 September 1945

17. Review of *Marc Chagall* by Lionello Venturi

Lionello Venturi has provided the short text to an excellent book of reproductions of paintings and drawings by Marc Chagall (Pierre Matisse Editions). Chagall's personality is very well understood here, but his art is taken too unqualifiedly to afford us the illumination we have the right to expect from such a mind as Professor Venturi's. The fault may lie with what I detect to be an unconfessed or unconscious hostility on his part to most of modern art since impressionism. The book perpetrates the banal and widespread misconception of cubism as essentially intellectual and "scientific." And by implication Chagall is counterposed to Picasso—which is just as unfair to Chagall as it is to Picasso.

The Nation, 15 September 1945

18. Pictures and Prattle: Review of *Abstract and Surrealist Art in America* by Sidney Janis

Almost the sole merit of Sidney Janis's *Abstract and Surrealist Art in America* is that it prints the names and reproduces, among other things, the paintings of several advanced artists whose

work deserves to be better known. Its text, however, is lamentable. This compost of exalted prattle ("New realities are symbolized which transcend commonplace representation; the secret life of the object; the dynamics of an expanding universe, etc., etc.") and irresponsible pronouncement ("Science is the open sesame of twentieth-century art, and artists have entered where angels fear to tread") is not new. A good deal of French writing about art since Faure exhibits it. But only lately, with the migrations of the surrealists and the expatriates, has it begun to show in English writing. Not that we don't have our own brand of flapdoodle, but it has been so closely associated with the rejection of modern art that it has long since lost its credit. The danger in rhetoric of Mr. Janis's sort (compare the art dealers on holiday who used to fill the text pages of the *Cahiers d'Art*) is that it sounds up to date and comes packaged with reproductions of Picasso and Mondrian.

There is no use quibbling: art writing has a bad name at present, and rightly. In no other field—except politics and perhaps music—can one get away with such hokum in print. The reason is obvious. There has not yet matured a body of good taste within the art world that could call to account statements made in public about art. If such a control were present, the patient work Mr. Janis has put in as a collector would not have been frustrated, for the purposes of this book, by audacities of language and sense committed simply because the license for them was found in contemporary practice.

The Nation, 13 October 1945

19. Review of the Ballet *Dim Luster* by Anthony Tudor

There having been a dearth of art along Fifty-seventh Street this past month, I trust Mr. Haggin[1] will forgive me for poaching on his preserve. I want to protest against the omission of Anthony Tudor's realistic ballet *Dim Luster* from the last and present runs of the Ballet Theater at the Metropolitan. I know

1. B. H. Haggin, music and dance critic for *The Nation*. [Editor's note]

little about ballet, but *Dim Luster* seems to me one of the most original and successful works of art produced in the last five years—regardless of whether or not ballet is the very minor art form some assert it to be.

Like opera, ballet in this country is a rite, but not so much a social and financial as a cultural and sexual one. Like all latter-day rites, ballet has a remote point of departure, and there is a little relation between life as lived in the audience and the notion of it conveyed from the stage. With opera, ballet belongs under the heading of what is called escapist art. But for a number of reasons which cannot be gone into here, ballet is not quite so uncompromisingly escapist. For one thing, it is less archaeological and more folkloristic.

The remarkable thing about Anthony Tudor's ballets is that at times they actually try to deal, in cogent terms, with some of the issues that right here and now agitate the private lives of a good section of the ballet audience.

True, in most of his works Tudor is either too pretentious—in a Weimar Republic, depth-psychological sort of way—or too cute, although even I can discern the brilliance of the choreography in almost everything he does. But in *Dim Luster* he delivers himself for the first time purely and inevitably; here his art bites off exactly as much as it can chew, not too much and not too little. The choreography is a sublimation of the ballroom, the kind of dancing most natural to the audience itself and the kind, after jitterbugging, most popularly alive. The story is not injected into the dancing, nor is the dancing superimposed upon the story. Every element, including the décor and Richard Strauss's slightly dissonant music—which alludes to and parodies ballroom music—flows into and out of every other element.

The scene is a ball: a couple in white among other couples, striding and whirling. During a slight pause someone puts his hand on the male partner's arm, which suddenly brings some memory out of his past. His body freezes in its momentary pose, while his partner stands wondering. Then the floor empties, the lights go down, and he is left to dance alone in front of the skilfully contrived illusion of a mirror, on the other side of which another dancer, dressed exactly as he is, dances back the illusion of his reflection. Then, as the lights go dimly up, a girl dressed in pale green appears and she and the man dance together: his

first sweetheart—innocence, enthusiasm, illusion, etc. The dance finishes, the lights go off and on again, returning the man to the ballroom and his partner. A moment later the latter too receives a flash of memory, from a dropped handkerchief, and she goes through the same pantomime, likewise dances with the wraith of her first sweetheart, and is then returned to the ballroom and her partner. This happens to both dancers two or three times, each time with a different lover out of their respective pasts, as in memory they advance from innocence to what I take to be sin and responsibility. In the intervals, when they are together in the ballroom, they grow more and more bored with each other, and by the time the curtain falls are dancing with the perfunctoriness of indifference and alienation. *Punkt*.

Dim Luster contains a rather dark view of contemporary sexual relations. The narcissistic passages offer a clue to a meaning underneath the obvious one, which is merely that the past is perfect while the present is incomplete. No, the partners are each in love with their respective selves, and because they are in love with their selves, they are in love with their own sex. Thus they may really be in love with each other's past, with the men or women the other has had. (Marlene Dietrich sings a song that goes "My past that makes you hate me makes you love me too.") The final impression is that the triumph of homosexual over heterosexual love is being celebrated; a homosexual pattern is shown imposing itself on a heterosexual situation.

This seems to me to be something much more realistic than anything ballet has ever dared to do before. It has behind it the courage of the truth, for the tendency toward the homosexualization of all sex in our society is becoming more and more apparent. What is involved is not simply homosexuality as such but the devaluation of love and sexual relations in general. Perhaps this is why the audience has rejected *Dim Luster*—it would not have been withdrawn for any other reason than lack of public approval. The audience does not want to be told anything about its own life, it does not want realism; it wants its art high-flown and fancy.

That one of the most original works of art of our small moment should have proved unpalatable to a presumably literate audience is—to use the first cliché that comes to hand—one

of the saddest commentaries upon the present state of art-consumption.

The Nation, 3 November 1945

20. Review of Exhibitions of De la Fresnaye and
 Stuart Davis

After the fauve color explosion there came around 1907–08—when Cézanne replaced Van Gogh and Gauguin as the dominant influence—a gradual sobering of the palettes of the younger avant-garde painters in France. By 1914, when analytical cubism was in full flower, Picasso and Braque were turning out pictures whose color ran no wider gamut than that between black, brown, and gray-white. Matisse was using monumental dark shapes to construct some of his greatest masterpieces; even Chagall's color was relatively somber in this period; while Derain, Vlaminck, and Segonzac were returning the emphasis from hue to value. Those artists who still kept their color high generally lowered its intensity and dulled its finish—with the notable exception of Modigliani. Yet something of the rawness of fauvism still lingered: an imprecision, a renunciation of crispness of finish and of tangible paint quality. The refinement of cubist and post-cubist painting was not to begin until around 1918, when the discovery and adumbration of that which still constitutes the essential elements of modern style were completed.

There were, however, one or two exceptions besides Modigliani—prominent among them Roger de la Fresnaye, who as soon as he had absorbed all that he wanted or could absorb of Picasso's and Braque's developing cubism proceeded to render it elegant, decorative, and cheerful. It is from De la Fresnaye, one of the secondary figures of the cubist movement, that a good deal of the academicism of post-cubist art takes it departure. He was not the first to put pure, high color into cubism, but he was almost the first to put it in flat, in roughly blocked-out shapes, and one of the first, along with Delaunay, to explore the possibilities of cubism as quasi-abstract decoration.

De la Fresnaye anticipated the softening and prettifying of cubism. Endowed with a feminine sensibility, he was quick to grasp the point of the new style and, in grasping it, to suppress all the struggles and resistances through which it had originally been developed. But even so, he came so early that he could not avoid a certain minimum of struggle. He was in his own way a pioneer, and he had for a time to grope and stumble; he was clumsy, he made errors, and he failed to understand completely what he was doing. The evidences of the struggle are in two big canvases, *The Artillery* and *Conquest of the Air*, executed in 1911 and 1913 respectively—the latter was to be seen at a fine show of De la Fresnaye's paintings, drawings, and sculpture at the Buchholz Gallery—in which cubism is used as a decorative façade rather than as a means of transforming space integrally.

It was in the still life that De la Fresnaye, restricting his data to inanimate, manufactured objects, finally revealed his full powers. Organized around the oppositions of straight lines and relatively exact curves and circles, with clear, fresh color applied so thinly that the white priming of the canvas underneath becomes a tonal ingredient in itself, his paintings of the period 1913–14 achieve in their delicacy one of the early culminations of cubist style. Yet even in these he betrays now and then the still insecure hold he had on the elements of that style. Thus the roll of paper in *Le Diabolo,* being presented in accurate perspective and somewhat strongly modeled, jumps out of context and clashes with everything else in the picture; while in the *Still Life with Cylinders* the pasted strips of white paper are arbitrary and their function could just as well have been performed by white paint.

De la Fresnaye was gassed at the front in the First World War and died of the after-effects in 1925, at the age of forty. Whether he had much left to say is doubtful, harsh as it may sound to say so. From 1917 on his work had beat a steady retreat from the positions he intrepidly occupied at the beginning of his career. What was lacking was a surplus of energy above and beyond that embodied in his taste, superlative as that was.

The same may be said, *mutatis mutandis,* of Stuart Davis, whose life work to date is surveyed in a one-man show at the Museum of Modern Art. The nature of Davis's gift is startlingly like that of his contemporary and compatriot Alexander Calder,

and their careers run closely parallel. Both have made modern art cheerful; both needed a trip to Paris and the absorption of French influence on the scene in order to find themselves; provincials in relations to the School of Paris, both show that eminent capacity of provincials for tasteful adaptation and also the felicity permitted by the un-obsessed mind. The felicity and taste of these two artists is, as a matter of fact, prodigious. Of the fifty paintings in Davis's exhibition, no more than three or four actually fail on their own terms; and I was struck by a similar evenness in Calder's one-man show at the Modern Museum two years ago.

Davis is a natural painter. Two town scenes—*Gloucester Street* and *Gloucester Terrace*—painted in 1916 at the age of twenty-two under the influences of Van Gogh and Gauguin, demonstrate that he had his gift under control almost from the beginning; his chief problem was simply where to direct it. And it is an open question whether anything Davis has painted since then is intrinsically superior to these two canvases, which are original in the same way De la Fresnaye's cubism is original: they generalize and make immediately pleasing what more seminal artists produced at the cost of strain and frequent error.

Davis early came under the influence of cubism, which he, again like De la Fresnaye in the beginning, appropriated as a decorative method at first. By 1928, however, he had painted a full-fledged abstract picture, *Eggbeater No. 3*, which helped establish *the* American inflection of post-cubist abstract style for the next ten years. In 1929, also, Davis went to Paris, where he painted a series of street scenes in which two-dimensional calligraphic patterns inclose flat planes in pastel shades. These represent in my opinion the most important work he has yet done. There is no great force behind them, they rely on hints from almost every contemporary member of the School of Paris—yet they are of their kind perfect. And they evoke the time and place in which they were turned out as little else of that period still does—that is, they are period and yet not limited aesthetically by being so. They are exquisite minor art, sufficient unto their moment and without a thing to say to the young artist who comes seeking examples; yet they will remain.

Since 1933 or so Davis's painting has become more and more abstract and at the same time decorative to the point where it is

hardly easel-painting any more. He has invented an idiom of his own, influenced as far as I can see by the diagrams of radio-set hookups—a calligraphy of zigzags, circles, and broken curves laid against flat, solid shapes in uniform color. This idiom he manipulates with varying success, one year better, the next year worse, but nothing has yet equaled his work of 1928–29. The moral is the same as in De la Fresnaye's case: taste is not enough for a lifetime of art.

The only salvation I can suggest for artists such as Davis, Calder, and De la Fresnaye is that society give them fixed, exactly defined tasks that require them to fit their cheerfulness and discretion into the general décor of modern life in a systematic way. Let Davis and Calder create an atmosphere in which to move, not solo works of art. There are the examples of Boucher and Fragonard, whose spirit their own resembles.

The Nation, 17 November 1945

21. Review of the Second Pepsi-Cola Annual

The second annual *Portrait of America* exhibition is now functioning, under the aegis of the Pepsi-Cola Company, at the International Building, Rockefeller Center. Here are 150 paintings by living American artists which were selected by a jury of fellow-artists from 3,270 items submitted in open competition from all over the country. The jury was divided into a "traditional" and a "modern" panel, and the entrants were asked to specify under which category they wished their work to be judged. Of the pictures finally hung, twenty were awarded prizes by a jury composed of a museum director, an art critic, and three painters. As it happened, all the prize-winning canvases were entered as either "modern" or both "modern" and "traditional," none being entered simply as "traditional."

This procedure of selection, with its unabashed assertion that two different yardsticks were needed for the fair evaluation of contemporary art, augured the worst. And the worst came about. Four-fifths of the pictures shown are rampantly bad—to

say they are mediocre would give an incorrect impression. What is shocking is that so many of the artists present do not seem to possess even a journeyman's control of their craft, much less an artist's. There are passages in not a few canvases that would not have been allowed to go unwiped in any decent elementary art school; let art lovers take a good look at Paul Burlin's *Soda Jerker*, which won the first price of $2,500.

Contemporary American painting at its best is not one-quarter as bad as this monstrous show makes it out to be. For the discrepancy the jurors, I suppose, must be held responsible—unless, as is possible, our better painters did not bother to submit their work. Abstract art is gingerly represented, in very bad examples. The School of Paris is admitted in its fourth-hand forms. It is perhaps because the title of the exhibition was taken literally that it abounds so in raw landscapes and street scenes. America apparently is not people but what you see from the window—not that it makes much difference. But the fact that the hues of the American scene are not held to be as soft and harmonious as those of the European is no excuse for coarse brushwork and muddy color.

The mass of art in any period is mediocre, but it is not often that a prevailing style is founded on a misconception. The curious thing about many of the pictures at the *Portrait of America* show is that they are not conceived with a banality equal to that of their execution. In many cases they were thought through with fair success in terms of the values of dark and light; complete disaster ensued only when color was laid on in the modern unvalued manner. The explanation for this lies in the unpublished fact that most American painters of the present period are more academic by instinct than they admit to themselves; their art has nothing to do essentially with anything later than Manet's first period; and they think and feel in the language of values—of darks and lights—rather than of color. Yet they insist on superimposing color, in the manner of Cézanne, Gauguin, or Utrillo, upon a framework that calls for glazes, half-tones, gradual transitions.

There are, of course, two or three mildly successful pictures present: for one, Max Weber's still life, which won the second prize—and which demonstrates again that Weber should leave

landscape and the human figure alone from now on. But taken altogether with the calamitous Whitney Annuals, the National Academy of Design's fliers into modern art, and the recent Critics Show at the Armory on Park Avenue—all of them, aesthetically speaking, of a supreme squalor—the *Portrait of America* exhibition makes the situation really grave. We are in danger of having a new kind of official art foisted on us—official "modern" art. It is being done by well-intentioned people like the Pepsi-Cola Company who fail to realize that to be for something uncritically does more harm in the end than being against it. For while official art, when it was thoroughly academic, furnished at least a sort of challenge, official "modern" art of this type will confuse, discourage, and dissuade the true creator.

The Nation, 1 December 1945

22. Review of the Exhibition *Landscape*; of Two Exhibitions of Käthe Kollwitz; and of the Oil Painting Section of the Whitney Annual

It is seldom that so many great pictures can be seen together as at the Brooklyn Museum's present *Landscape* show. Starting—a bit paradoxically—with a superb little *Crucifixion* by Lorenzo Monaco in the fourteenth century, it progresses through the Renaissance, the baroque, and the nineteenth century, to come to an anti-climactic stop with a dead bird in the grass executed with meretricious and astounding precision by the young American Andrew Wyeth. The great climaxes on the way are Van Goyen's gray-on-brown portrait of a cloudy sky, called *View of Rynland*; Guardi's *View of Mestre*—rectangular forms suffused with pink, pearl-gray, and light sienna or umber—and Matisse's magnificent *Paysage du Montalban*, in which effects are massed not only by design but also by color, green being summarily transposed into black, umber, and gray, and the trunks of saplings dealt with in cerulean blue.

Around these masterpieces are gathered other lesser ones—only to be called lesser because of the presence of the first three—by Sassetta, Veronese, Brueghel, Annibale Carracci (who on

the evidence of the sample here might have become one of the greatest of all landscapists had not his period and mistaken ambition forced him to pursue the grand style), Seghers, Ruysdael, Rembrandt, Fragonard, Constable, Corot, Courbet, Eakins, Cézanne, Henri Rousseau, and several others.

There are some disappointments: notably the two Claude Lorrains, which in spite of excellent passages are wooden. Renoir, who painted some of the best landscapes of all time, is represented by a picture in which only the foreground is inspired. And the hysteria in the Van Gogh street scene is merely mechanical.

Not all the paintings here are landscapes in the strict definition of the term, but one is grateful in the main for the broadness with which that term has been applied. Yet the looseness of terminology or slackening of taste that induced the museum to include Tchelitchew, Tanguy, Seligmann, Ernst, Berman, Burchfield, and Wyeth in the show cannot be forgiven. Since the museum was willing to go that far, room might also have been made for Mattson, Henry Varnum Poor, Russell Cowles, and Arnold Friedman. The first three are tame, it is true, but at least more solidly in possession of their genre than any other conventional American landscapists of the moment; while Friedman's rose and green mountain scenes can hold their own with anything in the line of open-air painting being produced right now (exception made for two or three Frenchmen). Incidentally, why were Pissarro, Sisley, Derain, Vlaminck, Utrillo, Segonzac, and Bonnard left out? To make room for Thomas Moran, Regis Gignoux, Ben Shahn, Walter Stuempfig, Jr., and a very doubtful and inferior Giorgione?

Käthe Kollwitz died in Germany two months ago and is being commemorated by two shows, one at the Galerie St. Etienne and the other at the Tribune Book and Art Center. Apparently a strong talent, she was deflected as well as inspired by her sympathy with the suffering and the oppressed. The problems she proposes herself in her etchings and lithographs are solved sometimes with considerable success, but always within the academic framework, with light and shade used much as Rembrandt would have used them—only more nervously. It is in her woodcuts, where silhouette and texture show Munch's influence, that she tries to attain a greater intensity of expres-

siveness. Here the power is such that one is disappointed that it is not more. The passion inspired in her by her theme required a complementary passion for her medium, to counteract a certain inevitable excess. Because this excess remains—in our failure to be stirred as much as we feel we ought to be—her art never quite manages to soar into that sphere where Goya and Daumier move. Nevertheless, Käthe Kollwitz will not be forgotten; her seriousness and moral passion suffice to create a lasting personality if not a lasting art.

The oil painting instalment of this year's Whitney Annual is a cut or two above the *Portrait of America*[1] fiasco at Rockefeller Center, but this does not prevent it from sinking to what seems a new low—but I have this impression every year. Abstract art is copiously represented, but its practitioners do just as badly as everybody else—with a few exceptions, who are Gorky, Adolph Gottlieb, Feininger, and Karl Knaths. There is also a very good seascape by Marin, and a passable picture by Sol Wilson. Léger's large decoration is on a high level but disintegrates around a red-white-and-blue cocarde (the artist's answer to current events).

One's first impulse as a result of this show is to write off a whole generation of American painters. But perhaps here again the jury is to blame—by jury I mean the museum's staff. Or perhaps we have no right to expect anything much better. I don't know. It is possible that I have a jaundiced eye. But I do know that I am fed up with contemporary American art in wholesale quantities.

The Nation, 15 December 1945

23. Review of *Cézanne's Composition* by Earle Loran

Really valuable texts on art are so few that whenever one appears the fact should be proclaimed in haste. I have had Earle

1. Sponsored by the Pepsi-Cola Company, and reviewed by Greenberg two weeks earlier (*The Nation*, 1 December 1945). [Editor's note]

Loran's *Cézanne's Composition* in my hands for almost two years and have delayed reviewing it—which was unfair to everyone concerned—only because I wanted to make sure that I understood Professor Loran's thesis exactly. In the meantime, however, I have learned a great deal from his book about modern painting in general.

Professor Loran—himself a painter as well as associate professor of art at the University of California—devotes his attention mainly to Cézanne's concrete means and methods, and he arrives thereby at an understanding of Cézanne's art more essential than any other I have seen in print. Professor Loran's thesis declares that the French master achieved his effects of volume and space primarily by "linear structure," not by color texture. This goes against the standard notion—presented impressively by the Austrian Fritz Novotny and more recently repeated in brief by Edward Alden Jewell in his preface to a thin volume of bad reproductions called *Cézanne*—which contends, in Mr. Jewell's words, that Cézanne "established recession from the picture plane by means of a system of modulated color or the use of different colors to mark the receding planes."

Professor Loran explains his own view in detail by diagrammatic analysis of some thirty-odd paintings, presented in black and white reproduction along with many interesting photographs of the original motif in nature from which the master made his open-air pictures. From his argument Professor Loran derives a system of principles through which not only Cézanne, he claims, but almost all great artists who explored the illusion of the third dimension on a flat surface obtained their best results. These principles—which are a matter of intuition and experience rather than of conscious thought—make it necessary to simplify, distort, and abstract in order to create spatial and volume tensions without violating the two-dimensional integrity of the picture plane. Here linear outline—not as final effect, as arabesque, but as a means of construction—is more decisive than modeling, whether in facets of pigment or in darks and lights.

Distortions, as we know, play a prime role in Cézanne's art. It is the drawing that they dictate which divides pictorial space into dynamic entities. The little color facets, subtly defining

each small variation of plane, do but clothe the skeleton, confirming and making more substantial what is already there in principle. One of the proofs of Professor Loran's thesis—which he himself does not mention—is how well Cézanne's pictures stand up in black-and-white reproduction, by contrast to strictly impressionist paintings, which depend far more on color and texture. But this fact should also give us to think whether Cézanne did not pay more attention to dark and light values than he himself realized.

Of course, Cézanne's color plays an enormously important part in the final effects of his art—and far from overlooking this part, Professor Loran deals with it at length. Cézanne's own conception of the importance of color is shown by his preference for the Venetian and Spanish schools of painting above others of the past. Those who choose painterly painting must stress color, and properly. Yet Picasso and Braque showed how profoundly they understood Cézanne when, in embarking upon cubism under his influence, they stripped themselves down to black, brown, gray, and white in order to lay bare the bones of the problem. In no other way could the meaning of the revolution Cézanne precipitated have been so relevantly made plain.

There is not the space here to go into the nature of that revolution. Suffice to say that it has been radically misunderstood by those critics who argue from Cézanne's example that volume—or "plasticity"—is the end-all and be-all of painting. If anything, the case is exactly the opposite with regard to Cézanne's historical effect, for his example as much as anyone's has strengthened the modern tendency toward flat painting.

And as for his epigones among painters themselves: they have applied his drawing in a fashion and they have applied the general tonality of his color, but they have not digested the inner logic of either. Thus their conception of pictorial space remains essentially pre-Cézannean. I cite as evidence the work of Max Weber, that estimable but somewhat overrated artist who has not yet perceived, as Cézanne did from the first, that it is the unity of a picture that constitutes its virtuality as a successful work of art, not the juiciness of brush strokes, not the amount of paint quality per square inch.

One more word. Professor Loran is no idolator of Cézanne and

is not blind to his few shortcomings. It is this among other things that helps make his book such a good textbook for the concrete understanding of modern painting. The failures of a great painter are often more illuminating to the student than his successes.

The Nation, 29 December 1945

1946

24. The Storage of Art from Germany at the National
Gallery, Washington

As we all know from the newspapers, two hundred important
paintings by masters ranging in time from Giotto to Daumier
have been brought to this country from damaged or destroyed
museums in Germany by the United States government for safe-
keeping in the storage rooms of the National Gallery at Wash-
ington. They will be returned to Germany when "definitely
established as being of bona fide German ownership . . . and
when conditions there warrant." Meanwhile, "it is not contem-
plated that any of these works of art will be exhibited to the pub-
lic at present."

I have seen the list of the pictures involved in this trans-
action, and the number of great masters and the quantity in
which they are represented take my breath away: four Alt-
dorfers, four Baldung Griens, five Botticellis, three Bronzinos,
three Cranachs, two Chardins, five Dürers, four Elsheimers,
three Guardis, six Halses, three Holbeins (including the por-
trait of Giesze), two Mantegnas, three Masaccios, three Mem-
lincs, two Giovanni di Paolos, two Poussins, two Raphaels, fif-
teen Rembrandts, six Rubenses, two Sassettas, three Signo-
rellis, two Steens, two Ter Borchs, three Tiepolos, two Tintoret-
tos, five Titians, five Van der Weydens, five (!) Van Eycks, two
Van Leydens, two Velasquezes, two Vermeers, two Andrea del
Verrochios, three Watteaus—not to mention single examples
by Fra Angelico, Bosch, Caravaggio, Carpaccio, Correggio,
Piero di Cosimo, Giorgione, Hobbema, the Lippis, Lorrain,
Patinir, Ruysdael, Schongauer, Seghers, Cosimo Tura, Manet,
and still others.

That these works should come to this country and remain un-
seen is of a piece with everything else that distinguishes an age
which, even when it wants to, can no more tell the difference

50

between man as an end and man as a means than it can tell the difference between things as ends and things as means.

These pictures are means, let there be no mistake about that—means to the gratification of man. When they are removed from sight their purpose is violated. And to handle them at the same time with such care (air-conditioned storage) is to regard them in effect as objects solely of great material value, which is to pervert their function. The money value the pictures represent becomes more important and more of an end than the delight they would afford countless people in this country who will never be able to travel to see them in Europe.

Naturally, it would cost money to put the pictures on public exhibition—and that is a consideration; especially since it would be better to show them all at once than piecemeal, and still better send them around the country. But if money is all that stands in the way, a collection could be taken up; or perhaps some rich benefactor of the arts would come forward to donate the costs. At any rate they ought to be shown; if they come and go without being seen by the American public it will amount to a scandal.

The Nation, 5 January 1946

25. Review of Exhibitions of Hyman Bloom, David Smith, and Robert Motherwell

What characterizes painting in the line Manet to Mondrian—as well as poetry from Verlaine through Mallarmé to Apollinaire and Wallace Stevens—is its pastoral mood. It is this that is mistaken for the "classical." And it is away from the pastoral, the preoccupation with nature at rest, human beings at leisure, and art in movement, that so much painting has turned of late. And what it has turned toward is not the "romantic" but the baroque, which Wölfflin (who died in Zurich the other day) has defined as the "open" style par excellence—open to variety and violence of emotion as well as to large and complicated formal rhythms.

Now the pastoral, in modern painting and elsewhere, de-

pends on two interdependent attitudes: the first, a dissatisfaction with the moods prevailing in society's centers of activity; the second, a conviction of the stability of society in one's own time. One flees to the shepherds from the controversies that agitate the market-place. But this flight—which takes place in art—depends inevitably upon a feeling that the society left behind will continue to protect and provide for the fugitive, no matter what differences he may have with it.

This feeling of pastoral security has become increasingly difficult to maintain in the last two decades. It is the dissipation of this sense of security that makes the survival of modern avant-garde art problematical. The first impulse is to rush back to the market-place and intervene in or report its activities. Here political art, some forms of expressionism, popular surrealism, and neo-romanticism complement one another in their anxiety to relate art to the current crisis of our civilization. What is wrong, however, with surrealism and neo-romanticism in particular is that they stay falsely pastoral in resorting to styles of the past in order to make emotions about the present plain and explicit. Genuinely pastoral art never turns to the past; it simply rejects one present in favor of another—and without escapism. Even today one must look still to avant-garde pastoral art to see revealed the most permanent features of our society's crisis.

It is only lately that the reaction against the pastoral as compelled by current events has begun to manifest itself in art of any real seriousness. The exponents of this seriousness are still few. Significantly enough, among the first of them are such one-time cubists or near-cubists as Picasso and Lipchitz. In common with surrealism and neo-romanticism, their reaction takes the form of the baroque, but it is a more profoundly disquieted baroque, less archaeological, more at odds with itself, and crowded with disparate elements. Thus Picasso's baroque is among other things a kind of neo-cubism, and Lipchitz's an attempted fusion of Bernini's chiaroscuro with expressionism.

Somewhat pertinent in this connection is the exhibition of the recent work of Hyman Bloom at Durlacher Brothers. Bloom is attracted to Jewish motifs in his art: Jews with Torah rolls and women who are brides—no motif is more distinctively Jewish than the second of these, the bride being one of the chief person-

ifications of the Sabbath and a favorite likeness in Hebrew poetry. Bloom's expressionism derives from Soutine, Rouault, and perhaps Chagall, but he asserts enough of himself to make his version of the baroque more than a sum of influences. Heavy in paint texture, its color "crushed jewels," with much scarlet, pearl-white, and ochre, his art reveals, however, no fundamentally new capacities of the expressionist style. In four of the thirteen canvases at the present show it attains, nevertheless, a curious quietness that, because it belongs exclusively to art, argues more strongly than the mere violence of feeling exhibited elsewhere. In *The Bride, Corpse of Elderly Female, Archaeological Treasure,* and *A Pot*—the last two semi-abstract—the concern with agitated, expressive texture and the compulsion to over-paint cede to the necessities of unity, which, significantly, is achieved by design rather than by disposition of color or texture.

I do not think that Bloom's expressionism offers great possibilities for the future; its postulates have by this time become slightly academic. Even in his best pictures they make it too easy for him to reconcile himself, on the score of expressiveness, to superficial execution and gratuitous flourishes. None the less, Bloom's approach is essentially uncompromising, and the chances are that his honesty will force him to transcend his present style with its limitations and fight through to a clarity that will still permit him to say effectively what he as an individual must say and what he as a Jew in the face of recent events may want to say.

With the sculptor David Smith—a selection of whose total *oeuvre* as well as all his most recent work is being shown at the Willard and Buchholz Galleries—the new incidence of the baroque with all that is problematical about it becomes fully evident. The work in steel, iron, and aluminum that Smith executed with machine tools between 1936 and 1940 was already strong and original enough—indebted though it was to Brancusi and Giacometti—to make him perhaps the best young sculptor in the country. Like all modern sculpture of any vitality since Maillol, it stemmed from painting rather than from any tradition of carving or modeling—Negro art excepted—and its virtue was the line, whether in wire-like form or as the contour of a two-dimensional surface. It closed itself around empty space and eschewed the chiaroscuro of monolithic sculpture. The

point of departure was usually anecdotal but the result highly abstract. A unity of style was achieved that did not inhibit extravagance but inevitably controlled it—generally toward "geometricity," precision, clarity. In its mixture of force and elegance Smith's sculpture in this period profited from the best that cubism and post-cubism have had to offer to the plastic arts of our immediate period.

A war job narrowed Smith's output to a trickle between 1940 and 1944. In 1944–45, however, he turned out no fewer than thirty new pieces of sculpture in a new, baroque vein answering to the mood inspired by late history. Gone is the relatively simple trajectory of line, interrupted now by almost ornamental multiplications of detail. Gone is the "geometricity"; under the new conception surfaces are broken, modeled, squeezed and incised within the smallest compass. Everything coils back upon itself or else explodes into rococo elaboration. No real unity of style governs here; the general impression is more gothic than baroque, but the elements are disparate. While none of this recent work attains the level of his best earlier sculpture, Smith's gift remains inalienable enough still to produce three or four pieces that will give pause to any newcomer to his art. I hesitate to criticize him. The pastoral tranquility of his former style is apparently no longer possible, and this phase of extravagance, disorder, and agitation is something he seems compelled to work his way through. It will take him much time to solve the new problems he has proposed to himself, but he at least proposes new problems and refuses to settle for the guarantees of the past.

Robert Motherwell, whose second one-man show is running at the Kootz Gallery, is an instance in which the baroque spirit of the times and something very unbaroque clash. In concept Motherwell is on the side of violence, diquiet—but his temperament seems to lack the force and sensuousness to carry the concept, while the means he takes from Picasso and Mondrian are treated too hygienically. The richness and complication of color are applied too deliberately and do not accord with the arbitrary, constricted design. Effects are left floating in air, unattached and unnourished by blood vessels, without organic relation to an artist who had to paint thus and not otherwise. The best of Motherwell's work is in his large collages, but even here

one feels that the constituent elements could be rearranged considerably without altering the final invariably anemic effect.

Motherwell's gifts—and he has shown that he possesses them—deserve better exploitation than this. At times in the past he has produced much better work. Yet he has always suffered from a radical unevenness; there have been too many sudden changes of direction, motivated perhaps by an inability to decide what he wants and by conflicting influences. But the essential is to decide what one is, not what one wants.

The Nation, 26 January 1946

26. Review of an Exhibition of David Hare

The sculpture in plaster, concrete, and other materials of David Hare, whose second one-man show is now being held at Art of This Century, is another instance—a rich, full-blown, open instance—of the contemporary baroque. Hare stands second to no sculptor of his generation, unless it be David Smith, in potential talent. But like Smith in his latest phase and like all those who practice the baroque seriously at this moment, he is overwhelmed by the challenge of what is thought to be the contemporary mood.

Hare's is the most intensely surrealist art I have ever seen—in the sense that it goes all the way in the direction of surrealism and then beyond, developing surrealism's premises with a consistency and boldness the surrealist doctrinaires themselves have hardly envisaged. The influence of Giacometti, received directly as well as through Matta's painting, operates here.

Now Giacometti himself in his best phase has near him the late presence of cubism to give some shape and formal direction to his literary adventurousness; in spite of himself, he absorbed a sense of style from his surroundings and his period which served to concentrate his energy. Surrealism of itself could not do this, because it never had a style of its own—that is, not in a formal or plastic sense—and without the infusion of cubism could offer no more than period-revival academicism. Thus it is not surprising that when cubism began to lose its prestige in the public

art world of the late thirties, Giacometti, never a very serious or resolute artist, relapsed into the most abysmal academicism.

Hare preserves Giacometti's demiurgic ambition to create in each work of art a non-aesthetic personality, a new element of "absolute" experience, but he has failed to possess himself as yet of a sense of style comparable to Giacometti's at his best. And he is not concerned enough with the necessity of making sure that the work of art be at least art before becoming a personality. There are, of course, extenuating circumstances in Hare's case. While Giacometti could raise his monsters by hand and in a hothouse, Hare has to meet the rush of a horde of late, hot, field-grown monsters coming from every direction of present-day history. They are not as easy to control as Giacometti's horrors.

Hare's art as a whole suffers from its diversity, its lack of a unifying formal principle, of a consistent plastic bias. The twenty-three "personalities" on exhibition belong to at least seven different periods of geology. Their variety is upsetting instead of stimulating, because it is the result of the absence of style and the presence of elaborations and complications too often motivated by nothing more than exuberance or mechanical facility. Nor does the individual excellence of so many of the pieces—some are superb—remedy their failure to relate to one another.

As I have said, Hare has a prodigious amount of talent. The linear inventiveness of his sculpture cannot be denied; it is almost possible, in fact, to argue that he is a great draftsman—which is, perhaps, why he is not a successful sculptor in any final way. He still derives too closely from painting and fails to distinguish between the different orders of feeling proper to it and to sculpture. And in this respect, particularly, gothic surrealism, with its deliberate obliteration of such distinctions, is a handicap. (Perhaps it is necessary to remind the reader that the surrealism of Picasso, Miró, and Masson is not gothic.) Only when Hare comes to include his surrealism in something larger and outwardly more impassive and controlled, something that scorns to compete with nature in procreation, will he realize the fulness of his unquestionable talent.

The Nation, 9 February 1946

27. Review of the Water-Color, Drawing, and Sculpture Sections of the Whitney Annual

This year's water-color and drawing section of the Whitney Annual achieves a higher and more even general level than did the previous oil-painting instalment. Like the English, we have usually managed more successfully to extract the virtues of our defects in the lighter mediums than in oil. But the cost is only too often the absence of emphasis and vigor. The total impression of this show is less sad, it is true; yet it offers almost no occasions for real pleasure. Where the oils sinned by commission, the water colors and drawings do so by omission. And their extreme tepidness seems to furnish but more evidence of the broad-front retreat of American art at the moment.

But perhaps we have here the emergence of a new cultural phenomenon. Perhaps my excessive irritation at the Whitney's oil-painting instalment and the Pepsi-Cola show was misdirected—the result of taking them for something they were not, at bottom, intended to be. As Kurt List, the music critic, says, we may be witnessing the emergence of a new, middlebrow form of popular art that, while it exploits many of the innovations of avant-garde art, lowers their intensity and dilutes their seriousness in order to convert them into something calendar and magazine can digest—as if in answer to a public that is making new and higher demands on the art offered to it. Thus there is, for instance, the increasing practice on the part of commercial firms of having what in popular estimation are high-art artists illustrate their advertisements. (Usually, these painters issue from the fanes of the Associated American Artists gallery, which plays a role as mediator between high art and *Kitsch* somewhat analogous to that played in literature by the *New Yorker* and *Harper's Bazaar*.)

The middle class in this country—though swelled by war prosperity with millions of new recruits who may be no easier to assimilate culturally than the previous 1918–1928 wave—is now surging toward culture under the pressure of anxiety, high taxes, and a shrinking industrial frontier. All this expresses itself in a market demand for cultural goods that are up to date and yet not too hard to consume. Such a demand, supported as it

is by so much buying power, inevitably attracts and compels the serious and ambitious artist; he is tempted—most often unconsciously—to meet this demand by softening, sweetening, and simplifying his product. But what distinguishes the present situation is that the artist must not soften and sweeten too obviously, he cannot outrightly vulgarize—for the public still wants something that has the smell of high art.

This state of affairs constitutes a much greater threat to high art than *Kitsch* itself—which usually keeps the distinctions clear. The demand now is that the distinctions be blurred if not entirely obliterated, that is, that the vulgarization be more subtle and more general. Artists—who in this period have tended to be aggressively anti-intellectual—become reluctant to insist on preserving the distinctions, because the contemporary cultural elite, on whom high art presumably depends, can furnish them with neither intellectual and moral support nor markets. Given the temptations of attention and money, even the best of the artists find it difficult amid the present confusion of standards not to surrender to Mr. Luce or the Associated American Artists.

The future of art and literature will brighten in this country only when a new cultural elite appears with enough money and enough consciousness to counterbalance the pressure of the new mass market. The other alternative is socialism, of course—but right now who talks of socialism in America?

The sculpture instalment of the Whitney Annual, running concurrently with the water-color and drawing exhibit, is another story—perhaps because sculpture is slower to feel the pull and tug of public taste. The sculpture section shows on the whole a great improvement over former years.

An abstract, skeleton-like piece in steel and bronze, *Transition*, by Theodore Roszak, whose work has not been shown in public for several years, is the best thing in the entire museum. It expresses almost dramatically the composite character of its material—the tensile strength of steel and the fluidity of bronze—and at the same time conveys speed, directness, draftsmanship. David Smith's *Cockfight—Variation* shows inventiveness and animation but seems too dispersed when measured, as it must be, against this artist's best examples. In Trajan's polychrome Keen's cement *Birth of Isis* I feel, as in most of this sculp-

tor's work, a very genuine impulse that still fails to realize itself, dissipated in expressionist extravagance.

There is, as always, a great deal of false and cliché-ridden sculpture on hand at the Whitney, but the frequency of interesting pieces this year is surprising. Even work such as Isamu Noguchi's marble *Figure*, a piece of contrived effect in inappropriate material, deriving from Picasso's "bone" period, and Martin Craig's *Lilith*, coming from somewhere near the same quarter, elicits at least interest and hope. And two relatively academic statues, a bronze Lipchitzian *St. Christopher* by Nathanial Kaz and a marble *Caress* by Oronzio Maldarelli (both, by some miracle, reproduced in the catalogue), overcome one's instinctive resistance enough to produce a definite pleasure—notwithstanding that the first is disfigured by a double anklet of bronze representing feet in water and the other's polished surface and stylized contours bring it very close to soap sculpture.

David Smith's work, David Hare's recent show, Theodore Roszak's return to activity, Calder's (somewhat undeserved) popularity, other signs—all point to the possible flowering of a new sculpture in America, a sculpture that exploits modern painting and draftsmanship, new industrial methods, and industrial materials. Certainly, of all arts, the new pictorial or constructivist sculpture relates best to American décor, understands it best, and would affect it most directly.

And—to return to the considerations touched on above—the new sculpture is protected as yet from public taste by its very novelty. This makes it rather hard, financially, for the sculptor himself, but he has the large or small satisfaction of knowing that his work will be bought for the right reasons in most cases. It still takes a certain independence of taste to invest in a Smith or a Hare.

Last but not least, the new sculptor has the advantage of working in a virgin medium, one in which even the groper and beginner can—as even gropers and beginners in naturalistic painting did in the fifteenth century—produce permanent works of art. Only a few hints are needed from the masters in Europe: Brancusi, Gonzalez, Gabo, the earlier Lipchitz, Pevsner, Giacometti. . . .

The Nation, 23 February 1946

28. The Camera's Glass Eye: Review of an Exhibition of Edward Weston

Photography is the most transparent of the art mediums devised or discovered by man. It is probably for this reason that it proves so difficult to make the photograph transcend its almost inevitable function as document and act as work of art as well. But we do have evidence that the two functions are compatible.

The heroic age of photography covered the half-century or more following immediately upon its invention in the late eighteen-thirties. During this period its physical technique was still relatively imperfect in result and clumsy in procedure. However, since art is a matter of conception and intuition, not of physical finish, this did not prevent—indeed it seems to have aided—the deliberate or accidental production of a quantity of masterpieces by such photographers as Hill, Brady, Nader, Atget, Stieglitz, Peter Henry Emerson, Clarence White, and others. Hill's photographs were conceived in accordance with the portrait-painting style of his time—he was a painter himself; Brady's documentary photographs, with the exception of his portraits, became art more or less unconsciously; Atget's likewise. In an instinctive way both Brady and Atget anticipated the *modern* and produced a legitimate equivalent of post-impressionism in painting; which was permitted them no doubt by a medium clean of past and tradition, through which they could sense contemporary reality naively and express it directly, untrammeled by reminiscences and precedents that in an art such as painting could be escaped from only by dint of conscious effort on the part of a sophisticated genius like Seurat. Stieglitz, for his part, absorbed impressionist influences in his early work but transposed them radically into terms proper to his own medium. And so, to a lesser extent did Clarence White.

Since the beginning of the twentieth century the procedure of photography has been made swift, sure, and simple. Yet its results, in the hands of those who strive to render it art, have on the whole become more questionable than before. The reasons for this decline are complex and have still to be cleared up. But a few of the more obvious ones become apparent in the work of such a serious and ambitious contemporary as Edward Weston, a

selection of whose *oeuvre* to date is being shown at the Museum of Modern Art.

Two of the most prominent features of latter-day art photography are brilliant physical finish—sharpness or evenness of focus, exact declaration of lights and darks—and the emulation of the abstract or impersonal arrangements of modern painting. In the first respect modern photography, eschewing the blurred or retouched effects by which it used to imitate painting, has decided to be completely true to itself; in the second respect, which concerns subject matter, it takes this decision back. This logical contradiction is also a plastic one. Merciless, crystalline clarity of detail and texture, combined with the anonymous or inanimate nature of the object photographed, produces a hard, mechanical effect that seems contrived and without spontaneity. Hence the estranging coldness of so much recent art photography.

It again becomes important to make the differences between the arts clear. Modern painting has had to reduce its ostensible subject matter to the impersonal still life or landscape, or else become abstract, for a number of reasons, historical, social, and internal, that hardly touch photography in its present stage. Photography, on the other hand, has at this moment an advantage over almost all the other arts of which it generally still fails to avail itself in the right way. Because of its superior transparency and its youth, it has, to start with, a detached approach that in the other modern arts must be struggled for with great effort and under the compulsion to exclude irrelevant reminiscences of their pasts. Photography is the only art that can still afford to be naturalistic and that, in fact, achieves its maximum effect through naturalism. Unlike painting and poetry, it can put all emphasis on an explicit subject, anecdote, or message; the artist is permitted, in what is still so relatively mechanical and neutral a medium, to identify the "human interest" of his subject as he cannot in any of the other arts without falling into banality.

Therefore it would seem that photography today could take over the field that used to belong to genre and historical painting, and that it does not have to follow painting into the areas into which the latter has been driven by the force of historical development. That is, photography can, while indulging itself

in full frankness of emotion, still produce art from the anecdote. But this does not mean pictures of kittens or cherubs. Naturalism and anecdotalism are required to be as original in photography as in any other art.

The shortcomings of Edward Weston's art do not usually lie in this direction, rather in its opposite. He has followed modern painting too loyally in its reserve toward subject matter. And he has also succumbed to a combination of the sharp focus, infallible exposure, and unselective atmosphere of California— which differentiates between neither man and beast nor tree and stone. His camera defines everything, but it defines everything in the same way—and an excess of detailed definition ends by making everything look as though it were made of the same substance, no matter how varied the surfaces. The human subjects of Weston's portraits seem to me for the most part as inanimate as his root or rock or sand forms: we get their coverings of skin or cloth but not their persons. A cow against a barn looks like a fossilized replica of itself; a nude becomes continuous with sand, and of the same temperature. Like the modern painter, Weston concentrates too much of his interest on his medium. But while we forgive the painter for this, because he puts the feeling he withholds from the object into his *treatment* of it, we are reluctant to forgive the photographer, because his medium is so much less immediately receptive to his feeling and as yet so much less an automatic category of art experience. This is why the photographer has to rely more upon his explicit subject and must express its identity or personality and his feeling about it so much more directly.

Nor do the abstract factors make up in Weston's art for the lack of drama or anecdotal interest. To secure decorative unity in the photography, the posing of the subject and the effects of focus and exposure must be modulated just as the analogous elements in painting have to be modulated for the same purpose. (Of course, decorative unity in photography is made more difficult by the infinitely more numerous and subtle gradations between black and white.) The defects of Weston's art with respect to decorative effect flow from its lack of such modulation. In this Weston resembles the Flemish "primitive" painters, who also liked to define everything in sharp focus and who likewise lost decorative unity by their failure to suppress or modulate de-

tails—rejoicing self-indulgently as they did in the new-found power of their medium to reproduce three-dimensional vision. Unlike the Flemish, however, Weston tries to achieve decorative unity at the last moment by arranging his subject in geometrical or quasi-geometrical patterns, but these preserve a superimposed, inorganic quality. Or else they overpower every other element in the photograph to such an extent that the picture itself becomes nothing more than a *pattern*.

The truth of this analysis is borne out, it seems to me, by the fact that almost the best pictures in Weston's show are two frontal views of "ghost sets" in a movie studio. Here the camera's sharply focused eye is unable to replace the details left out by the scene painter or architect; and the smoothly painted surfaces prevent that eye from discovering the details it would inevitably find in nature or the weathered surface of a real house. At the same time a certain decorative unity is given in advance by the unity, such as it is, of the stage set.

Weston's failure is a failure to select; which is moved in turn by a lack of interest in subject matter and an excessive concentration on the medium. In the last analysis this is a confusion of photography with painting—but a confusion not so much of the effects of each as of the approaches proper to each. The result, as is often the case with confusions of the arts, shows a tendency to be artiness rather than art.

If one wants to see modern art photography at its best let him look at the work of Walker Evans, whose photographs have not one-half the physical finish of Weston's. Evans is an artist above all because of his original grasp of the anecdote. He knows modern painting as well as Weston does, but he also knows modern literature. And in more than one way photography is closer today to literature than it is to the other graphic arts. (It would be illuminating, perhaps, to draw a parallel between photography and prose in their respective historical and aesthetic relations to painting and poetry.) The final moral is: let photography be "literary."

The Nation, 9 March 1946; *Edward Weston Omnibus*, ed. Beaumont Newhall and Amy Conger, 1984.

29. Letter to the Editor of *The Nation*

Dear Sirs,
It is one of the tragedies of our time that solicitude for any of the arts forces one to be a snob.[1] The mass public of industrial countries, wittingly or unwittingly, asks for such concessions to the limitations of its taste as cannot but debase the arts. The real trouble lies deeper, of course—in the causes of these limitations rather than in the limitations themselves. The fact is that most people in our society lack the security, leisure, and comfort indispensable to the cultivation of taste; and only a socialist society can provide security, leisure, and comfort.

Whether the Associated American Artists justified itself by popularizing Benton and Wood is a question I cannot decide. What I do know is that Benton is and Wood was among the notable vulgarizers of our period: they offered us an inferior product under the guise of high art.

<div align="right">Clement Greenberg
New York, February 28</div>

The Nation, 16 March 1946

30. "Americanism" Misplaced: Review of *Preface to an American Philosophy of Art* by A. Philip McMahon

This is a distressing book. It calls for a philosophy of art for Americans that would be "consistent with their other basic insights" and distinct from the one fostered in Europe and especially in Germany. Rational and romantic idealism, holding that the root of all phenomenal reality is the individual consciousness, produced, according to the author, an aesthetic that worshiped the genius, associated beauty exclusively with the fine

1. Greenberg had been accused of being a snob for his criticism of the Associated American Artists (*The Nation*, 23 February). "Is there any reason," wrote Toni Gale, "why talented artists cannot develop properly merely because they pick up a few extra bucks through the Associated American Artists and Lucky Strike cigarettes, who were smart enough to buy a series of paintings from Associated for an advertising campaign?" [Editor's note]

arts and literature, and identified the work of art with its non-sensory "idea." Hitler was in large part a creature of the doctrine of amoral egoism popularized in Germany by romantic-idealist philosophy.

But the fault goes all the way back to Descartes with his *cogito ergo sum* and to the neo-classic writers on art; thus it is interwoven with the whole development of Western thought from Descartes to Nietzsche. It is this tradition, which culminated in the "German" philosophy of aesthetics, that is now to be rejected in favor of a new "American" one. ". . . Americans who are realists in every other department of thought have no compelling obligation to adopt in art what they reject everywhere else."

Professor McMahon's own "American" philosophy of art, relying on vaguely pragmatist assumptions, yet invoking Aristotle, quarrels with the "Europeans" for their terminological untidiness (but what harm has that done?) and limits the term "art" to the arts of design, excluding poetry, drama, music, dancing, and such other audible or kinesthetic forms, to which the Greek word for "technique," often wrongly translated as "art," does not apply. The professor also shows that works of art are partly experienced as sensory objects—which no idealist ever denied; that beauty is not to be found solely in the beaux arts—which no idealist ever asserted; and that art is to be subjected to the same logical and ethical criteria as the rest of experience. (The author expresses himself unclearly in this last, for I cannot tell whether he means art as an activity or as works of art. If he means that the latter too are to be made to undergo the tests of logic and morality, then his statement is beneath criticism.)

What is thus offered as an "American philosophy of art" dwindles under analysis to a mere set of assumptions long since taken for granted by "European" aesthetics. Nothing in them controverts, essentially, the main arguments of the idealist position, or advances the problems of aesthetics any farther toward solution. And certainly they do not justify the distressing talk about "alien" ideas and a "structure of the American mind."

Xenophobia might explain the tendentious obtuseness with which Professor McMahon seeks to reduce the whole basis of aesthetic thought from Descartes to the present century to a series of gross fallacies. The Western tradition of art philosophy has

committed many errors, and I hold no brief for idealism, but it did greatly advance and clarify the subject. To deny these achievements and call for a return to Aristotle is obscurantism. It is characteristic of such obscurantism that it can interpret German idealism and romanticism only by taking one aspect of a philosopher's argument, stripping it of all qualifications and connections, and then deducing from that, with over-literal logic, the fallacies he is to be convicted of. Thus if a philosopher confines his investigation of the nature of the beautiful to works of art, he automatically becomes guilty of denying beauty to everything else.

Let it suffice here to point out but one instance of the way in which Professor McMahon "demolishes" the "German" school of aesthetics. He interprets Kant's statement, "Nature is beautiful because it looks like art; and art can be called beautiful only if we are conscious of it as art while it yet looks like nature," to mean that successful art must imitate nature. He then charges Kant with having contradicted himself by asserting elsewhere that "beauty has nothing to do with truth"—for how can that be if beautiful art depends on imitation? The error here is to assume, unwarrantedly, that by "looks like" (*sieht aus als*) Kant meant "mirrors," that is, that art *portrays* nature. Actually, as he explained both before and after this statement, all he meant was that the "purposiveness in its [art's] form must seem to be as free from all constraint of arbitrary rules as if it were a product of mere nature." That is, art, although it must look as though it *came* from nature, does not have to *resemble* any of the content of nature, anything already present in it. Nothing but polemical bad faith can explain Professor McMahon's failure to grasp this rather clear distinction and his subsequent complete misunderstanding of the aesthetics of Kant—than whom there has been no greater thinker on art and whose revolutionary insights into its nature go unappreciated or misunderstood even today.

Preface to an American Philosophy of Art is a more ominous book than its author realizes. What does he think the implications of his "Americanism" are? How can he, after having inveighed as he has against European thought, fail to realize that in railing at it as "alien" as well as "mistaken" he takes over precisely the worst that Europe has to give us?

The Nation, 30 March 1946

Dear Sirs,

Mr. Downes's [1] and my differences amount in the end to the fact that he enjoys looking at Edward Weston's photographs much more than I do.

When an artist gets bad results from the subject matter he handles right now, it is permissible to suggest that he change his subject matter, or his way of treating it. One certainly had a "right" to tell the painter David, at the time, to stop illustrating incidents from Plutarch and do more work from nature as he saw it around him. In this case the justification for one's "right" to tell the artist what to do lies in David's portraits, which are so much superior to his historical paintings.

Simplicity or transparency of approach does not exclude over-emphasis upon approach. It may be that Weston concentrates so much upon seeing his cabbages and sand dunes clearly that he forgets to feel them. More feeling for them would perhaps have prevented them from disappearing, as they do, into mere objects of "clear and luminous" vision.

As for "Marxian literature"—I think Mr. Downes has only the slightest notion of what he means by that. I hesitate to offend his intelligence by saying what most people would think he means. Aside from that, he has no basis whatsoever for assuming that I wish to prescribe any particular sort of subject matter to any art. True, I may be a Socialist, but a work of art has its own ends, which it includes in itself and which have nothing to do with the fate of society.

<div align="right">

Clement Greenberg
New York, April 1

</div>

The Nation, 27 April 1946; *Edward Weston Omnibus*, ed. Beaumont Newhall and Amy Conger, 1984.

1. Greenberg had been criticized by Bruce Downes, an editor of *Popular Photography*, for his review of an exhibition of Edward Weston's photographs (*The Nation*, 9 March). [Editor's note]

32. Frontiers of Criticism: Review of *Les Sandales d'Empédocle: Essai sur les limites de la littérature* by Claude-Edmonde Magny

In defining the limits of literary criticism, Mlle. Magny begins by rejecting the "fiction" of the objective, universal point of view assumed by whoever hands down an aesthetic judgment. She then goes on to cast suspicion on aesthetic judgments in general; they lack probative foundation and in any case have led to more error than truth. Mlle. Magny misunderstands Kant profoundly and thus fails to realize that whether or not a reader expressly delivers himself of an aesthetic judgment, he automatically makes one, conscious or unconscious, whenever he consumes a piece of literature for pleasure. The critic in particular is required to make himself aware of such judgments and speak of them aloud: it is part of his task and at the same time one of his credentials.

Her method, Mlle. Magny asserts, coincides with the "limits" of criticism. The most criticism can do is extract and translate into abstract terms what the literary artist has embodied in situations, personages, metaphors, rhythms, word order, tense, punctuation, etc. The aesthetic test boils down to a determination of the internal coherence of what is thus extracted and of the appropriateness of the artistic means to the abstract content. In order, however, to arrive at this determination it is self-evidently necessary for Mlle. Magny to assume as objective and universal a point of view as she can and to strip herself as much as possible of her biographical or psychological peculiarities. Thus she is forced to return to the position she tried in the beginning to abandon.

But it remains that for her the principal activity of literary criticism is hermeneutic, interpretative; its role is that of a midwife—maieutic. Mlle. Magny finds content inextricably associated with such formal details as tense and punctuation, and offers evidence for this in some remarkable perceptions that are enough in themselves to make her book worth reading. Yet she makes the mistake of assuming, in practice if not in theory, that the formal factors in a work of art remain exclusively formal until their meaning or intention penetrates our clear consciousness; they stay separate from content as long as their relation to

it is not capable of being exhibited conceptually. I should like to point out, however, that every work of art has an unconscious or pre-conscious effect, and this effect also constitutes part of its content.

Fallacies similar to this are responsible for the occasional superficiality of Mlle. Magny's critical method. That method may serve brilliantly to pry out Charles Morgan's or Sartre's or Kafka's "metaphysic," but it places all three writers on the same level of consideration. I may arrange them hierarchically on this level—with Kafka first and Morgan last—but even this will be misleading, since the most important differences between the three are precisely matters of level. As it is, Simenon or Marquand could go through the hopper of Mlle. Magny's method without necessarily revealing their shoddiness. They might even issue from it improved. For while Mlle. Magny's method can seldom reduce the importance of the work of literature to which it is applied, it can often exaggerate that importance, as it does when it inflates and dignifies Sartre's rather weak short stories out of all proportion by extracting the philosophical intentions they embody and disregarding their less tangible aspects. The very process of criticism here amounts to a purification and transcendence. Suddenly, with their unconvincing or banal plots and characterizations left behind, the ghosts of Sartre's short stories shine forth with a brilliance their living flesh never owned.

Yet it is the merit of her book and that which makes it worth discussion that, within the limitations of her method, Mlle. Magny's sharp and sensitive intelligence produces a maximum result. In addressing herself directly to the literary object, she sees subtly and profoundly, even if in the end she fails to place the whole object correctly. She detects the arbitrariness with which Morgan saddles metaphysics on his novels—even if she fails to point out how faded and stale that pseudo-Platonic metaphysics is. She well perceives the fallacy in Sartre's attempt to assert philosophical conclusions on the basis of psychological, subjective deductions; even more, she sees that *La Nausée* is jottings from a journal mixed with bits of fiction—that its insufficiency comes from a confusion of genres (although she does not see that a formal philosophical thesis is out of place in fiction only when it compels the progression to be logical instead of dramatic). Mlle. Magny sums up Sartre's case with the remark:

"In any case, as long as he presents himself to us as a novelist and story-teller he lacks the right to impose on us his own view of the world to the exclusion of every other."

In the first of her two excellent essays on Kafka, Mlle. Magny discards, correctly, those interpretations of his work that would *reduce* it to a religious or any other kind of allegory. Affirming that Kafka's very concrete method is applied to concrete situations and that the latter manifest in their concreteness the profoundest aspects of his art, no matter how much they may welcome exegesis, anagogical interpretation or psychoanalysis, she subjects Kafka to the most thorough, perceptive and well-balanced, if sometimes repetitious, analysis I have yet seen him receive. Here her method comes fully into its own—or almost fully, for it does overlook a factor that is of major importance in explaining Kafka: the history of both the society and the literature that led up to him.

Toward the close of her second essay on Kafka we discover, however, what Mlle. Magny has been leading up to. We begin to understand why she dwells so long on the inconsistencies of Morgan's and Sartre's metaphysics.

Kafka's metaphysics, she says, is incomplete, if not inconsistent—it contains no God or justifying principle. Thus, along with Morgan and Sartre, he too is a philosopher of despair. Most literature, Mlle. Magny continues, speaks a philosophy of despair today. But what is wrong is not so much the despair as the illegitimate claim literature has been making more and more frequently since Rimbaud to be a means, if not the principal means, of extending experience, of creating philosophy, of mastering the whole extent of knowledge, and even of grasping the absolute. Yet literature, she counters in the last essay of her book, is not "co-extensive with the life of the mind." Given the total realm of consciousness as field, abstract thought, or philosophy, functions more fruitfully and more honestly. A work of fiction has not the right to make such a sweeping conclusion as is expressed in total despair, because the evidence it brings to bear is too partial and too distorted by concerns that have nothing to do with the objective truth.

Mlle. Magny goes on to say that literature today, because it arrogates to itself the tasks of philosophy or religion, suffers

from a confusion of genres, of which Sartre's novel *La Nausée* is a typical case. *La Nausée* is more the description of a "phenomenological experience" than a work of fiction; the attitude to which its hero is gradually brought—that absolute existence is the only thing to be taken in earnest, while all the specific, contingent forms of existence are but so many ludicrous or "obscene" lies—is too general (also too arrogantly general) and at the same time too partial to justify itself as the resolution of a novel: it belongs at the end of a chain of reasoning rather than of a chain of acts and emotions.

In my opinion Mlle. Magny not only exaggerates the seriousness of the situation—in a way she actually creates the seriousness by taking certain claims, among them those of the Existentialist writers in France, too much at their face value. The shortcomings of Sartre's art or of Kafka's philosophy are not enough to constitute the crisis she sees. (There is a crisis indeed but it is a different one.) True, the German Romantics and Rilke, George, the Surrealists and such critics as Roland de Renéville have expounded the notion that art is a means of attaining to experience of the absolute. But no thinkers, as distinct from artists and critics, have ever made or taken this claim as seriously or as literally as some members of the Parisian avant-garde now seem to think—not even Schelling.

The novelist-philosophers at whom Mlle. Magny aims her book do not, in any case, write the way they do simply because they lay claim to the wider province of philosophy; but rather because literature, like all other contemporary art, is on the hunt for a set of ecumenical beliefs more substantial than those with which society—or religion—now supply it. It does no more good to tell literature to call off this hunt than it does to exhort poetry—as Roger Caillois did somewhere—to stop striving for purity. The hunt, as well as the purity, is socially, politically, philosophically, aesthetically—in short, historically compelled.

Mlle. Magny's failure to pose the problem correctly is owed, like Caillois's similar failure, to neglect of the historical factor. It is this neglect that accounts for much of what I venture to call the backwardness of recent French criticism. The problems of literature are never historical in themselves, but history does de-

termine which of them are to be placed on the order of the day. And unless history is taken into account they cannot be adequately understood.

Partisan Review, Spring 1946

33. Review of Exhibitions of the American Abstract Artists, Jacques Lipchitz, and Jackson Pollock

The Tenth Annual Exhibition of the American Abstract Artists (at the American-British Art Center) asserts a higher level than any other group show of contemporary art that I have seen this year. Not that it is crowded with masterpieces; indeed, there is more than enough to find fault with. Yet one can see at least six or seven strong paintings by young and for the most part unestablished artists; and the failures of the others take place on a high plane. Nobody tries to dodge the real problems for the sake of a facile, quickselling success.

What most markedly characterizes the group as a whole is the effort to continue and develop the premises inherent in cubism, in the face of all the currents that have flowed so fast in the opposite direction these past ten years or so. In some instances the fidelity to cubism goes so far as to render an artist's work nothing more than a series of pastiches—of Picasso or Gris or Braque, as the case may be. In other instances cubism is a constricting influence that rationalizes the artist's failure to exert his temperament and search his emotions—which is to misuse cubism, for it was originally and above all a vehicle of emotion. Today cubism remains a creative discipline, a force infusing style into the works of those—and especially those—who seek expression primarily. It is a means, not of inhibiting emotion, but of controlling and so exploiting it.

The three Americans and the one Englishman whose work particularly impressed me at this show represent at least two or three different inflections or expansions of the cubist tradition. Nell Blaine develops out of cubism by way of a purifying process leading through Hans Arp—whose own intention, however, was to depurify and "poeticize" post-cubist art; Fannie Hillsmith

goes in the opposite direction, with the help of Klee; similarly, Maurice Golubov; while the English artist Ben Nicholson, who is a guest exhibitor, seems to go toward Mondrian—but only seems: for Nicholson's art, whatever surface suggestion there may be of severity and renunciation in its precise circles and strict and not so strict rectangles, aims at a maximum of "poetry" achieved by a minimum of means, not at a purification or rationalization of the plastic elements. That Nicholson's work should be taken for cold and formal is the result only of many people's failure to look at it without preconceptions. The most that can be said to extenuate this misunderstanding is that Nicholson is no colorist and succeeds best in conveying his emotions when he confines himself to monochrome.

One of the master artists of our time and the first to put cubism into sculpture, Jacques Lipchitz, is having his second show in this country (at the Buchholz Gallery). There is not the space here, nor are there enough of his works in this country, to go into Lipchitz's case exhaustively. It is obvious, however, that in the last six or seven years he has been steadily shifting away from his former premises toward a newfangled kind of baroque. This is an attempt to answer the mood of the times, which proclaims its impatience with such serenity as cubism seems to imply. Having cast cubism off, Lipchitz now gives free vent to a bombast and a badness of taste that have always been latent in his art.

The distance he has gone in this respect is revealed by the difference between the semi-cubist figure in iron executed in the twenties and in the Museum of Modern Art's possession for years, and the bronze figure that the same museum has recently added to its permanent collection. The former piece, whose title I forget, is perhaps one of the greatest works of sculpture produced in our time, combining a paradoxical monolithic compactness with the modern harmony of its repeated and varied hollow circular forms. The later piece is also constructed of circular—or rather, round, bulbous—forms, but their repetition and mass achieve only a declamatory, overinflated effect, a kind of academicism that tries to conceal itself by exaggerated gestures.

Most of the larger pieces of Lipchitz's present show suffer in a similar way. Often the sculptor plays traitor to his own baroque aspirations—which aim at a denial of the laws of gravity and the

translation into airy flight of the heaviest materials—by assigning too much mass to the lower portions of his figures. The piece called *The Rescue*, for instance, would have been saved had the tubular forms at its base been radically attenuated.

Yet for all this Lipchitz remains a genius. As evidence, there are, first, the small bronze "sketches" that are far superior to the larger works for which they were prepared, moving as they do with a rhythm and spontaneity which disappear in the final result under infelicitous coloring, over-thumbed textures, and over-emphatic simplifications; second, the tempera drawings, whose uniform excellence leads to the suspicion that Lipchitz's present difficulties may come from the fact that most of his ideas have recently tended to be more pictorial than sculptural; third, a large, extravagant, hysterical, impossibly elaborated *cire-perdue* bronze called *The Prayer*, which seems like an overcrowded compendium of all the representations ever made of fertility deities. This statue, despite the excess of deliberate and imperious bad taste, or perhaps just because of that excess, has something of greatness about it. In overcoming its own defects it offers even more convincing proof of Lipchitz's creative vitality than the more integrated, balanced, and perfect masterpieces of his past.

Obviously, Lipchitz wants to do more than create beautiful works of art; he intends to realize himself completely in his sculpture, no matter what the cost. Thus he at least places us in the presence of a temperament, and where a real temperament is present, masterpieces will come sooner or later, translating and transcending the bad taste. It might be said that bad taste is often indispensable to great art, that without losses there can be no gains, and that the more one is willing to risk losing the more one stands the chance of winning. Like Courbet, who labored similarly under the handicap of a lumpy touch and bad judgment, Lipchitz stakes all on the strength of his temperament.

It is possible to accuse the painter Jackson Pollock, too, of bad taste; but it would be wrong, for what is thought to be Pollock's bad taste is in reality simply his willingness to be ugly in terms of contemporary taste. In the course of time this ugliness will become a new standard of beauty. Besides, Pollock submits to a habit of discipline derived from cubism; and even as he goes

away from cubism he carries with him the unity of style with which it endowed him when in the beginning he put himself under its influence. Thus Pollock's superiority to his contemporaries in this country lies in his ability to create a genuinely violent and extravagant art without losing stylistic control. His emotion starts out pictorially; it does not have to be castrated and translated in order to be put into a picture.

Pollock's third show in as many years (at Art of This Century) contains nothing to equal the two large canvases, *Totem Lesson I* and *Totem Lesson II*, that he exhibited last year. But it is still sufficient—for all its divagations and weaknesses, especially in the gouaches—to show him as the most original contemporary easel-painter under forty. What may at first sight seem crowded and repetitious reveals on second sight an infinity of dramatic movement and variety. One has to learn Pollock's idiom to realize its flexibility. And it is precisely because I am, in general, still learning from Pollock that I hesitate to attempt a more thorough analysis of his art.

The Nation, 13 April 1946

34. What the Artist Writes About: Review of *Artists on Art: from the XIV to the XX Century*, edited by Robert Goldwater and Marco Treves

Robert Goldwater and Marco Treves have compiled and edited a most valuable and unique book in *Artists on Art: from the XIV to the XX Century*. Almost the only fault I have to find with it is its shortness: the endeavor to cover so much ground within 500 pages often reduces the excerpts to mere fragments.

Mr. Goldwater's introduction points out how the nature of what artists have written about their métier has changed according to their social status, the problems of their art, and historical circumstances. While painting and sculpture were still considered crafts, the artist wrote handbooks of technical rules and formulas; when painting and sculpture came to be placed on a par with poetry, he wrote treatises on aesthetics. With the arrival of

romanticism, the emphasis was shifted from principles to personality, and the artist expressed himself most pertinently in journals and letters.

After the middle of the nineteenth century, however, there came a certain pause. Of all the impressionists, only Pissarro, in his letters to his son, recorded his opinions on art. Impressionism, as Mr. Goldwater says, was controlled by painterly intentions from which few concepts could be elicited for anything more than shop talk. The immediate successors of the impressionists and some of their remoter followers broke their silence. Whistler, Gauguin, Van Gogh, Redon, Signac, and others had very much to say in writing. Then came the manifestoes of the twentieth century.

It will be noticed, however, that the present-day masters of the School of Paris—from Matisse, Bonnard, and Maillol through Picasso and Braque to Miró—have not written very much about art, not nearly so much as their German, Dutch, and Russian contemporaries. They tend to confine themselves to short statements and interviews, with perhaps a lecture now and then. It may be that these artists, who in their practice have boiled art down to its essential elements as no others have, realize best the impossibility of putting the point of their art into words. And as Mr. Goldwater suggests, the most painterly painters of the past—the Venetians, for example—as a rule wrote least about their art.

But this does not explain why so little in writing has come down from the Dutch masters. In all likelihood social circumstances were responsible. The Dutch painters had the status of tradesmen, if not of artisans, and tradesmen are notoriously reluctant, even when literate, to reveal their secrets.

The Nation, 20 April 1946

35. Review of Exhibitions of Paul Gauguin and Arshile Gorky

Gauguin ranks with Cézanne and Van Gogh as a founding father of modern art. But the sharpness of his break with impression-

ism, like that of the other two masters, can be exaggerated. In his epoch-making *Déjeuner sur l'Herbe* Manet anticipates what Gauguin only isolates and emphasizes: the large, sharply silhouetted areas of flat, uniform color, the abrupt contrasts of hue, the suppression of accidents of light or detail, the simplified, open rhythms. It remained only for atmospheric impressionism to release the bright, silky color by which Gauguin most particularly proves himself a genius.

Granted to the full his genius, his revolutionary accomplishment, and the major influence he exerted on later painters—these still do not suffice to make Gauguin a great artist. As, during the last few decades, we have recovered from the first pleasurable shock of frankly decorative painting, Gauguin's reputation has suffered a decline—a decline so great that Somerset Maugham now has the temerity to write in his short foreword to the catalogue of the present Gauguin exhibition at Wildenstein's: "I should not say that Gauguin was a great painter."

Whether Gauguin can be judged fairly on the basis of the fifty-six oils and twenty-odd drawings in this show is doubtful. It seems that art dealers were, until lately at least, able to foist the lesser works of the impressionists and post-impressionists on American collectors with lamentable regularity. It is likely, therefore, that the bulk of Gauguin's best painting remains in Europe. Nevertheless, the consistency with which most of the work of his that I have seen reveals the same weaknesses encourages me to draw conclusions that I do not think future experience will refute.

Like "socialism" in Russia, Gauguin is a case of premature and uneven development. He would, perhaps, have realized himself more fully had he stayed closer to the spirit of impressionism. Renoir, Pissarro, and Monet may have become flaccid at times, but they never suffered from the divided aims that hurt so much of Gauguin's painting. Gauguin's instinct seems to have agreed with the pictorial unity that the impressionists imposed on their open forms by dabs of variegated paint much more than it did with the unity required of a picture composed of flat silhouettes. That he was premature in proposing himself the latter problem appears demonstrated, not only by the fact that the problem had to await the arrival of Matisse for solution, but also by the fact that the best picture at Wildenstein's is the earliest

one shown—a small impressionistic head of a woman painted in 1886 with a nervous, loose touch quite unlike the flat handling that became the foundation of Gauguin's later style.

In his other canvases, save for a self-portrait executed in 1898, Gauguin either too drastically simplifies the large, central masses or complicates excessively the distribution of the smaller, subsidiary spots of color. Frequently he commits both errors in the same picture. Hence they tend to be noisy; the brilliant hues and the spectacular contours strike us at their own will, so to speak, without coherence or dramatic unity. And frankly, Gauguin does not draw well enough. In adjusting a contour to the "negative" space between it and the next contour or the edge of the canvas, he seems to rely upon automatic stylization rather than upon intuition.

The "mystical literature" that Pissarro accused Gauguin of trying to inject into modern art and the romanticism of the primitive and the exotic that subsequently replaced it are the sources of this stylization, which is the encompassing fault of Gauguin's later painting—and the inevitable expression of his failure to let himself comprehend the world he lived in. For he did not understand that his dissatisfaction with Europe could not be relieved by transporting himself elsewhere in space and culture, that he remained in the nineteenth century wherever he went. Instead of criticizing and revealing the world of which he was an ineluctable part, as the impressionists and Cézanne and even Van Gogh did—with a pertinence, an insight, and a "healthy" materialism possible only because largely unconscious—Gauguin tried to find an immediate alternative. He was misled, as many a later artist has been, into thinking that certain resemblances between his own and primitive art meant an affinity of intention and consciousness. Renouncing the beneficent criticism that he could get only from the milieu that had formed him as an artist, he engaged himself in a forced and feverish effort to realize that insubstantial affinity. The result is something partly artificial, something that lacks reality, however much of genius it shows.

Surrealist influence has within the last few years loosened the painter Arshile Gorky's attachment to Picasso and convinced him that charm is not always reprehensible. There was a time when it seemed that he would succumb completely to the sur-

realist version of charm, and I expressed this fear in a review I wrote a year ago. However, Gorky's present show of eleven oils at Julien Levy's provides not only reassurance but also some of the best modern painting ever turned out by an American.

In lowering his aim and surrendering his ambition to create an art of historical dimensions, Gorky has finally succeeded in discovering himself for what he is—not an artist of epochal stature, no epic poet, but a lyrical, personal painter with an elegant, felicitous, and genuine delivery. What he lacks in invention and boldness he makes up for by a true sophistication that transcends the merely charming and exploits to the maximum the painterly instinct, the ability to think and feel paint that is Gorky's greatest asset. He has now produced four or five paintings in which the influences are completely digested and which add something no one else could have said to that which Picasso and Miró have already said.

Gorky has taken his point of departure from the most interesting canvas of his last year's show, the large white *Island*, continuing to paint thin—he abandoned his customary heavy, flat impasto some years ago—and to rely on the draftsmanship that has become his most powerful and original instrument. The majority of the pictures on view are essentially tinted drawings— which does not make them any the less important. Thin black lines, tracing what seem to be hidden landscapes and figures, wind and dip against transparent washes of primary color that declare the flatness of the canvas. Several of the paintings are in monochrome or almost so, and these demonstrate best the phenomenal sensitivity and sensuousness of Gorky's calligraphy; but the strongest, except for the white *Delicate Game*, are two more chromatic pictures, *Hugging* and *Impatience*, whose charm is solid and whose quick spontaneity—which only the superficial eye could mistake for sketchiness—is the result of a great deal of preliminary thought.

Gorky's art does not yet constitute an eruption into the mainstream of contemporary painting, as I think Jackson Pollock's does. On occasion he still relapses into dependence on Miró, though these relapses are no longer frequent or helpless enough to be compromising. Nevertheless, his self-confidence still fails to extend to invention. Yet the chances are, now that he has discovered what he is and is willing to admit it, that Gorky will

soon acquire the integral arrogance that his talent entitles him to. When he does acquire that kind of arrogance, it is possible that he will begin to paint pictures so original that they will look ugly at first.

The Nation, 4 May 1946

36. Review of Exhibitions of Max Beckmann and Robert De Niro

To one whose acquaintance with the German painter Max Beckmann is confined to his clumsy and callow triptych *Departure* at the Museum of Modern Art, the exhibition at the Buchholz Gallery of fifteen paintings he executed in Holland between 1939 and 1945 provides a surprise. Though the general style is the same as that of the triptych, it has here yielded far greater results. And these are such in five or six pictures as to warrant calling Beckmann a great artist, even though he may not be a great painter. He is certainly one of the last to handle the human figure and the portrait on the level of ambitious, original art. True, he reminds us of much we have already seen in German expressionism and in Marsden Hartley—his affinities with Hartley are amazingly close. And it is also true that he often paints badly, using black contour lines to animate and sustain his color; that his color itself gets muddy at times and is saved only by his drawing and the unity it gets from paint surface rather than from harmony. But for all that, the power of Beckmann's emotion, the tenacity with which he insists on the distortions that correspond most exactly to that emotion, the flattened, painterly vision he has of the world, and the unity this vision imposes—so realizing decorative design in spite of Beckmann's inability to think it through consciously—all this suffices to overcome his lack of technical "feel" and to translate his art to the heights.

In my opinion Beckmann is superior to Rouault. Rouault exploits black and raw umber in much the same way, but the adeptness with which he shows off his *métier* and the paint quality of his temperament put Beckmann's craft to shame. Yet

Beckmann realizes his whole being in paint, and Rouault does not, preferring instead to realize his pretensions. The German's paintings have, at the very first glance and even before one is reconciled to them, a reality that Rouault's much greater brilliance hardly ever embodies.

Peggy Guggenheim has discovered another important young abstract painter at her Art of This Century gallery—Robert De Niro, whose first show exhibits monumental effects rare in abstract art. In two of De Niro's ten pictures, *Ubi Roi* and *Fruits and Flowers*, the originality and force of his temperament demonstrate themselves under an iron control of the plastic elements such as is rarely seen in our time outside the painting of the oldest surviving members of the School of Paris.

His other canvases are much less successful but offer at least evidence of great possibilities, especially in their draftsmanship. Where De Niro usually goes wrong is in his hot, violent color, which, although it has digested the favorable influence of Matisse, often overasserts itself and distorts the drawing. A deep madder against yellow will pull the shape it fills out of place and send it too far forward; in other cases the color will expand a shape too far vertically or horizontally. It is as if De Niro wished to compensate himself for his restraint as a draftsman by self-indulgence and bombast in his color. His specific problem at the moment, however, is not to find or express himself so much as to produce objective works of art; he has already found himself and will always express himself—let him have enough self-assurance from now on to bother about maintaining the balance of the picture plane and other such "objective" problems.

The Nation, 18 May 1946

37. Review of an Exhibition of Marc Chagall

The large retrospective exhibition of Marc Chagall's art now at the Museum of Modern Art makes it clear that his natural endowment, if not his actual accomplishment, enrols him among the very great artists of our time.

The earliest paintings in the show, executed before 1910—

under the influence, it seems to me, of German expressionism and Munch—establish what remains narrowly and distinctively Chagall's color. The first picture to establish his style, however, is *The Wedding* of 1910—one of the best works in the entire exhibition, for all its maladroitness—which already reveals the dominating influence of cubism, then hardly born. Henceforth Chagall's development is synchronized with that of the School of Paris. Cubism gives him his style, his plastic conception, his aesthetic discipline, and the effects of cubism remain even when all visible sign of it seems to have disappeared. Matisse, in the course of time, teaches him how to unify his color. But Chagall clings to the dark-and-light modeling of cubism even when his color is purest, flattest, and most immediate; rectilinear in his earlier and best pictures, this modeling changes later into soft undulations of warm and cool color along the axes of volumes and planes. And in his most recent paintings there still linger ghostly traces of those patterns of right-angled, open triangles, cutting across volumes and space, that more conspicuously governed his design in the beginning.

Chagall's strongest work and his greatest frequency of success came between 1910 and 1920, the period in which Matisse, Picasso, Braque, and Gris were also at their peak. A new conception of reality and a new accumulation of creative energy, opened up and progressively organized since 1900, had on the eve of the First World War ripened into a great historical style that decisively reversed the direction of Western pictorial art. The premise of illusion and representation was canceled out, and it was asserted that the genesis and process of the work of art were what was to be most prominently offered to the spectator's attention.

Since this aesthetic repudiated finish, polish, surface grace, Chagall's initial clumsiness became in this period a factor to be capitalized upon. And, indeed, the frank and unconcerned exposure of his *gaucherie* was an element indispensable to the power of the paintings of his best period. Coarse surfaces, caked paint, crude design in criss-crosses and diamonds, glaring contrasts of harsh and silky, of black or earth tones with complementary primaries—all these added up to virtue, just as a similar if lesser clumsiness in the same time and place added up to the grace of Juan Gris.

Chagall's clumsiness was in part a function of his situation, balanced as he was between the culture which had formed him as an individual and that which was shaping his art. If you are an East European in Paris and if you remain one no matter what sort of art you practice, then you are committed to errors of taste—good and bad errors alike. Chagall abounds in both. His "surnaturalism," with its dislocation of gravity, anatomy, and opacity, is, like the early coarseness of his *métier*, an error all to the good, though it might have struck the first observers as excessively declamatory and theatrical. But Chagall was also capable of knocking off postcard views and snapshots of romantic couples under the illusion, apparently, that these constituted lyric poetry in the approved Western manner.

In the twenties Chagall set himself to assimilating French cuisine and suavity with the obsessiveness of a clumsy and sentimental man learning to dance. He overcame the provincial harshness that had once been such an asset; he polished, softened, and refined his art; and at the same time he sentimentalized and prettified it—relatively. By this time he was sophisticated enough to avoid bad taste. And yet in spite of the many beautiful paintings—the still lifes that a sweeter Matisse could have painted and the bridal couples hovering in luscious bouquets—Chagall has never recompensed himself with anything nearly as valuable as the roughness he sacrificed. His painting ceased to be an adventure in the sense that Picasso's and even Matisse's still are; it settled down to a routine on the order of Segonzac's, Vlaminck's, Derain's, Utrillo's.

However, it must be pointed out in partial excuse for Chagall that he was also the victim of a general tendency that overtook many other masters of the School of Paris after 1925 or so. At that moment Picasso too became softer and somewhat disoriented; Braque began to repeat himself with increasing sweetness; Matisse, as his influence spread, took to recapitulating his past; even Gris, before he died in 1927, had toned down his initial vigor; and Léger, becoming more and more eclectic, was departing from the high standard he had set in canvases like *La Ville* and *Le Grand Déjeuner*. The heroic age of modern art was over; its heroes had come to terms with the pessimistic hedonism then reigning in society itself; and the younger aspirants of the School of Paris had turned to surrealism and neo-

romanticism. Chagall was simply part of the general phenomenon. But like Chirico in those same years, he went in for "paint quality" in addition to poetry.

The large *White Crucifixion* of 1939 and *The Cello Player* of 1939 are strong pictures—particularly the latter—and the more recent *Revolution* (not in this show) demonstrates an amazing unity. But the bulk of Chagall's later production suffers chronically from the lack of concentration and pressure. We are given painterly qualities, but not whole works of art, not intense unities that start from *an* experience rather than from experience in general and subordinate general qualities to the total particular impression.

In the last analysis Chagall's accomplishment is incommensurate with his truly enormous gifts. Even in his earlier and best phase he failed to deliver himself of rounded, final conclusive statements. His masterpieces, unlike many of Matisse's, Picasso's, and Gris's of the same period, leave something still to be said in their own terms; either they lack ultimate and inevitable unity, or else they achieve it only by a relaxation of level, by academic softening.

Chagall's early maladroitness, at the same time that it signified power, represented something impure—he went too far in emphasizing the uniqueness of his personality and he did not know at what point to humble himself and modify and discipline his expression so that it became eligible to take its place in the social order called beauty.

So much for his painting. His work in black and white is another story. Chagall is altogether great in his etchings and drypoints, a master for the ages in the way he places his drawings on the page and distributes his darks and lights. Here his unpurged academicism stands him in good stead; nor is awkwardness any longer a necessary concomitant of the force of his personality. Here his work emerges fresh, pure—and humble. Its passionate severity, its willingness to accept discipline have no parallel in his oils. It may be in part because the black-and-white medium depends on a tradition which Chagall understands more instinctively than he does the tradition of Western painting.

It must not be forgotten that when Chagall first came to Paris he had to assimilate the past and present of Western painting simultaneously, whereas he was already familiar with the past of

graphic art through reproductions. And also, black-and-white has, since impressionism, always remained somewhat behind painting and therefore more responsive to academic tendencies. The revolution of post-impressionism was necessary to enable Chagall to publish his genius as a *Maler*, but no revolution at all was needed to prepare his way as a draftsman in black and white.

In any case and in spite of all reservations, Chagall's art remains a feat, in oil as well as in black and white. That a man from the Jewish enclave in the provinces of Eastern Europe should have so quickly and so genuinely absorbed and transformed Parisian painting into an art all his own—and one that retains the mark of the historical remote culture from which he stems—that is a heroic feat which belongs to the heroic age of modern art.

The Nation, 1 June 1946; A&C (slightly revised).

38. Review of an Exhibition of Georgia O'Keeffe

Georgia O'Keeffe's retrospective show at the Museum of Modern Art confirms an impression left by the *Pioneers of Modern Art in America* exhibition at the Whitney Museum last month— namely, that the first American practitioners of modern art showed an almost constant disposition to deflect the influences received from twentieth-century Paris painting in the direction of German expressionism. This tendency was more obvious and general in the period that saw Miss O'Keeffe's debut (1915) than it has been since, but it survives even today.

The first American modernists mistook cubism for an applied style; or, like many German artists, they saw the entire point of post-impressionist painting in fauve color—or else they addressed themselves directly to German expressionist art as a version of the modern which they found more sympathetic and understandable than that of the School of Paris. In any case they read a certain amount of esotericism into the new art. Picasso's and Matisse's break with nature, the outcome of an absorption in the "physical" aspect of painting and, underneath everything, a reflection of the profoundest essence of contemporary society,

85

seemed to them, rightly or wrongly, the signal for a new kind of hermetic literature with mystical overtones and a message—pantheism and pan-love and the repudiation of technics and rationalism, which were identified with the philistine economic world against which the early American avant-garde was so much in revolt. Alfred Stieglitz—who became Miss O'Keeffe's husband—incarnated, and still incarnates, the messianism which in the America of that time was identified with ultramodern art.

It was this misconception of non-naturalist art as a vehicle for an esoteric message that encouraged Miss O'Keeffe, along with Arthur Dove, Marsden Hartley, and others, to proceed to abstract art so immediately upon her first acquaintance with the "modern." (It should not be forgotten, however, that the period in question was one that in general hastened to draw radical conclusions even when it did not understand them.) Conscious or unconscious estericism also accounts largely for the resemblances between much of these artists' work and that of Kandinsky in his first phase; this being less a matter of direct influence than of an a priori community of spirit and cultural bias.

Later on, in the twenties, almost all these painters, including Miss O'Keeffe, renounced abstract painting and returned to representation, as if acknowledging that they had been premature and had skipped essential intermediate stages. It turned out that there was more to the new art than the mere abandonment of fidelity to nature; even more important was the fact that Matisse and the cubists had evolved a new treatment of the picture plane, a new "perspective" that could not be exploited without a stricter and more "physical" discipline than these pioneers had originally bargained for. A period of assimilation of French painting then set in that has led American artists to a more integral understanding of what is involved in modern art. But the cost has been a certain loss of originality and independence. Today the more hopeful members of the latest generation of American artists again show "Germanizing" or expressionist tendencies; and these, whether they stem from Klee, surrealism, or anything else, seem to remain indispensable to the originality of our art, even though they offer a serious handicap to the formation of a solid, painterly tradition.

The importance of Georgia O'Keeffe's pseudo-modern art is almost entirely historical and symptomatic. The errors it exhibits are significant because of the time and place and context in which they were made. Otherwise her art has very little inherent value. The deftness and precision of her brush and the neatness with which she places a picture inside its frame exert a certain inevitable charm which may explain her popularity; and some of her architectural subjects may have even more than charm—but the greatest part of her work adds up to little more than tinted photography. The lapidarian patience she has expended in trimming, breathing upon, and polishing these bits of opaque cellophane betrays a concern that has less to do with art than with private worship and the embellishment of private fetishes with secret and arbitrary meanings.

That an institution as influential as the Museum of Modern Art should dignify this arty manifestation with a large-scale exhibition is a bad sign. I know that many experts—some of them on the museum's own staff—identify the opposed extremes of hygiene and scatology with modern art, but the particular experts at the museum should have had at least enough sophistication to keep them apart.

The Nation, 15 June 1946

39. Review of an Exhibition of School of Paris Painters

Our natural and even urgent curiosity as to the developments in French painting since 1940 has been but meagerly satisfied by a few portfolios of reproductions and, in the last month, by a dozen or so oils shown at the Matisse Gallery: three paintings apiece by Matisse, Jean Dubuffet, and André Marchand, two by Rouault, and one apiece by Picasso and Bonnard.

The School of Paris remains still the creative fountainhead of modern art, and its every move is decisive for advanced artists everywhere else—who are advanced precisely because they show the capacity to absorb and extend the preoccupations of that nerve-center and farthest nerve-end of the modern consciousness which is French art. Other places—Berlin under the

Weimar Republic, for instance—may have manifested greater sensitivity to immediate history, but Paris has during the last hundred years revealed the most faithful understanding of the changing historical essence of our society.

The concern of French painting since Delacroix and Courbet with the "physical" or technical has reflected, more integrally perhaps than any contemporary phase of any other art, the conscious or unconscious positivism that forms the core of the bourgeois-industrialist ethos. It did not matter that the individual artist was a professing Catholic or a mystic or an anti-Dreyfusard—in spite of himself, his art spoke positivism or materialism: its essence lay in the immediate sensation, and it operated under the most drastic possible reduction of the visual act. It is exactly because Picasso is one of the most literary and super-structural of all painters in intention, and therefore incomparably sensitive to his age and milieu, that he was forced to produce cubism, the latest and most radical of all forms of positive art. His very genius—which involved this hypersensitivity to the fundamental moods of an age that expressed itself much more sincerely in its techniques and *methods* than in its conscious ideologies—made it too difficult for him to devote himself *ambitiously* to anything but the "physical."

After 1920 the School of Paris's positivism, which had been carried by the essentially optimistic assumption that infinite prospects of "technical" advance lay before it, began to lose faith in itself. At the same time that the suspicion arose that capitalism itself no longer commanded perspectives of infinite expansion, it began to be suspected that "physical" art was likewise faced with limits beyond which it could not go. Mondrian seemed the handwriting on the wall. But artists like Matisse and Picasso also appear to have felt that unless painting proceeded, at least during our time, in its exploration of the physical, it would stop advancing altogether—that to turn to the literary would be to retreat and repeat; whether the physical was exhausted or not, there was no ambitious alternative. All this—the despair of the physical and the doubt whether anything but the physical remained—is dramatically mirrored in the painting Picasso has done since 1927.

Materialism and positivism when they become pessimistic turn into hedonism, usually. And the path-breakers of the School

of Paris, Matisse and Picasso, and Miró too—no less than the surrealists and the neo-romantics, whose pessimism rests on cynicism rather than on despair—began during the twenties to emphasize more than ever the pleasure element in their art. The School of Paris no longer sought to *discover* pleasure but to *provide* it. But whereas the surrealists and the neo-romantics conceived of pleasure in terms of sentimental subject matter, Matisse, Picasso, and those who followed them saw it principally in luscious color, rich surfaces, decoratively inflected design.

In Matisse's hands this hedonism signifies at times something quite other than the decadence many people think to see in it. From reproductions one gathers that during the war he returned to "luxury" painting, after having in the several years previous shown increasing tendencies toward almost abstract simplification. The return to "luxury" seems to have resulted in a great gain—if not in his figure and conversation pieces, which seem casual and thin, then certainly in his new still lifes, which, benefiting at last by post-cubism, mark one more peak of Matisse's art. Their controlled sensuality, their careful sumptuousness prove that the flesh is as capable of virtue as the soul and can enjoy itself with equal rigor.

Picasso seems to have renounced hedonism at the time of the Spanish civil war. And his still life at the Matisse Gallery, for all its connection with the School of Paris's recent consumer's preoccupation with food and intimate objects, strives for the same *terribilità* as his figure pieces. This picture fails as sadly as does all of Picasso's recent work that I have seen in reproduction. He insists on representation in order to answer our time with an art equally explicit as to violence and horror, but at the same time the inherent logic of his genius and his period still pushes him toward the abstract. In my opinion it is Picasso's temperamental resistance to the abstract that has landed him in the impasse in which he now finds himself. It seems to be a case of split personality, which is rather shockingly reflected in the helpless and almost vulgar way in which he has painted the pitcher in the still life at Matisse's.

Bonnard's recent landscape at the same gallery is even more delivered up unto color and color texture than Monet's lily-pad paintings, with contour and definition so summary as to verge on abstract art. It is a fair picture, but not of the same high order

as most of the recent work of Bonnard's I have seen in reproduction—which I presume to be adequately faithful.

Rouault's recent work likewise shows an intensification of sensuous qualities, difficult as that would seem in his case. Otherwise it adds nothing to what we already know about his art.

André Marchand is presented as one of the best of the younger generation of Parisian painters. In him the pleasure principle according to the physical tradition is revealed nakedly and decadently. Marchand's drawing owes almost everything to Picasso, while his color has absorbed all that has been rich and juicy in French painting since Renoir and boiled it down to slick, fatty tones through which shine brilliant and exquisite but meaningless intensities of hue. Not all Marchand's tact, *expertise*, and taste can save his art from being confectionary.

Jean Dubuffet—in distinction from Marchand, Gischia, Lepicque, Pignon, Estève, and the other younger artists of the School of Paris who pay homage to the physical by crossing Picasso's drawing with Matisse's color and yet arrive at little more than confectionary—reveals literary leanings. But the literature, I must admit, is of a superior order. Dubuffet is the only French painter who, to my knowledge, has consulted Klee, but he has made of Klee's influence something monumental and far more physical, and he has taken advantage of the license won by Klee's whimsy and by children's art for the purpose of a savage attack on the human image. Of Dubuffet's three paintings shown at Matisse's, only one is successful—*Promeneuse au parapluie*, a powerful picture into whose thick, tarry surface a heroic graffito has been scratched. From a distance Dubuffet seems the most original painter to have come out of the School of Paris since Miró, and it is curious that he, like so many lesser American artists, should have followed Klee in order to find an escape from the physical into "poetry." It is too early to tell anything definite—and Klee is a deceptive support in the long run—but if Dubuffet's art consolidates itself on the level indicated by these three pictures of his, then easel painting with *explicit* subject matter will have won a new lease on life.

The Nation, 29 June 1946; A&C (slightly revised).

90

40. Jean Dubuffet and French Existentialism

I believe that the art of Jean Dubuffet—three examples of which I discussed two weeks ago—has been related to French Existentialism. As the brightest new hope of the School of Paris since Miró, it is quite fitting that Dubuffet should rise to notice on the wave of the first new aesthetic movement in Paris since Surrealism, which similarly inspired Miró. (The point would be that French painting since 1925 has become directly dependent as never before on literary philosophical movements.)

It is easy to perceive the affinities between Dubuffet's painting—which attacks the human form with graffiti modeled on children's drawings and with linear schemes in the manner of Klee (influenced by the blueprint and map)—and the world-hating attitudes revealed by French Existentialism in such works as Jean-Paul Sartre's *La Nausée*. On the assumption that the highest truth is always hidden, one has the impulse to deny the ultimate importance of a connection so obvious to the first comer. But one would be wrong here. And the problem is not even to ascertain the connection but to date it.

La Nausée was published in 1938 and Dubuffet has come into prominence only with the war. (I gather from an article in *Art News* by Aline B. Louchheim that he is in his forties, began painting shortly after the last war as a disciple of cubism, gave it up in frustration to become a successful wine-dealer, and returned to it only during the recent war.) Dubuffet's devalorization of the human image, the hatred he concentrates on public faces in public places would appear to have been motivated by events in France under the Vichy regime. And the same events are popularly made responsible for the vogue of Existentialism among French intellectuals. But Sartre adopted his philosophy before the war, and it seems to me that it would have attained a certain popularity even without the disasters of the war, while I am sure that Dubuffet's pessimism derives from an experience antedating and underlying that of the most recent history. Such nihilism, embodied as cogently and as successfully as it is in paint, could not have been improvised on the moment's notice of war that lasted five years. The very quality of Dubuffet's art makes it plain that it rests on the experience of a lifetime and on a deep-seated and constant view of the world.

What we have to do with here is an historical mood that has simply seized upon Existentialism to formulate and justify itself, but which had been gathering strength long before most of the people conerned had ever read Heidegger or Kierkegaard. Pessimism has become appropriate since 1918, and it only remained for the late 1930's to replace the exuberant and, in a sense, frivolous, hedonistic pessimism of dada and surrealism (the latter of which was at least optimistic enough to enroll itself behind the revolution) with the radical and logically responsible pessimism of Existentialism. So consequent is Existentialism that, although it pretends to discriminate between the stuffed shirt, the *tricheurs* or "stinkers," and the truly honest men, in actual fact it consigns all of humanity, regardless of status or function, to contempt and despair. The shrinking possibilities of bourgeois society in Western Europe, the hypocrisies it requires in order to keep it stable, seem no longer to leave room for anything else.

One cannot deny the historical justification of this attitude, and to see it bodied forth in such a strong work of art as Dubuffet's *Promeneuse au parapluie* is to realize its even profounder justification as far as daily life is concerned. Whatever the affectations and philosophical sketchiness of Existentialism, it is aesthetically appropriate to our age, and may make up in art for what it lacks as a complete philosophy. Precisely for this reason it may be able to reach a fuller expression in painting than in fiction—which is a less opaque medium and therefore more liable to expose the flimsiness of any formal philosophical support.

What we have to do with here, I repeat, is not so much a philosophy as a mood; and just as painting, after 1900, became the greatest and most satisfactory expression of the moods of Paris—perhaps even more cogent even than Apollinaire's and Valéry's poetry—so may it continue to express her moods after 1940.

The Nation, 13 July 1946

41. Henri Rousseau and Modern Art

The category of "primitive" is not large enough to contain the phenomenon of a talent such as that of Henri Rousseau (*le Douanier*). Unlike any other latter-day primitive, he painted monumental pictures and he helped determine the course of art. If the picture *Storm in the Jungle*, with its cunning and almost facile play of tones within a limited range, and its surface enriched by streaks of glaze representing rain, is really and truly by Rousseau and was actually painted in 1891, then he did not even begin as a primitive. The superb *plein-air* handling of color in such a painting as *Landscape, Pontoise* and the placing of the darks and lights in *Medieval Castle* and *Evening Carnival* likewise vouch for his learnedness as a painter.

Why, then, did Rousseau usually stiffen and simplify his art into something more characteristically primitive, so that while gaining pattern and decorativeness he lost the subtler modulations? He was far from the knowingness that would have led someone to become a primitive deliberately. The case is puzzling. Perhaps if we had more information about Rousseau's personality in the years before the *avant-garde* got to know him, it would be less puzzling. As it is, we can only venture hypotheses.

It seems certain that Rousseau did not paint as a primitive simply because he was isolated, or lacked training, or was without dexterity of hand and eye. Whether or not he was always the psychotic he appears to have been in his old age, he seems to have been at least simple-minded, a *naif*, from the first (and it is told that he used to "see ghosts"). It was perhaps his simplicity, translated into an aberration of the eye, that saved him from realizing in his own work the dead academic finish he admired so much in Gérôme's and Bouguereau's. In my opinion it was almost certainly the growing derangement of his mind that in later years freed him so completely from the conventions of nineteenth-century art and made it possible for him to attack his vision so directly and conform to it so exactly in his execution. It is this directness that is primitive.

Rousseau in his derangement, which made him paint as if six hundred years of Western art had never been, joined the company of two other more or less deranged artists, who painted precisely as if to refute those six hundred years. Cézanne too was

a little balmy, not to mention Van Gogh. (And there was also a lesser painter in America, Eilshemius, whose unbalanced mind permitted him a boldness he might have turned to better advantage for modern art had he lived in France and become well acquainted with impressionism.) Thus those who maintain that modern art was started by mental cases would seem to be right. But they are only partly right, in a way they do not intend—a way that does not at all compromise modern art.

Just as Rimbaud had to give birth to modern poetry by deliberately cultivating the "derangement" of his senses, so those who made the leap from impressionism to that which came after could find the courage to leave the practical reality of the bourgeois world (impressionism having already arrived at that sort of reality after leaving official, ostensible reality) only when pushed by mental impulses so strong and so disconnected from the actual environment that they had to be those of psychotics. It took an extreme eccentric to shut his eyes with Cézanne's tenacity to the established examples before and around him and go on pursuing his "little" sensations with such fidelity to an ideal only he had glimpsed—yet which represented a reality more valid than that recognized by high and low in his time. Without his madness Van Gogh would, in the beginning, have seen only too clearly the distance between his own painting and the official variety he, like Rousseau and Thomas Eakins, admired so much; and had he seen that distance well enough, he would have been able to close it, to the detriment of his art.

That which modern art asserts in principle—the superiority of the medium over whatever it figures: thus the inviolable flatness of the picture plane; the ineluctable shapedness of the canvas, panel, or paper; the palpability of oil pigment, the fluidity of water and ink—this expresses our society's growing impotence to organize experience in any other terms than those of the concrete sensation, immediate return, tangible datum. Modern art is now practiced by such relatively cold, hard heads as Matisse and Picasso, who produce it out of their sense of contemporary experience. But it needed mental cases to show them the way, to cut through to the ultimate truth of life as it is lived at present.

In this sense Rousseau deserves to rate as one of the founding

fathers of modern art. It is not only that he influenced Gauguin and, through him, Van Gogh. And it is not only that he painted some great pictures (and even so, we should be careful not to over-rate him, for his total work does not cover enough ground to rank him with the greatest painters). It is, even more, that his flat, direct, almost crass colors, contours, and modelling gave to many painters the first real impression they ever got of what life, reduced to solely empirical considerations and without the deception (but also protection) of faith in anything, looks like in art. Of course what we may also have in Rousseau is the very poetry of such elemental existence—but I doubt whether that poetry is the main thing.

The Nation, 27 July 1946

42. The Impressionists and Proust: Review of *Proust and Painting* by Maurice Chernowitz

The intimacy with which the arts in France intruded upon and cross-fertilized each other between 1848 and 1914 still appears remarkable. The confusion of the arts against which Lessing warned was here realized on a basis and with results that he could not, of course, have foreseen. For how could he have possibly anticipated that the arts, in their isolation from bourgeois public life, would be, "legitimately," driven in upon each other for sustenance?

The basis of this confusion, or fusion, was a community of production and consumption nowhere better exemplifed than in the person and work of Marcel Proust. It was the obligation of the French artist of his period to be at home, at least as a consumer, in arts other than the one he himself practiced. Witness, therefore, before him, Delacroix's sensitivity to music and literature, Gautier's and Baudelaire's to music and, particularly, to painting.

Proust's familiarity with music and the influence of Wagnerian form upon his great novel have already been dealt with in many an article. But now for what is, as far as I know, the first

time, his relations with painting are examined in some detail by Maurice Chernowitz in *Proust and Painting*, a conscientious and inevitably provocative, yet pedestrian and over-literal book that, while presenting the essential elements of the question, fails to sift and manipulate these with any real intellectual vigor.

On Mr. Chernowitz's deposition, painting, and especially impressionism, played an even greater role than music in forming Proust's sensibility and style. If music governed the larger formal aspects of his work, painting seems to have controlled him even more pervasively in the smaller aspects. Proust took in more of the world through his eyes than through his nose, ears, or epidermis. (Compare him in this respect with Joyce, for instance, who seems to have been all ear.) And, as Mr. Chernowitz and others show, the impressionist pictorial aesthetic influenced his content and such elements of his style as diction and syntax.

The question of syntax is particularly important, for it raises deeper issues. As much as he was influenced by Bergson's ideas, Proust appears to have found the diametrically opposed "metaphysic" of the impressionist painters equally attractive. (And in so far as it is one of the functions of art to keep contradictions in suspension, unresolved, he was entitled to the inconsistency.) Bergson's "duration" may have justified Proust's notion of "permanent memory" and hence the way in which he fictionally organized the passage of time; yet the attempt, expressed in the delaying syntax of his long sentences, to immobilize and protract the instant by subdividing it infinitely, by spreading and, so to speak, spatializing it, bespeaks the mathematical, atomic, Eleatic materialism of the impressionists, precisely that "mechanical" materialism against which Bergson argued.

It is in its attitude toward time that the symbolist and impressionist aesthetic of the nineteenth century differentiates itself most vividly from that of the Renaissance, Baroque, and Romantic past. Instead of shaping, organizing or elegiacally celebrating the flow of time, as previous art has done, it halts and fixes discrete moments; without faith in the future, without faith in the external reality of the past, it seeks to grasp the instant as if it were all—"*Verweile doch, du bist so schön*"—and treats the past as if it were a bundle of so many underived moments unified only by the identity of the subject who experienced them. In this desire to arrest time and movement in their

flight, in his aversion to or incapacity for the dramatic, Proust, it seems to me, was most profoundly of all an impressionist.

The Nation, 31 August 1946

43. A Martyr to Bohemia: Review of *Out of This Century* by Peggy Guggenheim

The book-reviewers, with their customary severity, have scolded Miss Guggenheim for not being a better girl than she is, or at least for not professing the minimum virtues we all owe to print. And some have pointed out to Miss Guggenheim what a spectacle she was making of herself in this book. As if she didn't intend that herself.

The general mistake has been to treat Miss Guggenheim as a subject when, as every one of her simple declarative sentences after page 24 should make clear, she has spent most of her life altogether as an object. And it is the self-contented naiveté with which she confesses her role as an object that makes her autobiography the true historical-social-cultural document it is, a piece of "modern evidence" indispensable to those who may want to investigate the state of mind of international culture and dissipation in the 1920's and 1930's.

Until the age of twenty-one, when she came into an independent fortune, Miss Guggenheim did show enough subjectivity to criticize the milieu into which she had been born, and to draw generalizations from her experience of it. It was after she was freed from her family that she became an object. The new world she then entered proved to be so overwhelming that she is able to record only the barest, most immediate details, boring and otherwise, of what has happened to her since. To these details the reader must apply his own insight and upon them make his own generalizations. Miss Guggenheim is not up to any.

Like the late Gertrude Stein, Miss Guggenheim is an American of German Jewish descent; like Miss Stein, she fled the *lares* and *penates* for Paris; and like Miss Stein, she succumbed uncritically, if on a different level, to international bohemia, becoming one of its most loyal citizens, faithful inhabitants, and

assiduous celebrators. But where Miss Stein entered on the wings of literature, Miss Guggenheim flew in on money and a kind of vitality that amounts almost to genius (of which this book gives only the most scattered hints, which the reader has to piece together.)

What Miss Guggenheim fled from was moneyed, bourgeois, claustrophobic stuffiness. And it was for fear of being recaptured and returned to it somehow—the unconscious conviction that she would be, simply because Jews are forced to remain bourgeois in spite of themselves—that she threw herself so unreservedly into bohemia and has dwelt in it so unqualifiedly, recklessly, and gullibly. But it is the same fear of bourgeois life, essentially, that accounts for the feverishness with which many non-Latins in general since the beginning of the century have gone in for bohemia. Whereas heretofore only artists had made this internal emigration, in our age, laymen, moved chiefly by a desire for pleasures of a kind or of a quantity not permitted in bourgeois milieux, form a larger and larger proportion of the population of bohemia. But in order to get into bohemia they still have to show "cultural" passports. Perhaps this is the reason why Miss Guggenheim still feels that her citizenship in bohemia is insecure. As a sponsor and as a gallery-director she has done a great deal of modern art—and literature, too—but she is not principally interested in either; she is mainly interested in the freedom and excitement that go with artists' lives—and therefore has, as I seem to detect, an anxious feeling that her presence is possibly illicit.

In any case, Miss Guggenheim is unable to take any distance from the milieu in which she has chosen to live her adult life. She accepts it on its own terms and claims, questioning and doubting nothing, incredulously grateful to be part of it, and therefore resigned to being victimized by it. Giving the details of this victimization with a helpless literalness, omitting nothing that might be humiliating, drowned in a self-absorption that flows from her total failure to solve either her environment or herself, Miss Guggenheim displays her career, unconsciously, as a martyrology. Her story is sadder than I can express. And that is, in a sense, her revenge on bohemia.

As a Jew I am disturbed in a particular way by this account of the life of another Jew. Is this how naked and helpless we Jews

become once we abandon our "system" completely and surren-
der ourselves to a world so utterly Gentile in its lack of prescrip-
tions and prohibitions as bohemia really is? It is no use objecting
that Miss Guggenheim's is a uniquely extreme case, and that
personal circumstance has more to do with it than her Jew-
ishness. In the list of the martyrs of bohemia, Jewish names
stand out, the names of gifted Jews, too, not merely aberrated
ones—beginning with Simeon Solomon in Pre-Raphaelite En-
gland and continuing through Modigliani, Pascin, and even
Soutine, in Paris. In proportion to the size of the Jewish con-
tingent in bohemia—which is smaller than one would expect—
the martyrs are too many, and examples like Miss Guggenheim's
too frequent.

[K. Hardesh[1]]

Commentary, September 1946

44. Introduction to "The Great Wall of China" by Franz Kafka

The revolutionary and hypnotic effect of the works of Franz
Kafka, a Jew born in Prague who wrote in German, upon the
literary avant-garde of the world has been without parallel.
Where Joyce, Proust, and Mann write finis to a whole age of
fiction, Kafka seems to initiate a new one single-handed, point-
ing a way beyond most of the cardinal assumptions upon which
Western fiction has rested until now. Kafka's writings represent,
moreover, perhaps the first time that an essentially and uniquely
Jewish notion of reality, expressed hitherto nowhere but in reli-
gious forms, has found a secular voice.

Kafka was born in Prague in 1883, the only son among four
children of a successful and self-made businessman, who at-
tempted to mold his male child in his own image. Kafka's
double-movement of resistance and appeasement toward his fa-
ther became the central experience of his life. He resisted in so
far as he preoccupied himself with literature and worked at his

1. Hardesh is Yiddish for Greenberg. [Editor's note]

writing, but he appeased his father by taking a law degree and earning his own living in a labor-insurance company; and to some extent he even occupied himself with his father's business affairs. The outcome of these divided activities was to confirm Kafka's already obsessive sense of guilt, felt originally toward his father alone, but now toward his art as well. He did most of his writing at night and, unable to break the umbilical cord attaching him to the patriarchy that was his family, went on living with his parents until the age of thirty-seven.

Shy, quiet, self-isolated, and neurotic though he was, Kafka mixed from youth on in literary and artistic circles in Prague, and his writing saw publication fairly early. Although his one complete and two fragmentary novels (*The Trial*, *Amerika*, and *The Castle*) were published only after his death, through the intervention of Max Brod, his best friend, seven small books containing short stories and sketches appeared during his lifetime.

In 1917, at the age of thirty-four, Kafka discovered he had tuberculosis, which eventually forced him to leave his job and spend much of his time in sanitariums and in the countryside. His interest in what he called his Jewishness grew considerably during this period, though it had never been altogether dormant, and he discovered Zionism, studied Hebrew, and read the Talmud in translation. He had already made two attempts to get married but had been thwarted in each by financial difficulties (as it is said), by his timidity in the face of women, or, perhaps by his fear of "competing" with his father by setting up an independent family. Yet at the same time he continued to long for children and a domestic life of his own. In the early 1920's he met a Polish Jewish girl almost twenty years his junior, and an ardent Zionist, with whom he was at last able to settle down successfully for the short amount of time left to him. Even so, he returned to his father's house in the last year of his life, 1924, and left it only to go to the sanitarium in which he died.

Kafka was not a religious writer, though many have interpreted him so, and his fiction is not allegory, though many have likewise, and just as erroneously, interpreted it so. The strangeness of his work arises from the fact that it abandons the immediate, historical reality that is the fluid in which most Western fiction, including allegory and fairy tale, has lived, and takes place, instead, in a dimension far removed from factual reality

and yet which seems the intensest texture of everyday life; there, only the quintessential situations of human life are experienced, those that recur again and again and make up, in their repetitive and uninteresting detail, the stock and staple of human existence. Kafka's fiction is composed of parables and *cases* and deals with the paradigms, the patterns or habits of individual existence, not its originality or unicity, not the personal, historical, or geographical identities that strike our eyes first. With a vision unobstructed by the meanings that religion, philosophy, ideology, and sheer hope read into the human condition, Kafka sees life as sealed off and governed by unknowable powers who permit us the liberty only to repeat ourselves until we succumb.

The finalities of life—the essential isolation of the individual, our inability to control the totality of existence for human ends, our ignorance as to why we are here on earth—all these, conclusions arrived at by processes of thought that abstract from the immediate, specific situations of life, are in Kafka's fiction related *directly* and *immanently* to the everyday and its routine. It is this identification of the ultimate with the immediate that accounts for the apparently perverse logic of Kafka's writing and for the way in which it violates the common assumptions of narrative literature.

Kafka's static, treadmill, "Chinese" world bears many resemblances to the one presented in the Halachic, legal part of post-Biblical Jewish religious tradition, that department of the writings of the sages which deals with the Law. Halachah, too, focuses on the paradigms of human existence, the recurring problems and situations rather than the exceptional or historical ones; it, too, is motivated by the same desire for logic and order that drives Kafka to "neurotic" lengths; and it likewise attempts to relate every iota, every habitual triviality of life, to the ultimate. Like the Amorites, the Tannaites, and all the rest, Kafka weighs, ponders, and questions everything from many sides in the effort to establish certainties that will survive chance and history; in him, as in them, we hear that characteristic double beat of dialectic: "on the one hand . . . and on the other"; and, again like them, he writes as economically, transparently, prosaically, and tonelessly as possible, rejecting emotional color and stylistic embellishments in order achieve the anonymous objectivity of a business letter, an official communi-

cation, a scientific report. But whereas Halachah arrests and systematizes life into case history for the sake of relating every jot and tittle of it to God, and is content, being away from Palestine, to go without history until the coming of the Messiah, Kafka, with his Westernized sensibility, finds the world static in spite of himself; and experiences, not only alienation, but also its lack of drama, resolution, and history as a nightmare paralyzing us in the face of a doom that wells up out of its very orderliness. His heroes are haunted by anxiety and dread, not because they see the approach of doom—which by the very fact of *approaching* would give them a chance to cope with or at least assume responsibility for it—but because they feel its unmotivated presence all around them—lurking, so to speak, in the very furniture of their furnished rooms.

Kafka's vision of the world was revealed to him before he ever dabbled in the Talmud. Some critics have traced its source to his position as a Jew in Prague, member of a minority within a minority within a minority (the Jews of Bohemia, being German in culture, were in a sense part of the larger German minority there, which was in turn surrounded by Czechs, who in their turn were subject to German Austria). I do not doubt that there is much truth in this explanation, but it seems to me that the larger truth underneath Kafka's unremitting sense of alienation and helplessness lies in the complex of his relationship with his father and, perhaps involved in that, his Jewishness—to which he sometimes looked for the real home he could not find with his father. I do not think it is chauvinism on my part to assert that Kafka is the most Jewish of all modern writers, including those who write in Yiddish and Hebrew. He expresses the contemporary Jew as he really feels himself and his situation, not as he chooses to see and solve himself and his situation. And one of the problems Kafka confronts, wittingly or unwittingly, is the subjective dilemma of the majority of 20th-century Jews, torn between the desire to act and to find a home and a safety really theirs, and the feeling that they are the objects of a history that runs along heedless of them and dangerous to them in what our Jewish bones feel, despite all our abstract ability to understand history, is its caprice.

But it would be a serious and a vulgar error to confine Kafka's

definition of the human plight to Jews, whose situation is but an intenser and more naked version of the general human situation. The more Jewish Kafka is, the more universally human he becomes. That is the paradox and—platitude—of great art.

Whether Kafka has anything of hope and encouragement to offer is a moot question. Some interpret him to counsel patience, carefulness, and humility—a typically Jewish resignation to the psychological and physical limitations of life and to the futility of trying to wish them away. (This is a resignation against which most imaginative Jews have, at least in their youth, rebelled with an extreme, often undirected, but always understandable passion.) But it is probable that Kafka had no message more explicit than a personal sense of life that included contradictions without resolving them. The very fact that he wrote and wanted above all else to be a great writer proves that he did not altogether despair. He kept alive as long as he could; he was more often miserable than not, but he did not commit suicide.

The epilogue to Kafka's life and work was furnished by history and the outside world—the world of officials and of strangers on the street, of janitors and peasants and coachmen, of Gentiles—the world that filled him with such apprehension. His dread was confirmed as senselessly and arbitrarily as he divined it would be: his sisters and their families, including two brothers-in-law, a niece, and a nephew, were taken from their homes in Czechoslovakia by the Nazis and sent to their deaths in Auschwitz. And one of the relatively few houses destroyed in the street-fighting that preceded the liberation of Prague was the home of Kafka's parents, in which he had lived so much of his life.

The story by Kafka printed below—which presents his universe in brief—is the one that gives its title to the collection of his short stories, sketches, and aphorisms which Schocken Books will publish in the near future, in translation by Edwin Muir, the Scotch poet and critic. This collection originally appeared in England before the war. Schocken, by whose permission the story appears here, will also publish a definitive German edition in ten volumes of Kafka's complete works, edited by Max Brod and including hitherto unpublished writings. The first five of these volumes will appear this fall. They will be followed at

some time in the future by an equally complete and definitive English-language edition.[1]

Commentary, October 1946

45. Review of *Thieves in the Night* by Arthur Koestler

Koestler's latest novel is even more negligible as art than his previous ones. But, as we know, art is not the main question with him. And yet this is not to say that the *ad hoc* novel, spot-news fiction, of which he is the most successful practitioner, has nothing whatsoever to do with art. The vulgarities and makeshifts this genre permits the novelist to get away with, even in the eyes of serious readers, contribute no little to the present decline in the general practice of the novel.

The journalistic novel exploits nonfiction in order to enable the writer to avoid the more difficult challenges of fiction proper, while on the other hand it uses fiction to make the shaping, manipulation, and adulteration of nonfiction easier. Where the genuine artist starts from a personal, particular experience, the journalist-novelist starts from a general, public one, whose automatic cogency relieves him of the necessity of making it cogent by means of art. His product enjoys the best of both worlds, and we read with fascinated attention—but only for the moment: as long, that is, as the *hoc* of the *ad hoc* retains the precise kind of interest it wears at the moment of writing. Afterwards the shoddiness of the craft overwhelms everything else.

Koestler is at least good journalism. For anything that, despite vulgarities, clichés, and oversimplifications, holds our attention as much as this latest novel of his does must be good as *something*. But the virtues of journalism, even at its best, are ambiguous. Good journalism can be made by reporting without comment the words of a stupid man, provided that the jour-

1. Greenberg contributed several translations to Schocken's English-language editions of Kafka (see the Bibliography at the back of this volume). He wrote again on Kafka, and specifically on "The Great Wall of China," in *Franz Kafka Today*, edited by Angel Flores and Homer Swander, 1958. [Editor's note]

nalist taking them down organizes them appropriately. And the journalist becomes all the better if the stupid man talks about a topic of general and urgent concern. (Were the journalist to take down the remarks of an intelligent man on the same subject he would be acting merely as a secretary or rewrite man, not as a journalist.) It is to the advantage of a journalist if his understanding is superficial, otherwise he will resist those momentary moods whose excitement flavors his writing, otherwise he will understand too much to become excited.

Koestler's is the case of a gifted reporter listening to his own remarks, which come from a man the epidermis of whose brain functions better than its core, a man highly sensitive as only the superficial can be to the changing moods of the international, up-to-date, and literate milieu in which he circulates and according to which he cuts his figure. His talent makes the best of superficiality, pretending more plausibly than those who actually do, to understand what it does not and causing his readers to feel that they understand the most precisely when they understand the least. The task of such a talent is not to illuminate our understanding and our experience but to enlighten our public emotions, to post us on the appropriate reactions of the day; it provides us with an etiquette for current events.

Koestler's way of subduing the difficult and rather impersonal material of contemporary politics is to see moral dilemmas everywhere, just as Malraux used to see Gidean philosophico-aesthetic problems. But one of the most truly problematical aspects of modern politics is precisely that it offers so little opportunity for moral choices and independent action—in other words, so little opportunity for fiction on a high level. He who today wants to write political novels must renounce understanding and be ready to tell or condone the lies of incompleteness. Thus, in Koestler's case as much violence is done to the truth as to fiction.

The very interest of *Thieves in the Night* as a vivid travel book and as a quick introduction to Palestine politics and society—all of which it is—flows from its oversimplifications. If it were less superficial it would be less interesting. For the moment I am willing to exchange, for the sole sake of reading matter, the true complexities of the situation for Koestler's contrapuntal effects; the beauty of the decaying Arab villages versus the healthy but

ugly utilitarianism of the Jewish settlements; the noisy, neurotic weakness of the European Jew versus the brawn and courage of the Palestinian "Hebrew"; the interestingness, on the other hand, of Einstein, Marx, and Freud versus the dull loutishness of the new Tarzans of the communal settlements; the dignity of resistance versus the humiliation of passiveness and caution—and so on.

It is in 1939, the period just before and after the issuance of the British White Paper restricting Jewish immigration and land-purchases in Palestine. The hero, Joseph, is a half-Jewish, half-Anglo-Saxon pioneer on a collective farm who has identified himself with the Jews because of a painful, melodramatic, and cheaply far-fetched incident in his past. Through his and others' eyes we get quick glimpses into every corner of the Palestinian scene: the Arabs, the British, Tel Aviv, Jerusalem, an American journalist, a high-born expatriate of Mayfair, a survivor of the Socialist uprising in Vienna, a survivor of the Gestapo with a "Thing to Forget"—and so on. And it is all done with a great deal of journalistic skill, notwithstanding—or perhaps just because—almost every figure is lay and every situation stock. Since we know so little about Palestine in the flesh it is better, no doubt, to drape that flesh in all its freshness and novelty on a familiar armature taken straight from a run-down novelists' costumes and furnishings firm.

The novel comes to a climax when Joseph joins up with a Jewish terrorist organization (modeled, apparently, on the Irgun Zvai Leumi, halfway in violence between the Hagana and the Stern group). Koestler's defense of the Jewish terrorists seems unqualified. Not only do they spirit illegal immigrants into the country, but they also keep the Arabs quiet by tossing bombs into Arab marketplaces in retaliation for attacks on Jews. They reassert Jewish dignity by taking fate into their own hands. The conclusive evidence as to Koestler's stand on Jewish politics is the fact that he dedicates his book to the memory of Vladimir Jabotinsky, the founder and late leader of Revisionism, a heretical Zionism that in its attitude toward socialism, the Arabs, and violence can, without distortion, be likened to fascism. Here, just where we most expect it, Koestler fails for the first time to see a moral dilemma. But just here something deeper than morality is at stake for Koestler; namely, his own Jewishness.

The chief feat of this novel and that which will some day be its only claim on our memories is that it is the first time a Jew openly confesses his own self-hatred. "Self-hatred is the Jew's patriotism," Koestler quotes somebody as saying. And Joseph writes in his journal: "I became a socialist because I hated the poor; and I became a Hebrew because I hated the Yid." When Jews bomb and shoot they are no longer Yids, they behave just like gentiles, they even begin to handle themselves and look like gentiles. Time and again Joseph suffers pangs of revulsion at the sight and behavior of the still unreconstructed Jews in Palestine, but when it comes to describing the junior officers of the terrorist organization, Koestler likens them, in his newfound Anglophilia, to the members of an (English) officers' mess, with the "air of young men from good families—with keen but reserved faces, well groomed hair. . . ."

Koestler is entitled to his opinion of European Jews, or rather his acceptance of the majority gentile verdict on them; I myself want to take time out only to quarrel with his lack of sophistication on this score. It is possible, I want to suggest, to adopt standards of evaluation other than those of Western Europe. It is possible that by "world-historical" standards the European Jew represents a higher type of human being than any yet achieved in history. I do not say that this is so, but I say it is possible and that there is much to argue for its possibility. No one, I say further, has any right to discuss the "Jewish question" seriously unless he is willing to consider other standards than those of Western Europe. And in so far as their acceptance of the gentile verdict on the European Jews motivates so many of the Zionist leaders, I question their right to decide the Jewish question.

—Aside from all this, and beyond all this, Koestler's own egregiously false notion of what the Anglo-Saxon is (a notion that moves underneath and informs this book) disqualifies him even more profoundly. If he fails to recognize the Anglo-Saxon, how can he recognize the Jew?

Partisan Review, November-December 1946

46. The Great Precursor: Review of *The Drawings of*
 Leonardo da Vinci, introduced by A. E. Popham

As both an artist and an event in history Leonardo da Vinci offers
paradoxes. These are brought to view even in his drawings—
which happen to be the most authentic evidence we have as to
his genius, since the authorities tell us that almost every one of
the paintings still attributed to him has been altered seriously
by the hand either of another artist or of time. Thus the book at
hand becomes doubly valuable, even to those more interested in
Leonardo as a personality than as a painter.

Remarkable in these drawings is the amount of intellectual
will manifested by a taut, deliberate line, by contours that de-
scribe a form as if asserting a final truth. Here, immediately, is
the first paradox. Was not Leonardo among those who did most
to deliver Italian painting from conceptualization and carry it
farthest on the way toward explicit emotion and naturalism?
Did it not go out of fashion after him for painters to be intellec-
tual? Where are the Piero della Francescas, the Uccellos, and the
Mantegnas of the Cinquecento? But like many of the paradoxes
attaching to Leonardo, this one can be plausibly explained by
his "uneven development." Born in 1542, he never quite suc-
ceeded in escaping from the intellectualist Quattrocento, al-
though he was, essentially, not of it; and despite his instinctive
naturalism he was unable to attain the uninhibited passivity
that made it possible for the next generation of painters to ren-
der a pictorial world so "natural" that its space became continu-
ous with that in which the spectator moved.

Leonardo's will was not only the will to know and to under-
stand but also the will to power. Where for his predecessors,
Piero and Uccello, graphic definition had been primarily a way
of identifying nature's essence, its perfection and harmony,
for Leonardo it was a form of control over his environment. In
his drawings we see a struggle between the Quattrocentist ideal
of harmony and his own instinct for immediate, physical con-
trol. Yet he seems to have been too impatient to make the unre-
served, if temporary, surrender of the intellectual will without
which the sensory truth cannot be assimilated. Although in his
notebooks he upheld the primacy of the unmanipulated evi-
dence of the senses, he continued to believe in geometry as the

supreme and a priori key to visible reality. Hence the vestigial stylization in his drawings, the cramped, but rhythmic, faintly Sienese arabesque of Quattrocento painting, which, although a great excellence in its own time, represents a frustration for an artist whose temper and ambition no longer belong to the fifteenth century.

Some of Leonardo's frustrations, as well as his unresolved contradictions, arose from his own temperament no less than from his historical position. His preoccupation with knowledge and power goes hand in hand with a certain coldness or detached impersonality, for which evidence is to be found in both his drawings and his notebooks. Yet his revolutionary contributions to painting were an emotional naturalism that inaugurated the High Renaissance, and his *sfumato*, which by swathing forms in soft, voluminous shading not only moved them into "real" space but made the emotion they bore more explicit. And yet who but a cold nature can calculate best when it comes to a question of dramatizing and exploiting emotion? And is it not also characteristic of a cold nature that, when called on to display emotion, it should resort, as Leonardo did, to sentimentality and exaggeration?

There is, however, a kind of valid feeling in Leonardo's seemingly most objective drawings. But it appears as puzzling to us as it proved troublesome, no doubt, to the artist himself. It is the alienated and the unsympathetic, and is expressed in depictions of violent struggles, of catastrophes by fire and flood, of invented facial types and facial deformities, of war chariots with revolving scythes that litter the ground with human limbs, and in the directions in his notebooks on how to paint a battle scene—but most particularly in his anatomical studies, which convey, as modern anatomical plates do not, the idea of a callousness that does not come altogether from the fact that these studies were done from life by a consummate draftsman in a period in which hardly anyone as yet had acquired the habit of viewing the insides of a human body detachedly and with curiosity. The mirrormaker who denounced Leonardo to the Pope for his anatomical drawings may have had ulterior motives, but I believe I can understand why he felt he had a good case.

The most precise definition I can give of the feeling I detect in Leonardo's drawings and writings is that it is the result of self-

withdrawal, of an unwillingness or inability to commit or reveal himself. His appetite for mystification would bear this out. (And by mystification I do not mean merely his practice of writing from right to left; after all, Leonardo was left-handed.) He was able to put emotion into his art more outwardly than anyone before him because it was not his own emotion but emotion that he chose for his not-self. He was able to write more copiously than any other artist of his time because he kept himself out of what he wrote. He willed because he assigned the performance of the acts of his will to his not-self.

Relatively few of the drawings reproduced in this book are finished works of art in the sense of being placed and executed in relation to the size and shape of the page. Many are preliminary sketches, notations, studies, and the like; others are sheer rumination, revery, wish-fulfilment, thinking. They amount to works of art only in the limited way that isolated passages of verse do—or even less, because their presumptive wholes never saw existence.

As I have said, most of these drawings are not quite free of the Quattrocento. The recurring types of the fierce, masculine, mature man and his contrast, the soft-chinned, effeminate youth; the flower-pieces, the landscapes, and especially the drawings of water in movement seem governed by notions of ideal types, or of abstract, mathematical harmonies. (The Quattrocento, while it drew from nature, corrected its observations according to a set of ideal, generalized patterns, drawing *the* arm and *the* tree instead of *an* arm and *a* tree.) Leonardo does not seem to have been comfortable with the remnants of a style that by his time, and particularly for him, had become equivalent to stylization. Had he been comfortable, his drawing would have been more mannered—like Botticelli's—which it is not at all, and would have betrayed the unity, self-indulgence, and repose that go with mannerism. But Leonardo's draftsmanship is rarely at ease; its revery as well as its will is nervous, almost convulsive. Its invention transcends the Quattrocento by far, and only its execution relapses into it—in the tapering of a limb, the slightly abstract rhythm and compression. And yet even here the truth and emphasis are too strong to be decorative in the Quattrocentist manner.

Leonardo was endowed with the talent of a great draftsman,

but we can appreciate that talent only as a potentiality. He left behind very few really great drawings, and most of those in the present book are but samples and demonstrations of talent, not its achievements. Those of them done most directly from life appear the most spontaneous and incisive; his male nudes, his female heads, and even his studies of drapery—which seem slightly stylized only because taken, as Vasari says, from clay figures draped with rags dipped in plaster. On the other hand— and here we meet another paradox—the best complete drawing in the book, in my opinion, is a more or less architectural sketch for the perspective of the unfinished *Adoration of the Magi*—notwithstanding its over-drawings, guiding lines, and erasures. And yet again, this drawing happens to be one of the most Quattrocentist of all, even though its conception, a wide, horizontal composition converging into depth, was to be taken up and repeated by Raphael and others in the sixteenth century.

The famous Burlington House cartoon of the Madonna, St. Anne, the Jesus child, and St. John, made as a sample sketch for an altar piece never executed, is considered by many the greatest and most genuine surviving example of Leonardo's genius. About this drawing, magnificent in the pictorial and emotional unity of its rhythms, there is nothing whatsoever of the Quattrocento. Although its volumes round off deeply into the third dimension, they are perfectly controlled on the picture plane, with the Quattrocentist handling of volumes as protuberances to be organized frontally like a bas-relief left far behind. And yet I feel something impure, mannered, cloying in the elongated figures of this drawing, in the faces, and in the sugary *sfumato* that haloes them. The emotion is sent too exclusively and too far in one direction, becoming unbelievable for the purposes of art; the artist seems to be staking his effect on the spectator's weaknesses as well as on his own skill. In the end, this charcoal drawing, like Michelangelo's Sistine frescoes, constitutes one of those rapes of the medium that result in something splendid and extraordinary but that leave us admiring the scale and force of the artist's nerve more than his art. And since these works have such a deleterious effect upon artists who come afterward, they amount almost to acts of hostility toward art.

We know how much Michelangelo preferred sculpture to painting and how he complained at the task set him in the Sis-

tine chapel, and so his hostility can be accounted as more than accidental. Leonardo's reluctance to commit himself fully to any of his pursuits—as indicated by such external evidence as his inconstant interests, his lack of perseverance, and his very neglect of the rudimentary physical aspects of his métier—may be interpreted as the sign of an unconscious hostility toward accomplishment in general, not only toward art. Whatever the personal facts concerned, it is as if Leonardo, once having embarked upon his revolutionary ventures, lost heart and became resentful when he saw that these were but beginnings that would have to be left to others for realization. And so for him the main question became that of proving and demonstrating his gifts rather than of creating works.

His faculty for divining the obsessions and challenges of the future led him into paths down which he could take only the initial steps. Just as his art, while reaching far ahead in conception, remained trapped between Quattrocento and Cinquecento in its embodiment, so in natural philosophy his genuine positivism, which anticipated so much to come, could of itself achieve little for lack of a scientific method; while his inventions and engineering projects, which manifested a very modern desire to exploit nature rather than propitiate it, came to nothing for lack of a source of power more generous than pulleys and cog-wheels. Leonardo arrived too early. "Tell me whether anything was ever finished?" he wrote more than once.

The Nation, 2 November 1946

47. Review of the Pepsi-Cola Annual; the Exhibition *Fourteen Americans*; and the Exhibition *Advancing American Art*

This year's Pepsi-Cola show at the National Academy, its name changed to *Paintings of the Year*, was a great improvement over last year's. But it was of necessity—as any attempt to present contemporary art wholesale must be—a relative failure. There is simply not enough good painting being done in this country to stock a respectable large-scale show out of current production.

The mistake of largeness arises from a more fundamental error, which is that of attempting to be representative, of refusing to be "prejudiced" or to select and back specific tendencies. True, the outright academic work that made such a fiasco of last year's show was excluded, but the catholicity of taste within "modern" painting that governed this year's effort served only to place its failure on a somewhat higher level, not to diminish it. It was overlooked that there are tendencies toward decay and retrogression inside "modern" art itself which are little less inimical to high art than the confessedly academic thing.

The show *Fourteen Americans* (actually fifteen) at the Museum of Modern Art suffers, if to a considerably lesser degree, from the same error. This, I think, causes the unfortunate total impression it leaves—an impression disproportionate, however, to the number of deserving artists included. At least half of them—Gorky, Hare, Roszak, Tobey, MacIver, Price, and even Motherwell—-have to be taken seriously, whether for good or bad. I myself hold greater or lesser reservations with respect to each of them and get full satisfaction from rather little of their work, but it remains that they are among the relatively few people upon whom the fate of American art depends at the moment. And the fact that they make up half this show would seem to stamp it unambiguously with a definite and chosen direction—toward the abstract in the line of Matisse-Picasso, or the abstract as the freedom to invent "poetically" in the way of Klee or Giacometti. And yet somehow this is not at all the impression one carries away. The presence of such artists as Sharrer, the ineffable Pickens, Tooker, Culwell, Aronson, even of the abstract painter Pereira, the sculptor Noguchi, and the gifted draftsman and cartoonist Saul Steinberg—whose drawings are surprisingly strong on their own terms—blunts the point, either because, as in the case of the first four or five, their tendency is ultimately academic or because, as in the case of Pereira and Noguchi, they adulterate the good tendency by faking it. And the inclusion of Steinberg, good as he is in his limited way, seems almost a last-minute gesture of despair: for even if he were much better, he would still be relatively unimportant in terms of modern art.

The net impression left by the *Fourteen Americans* show is of a kind of shabbiness, half-bakedness, a lack of seriousness and in-

dependence and energy, the fault of which lies more with the person who selected and arranged the show than with the artists shown. Whoever he was, he seems altogether devoid of personal taste—more reliant on tips than on his own judgment.

It is precisely personal taste that furnished the auspices of the Metropolitan's show of a group of contemporary American paintings bought by the State Department for exhibition in South America and elsewhere. In my opinion it was the best group show of this nature to be held in New York for years. Disagreement with many of his inclusions and omissions does not abate my admiration for the way in which J. Leroy Davidson of the State Department handled his job. Obviously, he realized that the cultural situation in Latin America is such that its connoisseurs of modern art are more likely to be impressed by daring and plastic originality than by the American "scene" or our home-grown surrealism; and that it was up to the State Department to show people whose taste is oriented toward Paris that we too keep abreast of the advances in art. Whether he wanted to or not, Mr. Davidson had to take a definite and bold line, and therefore a good half of his show goes determinedly in the direction of the abstract.

But Mr. Davidson's exhibition does not make the point of being advanced merely for the sake of being so; in proportion, there is almost as much bad advanced or abstract painting as there is any other kind. Mr. Davidson also has a taste, a personal and definite one, that accords with the line he took. Though he shows many bad pictures by poor artists, he shows enough good pictures, even by mediocre artists, to more than make up for them. And at least there is some relation to be discerned between the bad and the good; they are not thrown together helter-skelter by a jury the only connection between whose members is one of time and place; they have an organic relation to each other that is enlightening in itself. Mr. Davidson's exhibition is in a way a remarkable accomplishment, and its moral should be taken to heart by others who control the public destiny of art in our country.

The Nation, 23 November 1946

48. Limits of Common Sense: Review of *Years of Wrath: A Cartoon History, 1931–1945* by David Low

The success of Low's cartoons with the newspaper public would suggest that the public is more sensitive to art for its own sake than its members themselves realize.

Despite the claims made on the jacket of this latest collection of his cartoons—to the effect that Low "combines technical mastery of his medium with a political intelligence that puts many of our contemporary statesmen to shame"—his insight into world affairs turns out to be only what might have been expected from any liberal with decent instincts and a large endowment of common-sense humor. Low has never, in reality, seen beyond the headlines, and his penetration of events is rarely superior to that of his readers. Altogether without any positive political ideas, and equally devoid of political imagination, he has manifested political intelligence only by being more afraid of fascism than Stanley Baldwin and Chamberlain were.

In my opinion the attraction of Low's cartoons consists in some part in the vividness with which they mirror, to the mind raised on Anglo-Saxon common-sense liberalism, the exact quality of its own attempts to make sense out of contemporary history. But I doubt whether this reflection of futility would have gone down so smoothly with newspaper readers had it not been embodied in, and thus transcended by, art. For Low is at least a remarkable draftsman, a worthy continuator of the great but still largely unrecognized 19th-century English tradition of popular graphic art.

Examine almost any one of his cartoons and you will see how little its effect depends on its "idea" and how much on the drawing and design. Franco, at the end of the war, trying to buy a ticket for the "Victory Bus" from a ticket-seller who happens to be Stalin; Franco carrying a stick of confetti labelled "War on Japan (perhaps)" and a tag on his ship saying "Hooray for Liberty"—anybody could have thought of that. What is funny and even illuminating in an inexplicable way is the frowzy, wistful, pint-sized figure of Franco (in 1937 Low drew him much larger) standing in his silly uniform in the gray penumbra of the left foreground, while in the blank white background anonymous civilians crowd aboard a bus. Linear definition, composition,

and the distribution of darks and lights drive home something that is more satisfying to the emotional requirements of the occasion than any possible real insight could be. Like every first-rate journalist, Low provides us with a proper state of mind, not with truth or information; and in the day-to-day struggle, the right emotion is a more urgent necessity to the newspaper reader than right understanding.

Since the beginning, Low's art has developed steadily toward greater crispness, economy, and broad, dramatic effect. In the early 30's there was still something about it of the jiggly-jerkiness of British bourgeois cartooning in its post-Edwardian decline. That style had a tendency to bog down in the narrative detail and in human-all-too-human sentiment. Low escaped from it quickly, but retained its concern for the likeness, and for that which is instantaneously, incandescently characteristic. By 1931 his squat little Japanese soldiers are depicted with such an infallible eye for the right detail, whether of anatomy or uniform, that they become more Japanese and more soldier than the reality itself.

In dealing with public personalities, Low is usually most telling when they happen to be British—naturally he understands his own kind best. Now and then, however, he manages to nail Roosevelt, Goebbels, Mussolini. And he always gets those he can see around and behind—Franco, for instance, or any other small, shabby potentate. But he is completely taken in by the fellow-travellers' version of Stalin as a benign tomcat; and while he can get the Germans and the German situation, he is incapable of seeing Hitler as anything more than a popinjay, a mincing hotel clerk. Perhaps it is too much to ask of common sense that it comprehend the lumpy, fermented, "soulful" vulgarity which seems to have been the Fuehrer's most personal and most German quality. And perhaps the failure to get Hitler marks the limit of Low's talent. After all, he is no Daumier.

Commentary, December 1946

49. Review of the Whitney Annual

This year's Whitney Annual is no worse than last year's—which amounts almost to an improvement, since each of the Annuals in the three or four years previous had been worse than the one before it. That, apparently, is what American painting, sampled wholesale, has been like. But this is not a new discovery.

Of course, the fault lies chiefly with the artists themselves, and I am sure that not even the notorious egoism of painters has prevented some of them from recognizing that. Yet in view of the *evenness* with which the Whitney shows have been bad, the suspicion grows that a more considerable part of the blame than one used to think is assignable to those who run the place. Their lack of strong-mindedness, of serious bias, of any intense and constant perception of the tasks of modern art and of the direction in which it solves them best, their eclectic conformism, their eagerness to receive and their dread of finding, their affable timidity—all this creates something in its own image, and that image is any Whitney Annual as a whole. The same goes, with some modifications, for the people who run the Museum of Modern Art, the Carnegie Annual, the Pepsi-Cola shows, and so on. Obviously, American art is in the wrong hands.

However, the responsibility has to be placed even deeper. Primary is the fact that the selection of our museum directors and curators is not susceptible to the pressure of any real opinion from outside the academic world. There exists in this country no self-assured, self-intelligible class of connoisseurs and amateurs of art with defined and independent tastes. Collectors, critics, and simple enthusiasts depend on slogans, worded and unworded, that they cull from everything except their own experience.

Perhaps the fact that we have been the pupils of France in art for the last thirty years helps account for this. But even more important, I think, is the absence of a stable leisured or a self-confident intellectual class in this country, prepared to rally to each other's help against the attrition of journalism, fashion, publicity, and kitsch. As it is, the "art world" in America remains a parody the object of which varies—now the fashion world, now the literary world, now the night-club world, now Miss Dickinson's garden. And when it comes closest to the reality of that with which it deals, it parodies the stock market.

As for the paintings at the Whitney, their shortcomings lie not so much in their execution as in their conception. Everybody knows more or less how to paint. Examine any picture, and you will see a good amount of knowledge and manual competence in it, if not sensitivity. And you will even see enough of that. Everybody knows what has *already* made painting great. But very few know, feel, or suspect what makes painting great anywhere and at any time—that it is necessary to register what the artist makes of himself and his experience in the world, not merely to record his intentions, foibles, and predilections. The same tastes that lead one to prefer scrambled eggs to fried are not enough to furnish the content of a picture. The trouble with American art is that it substitutes pretension for ambition.

The best painting at the present show is Jackson Pollock's *Two*. Those who think that I exaggerate Pollock's merit are invited to compare this large vertical canvas with everything else in the Annual. Mark Tobey, too, is represented by a strong picture, but in the presence of the Pollock the minor quality of his achievement, original as it is, becomes even more pronounced than before.

I also liked Edward Hopper's landscape despite the crudeness of its greens and the academic superficiality of its facture. A special category of art should be devised for the kind of thing Hopper does. He is not a painter in the full sense; his means are second-hand, shabby, and impersonal. But his rudimentary sense of composition is sufficient for a message that conveys an insight into the present nature of American life for which there is no parallel in our literature, though that insight itself is literary. Hopper's painting is essentially photography, and it is literary in the way that the best photography is. Like Walker Evans's and Weegee's art, it triumphs over inadequacies of the physical medium; and the main difference between them is that while Evans's and Weegee's subjects do not give them time enough to calculate focus and exposure, Hopper simply happens to be a bad painter. But if he were a better painter, he would, most likely, not be so superior an artist.

The Nation, 28 December 1946

1947

50. Review of an Exhibition of Pierre Bonnard, and an
Obituary of Arnold Friedman

The Bignou Gallery's announcement of Pierre Bonnard's first
one-man show in this country may have struck some of us as
presumptuous in its bland statement that Bonnard is the great-
est living French painter. One's first impulse is to bring up
Matisse, whom many—and I among them—consider perhaps
the greatest living painter in the *world*. The fact is, however,
that the Bignou announcement merely echoes an opinion that
has spread wider and wider in France during the last fifteen or
twenty years and that represents a kind of hostile criticism of
Matisse, cubism, and cubism's aftermath—that is, of every-
thing the School of Paris has done since fauvism. This opinion
rejects what it holds to be the shock and flash effects of Picasso
and Matisse and prefers the "solidity" of French "tradition."

Bonnard is indeed solid painting. He is also late impression-
ism plus Toulouse-Lautrec, Gauguin—and Matisse. Originally
one of the "Nabi" group founded in the 1890's under the inspira-
tion of Gauguin's flat, decorative painting, Bonnard has devoted
himself to gathering up the loose strings left around by the
School of Paris's too rapid transition from impressionism to ab-
straction. Bonnard, for his part, has worked toward the abstract
in a slower and, in a sense, more organic way than did the cub-
ists. Before 1910 or so he painted in rather darkish tones, heed-
less of the fauves, but flattening his canvas more and more as he
went along; by 1915 he seems to have felt Matisse's influence—
he himself may have influenced Matisse previously—and his
palette brightened up radically and his painting blossomed into
big, boldly cut-out pictures that resemble screens or panels
more than easel paintings but are too hot in color to stay in place
as mere decoration.

It is to this last phase that Bonnard owes his present renown

among those who profess to know and like painting for painting's sheer sake—for the poetry of the immediate medium, of cuisine, paint texture, manual sensitivity. And it is precisely this concentration on his stuff, on juice and matter, that seems to have led Bonnard to paint more and more abstractly; the greater the attention to pigment and brushstroke the less becomes the concern with the original idea of the subject in nature. Thus Bonnard's conceptions have become steadily more summary; he simplifies shapes into flat areas of unbroken color modulated by nothing more than the brushstroke, and arranges these areas into patchwork paterns in which all planes merge into one, with no single color or shape receding or advancing too far or too dramatically and the human figure becoming but one more object among others. Warm colors, crimsons, oranges, pinks, yellows, mauves, acid viridians, and emeralds in off shades, all these are crowded close to one another—sometimes at dangerously close intervals that threaten to turn the effect into mud. And yet it is one of the tensions and dramatic virtues of Bonnard's art that such bright, hot colors should come so close to mud.

Here, moreover, is a way of approaching abstract painting that makes a detour around cubism and yet arrives at almost the same place in the end. But Bonnard never abandons the object, and never will—nor does he violate it as Picasso has done, while still retaining it. He holds on to the third dimension more tenaciously. He may simplify nature but he does not reorganize it with respect to anything except color; and so the world he shows us disorients no one familiar with that of Monet or Renoir. This is the main reason why conservative connoisseurs have found Bonnard easier to take than Matisse, despite the fact that the latter has never gone so far toward the abstract. But Matisse is no longer an impressionist, and he imposes his temperament too radically and inflexibly. Besides, abstractness, taken by itself, has never been a measure of the radicalness of art; if it were, Magnasco would have been more of an innovator than Delacroix. The abstractness of the cubists and Matisse's flatness are the symptoms of a new vision of art, whereas Bonnard's is an extension of the same vision by which Monet painted his lilypads.

But the intimacy and calmness of Bonnard's art, its concentration on gentle pleasures, and the fact that it smells perma-

nently of the fashions of 1900–14, expressing as it does the desire of the French middle classes to make history stop and stand still at 1912, and leave them undisturbed in the enjoyment of the modest but refined amenities that the Third Republic had permitted them to accumulate—all this should not mislead us into thinking that he lacks ambition as a painter. Bonnard has not been content to have his art called French and to let it rest at that. He can paint "French" easily enough and turn out any number of sure-fire successes; and from time to time he does, indeed, paint little landscapes and still lifes that Manet or the early Corot or even Courbet or Boudin would have been glad to call his own: pictures, precious enough in themselves, that depart from the standard traditional qualities of French painting only by their directness and by the fast, loose, modern execution which achieves their paradoxical delicacy. But these are in the nature of relaxations, and Bonnard also seeks to realize a more monumental art through his instinct for large-scale decoration. What he seems to want is a big *flat* picture with the massiveness and weight of Tintoretto or Veronese. Here he must gamble; there are no certain successes in this unexplored territory, and he makes many mistakes and paints many failures. But the audacity with which he cuts out his canvases and the no less audacious monotony with which he designs them are an effort to express something profound and entirely new and contemporary, and when success comes, the result is an important masterpiece and a further advance on the part of the total tradition of Western painting.

Alas, the present exhibition at the Bignou contains little but a selection of Bonnard's failures—and they are not even important failures, except for *The Open Window* of 1924. The two best canvases hung, *Cannes, the Harbor* (1919) and *Still Life with Fruit* (1926), are in Bonnard's relaxed vein; as exquisite as it is, the seascape might have been painted by a latter-day Decamps, and the still life by Renoir himself. One can, provisionally, explain the weakness of this show only by the assumption that the artist's best work has remained in France.

Bonnard is not the only contemporary to show that impressionism still has something left to say, even in the presence of cubism and post-cubism. There is Victor Pasmore in England—and there was Arnold Friedman here in America. Friedman's

death last week at the age of seventy-four closed the career of one of the best painters this country has ever produced—one who in a place where people were less illiterate in terms of painting for its own sake would have received far more recognition and understanding than he did. Only illiterates could ever have called a painter so completely in possession of his means as Friedman a "primitive." Forced to earn his living as a post-office clerk and to paint in his spare time until his retirement in 1933, Friedman took a long time to develop. But he did develop, and always in a determined direction, a direction that took him toward an abstract impressionism more radical than Bonnard's. In the last years of his life he painted a series of landscapes that for color and texture are without equal in our time. But they lack shock effect, they are too solid and complete to be "brilliant," and therefore his art may have to wait a long time before it receives its just recognition in this country. But I have enough confidence to add his name right now to those of Eakins, Ryder, Homer, Blakelock, Cole, Bellows, Eilshemius, and Hartley.

The Nation, 11 January 1947

51. Review of Exhibitions of Jean Dubuffet and Jackson Pollock

Jean Dubuffet, the new French painter so much discussed in Paris—a small sample of whose art provoked this writer to two successive pieces last June—is now the subject of a one-man show at the Pierre Matisse gallery containing twenty-two oils. Among them are three pictures painted in 1943, six in 1944, six in 1945, and seven in 1946.

Inevitably Dubuffet will be called a "primitivist," or "primitivistic," or even, by some of the more habitually unqualified critics, a "primitive." He has, indeed, gone to sidewalk graffiti and children's art for a considerable amount of plastic inspiration; he has reduced his drawing to the rudimentary linear schematizations by which children and untutored or ungifted adults reproduce nature; and he has, in his horizontal pictures, made design a matter of sectioning off the rectangle into smaller

rectangles with straight up-and-down and all-the-way-across lines—as Klee did, and as his followers and the gifted but incomplete Adolph Gottlieb (at the Kootz Gallery) and Torres-García and many others still do. But this is something that comes from impressionism and Cézanne and cubism even more than from primitive and children's art. Like so much of modern art, it is a kind of geometry impelled by the need, conscious or unconscious, to remind ourselves of, and repeat, and acknowledge the physical limitations of the medium among which is the shape, usually rectangular, of the picture space. Dubuffet is obviously, as every fleck of paint on his canvases shows, an erudite painter, and no more a primitive than Klee. Like the latter, whose influence he is one of the few Frenchmen to feel, he paints the primitive and the childlike at a remove, portraying it, so to speak, from the heights of culture, and as a state of mind, not a way of art.

In his earlier paintings, those of 1943 and 1944, Dubuffet tries to find an equivalent in color for the "primitivist" reduction to which he subjects his drawing. These pictures are in flat, thin, high, unmodulated tones. But they do not work, they falsify the artist's sensibility and experience; this elementary spectrum is not sincere; and none of the pictures of this period are truly successful. In contrast to the directness and richness obtained by Matisse and Miró when they take lessons in chromaticism from barbaric or children's art, the result is impoverished, giving us to suspect frustrated talent at the most.

The tonality of Dubuffet's 1945 and 1946 pictures is a radical departure. There is a sudden scaling down to blacks, browns, grays, and dirty whites, with pinkish, lavender, or bluish overtones running in and out like glazes. The pigment is mixed with tar, asphalt, or gravel and laid on thickly, roughly, and, apparently, with plenty of varnish. The drawing remains more or less the same in principle, but now the lines are scored or scratched into the paint as if with a stick. The result is, on the whole, original and profound. The large *Vue de Paris*, with its flat, cubed surface, is a major picture, not so much in its conception, which echoes Klee, Dufy, and Utrillo, as in the "artistry" of its rendering—"artistry" being the only word I can find for the subtlety and instinct with which Dubuffet maintains every part of the surface flush with the canvas and exactly inside the frame.

This painting is proof, if it is still needed, of how completely Dubuffet has assimilated all that the School of Paris has had to teach since 1908.

The almost outright abstract and somewhat smaller *Grand Paysage*, also of 1946, is a more original but less spectacular and immediately successful work than *Vue de Paris*, and bears resemblance at points to a sort of thing many painters over here have been trying to do with Klee's heritage: even, over-all treatment, scratches in bark, runes, graffiti scraped into limestone. But where the Americans mean mysticism, Dubuffet means matter, material, sensation, the all too empirical and immediate world — and the refusal to be taken in by anything coming from outside it. Dubuffet's monochrome means a state of mind, not a secret insight into the absolute; his positivism accounts for the superior largeness of his art.

Black Beauty, *Mouleuse de café*, and *L'Homme à la cravate rouge*, and perhaps *Minerve*, all of 1945 and monochromatic, are also strong paintings, if not equal to the above two. As it happens, none of these, including the two above, have the concentration and quiet intensity of the 1945 *Promeneuse au Parapluie*, which is missing from this show, although exhibited at the same gallery last June. Three or four more pictures on the level of *Promeneuse* would suffice almost of themselves to make Dubuffet one of the major painters of the twentieth century. This, even though his art still suffers under the limitation of being too essentially personal — which is a limitation it shares with Klee's. Where Picasso, Matisse, and even Mondrian speak for a whole age, Dubuffet still speaks for but a single mood inside a single period of that age.

Jackson Pollock's fourth one-man show in so many years at Art of This Century is his best since his first one and signals what may be a major step in his development — which I regard as the most important so far of the younger generation of American painters. He has now largely abandoned his customary heavy black-and-whitish or gun-metal chiaroscuro for the higher scales, for alizarins, cream-whites, cerulean blues, pinks, and sharp greens. Like Dubuffet, however, whose art goes in a similar if less abstract direction, Pollock remains essentially a draftsman in black and white who must as a rule rely on these colors to maintain the consistency and power of surface of his pictures.

As is the case with almost all post-cubist painting of any real originality, it is the tension inherent in the constructed, re-created flatness of the surface that produces the strength of his art.

Pollock, again like Dubuffet, tends to handle his canvas with an over-all evenness; but at this moment he seems capable of more variety than the French artist, and able to work with riskier elements—silhouettes and invented ornamental motifs—which he integrates in the plane surface with astounding force. Dubuffet's sophistication enables him to "package" his canvases more skilfully and pleasingly and achieve greater instantaneous unity, but Pollock, I feel, has more to say in the end and is, fundamentally, and almost because he lacks equal charm, the more original.

Pollock has gone beyond the stage where he needs to make his poetry explicit in ideographs. What he invents instead has perhaps, in its very abstractness and absence of assignable definition, a more reverberating meaning. He is American and rougher and more brutal, but he is also completer. In any case he is certainly less conservative, less of an easel-painter in the traditional sense than Dubuffet, whose most important historical achievement may be in the end to have preserved the easel picture for the post-Picasso generation of painters. Pollock points a way beyond the easel, beyond the mobile, framed picture, to the mural, perhaps—or perhaps not. I cannot tell.

The Nation, 1 February 1947

52. Review of Exhibitions of Gaston Lachaise and Henry Moore

The concurrent shows of the English sculptor Henry Moore (at the Museum of Modern Art) and of the late American sculptor Gaston Lachaise (at Knoedler's) present a difficult problem to criticism. Both demonstrate in opposite ways that style, finish, and historical relevance do not settle everything in art, and that no amount of facility or awareness can make good the shortcomings of what Croce calls personality.

Lachaise's is the more authentic talent; yet his achievement seems less complete and adventurous than Moore's. The terms he sets himself are narrow, but he fails, apparently, to satisfy even these—while Moore, setting his terms so much higher and wider, seems to fill them completely in an *oeuvre* already resonant with almost everything that twentieth-century sculpture, painting, and construction have had to say. And yet, still, Lachaise is the better artist.

Lachaise's bulbous distortions and his occasional fondness for the fragmentary should not conceal his relative orthodoxy: he was a sculptor in the old line, the one running from Egypt through Greece and finishing with Rodin, Lehmbruck, Despiau, Maillol, and himself. The new, "international" line, which departs from cubist painting under the influence of barbaric art, is an almost completely new kind of sculpture that incorporates and aims at pictorial effects and depends more on draftsmanship than on carving or modeling. Sharp profiles and plane surfaces are offered to a single point of view, in contradistinction to the old classical sculpture, which offers a monolith to be seen from many sides; flat variegated colors, lines and wires, open and sometimes geometric forms circumscribing empty air, in contradistinction to the classical play of light and shadow on unified, monochromatic surfaces; cast iron, sheet metal, and flexible alloys, in contradistinction to wood, stone, and bronze.

Henry Moore's sculpture represents a stage about halfway between the classical and the new—a stage, also, where modern sculpture becomes peculiarly obsessed with the archaic and the primitive. Moore's quintessential impulse is still sculptural rather than pictorial, but he avails himself of many of the stylistic means developed by Arp, Lipchitz, and the constructivists. His use of string forms and holes and, in his latest work, of flat perforated leaves of metal inclosing smaller and more detailed motifs is altogether in the new vein. At the same time he remains traditional in so far as he restricts his media largely to wood, fieldstone, bronze, and lead, and insists on "fidelity" to the respective natures of these materials. His large figures, invariably reclining and almost invariably derived from the female form, demonstrate his attachment to the past more obviously than do his smaller pieces, and the final effect, even in the latter, somehow discounts the actual presence of modernist

calligraphy and detail, to leave one with the impression, hard to define but nevertheless definite, of something not too far from classical statuary.

Moore possesses no mean talent, and some of his later work, from the two reclining figures of 1938 (one in stone and one in lead) and *The Helmet* of 1940 (in lead) to the two bronze family groups of 1945 and 1946, will surely outlast the transient ardors of that informed contemporary taste upon which Moore's art is now making what I feel is an exaggerated impression. But even at best this work is not so original as it intends itself to be. It answers too perfectly the current notion of how modern sophisticated and inventive sculpture should look, without at the same time disappointing the popular demand for the heroic. (Truly original modern sculpture like Brancusi's makes that demand seem irrelevant.) Nor are the expected archaeological reminiscences lacking—Egypt, Central America, Africa, and even Graeco-Roman bronze figurines. The very fact that it meets our taste so ideally banishes all real difficulty or surprise from Moore's art. It is, alas, this subservience to taste that condemns him, along with Calder, Stuart Davis, Graham Sutherland, and sundry Anglo-Saxons, to the category—not as populous as might be thought, but very popular just now—of the sincere academic modern.

The first number of a new London arts magazine, *The Arts*, publishes photographs of Moore's large elmwood *Reclining Figure* of 1946 in three different stages of progress. Because so few of the possibilities exposed at each stage are taken advantage of in the completed work, with its curvilinear monotony and water-silk surfaces, one might conclude that Moore is a case of the inability to *realize*, of the failure of that nerve which is required to pursue the original sensation in the face of whatever warnings one's own taste may flash. But in the light of Moore's water-colors, which are obviously first hand notations of feeling, one has to revise the diagnosis and conclude that, in spite of the photographic evidence, the original sensation itself is not very strong and that Moore needs his taste to expand it.

Lachaise's total work is very incomplete, and he never did quite affirm a style. But in his relatively short life he did affirm an artistic personality that has a potency and autonomy not yet approached by Moore's. The set of distortions to which he habit-

ually subjected the female figure sometimes threatens to become a mannerism, and he could stylize along with the worst of modern sculptors—but feeling was always there, some current of emotions always penetrated to the spectator from these over-literal attempts to negate the visual sensations of mass and weight by means of form. We do not see the feeling give out—as only too often in Moore's case—halfway through a piece, so that from a certain point on the art becomes nothing but a fumble and a stammer, a helpless fingering of archaeological reminiscences or a supine surrender to the best taste (see Moore before 1935). Where Moore fails because his feeling is incomplete, or because he has not pressed himself, or because he has not pressed himself to complete it, Lachaise fails only because he cannot organize his feeling to the very last jot and tittle. He hardly ever runs dry—not even in that series of stylized and repetitious women's heads in the first room at Knoedler's.

Moore will probably bulk larger in the history of contemporary sculpture, and for valid reasons, but I feel certain that in time to come there will always be a few people around to discover Lachaise in the corners of American museums and become worked up about him as no one will ever be about Moore.

The Nation, 8 February 1947

53. Review of the Exhibition *Painting in France, 1939–1946*

The large-scale show at the Whitney, *Painting in France, 1939–1946*, provides a much-looked-forward-to report on the present state of painting in the country that has been the undisputed capital of that art for the last hundred years. According to the catalogue's foreword, "It was our [the museum's] wish . . . that the work of younger artists and those less well-known in America should predominate." That wish, fortunately, has been met on the whole.

The show itself is shocking. Its general level is, if anything, below that of the past four or five Whitney annual exhibitions of American painting—about the lowness of which I have ex-

pressed myself rather strongly in the past, lamenting the sad state of American art in our day. Taking both American and French art wholesale, I now see that we have reason to congratulate ourselves on being as good as we are. Naturally, I except from this comparison the "old masters" of Paris—Picasso, Matisse, Braque, Rouault, Dufy, Bonnard, and Jacques Villon. These are represented at the Whitney by single examples—of which Bonnard's still life is the jewel, and a matchless one, while the other artists are generally shown in twos or threes.

The works of the older and less well-known artists, such as Goerg, Survage, Souverbie, Lhote, Marquet, Desnoyer, and others, demonstrate only too well the justice of their being less well known. Marquet remains his sober self, but most of these—Survage, Souverbie, Goerg—are not plodders on the trail of a limited or stale sensation but quick-change artists who orient themselves toward worldly public taste and pre-digest their betters for stylish consumption. The same corruption affects a good section of the younger generation, who, if generally less decorative, show a similar readiness to be content with superficial effects, provided only that they are flashy. Neo-cubists, neo-realists, neo-surrealists, neo-expressionists—they are alike in their brittle color and their excited and equally brittle design. Where their American equivalents tend to mud or garishness, French painters tend, apparently, to confetti and neon lights. If the Americans seem stodgy and dull, the liveliness and the knowingness of the French are empty. Nor, contrary to expectations, are the French more facile or tasteful. They are just as coarse, just as inept for the most part—and hysterical in the bargain.

Those who, like Ceria, Caillard, and Brianchon, stay closer to impressionism or who, like Oudot, Quizet, and Venard, slavishly imitate the generation of Derain and Utrillo, are at least occasionally pleasing. They have less affrontery and do not make a meaningless commotion. The Franco-Spaniard Borès likewise manages to please by treading humbly in Matisse's footsteps.

The most ambitious and advanced group is formed by the "synthesizers," those who marry Picasso to Matisse—Tal Coat, Tailleux, Pignon, Gischia, Fougeron, Bazaine. Tal Coat seems indeed to be the best of all the younger or less well-known artists present; in such canvases as *The Horse* and *The Rooster* he actually succeeds in making a quick Picassoish sort of calligraphy work

129

against a background of fauvist color. And next to him on the wall Tailleux's still life, *The Fishes*, while not so clarified, promises even more substance and force. These are the only ones of the younger painters whose work, on the evidence of this show, has both validity and the interest of the new. And even they are a trifle thin. Both Gischia and Pignon, whom I have seen to much better advantage in reproductions, are represented by big and emptily pretentious canvases—although Pignon does draw a ram's head beautifully in one of them. In Gischia's case the over-literal influence of Léger crushes all spontaneity; in Pignon's and Fougeron's, mannerisms taken from Picasso do the damage.

Except for two very bad pictures by Gleizes and Bazaine respectively, no outright abstract painting is to be seen. There is very little flat painting. Miró's influence is not to be detected anywhere, and no one, except Gleizes, ventures to go farther in surrendering the third dimension than Picasso and Matisse have done. Bernard Dorival suggests in the ornamental prose (translated) of his occasionally acute catalogue note that this relative conservatism—let one only compare it with American abstract painting—is motivated by the desire to place a synthesis of cubism and fauvism "at the service of the human aspiration of the expressionists and surrealists." And, indeed, most of these painters seem to be obsessed with the notion of violent and intelligible, explicit, obvious emotion, which they try to convey by expressive distortion applied to "significant" objects. The trouble is, however, that these distortions do not inhere sufficiently in *style*. Like the distortions in most of Picasso's recent work, they are arbitrary in an ultimate sense, not compelled by a style that is the emotion itself but superimposed or inserted with the label "emotion." The result is vulgarity and theater, and painters such as Lorjou, Ambrogiani, Aujame, Dany, Bertholle, Prassinos, and Alix upset all our notions about French temperament by outdoing the German expressionists at their wildest and most bathetic. The surrealists and neo-romantics present, like Coutaud, Labisse, and Courmes, are equally unspeakable.

Of course, it is quite likely that the whole show has been badly chosen. It is an institutional affair, supervised by curators, and we know from experience with the American variety how inept curators can become in the face of contemporary art—even when it happens to be their *Fach*. Some important

painters have been left out: among them, Eugène de Kermadec, whose work in reproduction is impressive, and Dubuffet. Also Estève, Lepicque, and several others—of whom reproductions give, however, an unfavorable idea. And in any case three such painters as Dubuffet, Tal Coat, and Kermadec, all under fifty, are enough to prove that French art still has vitality. Nevertheless, I myself feel more hopeful about American art. We lack poise, but we do seem to have on the whole—and at the moment—more originality and more honesty. And whereas, when all is said and done, Tal Coat, Kermadec, and even Dubuffet culminate in charm, we at least, when we do culminate, shall have force.

The Nation, 22 February 1947

54. Review of Exhibitions of the Jane Street Group and Rufino Tamayo

The more ambitious and serious of the youngest generation of American painters live south of Twenty-third Street, are shown now and then on Fifty-seventh Street (at Art of This Century, Betty Parsons Gallery, the Egan Gallery, and one or two other places), but never figure in the big annual group shows and get almost no publicity. They are all more or less abstract in mode, betray the influence of Picasso, Matisse, Miró, or Klee, and half or more come out of Hans Hofmann's school on West Eighth Street. A group of these young painters, the year before this, used to show regularly at the Jane Street Gallery just off Eighth Avenue. After that gallery—which was something of a cooperative enterprise—closed, they remained known as the Jane Street Group, and they are now receiving a show at the small new Gallery Neuf, which is run by a young writer from New Orleans, Kenneth Laurence Beaudoin. Mr. Beaudoin also publishes a little magazine, *Iconograph*, in collaboration with Oscar Collier. Mr. Collier's wife, Gertrude Barrer, is one of the most promising young painters in the country.

The members of the Jane Street Group are Nell Blaine, Frances Eckstein, Ken Ervin, Ida Fischer, Albert Kresch, Sterling

Poindexter, Judith Rothschild, and Hyde Solomon. None of these artists—not even Nell Blaine, the most developed of them—is anywhere near fulfilment as yet, and it would be unfair to attempt to draw up a critical balance sheet of their individual accomplishments. Suffice it to say that except for Miss Eckstein, who paints nice but irrelevant flower pieces, they are all ambitious and serious, and seem uncompromisingly determined to prolong and widen the path marked out by Matisse, the cubists, Arp, and Mondrian. My one provisional criticism, founded on a short acquaintance with their work, is that they have perhaps too narrow and too sectarian a conception of what being an artist involves.

The Gallery Neuf itself is the center of a tendency quite different from that represented by the Jane Street Group. This tendency, first made known by Steve Wheeler, takes its point of departure from Northwestern Indian art—more specifically that of the Haidas. Most of the work produced under this inspiration is still too literal in its dependence, too imitative of the influence itself, and too mechanical in execution. And it is, moreover, a style that lends itself to the fabrication of pastiches of Klee, who was himself considerably influenced by primitive or barbaric art.

Gertrude Barrer, who had her first show at the Gallery Neuf last month, is, however, one artist who succeeds in assimilating Klee and Haida art to her own personality. In Miss Barrer's hands Klee's influence serves admirably to expand the absolutely flat and formal patterns of Northwestern Indian art and render them permeable to contemporary feeling. A more delicate linearism breaks up and softens the stiff, stylized patterns, and floating washes of brownish-grayish color assert the picture plane without permitting that frozen, flat decorativeness which usually results when Haida or South Sea art is transposed too directly into easel painting. Miss Barrer is not a large and heroic talent; her effects are still minor at best and somewhat restricted—as must needs be the case with anyone who goes to school with Klee. But her gift is as indisputable as the physical presence itself of her pictures. One can only hope that she escapes those social and cultural handicaps that have in the past generally combined to frustrate female talent in the plastic arts.

Rufino Tamayo's recent show, at the Valentine Gallery, only

repeated the point previously made by his painting. This painting, while of the highest seriousness and awareness, and compounded of the best ingredients in the way of paint quality, format, and even inventiveness, fails to come off except in isolated single pictures. Thus a Tamayo "problem" arises. Though Picasso's massive example has formed his design and dictated his brush-handling, Tamayo's originality is beyond question, especially on the score of color, over which he has thrown a typically hot, dark Mexican cast. And he remains always an interesting and seemingly powerful painter. But interest is not enough, and power is only relative, and the appearance of it can be obtained sometimes at the cost of its substance.

I believe Tamayo's error to be the same as that made so frequently by Picasso since 1930—an error which seems to have been established as a canon by the latest generation of French painters. That error consists in pursuing expressiveness and emotional emphasis beyond the coherence of style. It has led Tamayo and the younger French into an academic trap: emotion is not only expressed, it is *illustrated*. That is, it is denoted, instead of being embodied. Instead of dissolving his emotion into the abstract elements of style—which is what the old masters and Delacroix did just as much as the cubists—and renouncing any part of feeling that his style cannot order and unify, Tamayo, like Picasso in his weaker moments, localizes the excess emotion—the emotion that his artistic means is not yet large or strong enough to digest—in gestures, the grimace on a face, the swelling of a leg, in anatomical distortions that have no relation to the premises upon which the rest of the picture has been built. This amounts in the last analysis to an attempt to avoid the problems of plastic unity by appealing directly, in a different language from that of painting, to the spectator's susceptibility to literature, which includes stage effects.

If Tamayo were not as good a painter as he is, one would not bother to point all this out. But since he is such a good painter, at least in potentiality, one not only points all this out—one also concludes that if so good a painter can make so crude a mistake, then painting in general has lost confidence in itself. In the face of current events painting feels, apparently, that it must be more than itself: it must be epic poetry, it must be theater, it must be rhetoric, it must be an atomic bomb, it must be the

Rights of Man. But the greatest painter of our time, Matisse, preeminently demonstrated the sincerity and penetration that go with the kind of greatness particular to twentieth-century painting by saying that he wanted his art to be an armchair for the tired businessman.

The Nation, 8 March 1947

55. Review of an Exhibition of Giorgio de Chirico

The Chirico revealed by his latest paintings, which are now on view at the Acquavella Galleries along with specimens of earlier work, is surprising only as an objective fact, but not in the perspective of his whole development, which was always colored by an ambiguous and guilty but thoroughly logical hostility to all truly modern painting since Courbet.

At the beginning of his career Chirico was struck by the German Swiss painter Böcklin, whose work is one of the most consummate expressions of all that we now dislike about the latter half of the nineteenth century; however, I cannot believe there was not some perversity, half-concealed from himself, some desire to shock his peers and betters, in this admiration of Chirico's—a desire that sprang perhaps from his despair of equaling the profound matter-of-factness of the impressionists and of Cézanne and Matisse. Like many a twentieth-century Italian, with the glorious past behind him and the glorious present elsewhere—in Paris, London, Berlin—he clowned out of a historical instinct that he himself was half unconscious of.

But Chirico still was and is a gifted painter, as he demonstrated in some of the pictures he painted before 1919. Although they show portents of the bankruptcy to come and signal across a decade to that retreat of avant-garde painting which began with the surrealists in the late twenties, these canvases have a substance and plastic quality that justify, in plastic terms, this last serious attempt to save literary easel painting. They will survive because they are *sui generis*. Though certain aspects of their design and subject matter owe much to cubism, they do not exist within the same order of criticism, and must be treated

as a point of exception and not approached with the demands we make on the great and *typical* painting of the first twenty years of the century. They are one of those tours de force that, like Michelangelo's frescoes, founded a misguided school.

As a colorist, Chirico was in this period a last emissary of mannerism, three hundred years behind Delacroix in its use. The emphasis of his gift lies in his draftsmanship, and his best works are tinted drawings in which color does not interfere or speak in its own right. (Thus his most prominent disciples—Dali, Ernst, and Tanguy—are likewise draftsmen, but so exclusively so that they cannot handle color at all, and in their painting it gets in the way of the drawing.)

Chirico's deep space, foreshortenings, and exaggerated perspective announce, in spite of himself, the absolute flatness of Mondrian. It is the latter who drew the correct conclusion from the Italian painter's early work, not Dali. The early work parodies the perspective of the Quattrocentist masters and the means in general by which the Renaissance attained the illusion of the third dimension; and because it parodies, it destroys. From his tangential position Chirico, by an exaggeration that amounted to ridicule, helped the cubists exile deep space and volume from painting. See only how completely schematic and secondhand is his delineation of depth, how flat all surfaces in these early pictures, how the shading and modeling are applied in undifferentiated patches, like a decorative convention, and how light is handled as if in a shadow box.

Having performed this parody, which was in the nature of a final summing up and relegation of all the problems that had occupied Western painting between Giotto and Courbet, Chirico had no place left to go. Failing or unwilling to understand either what he had done or the character of painting since Manet, he could find nothing to replace that remnant of the Renaissance which he had destroyed. His destruction had been too exclusively negative—unlike the cubists, whose attack on the third dimension had of itself generated something equally positive to take its place; a new conception of pictorial space.

Chirico went on into the twenties continuing to parody, this time Davidian neo-classicism, sculpture, architecture, literature. This was the period of broken columns, toppled statues, pale horses, and whitewashed gladiators, but handled with ba-

roque or romantic technique. The objects of the parody and the painterly means were both irrelevant. The literary effects themselves were boring, while the loose brush-stroke, the thicker paint, and the warmer colors were just so much inert machinery. His draftsmanship, now that it had abandoned the original inspiration of mannerism and nineteenth-century popular illustration, became as weak as his color. Chirico had lost touch completely. It was not even easel painting; it was elementary interior decoration.

This was not, however, Chirico's last word. He has now performed one more parody. These very latest, post-1939 paintings of his, more or less literal pastiches of Rubens, Delacroix, Géricault, Chardin, Courbet, and the baroque still life reduced in scale and simplified, are frontal attacks on the *malerisch* or "painterly" school, to which Chirico's own Florentine temperament, with its leaning toward hard, cool colors, firm modeling, and clear contours, seemed so directly opposed at the beginning of his career. Here, nevertheless, he has aped the heated, swirling effects of the baroque and romantic masters. The results that in their hands took days or weeks to be achieved are simulated and mocked in a few hours of slapdash, *alla prima* painting (though it should not be overlooked that baroque and romantic painting was fast and broad by definition). All that is added to the originals is a curious detachment and nostalgia toward the subject matter, an emotion that is the only overt testimony to the fact that these pictures were painted in the twentieth century.

Chirico admires Delacroix, Rubens, Courbet, *et al.*; he could not have imitated them so successfully—up to a point—did he not. He seems to be saying: this is the finest fruit of the painting of the *old* past, and now it is all over with; here is an anthology of ironic reminiscences—in any case, the end, the finish, the funeral; and as for myself, all I can do is comment on other painters.

These pictures are of no importance whatsoever in the development of painting. They are not even tours de force; they are just stunts. But this does not prevent a few of them—*The Folly of Horses*, *Departure*, and the Chardinesque *Still Life*—from coming off on their own terms and so revealing Chirico's gift for unity again after a lapse of twenty-five years, during which nothing he did came off, on its own or any other terms. And

negligible as this stuff is at its best and symptomatic as it may be
of a real degeneration and of an impotence to react cogently to
modern life, still it has some reality as a gloss on the history of
painting, an illustrated lecture on the ABC's of baroque paint-
ing. Irrelevant as painting inside painting, it is sheer cultural
evidence, a kind of funeral oration more affecting than anything
that could be put into words.

The Nation, 22 March 1947

56. Review of the Whitney Annual and Exhibitions of Picasso and Henri Cartier-Bresson

As usual the water-color, gouache, drawing—and sculpture—
instalment of this year's Whitney Annual reaches a securer level
of quality than the oils. The reason is still the same. Water color
is a more intimate medium than oil, and art tends to be rather a
private affair in this country; hence the American artist becomes
more direct and less ill at ease and pretentious when working in
water color or gouache. At the same time he has behind him the
Anglo-Saxon tradition of water color.

The greater success of American water color is particularly
evident where one would least expect it—in the more or less
abstract sections at the Whitney. Also evident is how increas-
ingly irrelevant the other art is becoming—that which stopped
short of cubism. Even so, advanced American art is still too un-
enterprising and narrow; our temperaments still seem to fit too
easily into the canonical modes already laid down by the School
of Paris, Kandinsky, and Klee. The successes are pleasing rather
than moving or upsetting. This goes for the best water colors
and gouaches at the present show; those by Byron Browne—
who is improving rapidly—Perle Fine, Chet La More, Jacob
Lawrence, Ezio Martinelli, Hans Moller, Ad Reinhardt, and
Louis Schanker.

The sculpture section is quite a different matter. It shows a
lot of the worst that American art is capable of, and yet at the
same time three or four things in it demonstrate better than does

oil or even water-color painting the very best we can do at the present moment. Theodore Roszak's steel *Raven* is, despite its bad tripod base, one of the strongest works of art I have ever seen turned out in this country; while Seymour Lipton's lead *Famine* and David Hare's sienna-plaster *Red Knight* are almost in the same class. All three of these works are more pictorial than sculptural; the spectacular polychromatic-cement *Fallen Angel* by the always surprising Trajan seems a combination of both. Somewhat academic plaster and terra cotta pieces by Arline Wingate and Hannah Small deserve mention, if only for the success with which they accomplish what they most modestly set out to do. David Smith, whom I think already the greatest sculptor this country has produced, is represented by a weak piece in fabricated bronze; Smith is strictly a pictorial sculptor, and his ventures into monolithic usually result in a loss.

Here, as in France, according to all the evidence I have seen, the future seems to belong to sculpture much more than to painting. The amount of new and potent talent that has sprung up in sculpture and construction within the last ten years—talent of a positiveness relatively rare in painting today—would indicate that the possibilities of post-cubist sculpture have actually become richer than those of post-cubist painting

Picasso's new lithographs at the Museum of Modern Art confirm the fact that he has remained a great artist in black and white, whatever the vicissitudes of his painting in the last twenty years. During this time one frequently saw preliminary sketches whose effect was far superior to their final version on canvas—and this was true even in the case of some of Picasso's most ambitious oils. The present lithographs, especially the series with the bull and that with the two nudes, and the cow in the miscellaneous group, have much greater unity, style, and invention than any of his post-1939 oils seen over here so far. Let the spectator who wants to see Picasso "explained" linger over the bull series and notice what changes the bull's anatomy goes through. Here the artist solves with astounding success, in four or five progressively more abstract versions of the same theme—all almost equally good—the problem that has obsessed him since cubism; how to compress the infinity or variety of visual detail offered by any given segment of nature in a set of linear

abbreviations that, under the pressure of the unity and economy dictated by the plane surface, would constitute a memorandum to the imagination. These lithographs should be published cheaply in book form to enlighten the public as to what modern art is about.

The unusual photographs of the French artist, Henri Cartier-Bresson, also at the Museum of Modern Art, provide an object lesson too—in how photography can assimilate the discoveries of modern painting to itself without sacrificing its own essential virtues. One thing that painting since Manet has emphasized is that a picture has to have a "back." It cannot simply fade off in depth into nothingness; every square millimeter of picture space, even if it represents only the empty sky, must play a positive role. This, Cartier-Bresson, like his fellow-photographer Walker Evans, has learned preeminently. At the same time, unlike Edward Weston and the later Stieglitz, he has not forgotten that photography's great asset is its capacity to represent depth and volume, and that this capacity's primary function is to describe, convey, and make vivid the emotional "use-value" of beings and objects. It is to anecdotal content that Cartier-Bresson, rightly, subordinates design and technical finish. I am told that he does not trim his prints, and it is obvious that he takes his shots under circumstances that make it difficult to calculate focus and exposure with any great exactness. This procedure testifies, even if the results did not, to his overriding concern with subject matter rather than with the medium—which comes into its own only in so far as it becomes transparent.

Not all of Cartier-Bresson's photographs are of equal merit. Certain of them are tinged with that artiness which, whether plastic or anecdotal, has so far haunted almost all ambitious photography in the twentieth century. Perhaps it is because photography still feels it has to fight for recognition as an art. For artiness arises usually—as we can see, I believe, in the example of American art in general—when the place of free or high art as opposed to applied, commercial, or past art is overlooked by society at large. Then the artist tends to retaliate both by over-emphasizing the nature of art as art and by exaggerating the differences between it and everything else. This would seem to explain Pre-Raphaelitism and British aestheticism in the

1890's, as well as the artiness of Stefan George's and Rilke's mil-
ieu in Germany before 1914. Today it handicaps American art,
and photography here and everywhere else.

The Nation, 5 April 1947

57. Review of Exhibitions of David Smith, David Hare, and Mirko

The relative poverty of American art in the last twenty years im-
poses superlatives in discussing anyone who shows a minimum
of talent coupled with seriousness. The gulf between the mass of
what is popular as modern art and the few items valid as modern
art is immense. To call the latter merely "better" than the former
is inaccurate and unjust; it has to be called the "best." Yet this
"best" has seldom meant "best" or even "better" in relation to
world art. Usually it has had to be given a local qualification.

Two weeks ago I wrote that David Smith was the best sculp-
tor this country has produced. The quality of four or five pieces
at his current show of work done in 1946 and 1947 (at the
Willard Gallery) requires me to say even more. Sculpture has
until quite lately been a poor thing in this country, and to call
Smith the best of all American sculptors is not to claim so very
much for him, the achievements of Lachaise, Flannagan, and
Calder notwithstanding. In my opinion Smith is already one of
the great sculptors of the twentieth century *anywhere*, deserving
to stand next to Brancusi, Lipchitz, Giacometti, Gonzalez, not
to mention Laurens and Moore. That is, he is making an abso-
lute contribution to the development of world as well as Ameri-
can art. The course of sculpture in other countries will be
affected by what he is doing; the French, British, Germans, and
others will have to take him into account. And almost equally
important at this moment to criticism is the fact that Smith
presents it with a relatively fixed point from which to measure
the rest of the field here in America.

The baroque exuberance and invention that disrupted Smith's
style in 1944 and 1945 has in this latest work been assimilated

into a new unity of style that moves again with that "classical" spareness and speed which is so indispensable to the new linear, pictorial sculpture of our time. That Smith has been so well able to subdue his embroidery and luxuriance to this streamlining without emasculating his invention represents a feat and establishes a strong example. It is easy to be elegant in Smith's vein at the cost of power; it is far from easy to combine the two. His sculpture for all its energy presents an elegance like that of Picasso's and Braque's high cubism: there is a similar clarity and a similar plenitude, both of which come from the artist's certainty of having a style that is able to say everything he has to say with the maximum of economy. Yet at the same time the content of Smith's art is worlds away from cubism, being the product of an age whose remaining optimism—of which Smith seems to have plenty—has become the private affair of individuals; whereas the cubists regarded the disenchantment of the world as a triumph for man, later artists like Smith have become so disillusioned with that triumph that they now seek new myths and new obscurities inside themselves.

The best piece at the present show is beyond question the steel, bronze, and silver *Orchard Landscape*, whose tail and spreading feathers are a feat of draftsmanship no less than of sculpture. Other successful pieces are *Deserted Garden* in the same materials, *Specter of Mother* in steel and stainless steel, the steel, bronze, and stainless-steel *Specter—Race for Survival*, the steel *Head*, the steel, bronze, cast-iron, and stainless-steel *Landscape with Strata*, and the polychromatic steel *Helmholtzian Landscape*. This last piece is not quite pushed through to final unity, but the richness of its suggestion and possibilities almost redeems that fault. In the future we may expect to see chromatic works from Smith's hand that belong as much to painting as to sculpture.

There are also some very bad pieces, among them the polychromatic carbon-steeled *Personage from Stove City* and the massive fabricated-bronze *Euterpe and Terpsichore*, the second of which demonstrates again how unsuited Smith's talent has become to the monolithic and how much he remains a draftsman, not a modeler or carver. But it can be said, really, that Smith needs his failures, for out of these arise ideas that go on to become the nuclei of masterpieces in the end.

It is to be hoped that Smith's show sells sufficiently to permit him to embark on larger-scale works. He shows every aptitude for heroic sizes, and it is only the question of expense that has confined him so far to relatively small table and pedestal sculpture.

David Hare's bronze, cement, and plaster figures at Art of This Century, although different enough in style from Smith's work, belong in the same category of pictorial sculpture. If Smith is baroque, Hare is gothic, more angular and awkward, less closely related to cubism and more directly inspired by surrealism. Although under thirty and working as a sculptor only in the last three or four years, Hare has already shown enough promise to place him in the forefront of what now begins to seem, not a renaissance, but a *naissance* of sculpture in America: sculpture that in its methods and very utensils no less than in its conceptions—which, like our architecture and engineering, tend toward linearism, flat surfaces, and the denial of weight and mass—attaches itself more intimately to industrialism than any other form of art now being practiced.

Hare is still somewhat too prone to the self-indulgence and whimsy of surrealism to channel his powers into a style. Thus, at his present show, any unity the very fact of his temperament might impose is still not enough to overcome the impression of eclecticism and capriciousness. But one feels, as in Smith's case, better this waywardness and muscle-flexing than the anemia of good taste. In the end, when Hare does develop a style, it will say and include more, precisely because of the excess it will have to subdue. The signs of such a style were present in his last year's show; they have not multiplied in this year's, but they persist even more strongly, so to speak, in such more recent pieces as the bronze *Fisherman*, and the bronze nude that was shown at the Hugo Gallery's surrealist show last month. It is my hope that Hare will confine his surrealism more strictly to the role of stimulation and not let it usurp as many of the functions of aesthetic preceptor as it has in the past.

The exhibition of works by Mirko, a new young Italian sculptor, at Knoedler's offers an epilogue. This, indeed, is the last gasp of academic sculpture—and that it is even a gasp and not merely a sigh is due to the fact that it is expelled by an artist of

real talent. Like Chirico's, Mirko's parody destroys—in this case, the classical tradition of bronze casting. His bronze figures have the texture and a suggestion of contours, if not the size, of eroded, oxidized archaic Greek figurines, although there is nothing of archaic stiffness about them. The distortions and simplifications are licensed by post-Rodinesque sculpture—which is about all they have to do with modern art. And yet Mirko's sculpture in such pieces as the *Pegasus*, the *Figure*, and the *Chimera No. 1* has a certain contained vehemence underneath its impressionism and period stylization. Nor do the classical and Renaissance motifs he favors retain enough of their original chasteness to hide a curious sexuality and sadism. This is academic, archaeological art all right, but it is also very up to date. Chirico set the example. And is all the new Italian art as academic and, at the same time, as full of the *Zeitgeist* as this? It is a shame to see a talent as natively strong as Mirko's waste itself and everything it has to say about modern life on the academic, only because Italian despair, pride, and nostalgia have made the academic *de rigueur*.

The Nation, 19 April 1947

58. Review of Exhibitions of Marc Chagall, the American Abstract Artists, the League of Present Day Artists, and Ivan Mestrovic

Decidedly, painting is now in a situation that forces it to live on accumulated reserves. Not a single important new impulse has manifested itself since cubism and abstract post-cubist art. Kandinsky, Klee, and Mondrian laid down positions almost thirty years ago that ambitious painting today has not succeeded in extending save in isolated and therefore minor instances. Painting has had in the interim to content itself with intensifying its occupation of territory conquered long since.

Marc Chagall, one of the best results if not prime movers of the revolution that is the School of Paris, is a case in point. The substance of his art has shrunk progressively during the last

twenty-five years. After becoming one of the most pungent and personal of all twentieth-century artists between 1910 and 1920, he has failed almost absolutely since then to add anything to himself beyond Frenchified refinement and a more hedonistic sensuousness. Not that he does not still betray twinges of ambition, but these very twinges serve now only to disorganize his work. Chagall's recent show at the Matisse Gallery makes it clear that today he has to keep his aims modest in order to produce successful pictures—compromised though these successes may be by their lack of seriousness or weight. Some of the thirteen gouaches Chagall has turned out as illustrations for *A Thousand and One Nights* are felicitous, but it is the felicity of prettiness. And his oils, which are quieter and more fulfilled than most of his recent ones, escape prettiness not because of the heavier medium but simply because of his permanent difficulty in unifying his canvases—present even in such obviously well-painted works as *The Red Rooster*, the *Resurrection*, and the *Madonna of the Village*. (It is curious how Chagall's original gaucherie persists no matter how syrupy his painting becomes.)

In the final analysis this art lacks an extreme, even the extreme of control. Chagall has no longer enough to say to fill out his style, which is left without strains or tensions. He was never an independent, self-fructifying master like Matisse, and the present deliquescence of his art reflects, precisely, the decay of the movement that quickened and nourished him in the beginning. It is Chagall's tragedy that he has never had much more than his genius.

The latest annual show of the American Abstract Artists makes in its own quite different way the same point as Chagall. Here the hand of the past descends more heavily because none of the thirty-seven artists represented can quite boast a temperament. Some of them have an abundance of vitality, at least of a mechanical kind, but nowhere does it break through the canonical modes of the School of Paris to assert a new independent personality—or an idea. Witness only the show of fruitless energy made by such painters as Judith Rothschild and Perle Fine. Of all the people present Fannie Hillsmith and Maurice Golubov, both of whom used to take from Klee but now appear to have parted company with him, demonstrate the most valid native talent, grasp the identity of a picture most instinctively,

but both confine themselves to slight effects, effects they get without forcing. And the same can be said of the other painters who show respectable works at this show: Maurice Berezov, Eleanor de Laittre, Irving Lehman, Ad Reinhardt, Max Spivak, and the sculptor Harold Krisel. Not one is bold, extravagant, pertinacious, or obsessed. Like American poets and critics, they are mortally afraid of making fools of themselves. Politeness covers all.

The League of Present Day Artists, whose thirty-odd members showed recently at the Argent Galleries, are not so polite by half, but small good it does them. If the A.A.A. are like the *Kenyon* and *Sewanee Reviews*, the league is like Kenneth Patchen and Henry Miller in his so frequent off moments (I assume my readers are more familiar with literature than with art). Nothing sinks so low as revolt for the sake of revolt—especially when the opposition has succumbed decades ago. The A.A.A. takes off at least from Cubism, whereas the League of Present Day Artists begins from Vlaminck, Rouault, Franz Marc, *Schwärmerei*. This is the lamentable backwash—refuse-laden and inexplicable, talentless, pointless—of the expressionism that flowed past the point where we are now standing twenty-five years ago. One wonders how these artists deceive themselves—can't they see how much better-packaged this tripe is at any Whitney Annual? I would like, however, to save the names of Pennerton West, a painter, and Harvey S. Weiss, a sculptor, from the morass that surrounds them. Compromised as they are by their company, they have enough innate talent to keep their heads above the general muck.

Ivan Mestrovic, the Yugoslav sculptor and, according to the release of the Metropolitan Museum, where his latest work is now being shown, "one of the world's most famous artists," hardly belongs in any discussion of modern art—and will, eventually, belong in the discussion of no art whatsoever. Mestrovic may have been a better sculptor in the past; his bronze pieces have at least a sort of cuteness. But his stuff is also one of the sources of that awful archaeological, archaic, stylized, ornamental, decorative nonsense which is the bane of contemporary stone and bronze sculpture. A lot of modeler's talent has been put into the expressive distortions and simplifications of Mestrovic's bronze studies for his *Job*, but it is just so much tal-

ent invested to keep Madame Tussaud's Waxworks going. Anybody from Rockport or Provincetown could show him how to make it "art."

The Nation, 3 May 1947

59. Ideal Climate for Art: Review of *The Grass Roots of Art* by Herbert Read

In this latest book of his, composed of four lectures delivered at Yale last spring, Herbert Read continues to investigate the relations between art and society. As before, a high instinct leads him to the very center of the main problem. Mr. Read asks: What are the social conditions that best promote art? What repayment, given these conditions, can art make to society?

The answer to the first question is: "1. The reconstruction of our physical environment to secure the most favorable framework for a vital culture. 2. A social system without wide diversity of personal wealth. 3. An industrial system which gives the worker a direct responsibility for the quality of his work. 4. An educational system which preserves and matures the innate esthetic sensibility of man."

The answer to the second question is implied in the last statement. By abandoning the more or less rigid patterns of art education handed down from the Renaissance, and by substituting for them a pedagogic subtlety and sympathy that encourage the child to express himself with the greatest spontaneity, human beings will be raised up who are whole, whose personalities and skills rest on an "integration of the senses" that accords with nature inside and outside themselves. And, to repeat Plato, by putting oneself in harmony with the laws of nature, one acquires "that sense of form or grace which is the foundation of moral goodness." In other words, moral maturity will develop out of esthetic awareness.

Mr. Read can no more support this assertion than Plato could. I myself would like to believe it, but it is, alas, so untenable that it can be cancelled out by a contemporary platitude: that, by and large, men cannot behave themselves—nor, for

146

that matter, develop esthetic awareness—until they are free from want and insecurity. Alas, again, one begins to suspect that only the truth becomes platitudinous.

In his final lecture, Mr. Read comes out for a "duplex civilization." This would be one in which the manual crafts would flourish alongside the "geometric" rationalized machine arts; there would be an intimate "private art standing over against the public art of the factories," so that the life of the senses could be maintained in the face of the abstract rationality of production for use or profit. For the "foundations of a civilization rest not in the mind but in the senses, and unless we can use the senses, educate the senses, we shall never have the biological conditions for human survival." It is, I think, precisely because Mr. Read accepts the traditional differentiation between the mind and the senses that his argument falls so flat when it has to enter into the problem as well as indicate it.

For one thing, man was unable to attain to civilization until he could make some sort of mental abstraction from the evidence of his senses. For another, the failures of civilization usually have come about because the senses were not sufficiently informed by the mind, and not because civilized men became too rational.

If ever the machine arts do advance decisively in the direction of the esthetic functionalism most enlightened people now desire, and if ever our social system is so re-ordered as to make that possible, it is equally possible that a new synthesis of productive methods will emerge that will permit us to integrate the activity of the senses with machine production in a way we cannot now foresee. If not, Mr. Read's handicrafts will exist only as hobbies, and hobbies have too precarious a place to enable them to defend sensuous intuition against abstract rationality.

New York Times Book Review, 4 May 1947

60. Review of an Exhibition of Victor Brauner

The influence of Paul Klee has had, in the past ten years or so, a more immediately rewarding effect upon contemporary paint-

ing than that of Matisse, Picasso, or Miró, who are all greater than he. The latest evidence of this has come, surprisingly enough, from Paris, which in contrast with England and this country had until recently shown an indifference to Klee. The only new Parisian painters of any originality to be exhibited in New York since the war—Dubuffet and now Victor Brauner—are both products of his school. Brauner, Rumania and surrealist, used to turn out neo-academic pictures of tables with wolf's legs and heads and human testicles. Judging by the ten or twelve of his more recent paintings shown at Julien Levy's last month, he has undergone a remarkable transformation since 1939—that is why I call him a new painter. His old canvases revealed a glimmering of some sort of obscured talent and the presence of a perverted sincerity; he was irrelevant but, unlike most other surrealists, he was irrelevant in an affecting way. Now, however, he has produced some actually good painting which, if it is less important than Dubuffet's as statement and manifestation, is not inferior in intrinsic quality.

Brauner's new paintings and tinted drawings are done in wax, which he was forced to use because of a shortage of oil colors during the war. This medium compels a flatter and tighter handling and excludes the broad modeling that oil invites. Brauner has abandoned his former smoky effects for a flat-patterned, ornamental, emblematic kind of painting that clings as closely to the picture surface as inlay work—which indeed it resembles. He also demonstrates an entirely unexpected inventiveness that has nothing to do with the usual surrealism but stems directly, more directly than his color, from Klee.

Brauner, coming after Dubuffet, Mark Tobey, and Morris Graves, raises more sharply than ever the question why Klee's influence should be so much more immediately fructifying than Picasso's, whose influence has certainly been greater in extent and more pervasive. Here is a former third-rater who now, suddenly, is well on the way to becoming accepted as an important *petit maître* under Klee's tutelage, and there are five or six others like him abroad in the world; whereas of those who follow Picasso closely, hardly one—not Graham Sutherland in England or Pignon and the other epigones in France—has been able to realize himself half so satisfactorily.

The explanation is both obvious and complex. Picasso's influ-

ence carries with it the flavor of a potent personality, and the style he formed for himself, in the later even more than in the earlier stages of cubism, is designed to accommodate that personality. Artists taking his style as a point of departure find it difficult to disembarrass themselves of Picasso's personality, difficult to push it out of the way and fill in with their own. Even Picasso himself has since 1925 been largely unable to supply the power and fulness his original style requires and must resort to inflation. Painters with talents self-assured and imperious enough to shape these mighty means to their own ends are in any case very rare. (If Jackson Pollock has been able to profit by Picasso, it is because he has diluted him with Miró and Kandinsky.)

Klee, on the other hand, is a small artist—genuine, enormously original, a master, but nevertheless *diminutive*, working within a restricted range; an interior decorator rather than an architect. His personality, however authentic and intense, does not oppress but rather frees the painter who comes under his influence. If the artist's temperament is a modest one, as is usually the case in a period like ours that drives passionate people away from art, contact with Klee encourages him to release it in sincerity rather than suppress it in imitation. Seeing how much Klee made of relatively little, the aspirant is moved to confess how little he himself has and to make the most of that little. While Picasso tempts one to inflate and distend himself and deny weaknesses, Klee invites one to tell all—work your brushpoint idly over the surface, let it be a seismograph that answers every tremor in yourself: invent, invent.

Picasso asks you to construct rather than invent, to survey the terrain of your emotion more consciously and build upon it the largest and most substantial edifice possible—not, like Klee, to send up demountable tracery and momentary mists of color. This does not mean that Picasso is more "intellectual" or deliberate than Klee; he works, in fact, faster than Klee did, and with less meditation. It is simply that he sees the picture as a wall where Klee sees it as a page, and when one paints a wall one has to have a more comprehensive awareness of the surroundings and a more immediate sense of architectural discipline—though Klee's sense in that respect, if slighter in scale, should not be discounted.

It is the old difference between Nordic and Mediterranean. Klee's influence has been reinforced by the fact that the centers of artistic production having moved northward—even within France itself—fewer new artists appear whose native milieux instil temperamental affinities with Picasso's positive, public, monumental style. Klee's private lyricism is more sympathetic to those who come from industrial countries, where the effort to assert a private life of emotion displaces the ambition to externalize and to synthesize a total view of the world.

Yet the doubt persists whether Klee's art, as compared with the still unexploited potentialities of the cubist heritage, has enough carrying power to support a school of major importance. I myself would say that even the earlier abstract painting of Kandinsky provides a firmer *point d'appui*. So far none of the products of the Klee school has been able to do more than make an original initial statement of his personality and then stop short, with nowhere else to go. Witness Graves and Tobey. And Klee himself, in the last decade of his life, found that his means were no longer adequate to express what he still had to say. Therefore one awaits Dubuffet's and Brauner's next moves with pessimism—less warranted perhaps in the case of Dubuffet since he has more bravado than is usual with Klee's disciples.

The Nation, 17 May 1947

61. Review of Exhibitions of Theo Van Doesburg and Robert Motherwell

Theo Van Doesburg, the Dutch painter, architect, and designer, was a herald of the new rationalist enlightenment that dawned with the opening of the century and faded away at the approach of Hitler. The close of that period saw Van Doesburg's own early death in 1931 at the age of forty-eight. He was for a time a collaborator of Mondrian's, but whereas Mondrian confined his energies to easel painting, Van Doesburg extended their common ideas into architecture and interior decoration, for which they were ultimately intended by Mondrian himself. In both fields these ideas now seem somewhat premature, but only be-

cause of historical circumstances; they were not premature in easel painting.

Yet Van Doesburg has been the only one to paint in the same direction as Mondrian with both independence and success. This was made very clear by the recent retrospective show of his paintings and designs at Art of This Century. His gift for painting was such, in fact, that one regrets that he dispersed that gift in other fields and did not concentrate more exclusively on painting. His first cubist efforts, in 1917, already show a crispness and originality that make them much more than promising apprentice pieces. And no less than six of his seven post-1920 canvases at Art of This Century are actually and sufficiently successful—which, if this is a truly representative show, is a phenomenal rate of success, equaled, perhaps, in the twenties only by Mondrian of all the School of Paris.

Van Doesburg did not confine himself to pure or primary colors, and therefore his color is somewhat duller than Mondrian's. Where Mondrian's art is stronger, intenser, more profound, we see in Van Doesburg's a greater openness, not at all the same fanaticism but rather an exuberant doctrinairism. Mondrian, perhaps, foresaw a period that would demand tenacity and fanaticism on the part of the rationalist; Van Doesburg still belonged completely to the open, all-embracing, almost irresponsible hopefulness of the first quarter of our century. *Et ego in Arcadia. . . .*

The Van Doesburg show, incidentally, is the last to be given at the Art of This Century gallery, which will not reopen next season, since Miss Guggenheim plans to transfer her permanent collection of contemporary art to Italy, where she will make her home. Her departure is in my opinion a serious loss to living American art. The erratic gaiety with which Miss Guggenheim promoted "non-realistic" art may have misled some people, as perhaps her autobiography did too, but the fact remains that in the three or four years of her career as a New York gallery director she gave first showings to more serious new artists than anyone else in the country (Pollock, Hare, Baziotes, Motherwell, Rothko, Ray, De Niro, Admiral, McKee, and others). I am convinced that Peggy Guggenheim's place in the history of American art will grow larger as time passes and as the artists she encouraged mature.

Robert Motherwell is among the newer painters who received their first showing at Miss Guggenheim's gallery. At that time—almost three years ago—this writer pointed out Motherwell's promise if not his achievement. Since then I have also pointed out his failure to fulfil that promise. Now, on the occasion of his most recent show, at Samuel Kootz's last month, I have the happier task of saying how well indeed he has, in two or three pictures out of sixteen, begun to live up to it. It is not only a matter of two or three items, but that the general level of his work this year is so much higher than ever before.

The most important reason for this improvement seems to be the shift of emphasis from collage to oil; for the few collages in Motherwell's most recent show betray the same chaos that disastrously characterized the many in his previous ones. The great difference lies in the oils. These used to suffer, in their turn, from an absence of ideas and substance; now they body forth in their quasi-geometric purism and accomplished simplicity a quantity of feeling and experience such as one had hardly expected of this artist. It appears as though, for Motherwell, the activity of placing and selecting, as required by collage, could elicit nothing of that indispensable order which art demands of the artist's personality; this, in his case, could be provided only through the activity of drawing on canvas and applying paint. The resistance of the physical stuff itself was needed to produce such a splendid picture as the *Yellow Still Life*, which was the best thing in the show. And if the large *Construction* had not been over-painted on gravel, it would perhaps have equaled it. *In Yellow Black* is another canvas that probably would have been completely achieved if there had not been a certain reluctance to trust thin paint, an anxiety about texture and surface.

Motherwell's ambition, which is to simplify and to manipulate the results of the simplification into expression, is one that places him at the very center of all that is serious and ambitious in contemporary painting. The expression is that of a desire for order and rationality, and its success means that the artist has achieved such order and rationality at least for himself.

The Nation, 31 May 1947

62. Review of an Exhibition of Joan Miró

The first representative showing anywhere outside Spain of the
work Joan Miró has done since 1939 (at Pierre Matisse's) is an
event whose importance to the American art world cannot be
overestimated. Miró is the only painter to have emerged since
1925—that is, after Matisse, Picasso, Klee, and Kandinsky—
whose art has extended the limits of Western painting in a way
at all comparable to theirs. He took up the cubist tradition
where Picasso left it and added not only a positive personality
but a wider demonstration of what is possible in the use of flat
color and the closed silhouette. A Mediterranean like Picasso,
Miró adheres similarly to a certain quasi-sculptural conception
of the picture as involving the monolithic definition of shapes,
flat surfaces, smooth, compact brushwork, pure, uniform color.
He too favors the figure as a motif, hardly ever the landscape,
rarely the still life. In his rejection of impressionist and expres-
sionist immediacy as conveyed through open forms and loose
brushwork, Miró brings himself closer at the same time to
Mondrian; however spontaneous and instinctive his mode of
operation, however open his art to instantaneous suggestion,
he likewise conceives of the picture as primarily a finished,
sealed product and only secondarily as a direct revelation of the
artist's temperament.

If Miró were only the quintessential lyric painter he is com-
monly held to be, his influence would not be such a potentially
great factor in the future of painting. That influence, para-
doxically, has been felt mainly in this country, since both the
younger French and the younger British painters, in their desire
to hold on to traditional easel painting, seem reluctant to go
beyond Picasso and cubism proper. That desire has been less
strong in this country, and in any case the presence and the pre-
cepts of Hans Hofmann have been enough to insure that our
most alert and ambitious young painters do not overlook the
Catalonian artist. And it is indeed impermissible that any new
painting which transcends the merely pleasing and advances the
frontiers of art historically should fail to deal with Miró any
more than with Matisse and Picasso. It is significant that Miró's
influence is prominent, along with Picasso's, in the formation of

Jackson Pollock's art; and Pollock is the most important new painter since Miró himself.

Miró's development is somewhat difficult to trace in a straight line after about 1930, at which time he precipitated the integral elements of his style; upon these he has played powerful variations but without adding anything essentially new—refining and elaborating rather than expanding and assimilating. Nor does the present exhibition, crowded as it is with successful pictures, large and small, in oil, gouache, and pastel, add anything essentially new to what we already know about Miró. As usual, he shows almost infallible tact in setting himself terms that he is able to fill exactly. Again we have his marvelous calligraphy, the inevitable justness with which he handles black, royal blue, deep red, and yellow, his control of and agreement with the flat surface, again the pastoral, everyday subject, the mocking descant on the phallus and the pudenda. Here and there an even greater tendency toward linearism is perceptible, but where Miró, as in a picture like the vertical *Woman and Bird in Sun*, tries to escape from the arabesque and soften the silhouette into a more "painterly" harmony with the supposed background (really, there are no backgrounds in Miró's pictures), he falls flat with a definiteness of failure such as he shows nowhere else.

Miró remains still in the private hedonism of the first decade after the First World War, his impulse still the personal optimism of the twenties, the optimism that said, "We can at least have fun." In retrospect it is he who seems the painter-laureate of the Left Bank in its heyday, and aptly enough, he was the inspirer of such other celebrators of that same place and period as Calder and Stuart Davis. And perhaps it is because Miró's mood fitted the American one at that time better than any other that Americans have shown greater receptiveness to his art.

Miró's hedonism is responsible for that elegant, tactful exuberance which has led some people to charge him with *chicté*, frivolity, thinness. It is true that some of his most ambitious pictures seem to lose their substance under long scrutiny and that his invention—whose impulse owes so much to Klee—appears unsuitable at times to the large surfaces it tries to populate. Whimsey does not translate into murals—or does it? And is Miró wrong to be more ambitious than Klee, who was more

original? The fact is that we are sometimes puzzled to see so much originality, in both painters, put to the service of what seem small ideas. But I think we may be wrong, and more so in Miró's case than in Klee's.

The same charge of frivolity and superficiality has been made against Matisse. And just as Matisse's cold hedonism and ruthless exclusion of everything but the concrete, immediate sensation will in the future, once we are away from the present *Zeitgeist*, be better understood as the most profound mood of the first half of the twentieth century, so, I feel sure, Miró's warmer and gentler hedonism will take on greater seriousness, and we shall see that this art, like Tiepolo's, is larger than the mood from which it springs. Many of Miró's paintings, perhaps even that large one in the Museum of Modern Art's permanent collection with which I myself have fallen so much out of love, will then regain their potency and their creator receive more convinced recognition as one of the masters of Western painting. Time will perhaps do as much for him as it has just done for Pissarro and Sisley.

The Nation, 7 June 1947

63. Review of *Eugène Delacroix: His Life and Work* by Charles Baudelaire

In Baudelaire and Apollinaire French poetry supplied us with two outstanding art critics. The former was by far the completer: he not only felt (which was all Apollinaire could do), he also discriminated and understood and explained. His interest in painting was not merely the expression of an overflow of vitality, but a directed passion, centered on its object and fed by it.

One of Baudelaire's best pieces of art criticism is the appreciative and much-quoted essay he wrote on Delacroix just after the painter died, in 1863. It is here published for the first time in an English translation (adequate enough), accompanied most felicitously by a selection of Delacroix's drawings in various me-

dia. Inasmuch as this side of the master's art is still too little known, the publishers are to be congratulated all the more for having chosen to emphasize it.

The essay itself furnishes a model specimen of art writing, being rich in perception and analysis, and at the same time colored throughout by the original emotion generated by the works of art themselves. The only objection one can raise is that Baudelaire grants Delacroix everything and omits mention of the "indispensable" faults that lay behind his virtues, and of which the writer himself, to judge by the still completely vivid accuracy with which he describes the impression made by Delacroix's art, must surely have been aware. This accuracy would have been impossible, I feel, without some consciousness of the tendency toward muddiness and coagulation that Delacroix had to struggle with in order to paint his greatest pictures. To have touched on such a fault would have reinforced it. And it would have given us one precedent the less for the practice of wholesale appreciation, which remains the bane of art writing today.

Baudelaire anticipated and made articulate much that later art critics—Roger Fry, for example—could realize only through the experience of post-impressionist painting. He was the first to put the subject in its proper place and one of the first to foretaste abstract art: "A picture by Delacroix, hung at too great a distance for you to judge the harmony of its contours and the more or less dramatic quality of its theme, already fills you with a kind of supernatural voluptuousness. . . . And an analysis of the theme, when you draw closer, will neither add nor subtract anything from this initial pleasure. . . . The limbs of a tortured martyr, the body of a swooning nymph, if they are skillfully drawn, connote a type of pleasure in which the theme plays no part, and if you believe otherwise, I shall be forced to think that you are an executioner or a rake."

Baudelaire saw, that is, that Delacroix painted, by conscious or unconscious intention, for the medium's effect as one transcending, forestalling and persisting beyond anecdotal or thematic interest. Because he could surrender himself so readily to the effects of painting, the writer was compelled to understand an intention that perhaps not even the artist who acted on it realized with his own full consciousness.

The drawings reproduced in this book (whose text is marred

by bad proofreading) show the same "musicality" as Delacroix's paintings—especially when their subjects contain violence and movement. If some of the drawings, which I take to be early, are labored, the rest only confirm the opinion that Delacroix's draftsmanship is equal to the rest of the art. And if some critics used to compare him unfavorably with Ingres on this score, it was simply because they failed to recognize that he drew in a different tradition which put less stress on contour. The best of the drawings here are the quickest, most abbreviated and least careful ones, in which line and shading, as they capture movement, attain a movement almost independent of the objects depicted. Like Géricault's, this manner of draftsmanship began something that was to end rather shortly with Rodin's wash sketches from a dancing model. Courbet already refused to deal with movement in his subjects; and from impressionism on through cubism the model was to remain static. For while Delacroix indicated the color and brushwork of the future, it was the "cold" Ingres who prescribed the mood of its composition and draftsmanship.

That part of Baudelaire's essay which deals with Delacroix's personality and habits has become by now almost the most interesting of all. Though Delacroix mixed with the powerful and the beautiful of this world and received official commissions, he remained essentially an isolated man, obsessed by his art in a socially irresponsible way and devoid of religious and patriotic feeling for the religious and patriotic subjects with which he was commissioned to decorate public places.

What, in the last analysis, was most remarkable about Delacroix, aside from his gift, was his culture. In the eighty-odd years since his death no artist has appeared equal to him in breadth of learning or intellectual sophistication. This does not, however, prevent some of them from talking much and pretentiously, and—what is worse—from misrepresenting their own trade.

New York Times Book Review, 21 September 1947

64. Pessimism for Mass Consumption: Review of *An Essay on Morals* by Philip Wylie

It is to the credit of the American way of life that it intends everything and everybody for mass consumption. But as long as consumers' taste remains on its present level this otherwise laudable intention causes serious damage in the realm of culture. Culture for the "masses"—yes. Joy for the "masses"—not yet. The mass digestion has to be prepared. To trim, rationalize, and pre-digest for mass consumption such difficult cultural objects as the fine arts, poetry, and philosophy will at the present moment only mislead where we seek most to enlighten. (Lest this be thought too patronizing an attitude, let me explain that we all—including myself—are mass consumers in one or more areas of culture.)

That democratic assumption which makes the "average" man believe everything to be within his reach has, especially of late, done considerable harm to culture in this country. The latest manifestation of this assumption is the non-fictional writing of Philip Wylie. Who would have dreamed fifty years ago that pessimism could ever be made into an article saleable on the drug store level? Mr. Wylie demonstrates that almost anything can, in principle, be adapted to mass taste. Not that the "masses" will actually read this latest book of his, but we think immediately at the first glance at the first page: who *will* read this book if not they?

Mr. Wylie's earlier work of non-fiction, *Generation of Vipers*, as banal as it finally is, may have had the spark of something valid in its first impulse. At least it was negative. Unfortunately, his new book is positive, and it is a farrago of such arrantly assertive and militant nonsense as the editor of even an American publishing house rarely lets go to the printer. This, perhaps, is what the contemporary village atheist really looks like in print—sad decline of the provincial iconoclast, of the little shoemaker who used to read Schopenhauer and Nietzsche! Only in this awful age could half-bakedness sink so low, only in this age could such half-bakedness reach print in anything but subsidized editions.

Mr. Wylie claims that man can solve his present difficulties only by freeing his instincts from the domination of the ego. The ego means churches, institutions, Communism, most pub-

lic issues, etc., etc., all of which man ought to repudiate in order to realize himself and the fact that he is, to start with, only an animal. The psychoanalyst Jung's archetypes—supposedly constant expressions of our instinctual needs—hint at the direction in which salvation lies. Down with almost everything. But for all Mr. Wylie's subversive bluster in the name of the instincts, we discover that Americanism remains intact and that in the end he doesn't even really mean what he says about religion. Everything can be taken back. And in any case Mr. Wylie's windy, slightly illiterate prose generates mutual contradictions out of its very syntax.

This is, among other things, revolution for the timid layman. Without having to go to the bother of making one, he will get the sensation of a revolution from an attitude of violent, insubordinate, and irrelevant assertiveness. The emptier the assertiveness the purer the sensation. But what he will get more than anything else in the end is the sensation, without the difficulty of the actual experience, of having read something profound. Profundity for the masses, too. In the final analysis, if we go by Kant's aesthetics, Mr. Wylie's book has to be considered as a work of art, however low the level of that art—since, according to Kant (and this reviewer agrees with him), art gives one the sensation of a thing without necessarily including its meaning.

But I have already taken this book too seriously. The important thing about it is not its absurdity or anything else that pertains to its explicit content. What, aside from its character as a new form of culture for the "masses," makes it worth noticing at all is that it constitutes one more symptom of a dissatisfaction with the quality of contemporary American life that is spreading even to the smuggest and most worldly-successful sectors of our society. *Essay on Morals* is a banal symptom; nevertheless the state of mind it bears witness to is in a historical and sociological context a serious one. When people like Mr. Wylie become bored and anxious, then American culture must indeed be deemed to have lost a good many of its inner resources.

I do not believe that our society's failing ability to allay the anguished boredom of the individuals who compose it can be blamed altogether on the international situation and the threat of the atomic bomb. The social mechanisms for maintaining interest in life and the expectation of satisfactory rewards had be-

gun to break down in this country before 1939. The war may
have speeded the process up but it did not initiate it. Conversa-
tion had already begun to flag ten years ago; our pubic pro-
nouncements, our pleasures, our entertainment, our literature
and art were already losing their pertinence. Today they seem so
radically irrelevant that even people like Mr. Wylie, a writer of
popular fiction undistinguished even in its own sphere, have be-
gun to notice it and no longer know how to keep their place.
The situation must be even more serious than we realize.

Commentary, October 1947

65. The Present Prospects of American Painting and Sculpture

The American artist with any pretensions to total seriousness
suffers still from his dependency upon what the School of Paris,
Klee, Kandinsky and Mondrian accumulated before 1935.
Hardly anywhere around him does he find, in either décor or
activity, impulses strong enough to send him further. The three,
four or five best artists in this country yearn back to Paris as it
was, almost, in 1921, and live partly by time transfusions. Not
that they do not reflect the present period—they would not
count if they did not—but they cannot consult the present for
any standard of quality and style: all excellence seems to flow
still from that vivacious, unbelievable near past which lasted
from 1905 until 1930 and which not even the First World War,
but only Hitler, could definitely terminate.

American culture has in any case seldom fed our painters and
sculptors as it has our novelists and poets. We have had painters
in this country, and some of them—Allston, Cole, Homer,
Eakins, Ryder, Blakelock, Newman, Whistler—accomplished
more than a little; yet they could in the end distinguish them-
selves only by a heightening or idiosyncratic twisting of ideas
imported from Europe, and could never create or re-create a new
vision that the rest of the world had to take account of and on
which artists coming after could nourish themselves substan-
tially. Washington Allston played a variation on the Baroque

landscape; Cole inflected it in another way; Eakins got something more out of that last dramatic chiaroscuro derivable from French painting before Courbet; and Ryder worked from the Barbizon School and Monticelli without breaking out of the frame of academic art. John Sloan, George Bellows, William Glackens, Maurice Prendergast, and Arnold Friedman (a contemporary of theirs who came to fruition thirty years later) managed, along with John Marin, what is still the most considerable effort of American art in the twentieth century, yet they simply extended and refined various phases of French impressionism without—except perhaps in Friedman's and Marin's cases—driving them towards the future. Winslow Homer, in small part, and John Kensett of the late Hudson River School, in even smaller, anticipated Europe—that is, the bright *à-plat* color of early impressionism—by five or ten years. But Homer, with nothing to answer or echo him in the America of his time, could found a school on his gift only when he had thinned it down, toward the end of his life, in water color; while Kensett was a mere picturesque flash in the pan (still underrated, however).

The situation is no longer what it was, but I hardly know whether the gains have or have not cancelled out most of the losses American culture in general has sustained since 1918. America, in two or three big cities, is being rapidly divested of its provincialism, but the cosmopolitanism replacing it is the product of a levelling out and rationalization of culture, which we now import or imitate the way we do French wines and British cloth. The cultured American has now become more knowing than cultivated, glib in a kind of fashionable *koinê* but without eccentricity or the distortions of personal bias, a compendium of what he or (more usually) she reads in certain knowing magazines—anxious to be right, correct *au courant*, rather than wise and happy.

He or she may have a minimal judgment in literature but hardly any in art. It is merely the stumbling ability to read the language of paint that the American artist asks for and so sadly fails to find. In our advanced circles there is an amazing disjunction between literature and art. Delacroix wrote to Baudelaire: ". . . bien des gens . . . regardent un tableau comme les Anglais regardent une contrée quand ils voyagent." In this country ninety-nine—not eighty-five—percent of the art world itself is

composed of tourists, some of them permanently in pension no doubt, but tourists for all that, flashing the stickers on their bags and always on the point of leaving for the equivalent of Mexico or of having just returned from there. The discussion of American art, even in the most exalted circles, is a kind of travelogue patter—this is what fills the three or four art magazines that live an endowed existence in New York and whose copy is supplied by permanent college girls, male and female.

It might be thought that in a country like ours, where pictorial communication, as in the movies, comics and tabloids, has encroached so much on the printed word, even for very literate people, and where industrialism insists more and more on the graphic—it might be thought that in such a country painting even at its remotest from mass taste would receive some stimulus from the sheer overflow of pictorial consumption. Certainly a kind of vulgarized modern art derived from impressionism and its immediate aftermath has penetrated *Life* magazine, the calendars and advertisements. But all this has had but the same effect as the invasion of the *New Yorker* and *Harper's Bazaar* by *ex—avant-garde* literature. Art has become another way of educating the new middle class that springs up in industrial America in the wake of every important war and whose cash demands enforce a general levelling out of culture that, in raising the lowest standards of consumption, brings the highest down to meet them. For education always means a certain number of concessions.

In any case the very improvement of general middlebrow taste constitutes in itself a danger. Whereas high art used to remain untempted, simply because it had no chance whatsoever of complying with the market demand, today the new mass cultural market created by industrialism is seducing writers and artists into rationalizing and packaging for mass distribution even the most pretentious products.

Taken on other terms, however, the American effort at mass culture—not, let me emphasize, mass education, which has already been accomplished—is an unparalleled venture, one not to be sneered at. Culture means *cultivation*. Only the enormous productivity of American industrialism could have led any society to think it possible to cultivate the *masses*. Given our ethos, given our public education, given the fact that nine out

of ten Americans know how to use water closets and automobiles—that is, already have culture in the Soviet Russian sense—given all this, as made possible by our productivity, it was to be expected that sooner or later the American "common man" would aspire to self-cultivation as something that belonged inevitably to a high standard of living as personal hygiene. In any event the bitter status struggle that goes on in a thoroughly democratic country would of itself have served by now to put self-cultivation on the order of the day—once it became clear, to the commonalty, as it has by now, that cultivation not only makes one's life more interesting but—even more important in a society that is becoming more and more closed—defines social position. Whether it succeeds or not, the very fact of this experiment in mass cultivation makes us in several respects the most historically advanced country on earth.

Yet high culture, which in the civilized past has always functioned on the basis of sharp class distinctions, is endangered—at least for the time being—by this sweeping process which, by wiping out the social distinctions between the more and the less cultivated, renders standards of art and thought provisional. In his effort to keep a step ahead of a pedagogic vulgarization that infects everything, and in his endeavor to locate the constantly shifting true center of seriousness, the ambitious American writer and artist must from moment to moment improvise both career and art. It becomes increasingly difficult to tell who is serious and who not. At the same time that the average college graduate becomes more literate the average intellectual becomes more banal, both in personal life and professional activity.

There is also the fact that a society as completely capitalized and industrialized as our American one, seeks relentlessly to organize every possible field of activity and consumption in the direction of profit, regardless of whatever immunity from commercialization any particular activity may have once enjoyed.

It is this kind of rationalization that has made life more and more boring and tasteless in our country, particularly since 1940, flattening and emptying all those vessels which are supposed to nourish us daily. Our difficulty in acknowledging and stating the dull horror of our lives has helped prevent the proper and energetic development of American art in the last two decades and more. The emptiness of our American life is not some-

thing to be declaimed about or expressed as such. What has to be recognized are the circumstances in which such emptiness becomes the common fate. These, endemic to bourgeois industrialism, were already recognized, among painters, by the French impressionists; and if their outlook, as that of most Parisian art up to 1925, was not dark, it was because industrialism—and history—still permitted the individual a little confidence in his own private solution, a modicum of space in which personal detachment could survive and work up its own proper interestingness. Standing off in the preserves of Bohemia, the impressionists, fauvists and cubists could still indulge in a contemplation that was as sincere and bold as it was largely unconscious; and the soberness of their art, a soberness indispensable to all the very greatest painting, from Ajanta to Paris, stemmed from this automatic contemplation.

The impressionists and those who came after them in France put themselves in accord with the situation by implicitly accepting its materialism—the fact, that is, that modern life can be radically confronted, understood and dealt with only in material terms. What matters is not what one believes but what happens to one. From now on you had nothing to go on but your states of mind and your naked sensations, of which structural, but not religious, metaphysical or historico-philosophical, interpretations were alone permissible. It is its materialism, or positivism, presented more explicitly than in literature or music, that made painting the most advanced and *hopeful* art in the West between 1860 and 1914.

The dominant creative tradition in America during the last century and a half, as in England and Germany, has, however, been Gothic, transcendental, romantic, subjective. Industrialism exacerbates and drives us to extreme positions where we write poetry but are unable to calm ourselves and live long enough to fix abiding plastic representations. The School of Paris rested on a sufficient acceptance of the world as it must be, and it delighted in the world's very disenchantment, seeing it as evidence of man's triumph over it. We, confronted more immediately by the paraphernalia of industrialism, see the situation as too overwhelming to come to terms with, and look for an escape in transcendent exceptions and aberrated states. True, it was a Frenchman who eminently taught the modern world this way

out—but one suspects that one of the reasons for which Rimbaud abandoned his own path was the realization that it was an evasion, not a solution, and already on the point of becoming, in the profoundest sense, academic.

It is only by one of those inevitable confusions prompted by uneven cultural development that the aberrated and deranged could have become so intimately involved with modern art. Cubism and impressionism have nothing to do with them, nor has Matisse. The great modern painters and sculptors are the hard-headed ones—or at least they are great only as long as they remain hard-headed: Cézanne, his paranoia notwithstanding; Bonnard; Picasso, as long as he was a cubist; Gris; Léger; Miró; Brancusi; Kandinsky, before he discovered the Spiritual; Lipchitz, before he re-discovered the Mythological. Here, as in all great periods of art, scepticism and matter-of-factness take charge of everything in the end, even as they did for the architects of the Gothic cathedrals.

A temporary solution for the latest American painting has been Klee, the one original modern painter whose nominal inspiration was the "mystical," fantastical, transcendental-subjective—the one twentieth-century artist, moreover, who was able to assimilate the School of Paris and still stay apart from it without suffering harm (unlike Kandinsky). Klee was a genius and he founded a school, but he was not a big genius, remarkable as he was, and his influence has been viable precisely because it could not occupy for its exclusive use all of the new territory it opened up. Klee could go as far as he did because he was capable of a detached irony toward himself as well as toward the world (in any case the mysticism attributed to him seems more and more a fiction of the critics). But his American disciples, however worthy, are less capable of detachment and irony than of almost anything else; therefore they are incapable of varying and extending themselves and they have all remained minor artists in a way Klee never was.

The two most original American painters today, in the sense of being the most uniquely and differentiatedly American, are Morris Graves and Mark Tobey, both products of the Klee school, both somewhat under the influence of Oriental art, as Klee himself was, and both from Seattle in the Northwest. But since they have finished stating their personalities, Graves and Tobey have

turned out to be so narrow as to cease even being interesting. Sensibility confined, intensified, and repeated this way has been a staple of American art and literature since Emily Dickinson; but it has also been an evasion, even in the person of such a wonderful poet as Marianne Moore. The art that results does not show us enough of ourselves and of the kind of life we live in our cities, and therefore does not release enough of our feeling.

In painting today such an urban art can be derived only from cubism. Significantly and peculiarly, the most powerful painter in contemporary America and the only one who promises to be a major one is a Gothic, morbid and extreme disciple of Picasso's cubism and Miró's post-cubism, tinctured also with Kandinsky and Surrealist inspiration. His name is Jackson Pollock,[1] and if the aspect of his art is not as originally and uniquely local as that of Graves's and Tobey's, the feeling it contains is perhaps even more radically American. Faulkner and Melville can be called in as witnesses to the nativeness of such violence, exasperation and stridency. Pollock's strength lies in the emphatic surfaces of his pictures, which it is his concern to maintain and intensify in all that thick, fuliginous flatness which began—but only began—to be the strong point of late cubism. Of no profound originality as a colorist, Pollock draws massively, laying on paint directly from the tube, and handles black, white and grey as they have not been handled since Gris's middle period. No other abstract painter since cubism has been so well able to retain classical chiaroscuro.

For all its Gothic quality, Pollock's art is still an attempt to cope with urban life; it dwells entirely in the lonely jungle of immediate sensations, impulses and notions, therefore is positivist, concrete. Yet its Gothic-ness, its paranoia and resentment narrow it; large though it may be in ambition—large enough to contain inconsistencies, ugliness, blind spots and monotonous passages—it nevertheless lacks breadth.

David Smith, a sculptor and kind of constructivist, is several years older than Pollock and more fully realized. He is the only

1. Greenberg was ridiculed for this judgment of Pollock, as well as for the favorable comments in the article about David Smith and Hans Hofmann, in *Time* magazine (1 December 1947). George L. K. Morris also objected to Greenberg's judgments in an article in *Partisan Review* (June 1948)—to which Greenberg responded in the same issue. [Editor's note]

other American artist of our time who produces an art capable of withstanding the test of international scrutiny and which, like Pollock's, might justify the term major. Like Brancusi, Arp, Lipchitz, Giacometti, Gonzalez, Pevsner, Smith derives from painting much more than he does from what we usually know as the tradition of sculpture: his art being linear, open, pictorial, rather than monolithic. Identified by its materials and methods—steel, alloys, the blowtorch—with industrial procedures, this art also reflects American industrialism and engineering by its denial of weight and mass and its emphasis on direction and trajectory rather than locus. If Pollock is Gothic, Smith revolves between the Baroque and cubist classicism; a wide-open temperament supplies substance and invention that require for their ordering a cubist sense of style. Smith's periodic lapses from excellence come when the Baroque gets the upper hand, yet these lapses are essential, so to speak, to his art, for they provide the raw material for the successes. Smith's art is more enlightened, optimistic and broader than Pollock's, and makes up for its lesser force by a virile elegance that is without example in a country where elegance is otherwise obtained only by femininity or by the wistful, playful, derivative kind of decorativeness we see in such artists as the sculptor-constructor Alexander Calder and the painter Stuart Davis, both of whom have great taste but little force.

The presence of two artists like Smith and Pollock, both products of a completed assimilation of French art, relieves us somewhat of the necessity of being apologetic about American art. But they are far from being enough. The art of no country can live and perpetuate itself exclusively on spasmodic feeling, high spirits and the infinite subdivision of sensibility. A substantial art requires balance and enough thought to put it in accord with the most advanced view of the world obtaining at the time. Modern man has *in theory* solved the great public and private questions, and the fact that he has not solved them in practice and that actuality has become more problematical than ever in our day ought not to prevent, in this country, the development of a bland, large, balanced, Apollonian art in which passion does not fill in the gaps left by the faulty or omitted application of theory but takes off from where the most advanced theory stops, and in which an intense detachment informs all.

Only such an art, resting on rationality but without permitting itself to be rationalized, can adequately answer contemporary life, found our sensibilities, and, by containing and vicariously relieving them, remunerate us for those particular and necessary frustrations that ensue from living at the present moment in the history of western civilization.

What did Nietzsche say? He knew in spite of his profession of the Dionysian: "Zukünftiges.—Gegen die Romantik der grossen 'Passion.'—Zu begreifen, wie zu jedem 'klassichen' Geschmack ein Quantum Kälte, Luzidität, Härte hinzugehört: Logik vor allem, Glück in der Geistigkeit, 'drei Einheiten,' Konzentration, Hass gegen Gefühl, Gemüt, *esprit*, Hass gegen das Vielfache, Unsichere, Schweifende, Ahnende so gut als gegen das Kurze, Spitze, Hübsche, Gütige. . . ." Balance, largeness, precision, enlightenment, contempt for nature in all its particularity—that is the great and absent art of our age.

The task facing culture in America is to create a *milieu* that will produce such an art—and literature—and free us (at last!) from the obsession with extreme situations and states of mind. We have had enough of the wild artist—he has by now been converted into one of the standard self-protective myths of our society: if art is wild it must be irrelevant. We stand in need of a much greater infusion of consciousness than heretofore into what we call the creative. We need men of the world not too much amazed by experience, not too much at loss in the face of current events, not at all overpowered by their own feelings, men to some extent aware of what has been felt elsewhere since the beginning of recorded history.

As it happens, and for reasons not too difficult to expound, painting and sculpture have been in the twentieth century those of all the arts most intimate with Bohemian life, and therefore most sensitive to its passing fits and spasms. Bohemia has been able to influence painting and sculpture with an immediacy unthinkable in literature or music.

The purchase taken by international Bohemia on these arts in New York since 1940 has served to counteract the influence of artiness on the one hand and the Whitmanesque blowhards on the other; but it has also reduced the climate of American art to an even more neutral temperature, since international Bohemia has not asked anything really positive of it and has merely im-

posed upon it the rule of its own banal good taste, which is superior to what we had before only in being less provincial.

The Museum of Modern Art, which fifteen years ago replaced Alfred Stieglitz as the principal impresario of modern art in America, is the chief exponent of this new good taste, substituting for Stieglitz's messianism a *chicté* that in the long run is almost an equal liability. Pusillanimity makes the museum follow the lead of the most powerful art dealers; only once in a while will it show or buy an artist lacking 57th Street's imprimatur. But it cannot be blamed too much, since it reflects rather accurately the prevailing taste in American art circles.

In any case the fate of American art does not depend on the encouragement bestowed or withheld by 57th Street and the Museum of Modern Art. The morale of that section of New York's Bohemia which is inhabited by striving young artists has declined in the last twenty years, but the level of its intelligence has risen, and it is still downtown, below 34th Street, that the fate of American art is being decided—by young people, few of them over forty, who live in cold-water flats and exist from hand to mouth. Now they all paint in the abstract vein, show rarely on 57th Street, and have no reputations that extend beyond a small circle of fanatics, art-fixated misfits who are as isolated in the United States as if they were living in Paleolithic Europe.

Most of the young artists in question have either been students of Hans Hofmann or come in close contact with his students and ideas. Originally from Munich and himself a painter, Hofmann lived in Paris for a time and felt the point of School of Paris painting as only an outsider could—and as no one else in our time has. Hofmann will in the future, when the accomplishment of American painting in the last five and the next twenty years is properly evaluated, be considered the most important figure in American art of the period since 1935 and one of the most influential forces in its entire history, not for his own work, but for the influence, enlightening and uncompromising, he exerts. Hofmann's approach, in spite of himself and his own verbalizations, is essentially a positivist, immediate one that insists on a radical discrimination between what is pertinent and permanent in the art of our times and what is merely interesting, curious or sensational. Like the best literature, the best visual art of our time is that which comes closest to non-

fiction, has least to do with illusions, and at the same time maintains and asserts itself exclusively as art. Hofmann is not at home in English and his terminology, no less than his private and irrelevant preoccupation with the "spiritual," may mislead one at first, but those who spend time with him and watch his taste operate are soon disabused: this is the core of the artistic sensibility and intelligence of our age. Hofmann's presence in New York has served to raise up a climate of taste among at least fifty people in America that cannot be matched for rigor and correctness in Paris or London. No matter how puzzling and ugly the new and original will appear—and it will indeed appear so—the people who inhabit this climate will not fail to perceive and hail it.

So far, however, all this has not received commensurate expression in works of art themselves. The tentatives are promising, seven or eight people make them; but still, aside from Jackson Pollock, nothing has really been accomplished as yet. The difficulty remains our failure to relate this high conception of contemporary art to our own lives, our inability to be detached about either art or life, detached and whole as people are who are at home in the world of culture. What we have instead is the ferocious struggle to be a genius, which involves the artists downtown even more than the others. The foreseeable result will be a collection of *peintres maudits*—who are already replacing the *poètes maudits* in Greenwich Village. Alas, the future of American art depends on them. That it should is fitting but sad. Their isolation is inconceivable, crushing, unbroken, damning. That anyone can produce art on a respectable level in this situation is highly improbable. What can fifty do against a hundred and forty million?

Horizon, October 1947

66. Review of an Exhibition of Contemporary British Art and of the Exhibition *New Provincetown '47*

The exhibition of fifty-eight paintings by thirteen contemporary British artists, organized by the Albright Art Gallery of

Buffalo and now running at the Metropolitan, is one of the saddest samples of recent transatlantic art that I have seen. The new French painters revealed at the Whitney late last winter were aesthetically corrupt in so far as they tried to make a show of vitality out of the patched-together debris of a great immediate past; but these British painters seem to function on a level of potency so low as to make the very faking of vitality, interest, or novelty altogether out of the question. They are sincere—which is not the same as honest—simply because they have not the energy to be anything else. Though the tendencies they embody are various, ranging from modified impressionism to the outrightly abstract, almost all the painters present are emphatically characterized by a lack of conviction that is most marked with respect to color but also affects structure, unity, surface, and everything else required of painting as an art. There is also an inclination, not surprising in the light of the past of English art, to weaken the influences of French painting in the direction of book illustration; uncertain surfaces, the false and meaningless diffidence with which paint is laid on, dull receding color make these pictures shrink to page size, and we forget that they hang on walls.

Henry Moore's tinted drawings are as tasteful and monotonous as ever. John Tunnard, whose abstract oil paintings used to show such remarkable quality in their drawing ten years ago, has declined into a kind of gimcrackery that plays with deep space in a way resembling Dali's; even so, Tunnard retains a bit of distinction. John Piper is an eclectic virtuoso of some skill but little importance. Stanley Spencer lacks that elemental subtlety without which painting cannot attain to the status of art. William Coldstream is represented by a single very sensitive landscape that, conventional as it is in its pre-fauvist way, meets its own terms successfully; yet on this evidence he could hardly be called a serious modern painter. The most authentic work present, and that by far, is David Jones's singing water colors; however low their pressure and however derivative of Paris expressionism their means, these contribute a little something not seen before. Here the tentativeness is not misplaced, is not a result of the artist's difficulties with his medium, but a true and intended expression of his feeling. The other painters shown, of whom the less said the better, are Edward Bawden, Edward

Burra, Robert Colquhoun, Frances Hodgkins, Vivian Pitchforth, Eric Ravilious, and Graham Sutherland.

Bearing in mind Matthew Arnold's remark on "a tendency in Americans . . . to overrate and overpraise what is not really superior," it is with trepidation that I cite the more or less abstract student paintings of a few young Americans, none over thirty, as a demonstration of what begins to seem our superior literacy in the practice, if not consumption, of art. None of the ten artists presented—in a single picture each—at the *New Provincetown '47* exhibition at Jacques Seligmann's last month has yet achieved a personality, and there is still far too little assertion of individual temperament in their work; yet how high the level is on which most of them paint, how firmly they wield their medium, and with what awareness of the true direction of all that is serious in modern art. In this last respect at least three or four of them already paint more importantly than anyone at the British show; and at least seven of the ten embody a *painterliness* that none of the British except David Jones even surmises.

That "school" paintings could ever go this far in taste, sophistication, and competence in this country is something no one would have anticipated ten years ago. Think only of the crudeness we still see exhibited every year at the Whitney Annual by supposedly mature and actually accepted artists. Almost all of the exhibitors at Seligmann's have studied at one time or another with Hans Hofmann, and credit for the level of their work—in a country for whose art the question of *level* is the most crucial of all—belongs to him doubly. I doubt whether any other American group show this year will reach an equally high and consistent level.

By way of a postscript on the British show, let me say that I would hesitate to judge contemporary British painting on the basis of the evidence here. Museum directors had their hand in the selection of the pictures and painters for the show—and we should know by now what museum directors do with this sort of thing. Also, Matthew Smith, Victor Pasmore, and Ivor Hitchens are missing. (I have seen Pasmore's work only in reproduction, but I am sure that reproductions cannot lie beyond a certain point; and in this late impressionist the English may have one of the four or five best—or at least prettiest—minor painters of the new age.) I also suspect that, aside from the inef-

fable Burra, a better selection could have been made of the work of every one of the painters shown at the Metropolitan.

The Nation, 11 October 1947

67. Review of an Exhibition of Ben Shahn and of the Pepsi-Cola Annual

Ben Shahn's gift, though indisputable, is rarely effective beyond a surface felicity. What his retrospective show at the Museum of Modern Art makes all too clear is how lacking his art is in density and resonance. These pictures are mere stitchings on the border of the cloth of painting, little flashes of talent that have to be shaded from the glare of high tradition lest they disappear from sight.

Shahn first came to notice as a "socially conscious" painter, working in that routine quasi-expressionist, half-impressionist illustrative manner derived from Cézanne, Vlaminck, and other pre-cubist French artists, examples of which year in and year out fill the halls of the Whitney, Carnegie, and Pepsi-Cola annuals and the showrooms of Associated American Artists (Bohrod, Brook, Blanch, Bouché, Dodd, Pène du Bois, Sterne, etc., etc.). Shahn appears to have been momentarily successful within the very narrow limits of this style: thus in the gouache *Walker Greets the Mother of Mooney*, a real instinct for pictorial unity imposes itself on tawdry color and banal drawing. But his real originality, such as it is, emerges only with the entrance of the influence of photography, a medium he has practiced in addition to painting. It was the monocular photography, with its sudden telescoping of planes, its abrupt leaps from solid foreground to flat distance, that in the early 1930's gave him the formula which remains responsible for most of the successful pictures he has painted since then: the flat, dark, exact silhouette placed upstage against a receding empty, flat plane that is uptilted sharply to close the back of the picture and contradict the indication of deep space. Chirico is felt here.

Some striking pictures issue from this formula. They are all in tempera, which lends itself best to Shahn's precise contours

and extremely simple color sense; among them are the *Handball* of 1939, the *East 12th Street* of 1947, the *Ohio Magic* of 1945. The influence of the photograph, with its startlingly irrational unselectivity of detail, is also applied to advantage in the *Self-Portrait among Churchgoers* of 1939.

On the whole Shahn's art seems to have improved with time. The later pictures become more sensitive and more painterly. That his "social consciousness" has at the same time become less prominent does not, in my opinion, play much of a role here, it is simply that Shahn gains better control of his medium as he goes along. Yet there has been a certain loss of vigor. Nothing improves upon or repeats the shock of *Handball*. There is an attempt to strengthen and vary color, but to little avail. Shahn, more naturally a photographer than painter, feels only black and white, and is surest of himself when he orients his picture in terms of dark and light. All other chromatic effects tend to become artificial under his brush.

This art is not important, is essentially beside the point as far as ambitious present-day painting is concerned, and is much more derivative than it seems at first glance. There is a poverty of culture and resources, a pinchedness, a resignation to the minor, a certain desire for quick acceptance—all of which the scale and cumulative evidence of the present show make more obvious. Yet Shahn has a genuine gift, and that he has not done more with it is perhaps the fault of the milieu in which he has worked, even more than his own.

Although Pepsi-Cola's *Paintings of the Year* annuals have improved, at least by omission, under Roland McKinney's direction in the last two years, they continue to pay diminishing returns as an effort to promote American art. It is good to see new talent outside New York being encouraged, but when this talent is as mediocre and as timid as the Pepsi-Cola shows reveal it to be, what's the use? Does it matter that twenty or thirty more young painters west of the Hudson and north of the Sound have adopted the manner of Alexander Brook and become eligible for commissions to illustrate Lucky Strike advertisements?

This year's exhibition at the National Academy of Design makes a decided retreat in so far as it confines the quota of abstract paintings to two or three—and very bad ones at that. The tendency seems to run even more strongly than before to a popu-

list modern art that, without going back all the way to conventional academicism, will not make things too difficult for the lay observer. The fact that the most ambitious and original American painting of the moment lies almost entirely in the direction of the abstract is disregarded. The reason for this becomes apparent, however, when we look at the list of jurors. Most of them are painters themselves and members of an academy with a vested interest to protect. None of them have gone farther than Vlaminck and Hartley, and it is only to be expected that they should discourage their juniors from attempting to do so. It is too bad that the Pepsi-Cola Company, whose intentions seem sincere, has let itself become their instrument. Doesn't it want its shows to be representative?

This year the first prize of $2,500 was awarded to Henry Kallem of New York for his Klee-ish *Country Tenement*, which seems a good and almost a fresh picture when seen in color reproduction in the catalogue. It turns out, however, that this reproduction has by its very unfaithfulness—which steps the colors up at least three tones in key, converting the grays into whites, the violets into lavenders, and the reds into vermilions—greatly improved a painting whose original is rather muddy and timid, even if well drawn. Perhaps Mr. Kallem will be instructed by this enlightening accident and take more chances—in which case he would have to forgo Pepsi-Cola prizes for a while.

The Nation, 1 November 1947

68. The Wellsprings of Modern Art: Review of *Modern Painters* by Lionello Venturi

Lionello Venturi is one of the few serious and informed art critics now alive, and nothing he says on art can go unheeded. The present book, already extant for several years in Italian and French, is his most important publication since *History of Art-Criticism* and takes its point of departure from the theories advanced in the latter work. Professor Venturi's esthetics are Crocean, hence are governed by historical relativism in respect to

styles of art but adhere, implicitly, to an absolute standard of quality. A great work of art is the result of an interaction between the artist and his age whereby the personality of one and the content of the other receive their most appropriate, most spiritualized or "ideal" expression and thus touch, by a kind of dialectical process, that which is profoundly common to all humanity in all ages. Pigment, canvas, stone, bronze are resolved into forms that belong purely to the human consciousness. Who can disagree?

Professor Venturi devotes a chapter each to a critical examination and evaluation of the work of Goya, Constable, David, Ingres, Delacroix, Corot, Daumier, and Courbet. He claims ". . . our times have only one tradition, one mainstay, one point of departure: the art of the nineteenth century." But it is precisely the shortcoming of this book—the omission which makes it no more than a collection of critical essays—that it fails to chart sufficiently either the historical or the esthetic current that runs through each of these painters to reach the impressionists, and beyond them the art of our own time. All that comes clear is that the nineteenth century was dominated by romanticism— but what of that? It is no longer enough to say romanticism.

Venturi himself acknowledges the necessity of relating a work of art to the spirit of its age, and himself emphasizes that "creative liberty does not act in a void, it acts under given historical conditions—conditions of life." But only in the cases of Goya and Daumier does he really bring these conditions into any sort of focus and, even then, in how conventional a way: "During the nineteenth century the state of mind provoked by the idea of the people seems to have been the state of mind most fecund for artistic production." Or: ". . . Daumier intuitively grasped the heroic nature of the people." What people? Where are the complexities of history as we now know it? What about the effect upon art of the new ascendancy—so important, for example, in Constable's case—of the middle classes? What about the changing class and political alignments of the Parisian Bohemia, so important for an understanding of Daumier and Courbet? What about the history of *thought* in the nineteenth century, of that thought by which the totality of historical events makes its most lasting impression upon the attitudes of artists?

I do not reproach the author for having failed to touch on

these things; I reproach him only for not having admitted at the outset that he was more concerned to draw up separate critical estimates of the artists under consideration than to trace the connecting threads between them; I reproach him for having given the impression, on the contrary, that it was his main intention to show what they had in common historically. Professor Venturi discusses Daumier's and Corot's virtues, Delacroix's and Courbet's failings, and he does not relate them to the main direction of history in the nineteenth century, or show them as organic to the whole process that culminated in impressionism; they are simply entered as so many credits and debits to the separate account of each artist.

This reviewer happens to be altogether in favor of such critical accounting provided only that the critic specify this to be his intention to begin with. As critical accounting pure and simple, Professor Venturi's book is excellent. I disagree with a good deal in it and find that it omits a good deal. Also, I often have difficulty understanding the professor's elliptical concept-juggling prose, so much in the tradition of philosophical idealism. Yet my disagreement and fault-finding are respectful. The main thing is the high level of seriousness demonstrated, the writer's familiarity with and love of art, and the audience of peers he assumes for his words. Here, after a long while, is true criticism, which delivers strictures as well as appreciation.

Describing Goya's style, Professor Venturi concludes that "it was the open door through which all the best painting of the nineteenth century had to pass." (If only he had backed this statement up with a detailed analysis.) Of Constable, he says: "And how sad it is that Constable could not explicitly manifest the consciousness of his genius, and thus was not able to place his imprint, by means of his real creative capacity, on European painting!" David and Ingres barely manage to get passing marks at Professor Venturi's hands. Delacroix is, on the whole, given credit for his great accomplishment, but his deficiencies are made prominent. I feel that the author underrates Delacroix's murals, which toward the end of his life attained a grandeur that puts into the shade the smaller excellencies of his easel paintings of the same period. I myself would be prone to argue that these murals are the greatest painting of the nineteenth century anywhere.

Corot and Daumier are judged to be the two greatest artists of the first half of the century and a fairly good case is made for this verdict—but the case, as a piece of critical writing, is not made quite good enough. One suspects that it may be the professor's unconscious nostalgia for the academic that sways him in his judgment here; for the fact is that Corot and Daumier are the last great *academic* painters.

Professor Venturi's best essay, and that by far, is on Courbet, whose art he analyzes with a concreteness and perspicuity such as he shows elsewhere only rarely. In this materialist he finds an esthetic substance, a stuff that he himself, so much of the nineteenth century, can feel with every facet of his sensibility. Here it dawns on one that, for all his professed idealism, the author is as instinctive a materialist as his subject, and that what troubles his writing is this disjunction between profession and sensibility.

New York Times Book Review, 9 November 1947

69. Review of an Exhibition of Albert Pinkham Ryder

The total impression made by the centenary exhibition of Albert Pinkham Ryder's paintings at the Whitney Museum is that of an unrealized vision. The vision itself, had it been more completely precipitated, would have sufficed to establish the artist beyond dispute as the greatest American painter. As it is, taking the evidence of this show into account, I would find it uncomfortable to argue his case against Eakins's and Homer's.

The evidence is unsatisfactory because of its scantness and because of the bad physical condition of many of the canvases themselves. As Lloyd Goodrich explains in a well-written catalogue note, Ryder "strove half-consciously and without adequate training, for the richness of the old masters. His pictures were built up with underpainting and layer on layer of pigment and glazes. . . . Unfortunately he had little knowledge of traditional techniques, and in trying to secure his effects he used dangerously unsound methods. He painted over pictures when they were still wet, thereby locking the under surface in before it had dried and hardened, so that the different surfaces dried at differ-

ent rates of speed, causing serious cracking. He used strange mediums—wax, candle grease, alcohol; and he made much too free use of varnish. In showing visitors his paintings he would wipe them with a wet cloth or literally pour varnish over them." Among the most unhappy effects of these procedures, aside from cracking, has been the radical obliteration of gradations of value by excessive darkening, so that one color mass merges into another. Given Ryder's fondness for heavy greens, blues, and browns, the result is sometimes altogether disastrous, making it impossible, as in *Moonlit Cove* and *Macbeth and the Witches*, to tell what the picture was meant to look like when it left the artist's hand.

Ryder was beyond question one of the most original and affecting painters of his time, whether in Europe or this country. In the task of stating his originality he seems to have had no help at all from his contemporaries. Taking his departure from the academicism that dominated his age—he mentioned Corot and Maris as his favorite painters—he had to cut his art out of the whole cloth and search in isolation for a means to convey the surprisingly new things he had to say. He knew little or nothing of those of his early and late contemporaries—Daumier, Monticelli, and Munch—who in their various ways were exploring some of the same realms of pictorial sensation.

The loneliness of his effort condemned Ryder to aesthetic as well as personal eccentricity. We can understand why he took so long to finish pictures to his own satisfaction: in his endeavor to make concrete the dramatic, visionary nature of his idea he had nothing he could use to guide him at least part of the way—as Cézanne, for instance, had impressionism. He was on his own almost from start to finish. What we miss in his work, as a result of this, is amplitude of realization, pictures that come off conclusively because the painter has created himself a style, with the aid of his time and milieu, secure enough to contain and redeem his inevitable mistakes. The few masterpieces in the present exhibition—*The Forest of Arden*, *Moonlight on the Sea*, *Sunset Hour*, perhaps *Under a Cloud*—seem happy accidents unsupported by sufficient testimony from the pictures surrounding them. It is as if the artist exhausted himself in these rare completely successful pictures and had each time to begin all over again.

Ryder's main impulse was to simplify nature into silhouetted masses of darks and lights; color was a matter of dark and light modulations within these masses. The primary effect is of simple, blocked-out pattern, startling because of the emotion discharged by the novelty of a relatively few shapes, novel in their contours and in their placing. Yet his most successful canvases—I think here of *Moonlight on the Sea* and *The Forest of Arden*—owe more of their final effect to a subtle, rhythmic weaving together of color and value tones. Where the picture did not stand or fall entirely by the placing of three or four large shapes, the artist was able to retrieve his uncertainty and clumsiness by imposing a general, all-inclusive tonal harmony. Here Ryder resorted to more conservative means and renounced in effect such complete correspondence between his vision and its embodiment as he attempted in his more startling but less successful pictures— where he attempted to qualify the solid simplicity of the silhouette by building up a thick, enamel-like surface that by reflected light would intensify the few color tones.

The moral is that one should never go too fast in art. It is the tragedy of Ryder that he attempted to go too far too fast—alone. I say tragedy, because Ryder had, obviously, gifts enough to have made him a major artist in a better place and time. Once again it is necessary to register another casualty of American provincialism.

Ryder left behind a manner rather than a style. This made him a plausible victim of forgers, who could by diluting his invention, in one instance at least, contrive a painting more harmonious than many of his: I mean *A Spanking Breeze*, which is included in the present show as an example of a faked Ryder— with a placard underneath, pointing out the "weak drawing," "unpleasant color," and "crude, direct handling." One wonders more than ever whether museum people ever see things with their own eyes. Forgery that it is, *A Spanking Breeze*, manages to be a rather good picture precisely because it takes nothing from Ryder except his manner, leaving out the difficult intensity and originality of emotion he could not realize often enough in his own work. While Ryder could not always meet the high terms he set himself, the forger, even though he was only a hack, could meet them when reduced.

The Nation, 15 November 1947

70. Review of *The Etchings of the French Impressionists and Their Contemporaries*, selected by Edward T. Chase

The partnership of color and drawing in the pictorial arts is an unequal one. Drawing can do without color much better than color can do without drawing. Behold Ingres, behold Raphael, behold Michelangelo—behold the insufficiency of their color, which doesn't matter, because their draftsmanship and their grasp of dark-and-light values are enough of themselves.

Delacroix, Géricault and the impressionists restored the primary emphasis to color, but they could not have done so without the help of consummate draftsmanship. The richest and most harmonious colors will not work unless they are distributed and described harmoniously. And so, contemporaneous with impressionism, there appears a new accent on drawing. It is not the same as that of Ingres; it is a kind of drawing that no longer tries—except in the hands of Degas—to convey volume and mass by means of the tension of line—the line that, according to Ingres, should unaided indicate the turning away and invisible continuation of the surface of round solid. The main point of drawing now becomes to animate the picture plane in all its flatness by dividing it into areas of tension. This happens to be a point that Ingres himself observed pre-eminently in his portraits, if not in his "machines"; but he was not explicitly aware of it, and his academic followers seem entirely unaware.

Edward T. Chase, in his introduction to the book of reproductions at hand, notes the seeming paradox that the period of impressionism should also see a revival of the original print, which had for a time fallen into desuetude as a high art in France. (However, the steel and wood engravings, mezzotints and woodcuts of the popular artists who illustrated the magazines of that and the preceding periods are, in my opinion, far from contemptible.) Mr. Chase himself attempts no real explanation of the paradox, and I can only offer a rather weak one to the effect that the very advent of the impressionists generated a certain amount of new vitality in every department of the pictorial arts.

The impressionists themselves seem for the most part to have used the engraving media simply to exercise and precipitate lessons they had already learned in their painting, and, except

for Degas and Pissarro, none of them did much substantial work here. It remained for lesser talents such as Bresdin, Bracquemond, Legros, and others, effectively to support the short-lived revival of the print as such. It was only in the lithograph and the woodcut—both more "painterly" media than etching—and in the hands of artists standing aside from or coming after the impressionists—Daumier, Gauguin, Toulouse-Lautrec—that the second half of the nineteenth century in France delivered itself of major statements in the engraving arts.

The reproduction in the present book (whose title is misleading, since it includes lithographs and woodcuts as well as etchings) contains examples of the work of Manet, Bresdin, Corot, Millet, Daumier, Jongkind, Renoir, Degas, Pissarro, Rodin, Legros, Fantin-Latour, Rops, Buhot, Gaillard, Bracquemond, Zorn, Carrière, Besnard, Cassatt, Rivière, Redon, Morisot, Cézanne, Gauguin and Toulouse-Lautrec. The selections do not offer much to quarrel with. That small but bizarre talent, Rudolphe Bresdin, could have been represented more advantageously—as could Daumier, with whose variety the modern public is not so well acquainted as with his reputation. Pissarro, too, and some of the lesser figures might have been better chosen.

The purely mechanical quality of the reproductions is fair, given the price of the book, but the cheap paper grays the blacks out of all proportion to the whites and blurs the etched line, both of which distortions are unforgivable in a book that tries to make the point this one does. Nor can I believe that Renoir and Toulouse-Lautrec filled in their colored lithographs quite this sloppily.

New York Times Book Review, 23 November 1947

71. The Jewish Joke: Review of *Röyte Pomerantzen*, edited by Immanuel Olsvanger

> *Iz antkegen a vits muz men ophitn de töyre mer vi fun jeder anderer zach.* (The Torah must be protected from a jokester more than from anything else.)

The Hasidic rabbi Pinhas of Koretz said: "All joys hail from paradise and jests too, provided they are uttered in true joy."

True joy may be a result of the Jewish joke or anecdote, but its original inspiration and the situation provoking it lay in quite another quarter than that whence all joys hail. What is specifically Jewish about the Jewish joke arose from the limitations and paradoxes of the specific Jewish condition in East Europe.

The Jews' way of life there, as perhaps elsewhere in Europe and Asia until the 19th century, was anomalous in that it was lived self-absorbed in the midst of alien peoples: fundamentally uninterested in the social and cultural life that surrounded it on every geographical and political side, and regarding only the events and preoccupations of its own inner world as of real moment. The formal culture of the Jews took hardly any more cognizance of the non-Jewish human environment than it did of the natural one; it seems to have turned its back on both with a shrug conveying its despair of reading rational meaning into either. And yet the position of the Jews, far from being that of a ruling or conquering class which could afford to disdain the concerns of subject peoples, was that of a powerless and disliked minority protected only by its economic indispensability.

The peasants roundabout also lacked power but, unlike the Jews, they were not indifferent to those who did possess it. The nobility held the center of peasant attention; the heroes of their tales and legends were more often than not aristocratic or military, and their own culture constantly took over outmoded elements of the manorial one. That is, the peasants always showed that they were aware of the existing power structure. Power, political or physical, was something that the Jews, on the other hand, almost always censored from their consideration.

It is true that the peasant's relation to the sources of power in a feudal society was usually more comprehensive than the Jew's. Yet the Jew was made to feel sharply enough—and even more directly—his dependence on the feudal lord for his safety. The individual Jew knew how helpless he was; it was only his culture that refused to linger over this fact, giving it nothing more than academic recognition. And even when that culture became as informal as it did among the Hasidim, and as emotionally immediate, it still persisted in its indifference to the question of power and the nature of those who held it.

Until the rise of Yiddish literature in the latter half of the 19th century, the formal culture of the Jews of East Europe was entirely religious. This is not to say that it shunned secular life

altogether, but it dealt with that life only insofar as it could enclose it in a religious vessel and relate it to religious ends. This religious culture taught, as we all know, that the Jews were *the* chosen people, singled out by God to be the protagonist of humanity vis-à-vis himself in the cosmic drama. Thus their indifference to the Gentile seemed justified, even had his culture been superior to theirs—which it was not. The Jews were occupied with final ends; the Gentile and his temporal power belonged, like nature, to the field of contingency. Therefore the Gentile was not interesting, nor was his power.

In any case the whole question of Gentiles and power was something that could only hurt Jewish feelings were it ever to be dwelt upon at any length. Jewish culture, like every other, was concerned, among other things, to maintain self-esteem.

But reality always revenges itself on consciousness. In the Jews this revenge may have been long delayed, but when it did come it was a psychologically drastic one. The consolation the individual Jew got from his religious life and from the glorious promises it made to the people he belonged to could not conceal forever the fact that he as an individual had only his present life on earth, and that that life was becoming a more and more wretched and precarious one. A great disparity—which signified a lack of contact with reality such as could not be kept out of the sane consciousness—was felt between the ostensible conviction of superiority that made the Jew so indifferent in any but a practical way to the alien power surrounding him, and the secular and individual actuality of his life, which was lived at the mercy of that power—a power which erupted from time to time with the arbitrary destructiveness, it seemed, of a volcano.

The Jewish joke was, among other things, reality's revenge upon the Jewish consciousness. It blossomed with the disintegration of the old Jewish life in East Europe and it came to remind the Jew, as several critics have already pointed out, of the discrepancy between the divine promise and the secular reality. But even more fundamentally, the Jewish joke came to remind him that his self-absorption, as expressed in a millenial culture that, for all its modifications according to time and place, still attempted to perpetuate itself as if in a timeless and placeless vacuum, was foolhardy. (My son has just lost his wife, who left him with three small children; his house has burnt down, and

his business gone bankrupt—but he writes a Hebrew that's a pleasure to read.) The Jewish joke criticized the Jew's habit of explaining away or forgetting the literal facts in order to make life more endurable to himself. (So what if the only thing wrong with the prospective bride is that she is a bit pregnant?) It also criticized the way in which the Jew violated his traditional decorum, while still trying to put a face on it, in his desperate struggle for individual survival. It criticized, finally, the self-absorption of individuals so devoid of power and status as most Jews had become by the 18th century. (What God does is probably good.)

The peasants, too, had jokes in which they wreaked—on themselves—their resentment at their own lack of power or status. But the peasant joke is almost altogether without that final, cosmically subversive irony with which the Jews punished themselves. The peasant joke puts a premium on intelligence, or, at least, shrewdness; one of the most typical peasant heroes is the man who by superior slyness overcomes the social and economic handicaps imposed on him by established society. The Jewish joke, on the other hand, makes fun even of intelligence; it shows intelligence being put to the pettiest uses for the pettiest ends—simply because intelligence can only agitate itself in vain and split hairs when it is so completely unaccompanied by power. Religions have criticized intelligence in the name of the transcendental, but Jewish humor is almost alone in criticizing it in the name of immediate reality.

The Jewish joke and funny story were for a long while, perhaps, the only secular culture the East-European Jew had; his only means, perhaps, of shaping secular experience that lay outside the confines of religion. And when religion began to lose its capacity, even among the devout, to impose dignity and trust on daily life, the Jew was driven back on his sense of humor. That sense of humor, in being called upon to restore confidence in life, underwent a development that has rendered it the most astounding and prodigious sense of humor in modern times. Invoked to correct a disequilibrium caused by religious preoccupations and by the need to preserve self-esteem, it learned to argue with God and dispute with him, ironically, those final questions around which generations of sages had spun their reverent dialectics. That sense of humor even began, after a fashion, to sup-

ply the Jew with all those things his formal culture had more or less omitted: a kind of political theory, a sort of economic doctrine, even a history in Galut, as in the jokes and stories in *Röyte Pomerantzen* that have to do with the First World War.

When Jewish literature arose to give the secular life of the East-European Jew a more formal hearing, the Jewish joke and anecdote became, as we see in Mendele, Sholom Aleichem, and others, one of its major ingredients. In no other literature, as far as I know, has humor played such a central part. This was because the Jewish joke had already become, a long time ago, the *underground* culture of Jews.

The disasters that periodically overtook the Jews in East Europe played their part in this. These disasters were, to them, so inscrutable and captious that nothing they could do seemed to matter one way or the other, and grief and rage themselves seemed inadequate emotions in the final analysis. Humor became ultimately the only psychologically satisfactory way in which one could answer a situation permanently exposed to irrelevant catastrophes.

The Jewish joke may have been, paradoxical as that sounds, the one way aside from Zionism in which the Jew divined the future that awaited him at Auschwitz. Not only did it divine, I feel, the fact that he was living in a historical trap in East Europe, it was also, in a sense, the only appropriate answer to a fate that, as Hannah Arendt has pointed out, was incommensurable, entirely out of relation with, and radically disproportionate to anything that any group of human beings could possibly have deserved.

Röyte Pomerantzen is a collection, somewhat uneven but rarely disappointing, of Jewish jokes and stories published in their original Yiddish, which is transposed, however, from Hebrew into Roman characters. Anyone retaining some ear for the *mame loshen* should have no trouble acclimatizing himself after a few minutes of effort. Dr. Olsvanger has done a good job in the main in devising a system of Roman orthography that accurately conveys Yiddish sounds to the ears of English-speaking readers, and he has provided footnotes and a glossary for words derived from Hebrew, Russian, and other languages beside German. But, as he himself says in his introduction, an almost equally important factor in the understanding of this text is familiarity with

186

the cadences of Yiddish speech. Without that, much of the humor is lost.

Schocken Books promises to put out a second collection of Jewish humor under Dr. Olsvanger's hand. It is to be hoped that they will make Yiddish texts in Roman letters a staple item of their lists. I would suggest Sholom Aleichem and Mendele as the next candidates.

Commentary, December 1947

72. Review of Exhibitions of Hedda Sterne and
 Adolph Gottlieb

The rising general level of advanced or "radical" art in this country is on the point of becoming a substantial fact. The even more rapidly declining general level of the standard expressionist-impressionist sort of painting that is shown so plentifully at the Whitney, Carnegie, and Pepsi-Cola annuals should not conceal this fact from us, should indeed make it even more visible, since the growing inferiority of the one serves to clear the air for the other. The issues become plainer, and the areas in which serious and ambitious modern art can still be produced, easier to define. Except in the hands of a few gifted individuals, survivors who gather up the threads of a previous generation, descriptive art is pretty well finished. Art, which succeeds in being good only when it incorporates the truth about feeling, can now tell the truth about feeling only by turning to the abstract. I do not say this out of dogmatism—art cannot be prescribed to—but only because the incidence of good art has become so much greater in the area of the abstract than elsewhere.

The most recent evidence to support the supremacy of the abstract was provided by Adolph Gottlieb's latest one-man show at the Kootz Gallery and Hedda Sterne's latest show at Betty Parsons's. The second show is even more striking testimony than the first, for whereas Gottlieb proved himself as a painter on a high level several years ago, Miss Sterne is now taking her first steps in abstract painting and would seem to have as yet little more to bring to bear than a delicate sensibility and a careful

taste. Nevertheless, this show of hers contained at least five pictures whose sureness and originality lift them far above the general run of stuff on Fifty-seventh Street. Admittedly, this art lacks force—but force is not everything; there is also room for delicacy.

Miss Sterne's success is due principally to the instinct with which she fits her open and economical draftsmanship to the off-shades she favors in color: tans, ochers, gray-whites, off-blues. Everything is handled with a nice flatness, an insistence on keeping the picture very close to its surface that insures decorative unity before anything else. Miss Sterne's art is not quite enough as yet; there is a danger that it will content itself with decorative successes: the effect is of panels rather than of easel-pictures. More emphasis is required, and more "ideas." None the less the chief issue at the present moment lies in the high level her painting reaches. And her level is her triumph.

Adolph Gottlieb, though still confining himself to his formula—a set of juxtaposed rectangles on which hieroglyphic forms are inscribed—increases in strength as well as felicity with every new show. That he can get the variety he does within the narrow and too decorative design to which he limits himself becomes more and more surprising. Two of his new canvases—the large *Water, Air, Fire,* with its novel color, and *The Oracle*—achieve a power that belies the timidity we otherwise feel too frequently in his work. And *Vigil of Cyclops* and *Pursuer and Pursued*—the latter a departure in the direction of deep, translucent color—also succeed, with less force.

Gottlieb is perhaps the leading exponent of a new indigenous school of symbolism which includes among others Mark Rothko, Clyfford Still, and Barnett Benedict Newman.[1] The "symbols" Gottlieb puts into his canvases have no explicit meaning but derive, supposedly, from the artist's unconscious and speak to the same faculty in the spectator, calling up, presumably, racial memories, archetypes, archaic but constant responses. Hence the archaeological flavor, which in Gottlieb's painting seems to come from North American Indian art and affects design and

1. Newman responded to this article in a letter which *The Nation* did not print. The letter was eventually published in Thomas B. Hess, *Barnett Newman,* 1969. [Editor's note]

color as much as content. I myself would question the importance this school attributes to the symbolical or "metaphysical" content of its art; there is something half-baked and revivalist, in a familiar American way, about it. But as long as this symbolism serves to stimulate ambitious and serious painting, differences of "ideology" may be left aside for the time being. The test is in the art, not in the program.

Gottlieb has produced enough successful pictures by now to demonstrate that he has an original and valid gift. These pictures of his aspire, however, to be more than minor successes; in some of them at least one senses the possibilities of a large art. It is just here that dissatisfaction intervenes—dissatisfaction with a policy of limited objectives. It is as if Gottlieb might go on forever refining, dividing, and elaborating a sensation that remains identical throughout. Each painting is different, it is true, but the difference becomes the less essential part. The design, which is always the same in principle and which—notwithstanding the subtlety and surprising range of Gottlieb's mat, Indian-like color—always delivers the main blow, assures the artist a certain safety that he should neither desire nor need. However numerous the sub-sensations he can discover within this safety, they count only as the phrases of a single statement. We have the right to ask of Gottlieb that he tax himself to say more.

The Nation, 6 December 1947

73. Review of Exhibitions of the Pyramid Group and Alfred Maurer

It is to be hoped that the first show by the newly organized Pyramid group of artists—there are twenty-six of them—at the Riverside Museum will not be taken as a conclusive demonstration of what the latest generation looks like in paint. Where we might expect freshness and energy, a glimpse of the new, we find only the shabbiest and most non-descript expressionism and post-cubist abstract art. Where we would assume that the reason these artists are not shown on Fifty-seventh Street is that

they are ahead of it, we find on the contrary that they are behind it. Aside from the ineptness and natural lacks of most of the exhibitors, what is most distressing is a general backwardness, an expressionist constriction that no amount of self-assertive violence can break through. The effect is one of a dun monotony.

I wish to complain specifically about the color—the muddy, the gray, the blear, the garish, the pallid. Why do these painters, even when they use fresh pigment, insist on harmonies that convert it into mud? Why are they unable to achieve positive tones? Is it because they are timid, provincial, uncultured? They are all that, and more. Meanwhile the genuine painters of the youngest generation remain in their cold-water flats, uncompromised. There are almost none of them in this show.

Two or three of the Pyramid artists should be exempted from the full force of these strictures. The delicate, pictorial sculpture of Blanche Sherwood, the only sculptor of the group, stands up despite its derivativeness; like most of the best contemporary sculptors she has a draftsman's gift. Howard Mitcham's abstract *Tropical Submarine*, markedly influenced by Jackson Pollock, is the best painting shown and the only one well painted in the full sense of the term. However, the fatty greens and browns of Mitcham's other canvas darken it down, despite the real feeling with which it is handled, to a great gaping hole in the wall. Lewin Alcopley's work, too, should be spared a bit; sadly uneven as it is, it contains at least a promise.

The case of the late Alfred Maurer, a show of whose work was given recently at the Bertha Schaeffer Gallery—and is now running at the Baltimore Museum of Art—is not unlike Ryder's. Maurer, who died in 1931, was not only one of the most distinctive American painters of the twentieth century; he was also perhaps the only authentic cubist we have produced. After going through an illustrative variety of impressionism, and his own original version of German expressionism, he came late under the influence of Picasso's and Braque's cubism, which he digested in a more integral way than did other American followers of the style, such as Max Weber. Nevertheless, Maurer's assimilation of cubism was not quite complete, and his later cubist still lifes, while they demonstrate a vivid talent and a growing control of it, suffer from a failure to understand and convert into instinct that one great lesson of French painting

since Cézanne—namely, that from now on three-dimensional experience must be described in or transposed into strict two-dimensional terms (here Matisse and Bonnard have as much to say as cubism). Maurer wanted to put more color and variety into middle cubism than Picasso and Braque had; but he did this only by picking out an object here and there in the picture, and modeling it conventionally and tinting it more brightly, with the result that it was thrown into a three-dimensional relief that clashed disturbingly with the logic of the rest of the canvas.

One has the feeling that Maurer would have eliminated such errors had he lived longer, and that he would have struck out beyond the School of Paris. His powers were large enough. In any case his art deserves more attention. Perhaps the Museum of Modern Art will provide the occasion for more lengthy consideration by giving Maurer a commemorative show.

The Nation, 14 December 1947

1948

74. The Situation at the Moment

"To ascertain the master-current in the literature of the epoch, and to distinguish this from all minor currents, is one of the critic's highest functions; in discharging it he shows how far he possesses the most indispensable quality of his office—justness of spirit." The justness of spirit that Matthew Arnold asks of the critic leads, in this rather corrupt and declining age, to an attitude which in the eyes of the age itself must seem hostile. Once distinguished, the master-current, whether in art or literature, must seem an aberration—to point out which requires a quirkiness not at all resembling justness of spirit.[1] Detachment, which is the indispensable preliminary to justness, seems on the contrary eccentricity, and eccentricity means isolation, and isolation means despair.

To define the exact status of contemporary American art in relation to the history of art past and present demands a certain amount of mercilessness and pessimism. Without these we shall not know where we are at. There is no use in deceiving ourselves with hope. Our most effective course is to confront the situation as it is, and if it is still bad, to acknowledge the badness, trusting in the truth as the premise of any improvement, and feeling a new security because of the very fact that we have met and verified the worst.

True, the situation of culture in this country has been lamented often enough in the last twenty-five years, and the lamentations have had no more effect, seemingly, than the songs of the Sirens on the plugged ears of Ulysses' sailors. Yet these lamentations have, in spite of appearances, changed something in

1. This essay was accompanied by illustrations of two paintings, not referred to in the text, by Jackson Pollock: *Totem Lesson II* (1945) and *Grey Center* (1946). [Editor's note]

the American consciousness, and it is necessary to keep repeating them, and in repeating them to move ever closer to the exact truth, which is a difficult one, difficult in its exactness.

American art is today involved in the general crisis of Western art, whose historic impulses, with all they carried in the way of enlightenment and of compensation for the hygienically destructive effects of enlightenment, have ebbed away in Europe under the suction of events and a declining bourgeois order. One has the impression—but only the impression—that the immediate future of Western art, if it is to have any immediate future, depends on what is done in this country. As dark as the situation still is for us, American painting in its most advanced aspects— that is, American abstract painting—has in the last several years shown here and there a capacity for fresh content that does not seem to be matched either in France or Great Britain. Yet the general crisis does not spare us and, given the obstacles American art continues to face since the Civil War, the situation still opposes itself to the individual artist with an unfriendliness that makes art life in Paris or even London idyllic by comparison. With all our present relative advantages, much more is still required of us in the way of exertion, tenacity, and independence in order to make an important contribution. The American artist has to embrace and content himself, almost, with isolation, if he is to give the most of honesty, seriousness, and ambition to his work. Isolation is, so to speak, the natural condition of high art in America.

Yet it is precisely our more intimate and habitual acquaintance with isolation that gives us our advantage at this moment. Isolation, or rather the alienation that is its cause, is the truth— isolation, alienation, naked and revealed unto itself, is the condition under which the true reality of our age is experienced. And the experience of this true reality is indispensable to any ambitious art.

Now when it comes to the Zeitgeist, we Americans are the most advanced people on earth, if only because we are the most industrialized. The activity that goes on in Paris, the talk, the many literary and art magazines, the quick recognition, the tokens of reward, the crowded openings—all these, which once were signs of life, have now become a means of suppressing reality, a contradiction of reality, an evasion. Whistling is perhaps as

real as the dark but it is not as real as the fear it dissembles. What is much more real at this moment is the shabby studio on the fifth floor of a cold-water, walk-up tenement on Hudson Street; the frantic scrabbling for money; the two or three fellow-painters who admire your work; the neurosis of alienation that makes you such a difficult person to get along with. The myth that is lived out here is not a new one; it is as old as the Latin Quarter; but I do not think it was ever lived out with so little *panache*, so few compensations, and so much reality. The alienation of Bohemia was only an anticipation in nineteenth-century Paris; it is in New York that it has been completely fulfilled.

I would say that most of the best painting done in this country at the moment does not reach the public eye, but remains west of Seventh Avenue, stacked against the wall. It is not a case of the unknown genius in a garret—there are very few geniuses—so much as that of the unknown art in a social pocket. After all, the easel painting is on its way out; abstract pictures rarely go with the furniture; and the canvas, even when it measures ten feet by ten, has become a kind of private journal.

The master-current in the painting of our epoch is a paradox. We know that it flows out of cubism and Matisse and through Mondrian and Miró—but in what direction does it flow since them? In France high tradition means, for the latest generation, Matisse's color and Picasso's drawing and composition. (Some, like Jean Dubuffet, may escape the paralysis of culture via Klee and the deliberate surrender to infantile experience, but they do little to vitalize tradition; Dubuffet is a first-rate painter but he leaves nothing to the future of painting.) Here in America there is also a general recognition among the most advanced young painters that Matisse and Picasso are indispensable to a great contemporary style but, in distinction to the French, they incline to accept more of Matisse than of Picasso. In Greenwich Village the attempt is being made to create a larger-scale easel art by expanding Matisse's hot color, raised several degrees in intensity, into the bigger, more simplified compositional schemes which he himself usually reserved for blacks, grays, and blues—all this to be articulated and varied with the help of Picasso's calligraphy.

There is a persistent urge, as persistent as it is largely unconscious, to go beyond the cabinet picture, which is destined to

occupy only a spot on the wall, to a kind of picture that, without actually becoming identified with the wall like a mural, would *spread* over it and acknowledge its physical reality. I do not know whether there is anything in modern architecture itself that explicitly invites this tendency. But it is a fact that abstract painting shows a greater and greater reluctance for the small, frame-enclosed format. Abstract painting, being flat, needs a greater extension of surface on which to develop its ideas than does the old three-dimensional easel painting, and it seems to become trivial when confined within anything measuring less than two feet by two. Thus, while the painter's relation to his art has become more private than ever before because of a shrinking appreciation on the public's part, the architectural and, presumably, social location for which he destines his product has become, in inverse ratio, more public. This is the paradox, the contradiction, in the master-current of painting.

Perhaps the contradiction between the architectural destination of abstract art and the very, very private atmosphere in which it is produced will kill ambitious painting in the end. As it is, this contradiction, whose ultimate causes lie outside the autonomy of art, defines specifically the crisis in which painting now finds itself. (It is worth pointing out that the surviving old masters of our time, except for Matisse, appear to have reacted to this crisis in a conservative way. The best work of Picasso and Chagall in the last twenty years, and of Miró in the last five, has been in black and white and in reduced format; the etchings and pen-and-ink drawings of the first and the etchings and lithographs of the latter two, as a rule, surpass by far their recent oils. Their genius, if not their consciousness, recognizes the demise of the easel picture and, with only two destinations left for pictorial art—the wall area and the page—they have chosen the latter, for which they find at least precedent. They are too old by now to venture on anything so unprecedented as a genre of painting located halfway between the easel and the mural.)

The only solution to the crisis would be an increasing acceptance by the public of advanced painting, and at the same time an increasing rejection of all other kinds. "Destructiveness" towards what we now possess as American art becomes a positive and creative factor when it is coupled with a real longing for genuinely high art, a longing that will not be deceived into sat-

isfaction with anything else than the genuine, and which is protected against such deception precisely because it goes hand in hand with the courage to reject and to continue rejecting.

Partisan Review, January 1948

75. Review of an Exhibition of Karl Knaths and of the Whitney Annual

Serious, honest, and enlightened in the fullest sense, Karl Knaths has never been tempted to adulterate his art to the uses of fashion or transient taste. Nor is there any doubt about the level of his work, which has sufficiently demonstrated his purity of intention, his genuine command of modern idiom, and—not least of all—its educational value for younger painters desirous of assimilating the School of Paris without direct contact. Knaths's art is open and straightforward, yet it is modest. This, he says in effect, is how I propose to rearrange the elements cubism has furnished; my originality lies in the rearrangement, and in the nuance contributed by my humble personality. We know the neat, precisely sketched, but somewhat timid pictures that have issued from this attitude; the muted color, unsaturated paint surface, tasteful placing: all of this gentle, dim, entirely unemphatic—the product, that is, of a minor artist, one who extracts and preserves the purity of a style into which its originators have put enviable passion. Knaths adds little that is positive, takes few changes, confines himself to the already known. What he does, in the end, is to set limits.

However, the limits Knaths's painting affirms are not necessarily constricting ones. They are derived from the discipline of cubism, and it is within them that ambitious painting must be produced in our times. Like the walls of a corridor, they force the artist to go straight ahead—and in art, when you keep going straight ahead, you arrive at the unknown. Knaths himself does not go toward the unknown, he seems to have neither the desire nor the force to do so. Yet it is enough that he continues to define the guiding limits within which modern painting must proceed in order to reach it.

Knaths's latest show at Rosenberg's was his best in years. The large landscape, *Tidewash*, is a beautiful demonstration of how he has simplified late cubism—a few planes, firmly demarcated by intermittent lines, hovering in the middle distance under a veil of milky color. The picture does not altogether pack its space, is more tentative than that, remains un-solid, air-borne; but in that lies its particular virtue. It is the best fruit of American understatement—at bottom a little academic perhaps, but in a nice way. The still life *Tea Pot* assimilated Derain and Vlaminck to cubism under low pressure, but successfully. I am sure this sort of painting was to be seen in Paris often enough twenty years ago; nevertheless Knaths puts in his own little accent, and the result is more than an American imitation of Paris. The color itself may be nondescript, but the general tonality and the firm design convey something very personal.

Knaths's big vertical, dark-green *Horse Mackerel* in this year's Whitney Annual is much more ambitious and monumental than is usual with him. And although it has a slight tendency to buckle on the left-hand side, it is almost the best-painted canvas in the entire show. For once both color and surface affirm themselves, and the quick black lines of which Knaths is so fond lose their fragility, grow thicker, and sink down into the paint texture. Nevertheless, this picture still abides by a few too many rules, and it could shine and thrust itself forward just a little bit more. Knaths should remember that it was Picasso, not Braque, who said the last word on cubism.

As for the Whitney Annual, it shows an enormous improvement over the Annuals of the past several years, and this improvement is apparent even among the routinists of the American Scene—especially among the younger ones—Pellew, Sterne, Scheuch, Thon, Wyeth. At the same time abstract painting is more heavily represented than ever before, taking up, it would seem to me, at least one-third of the wall space.

Arshile Gorky's large *The Calendars* is the best painting in the exhibition and one of the best pictures ever done by an American. However close a second Knaths may run him, it is still only a second—and Adolph Gottlieb's very strong, very solid and flat *Totem* is only a third. Reminiscences of Miró's design and Matta's calligraphy may be found in Gorky's picture, but the artist adds a richness of his own and an elegance that are the result of a fu-

sion of sensuousness, learning, and intelligence such as has been rarely seen outside French painting in modern times. I would hold Gorky the only artist in America to have completely assimilated French art—an assimilation that reveals itself in the fact that, whatever else his painting may be, it is never dim or dull, and never unfeeling in touch or texture. The Frenchness of *The Calendars* is astounding, yet it is not a question simply of felicity and taste; it also gives us a wealth of sensations, a plenitude of matter, all under a control as firm as it is delicate. One should not be deceived by the familiarity of the conception of this picture, by the slightly sweet color, or by the traditional grace with which it is brushed into thinking it unoriginal. What we have here is a synthesis of a kind rare in modern painting—"mannerist" in the best sense of the term. The fluid color surfaces of Kandinsky's early abstract style are laid over Miró's neat, profiled design, and the result is a genuinely new style. True, it is an end product and begins nothing in the history of art; yet it does seem to promise a series of masterpieces from at least this one painter—who has taken such a long time to arrive at himself, and whom chronic diffidence in the face of Parisian art has now at least been turned to full account.

Among other artists creditably represented at the Whitney are Marin, Stuart Davis, and Hofmann, even though the first two do repeat themselves, and Hofmann's canvas goes out of control on the right-hand side. Jackson Pollock shows a rather unsatisfactory painting in which white lines are so evenly laid out on an aluminum-paint ground that all intensity is dissipated and the picture becomes merely a fragment. This may mean only a momentary easing up on Pollock's part—an easing up to which he is entitled—but he should have been better represented at so large a show.

On the whole, American art has reason to congratulate itself on this year's Whitney. It is far from being satisfying; and plenty of trash is still present; but something does seem to be fermenting, and for once I look forward with curiosity to next year's Annual.

The Nation, 10 January 1948

76. Calling All Philistines: Review of *Mona Lisa's
 Mustache: A Dissection of Modern Art* by
 T. H. Robsjohn-Gibbings

Very obviously, this book was written to make money. The vul-
garity of its learning and thinking, the misinformation it con-
tains, and the violent and banal simple-mindedness with which
it mauls its material to fit its thesis—all these disqualify it from
serious discussion. But, as sometimes happens with very, very
stupid people, its author does have hold of the truth by a hair on
its tail, a hair that many infinitely more intelligent writers on
modern art have not even brushed. Mr. Robsjohn-Gibbings has
discovered somehow that there was, indeed, something very
wrong with surrealism, futurism, and pre-Raphaelitism. But
since he is out to attack all modern art, he must extend their
fallacies, which he so crudely describes, to cubism, expres-
sionism, and abstract art in general.

So far as art is concerned, the real mistake that pre-Raphael-
itism, surrealism, and futurism made in common is academ-
icism: the attempt to take painting back beyond impressionism.
(Futurism, for all its surface show of modernism, unwittingly
approached art in academic terms; Marinetti, Severini, and
Balla never got the point of what had happened since Courbet,
and Carrà got it once or twice only by accident.) But Mr.
Robsjohn-Gibbings is not against academicism; what he charges
these aesthetic movements with is having promoted occultism,
mysticism, magic, and authoritarianism in opposition to de-
mocracy, the middle classes, and science. There is, as I have
indicated, a twisted bit of half-truth in the first part of this ac-
cusation. In their sincere dissatisfaction with modern life pre-
Raphaelitism and surrealism did cultivate an obscurantism of
opposition, while futurism, on the other hand, made of its very
enthusiasm for the machine age a kind of obscurantism of ap-
proval. But where Mr. Robsjohn-Gibbings should explain, he
can only go on repetitiously about magic, dictatorship, and
Madame Blavatsky, compromising his thesis with such a wealth
of irrelevancies, clumsy distortions, and falsifications that the
mind refuses to grant even the very small half-truth the book
contains for fear of being infected by its total vulgarity.

Though Mr. Robsjohn-Gibbings is astute enough to exempt

the impressionists, Cézanne, and Matisse from his animadversions, it is obvious that he cannot tell the quality of one picture or piece of sculpture or school of art from another; for that matter, he attacks modern art not on the score of its quality but only because of the social and ideological tendencies he attributes to it. And toward the end of the book one realizes that the author is not even sincerely opposed to these tendencies, that his defense of the bourgeoisie and science is motivated mostly by a desire to be super-chic, by an archness that has little to do with the middle-classes and nothing all to do with science. What we have here, in the final analysis, is treachery. To hear Mr. Robsjohn-Gibbings argue that Picasso's art and surrealism must be sinister because they have been taken up by the *haut monde*, fashion, *Vogue* and *Harper's Bazaar* is like seeing a baby bite the nipple it sucks.

The people who are bewildered by modern art have indeed become restive of late, and there is no question that they feel a real desire for some intellectually respectable justification of their bewilderment that would enable them to go over to the counter-attack. It is no longer enough to say "insanity." What's wanted is a weapon on a "high level." And it is the necessity of a "high level" that accounts for Mr. Robsjohn-Gibbings's mumbo-jumbo. But the mumbo-jumbo defeats itself. The people whose need this book is designed to fill will either see through it or be bored by it. It is hard even for philistines to be insensible to such vulgarity.

The Nation, 17 January 1948

77. Review of Exhibitions of Worden Day, Carl Holty, and Jackson Pollock

Nineteen forty-seven seems to have been one of the best of recent years for American painting. I doubt whether it is simply a transient illusion that makes me note so much progress by known painters and see so much promise in so many newcomers.

The abstract canvas *Strata at Broken-Moon Cut* in Worden Day's first show, at Bertha Schaeffer's is as concrete in the excel-

lence of its flat, cut-out Red Indian blacks and reds as the wall it hangs on. Miss Day's originality is narrow but her level is high, and the utterly two-dimensional field in which her talent has chosen to risk itself is the most uncompromising of all for contemporary artists. However, in spite of the mystical pretensions announced by the titles of Miss Day's pictures and her own catalogue note, her art does not as yet go beyond felicity, does not say enough yet to be important.

Carl Holty is a painter who, it seems to me, has struggled for years with his own greatest gift—his enormously facile draftsmanship, which comes from Germany and submits unwillingly to the canons of post-cubist art. Holty's latest show, at the Kootz Gallery, is his best yet, for here at last decoration begins to be overcome by easel painting. In such pictures as *Cup of the Sea*, *Le Flambeau*, *The Golden Unicorn*, and *With Dim Eyes* (I wish someone would caution modern painters about their titles) the play of line subordinates itself to the placing of color masses, and the picture no longer annihilates itself in repetitious calligraphic rhythms (as William Hayter's paintings, at Durand-Ruel's this month, still do), but becomes centered and dramatically unified. Holty's color is still, however, much too thin and his handling of surface too transparent, and for these reasons his art still remains trapped in impressionist feeling—which by now is equivalent to academicism. It continues to amaze me how anyone commanding his craft as Holty does can let himself be satisfied with such dim, un-intense effects. If he maintains his present rapid rate of progress he will find himself, I think, soon faced by a crisis—a crisis that will involve his capacity for emotion and be precipitated by the fact that his prowess as a painter will have so little to exert itself on.

Jackson Pollock's most recent show, at Betty Parsons's, signals another step forward on his part. As before, his new work offers a puzzle to all those not sincerely in touch with contemporary painting. I already hear: "wallpaper patterns," "the picture does not finish inside the canvas," "raw, uncultivated emotion," and so on, and so on. Since Mondrian no one has driven the easel picture quite so far away from itself; but this is not altogether Pollock's own doing. In this day and age the art of painting increasingly rejects the easel and yearns for the wall. It is Pollock's culture as a painter that has made him so sensitive and receptive

to a tendency that has brought with it, in his case, a greater concentration on surface texture and tactile qualities, to balance the danger of monotony that arises from the even, all-over design which has become Pollock's consistent practice.

In order to evolve, his art has necessarily had to abandon certain of its former virtues, but these are more than compensated for. Strong as it is, the large canvas *Gothic*, executed three years ago and shown here for the first time in New York, is inferior to the best of his recent work in style, harmony, and the inevitably of its logic. The combination of all three of these latter qualities, to be seen eminently in the strongest picture of the present show, *Cathedral*—a matter of much white, less black, and some aluminum paint—reminds one of Picasso's and Braque's masterpieces of the 1912–15 phase of cubism. There is something of the same encasement in a style that, so to speak, feels for the painter and relieves him of the anguish and awkwardness of invention, leaving his gift free to function almost automatically.

Pollock's mood has become more cheerful these past two years, if the general higher key of his color can be taken as a criterion in this respect. Another very successful canvas, *Enchanted Forest*—which resembles *Cathedral*, though inferior in strength—is mostly whitish in tone and is distinguished by being the only picture in the show, aside from *Gothic*, without an infusion of aluminum paint. In many of the weaker canvases here, especially the smallest, and at the same time in two or three of the most successful—such as *Shooting Star* and *Magic Lantern*—the use of aluminum runs the picture startingly close to prettiness, in the two last producing an oily over-ripeness that begins to be disturbing. The aluminum can also be felt as an unwarranted dissimulation of the artist's weakness as a colorist. But perhaps this impression will fade as one grows more accustomed to Pollock's new vein. I am certain that *Phosphorescence*, whose overpowering surface is stalagmited with metallic paint, will in the future blossom and swell into a superior magnificence; for the present it is almost too dazzling to be looked at indoors. And the quality of two other pictures, *Sea Change* and *Full Fathom Five*, both in much lower key, one black-green and the other black-gray, still remains to be decided.

It is indeed a mark of Pollock's powerful originality that he should present problems in judgment that must await the di-

gestion of each new phase of his development before they can be solved. Since Marin—with whom Pollock will in time be able to compete for recognition as the greatest American painter of the twentieth century—no other American artist has presented such a case. And this is not the only point of similarity between these two superb painters.

The Nation, 24 January 1948

78. Matisse, Seen Through Soviet Eyes: Review of *Matisse: A Social Critique* by Alexander Romm

Can anything decent come out of the cultural offices of the Soviet Union? We would least of all expect it to be art criticism. Yet here is Alexander Romm's little book on Matisse, which, though not quite decent, is as serious as it can afford to be and contains only the absolutely required minimum of Stalinist vulgarity. Its description of the evolution of Matisse's art is founded on an intimate acquaintance with the latter, and is accurate and intelligent. Mr. Romm loves his subject more than he dare admit in the face of official compulsion to find Matisse an exponent of decaying capitalism.

Yet he is not a very original critic and his insights do not reveal much that we did not know before. For all his professed Marxism, Mr. Romm accepts that very bourgeois art form, the easel painting, as given and fails almost completely to recognize what Matisse has done to alter both the idea and function of the framed wall picture. Nor does he perceive the meaning of that great change from three to two-dimensionality which modern art has affected in pictorial space—a change that expresses our industrial society's abandonment of Cartesian rationality for empiricism and positivism. An intelligent Marxist art critic should be aware of such things; and had the present one been aware of them, his "social critique" would have been less banal.

The fact is that merely a minimum of Stalinist vulgarity, merely a tincture of it, is enough to compromise wholly anything it comes in contact with. Thus the crass pseudo-Marxist analysis Mr. Romm makes at the beginning of his monograph

forces his hand later on and compromises, directly or indirectly, almost everything he thereafter tries to say sincerely.

To confine the notion of subject matter exclusively to the anecdotal interest of a picture is by now a piece of backwardness that cannot escape being dishonest at the same time. To declare that painting begins to lack "ideas" when the motifs it takes from nature lack them, is so obviously stupid that Mr. Romm himself must have been aware of it. Matisse, like the impressionists, only made explicit what had been implicit in art from the very beginning: namely, that the "ideas" contained in a work of art, in so far as they belong to the individual artist, lie just as much in its style as in its professed content, and that the main "idea" of those who approach art as art, and not as something else, inheres almost always in the *way* the artist handles the subject matter at his disposal, not in the subject matter itself. (In any case, art never does express ideas as such; it may contain them, but it makes a point that goes beyond them.)

Mr. Romm's book appeared in Russia shortly before the recent war. One doubts whether, in the light of the latest Soviet ukases on literature and art, its publication would be permitted now. Though he castigates the French master's "hedonistic outlook" the author does call on Soviet art to find a "corresponding expression" for the "positive elements" of Matisse's art: his "powerful, intensive color, his daring and dynamic treatment of form, mastery of the laws of decorative rhythm." I feel sure that Mr. Romm will in the future no longer dare to find these elements "positive."

New York Times Book Review, 25 January 1948

79. Letter to the Editor of *The Nation*

Dear Sirs,
Since Mr. Finkelstein [1]—as he says—knows little of my positive aesthetic ideals, he should have hesitated before deducing them

1. Louis Finkelstein, chairman of the Pyramid group of artists, had criticized Greenberg for his review of an exhibition of the group's work (*The Nation*, 20 December 1947). [Editor's note]

all from my espousal of Jackson Pollock. As far as I know, I do not prescribe to art, and I am willing to like anything, provided I enjoy it enough. That is my only criterion, ultimately. If I happen to enjoy Pollock more than any other contemporary American painter, it is not because I have an appetite for violent emotion but because Pollock seems to me to paint better than his contemporaries. I also happen to think Matisse the greatest painter of the day. Is he an exponent of violence, irrationality, sensationalism, or "unwholesome romanticism"? Or is cubism that? For I think cubism the highest school of painting in our century.

I pitched into the Pyramid show because I found it so violently unenjoyable, not because the artists failed to meet any particular prescriptions. Mr. Finkelstein mentions craft. I find more craft in any corner of a Pollock painting than I did in the entire Pyramid show.

<div align="right">

Clement Greenberg
New York, 15 January
</div>

The Nation, 31 January 1948

80. Review of Exhibitions of Alberto Giacometti and Kurt Schwitters

Apollinaire's true progeny in the arts were not the cubists but those more ebullient and literary artists who sprang up in cubism's wake and came to notice along with Dada or surrealism in the years shortly after the 1914–18 war. Chief among them were Arp, Brancusi, Klee, Kurt Schwitters, Gonzalez, Miró, Alberto Giacometti. The last-named was for a while one of the most important inventors in twentieth-century art, a sculptor whose ideas have begun lately to find a precipitation—though a somewhat false one—even in painting (see Matta).

Giacometti started from cubism and in his best work never altogether left it. Without cubism he would have lacked, I think, the impulse that made him break with monolithic sculpture as radically as he did. And he translated cubism into sculpture more integrally, if not so literally, than did any other sculptor of

his time—not excepting Lipchitz, Laurens, or Zadkine. It is the spirit of cubism rather than its letter that forced Giacometti to become such an inventor, introducing him to the conception of sculpture as something linear, free from mass, transparent, enclosing space and emptying instead of filling it. This, and not cubes, is what cubism means when integrally translated into sculpture—as the constructivists, too, can testify.

The surrealists attribute the effect of Giacometti's art to its literary dynamics: the unexpected juxtaposition of the suggestions given off by its shapes. But this unexpectedness was only the means by which the artist incited himself to work. The ultimate motives and factors lay beyond, in the play against each other of the curve and the straight line—as in the best canvases of Picasso, Braque, Gris, and Léger; in the frontal approach that demanded only a single viewpoint on the part of the spectator; and in the transposition of all sculptural problems into the pictorial terms of line and flat plane. The freely created, arbitrary object, of which surrealism made so much, is only a by-product of these factors, not their end. What deceived the surrealists was the fact that these works of sculpture were no longer *statues*.

Giacometti's feeling for form has never been sure, and the best of his sculpture is not so clean in style as the best cubist painting; at the same time it is less academic, because it is not haunted by all that the past has done with paint and canvas, and is able therefore to adumbrate things more intensely new. Thus while he is not quite a major artist, Giacometti has become almost the main wellspring of contemporary advanced sculpture, at least in this country. David Smith, David Hare, Calder, Theodore Roszak, and others would not be possible without him.

Giacometti's plaster and bronze compositions of his best period, between 1925 and 1934, are in almost every case successful. It is *style* that makes such consistency possible, a style borne up by the presence around him of great contemporaries, and also by the faith in the future that he shared with most of them. His projects for public places and tunnels, his cages and strangled women, his figures and heads, aim ultimately at a reconstitution of the world on a more sincere basis. It is only here that the surrealists are right about Giacometti. His fitting together of tube and block, bar and rod, in new ways, his scratched plaster tablets and geometrical landscapes aim at a

new sincerity that will no longer conceal what is, humanly speaking, the arbitrary absurdity of the present world.

In the meantime Giacometti has lost his sincerity and optimism. His present full-scale show at Pierre Matisse's, which includes very late as well as early work, makes this clear. The tall, elongated withered figures in bronze and plaster that are his latest productions—most of them dating from 1947—mark a drastic change of direction and style and at the same time, alas, a sad falling off from his previous standard. They constitute nothing more or less than a retreat to the statue, to the monolith. These unwrapped mummies are the same kind of expressionist archaeology that other contemporary Italian artists—including Chirico—have resorted to in the effort to stay "modern." Gone is the bold, rough geometry that gave Giacometti's former flights of imagination their motive power; gone the audacious inventiveness that shocked the spectator's vision only to stabilize it on a higher and securer level. True, these later things are striking in a way—especially the bronze *Tall Figure, Half Size*—but their effect verges on the sentimental, however grimly disguised that sentimentality is, and their conception remains in the end perfunctory.

Let no one think that the prominence of the human figure in Giacometti's latest work means a return to "humanism." Today "humanism" in art means the very opposite—pessimism about man's powers, a fear of facing any reality without precedent. Giacometti's earlier, more abstract work, which showed as little concern for the shape of the human figure as it did for that of a car barn, expressed a far more genuine humanism, a humanism that took into itself the whole realm of sight and touch.

Kurt Schwitters, the German collagist, sculptor, architect, and writer (the news of his death at sixty-one in Westmoreland, England, on January 8 has just reached us), belonged to the same artistic generation as Giacometti; and his debt to cubism is much more obvious. Schwitters was one of those artists who, because they go very far ahead in a narrow direction, tend to be overlooked for a time. It is to be hoped that his first one-man show in this country, at the Pinacotheca, will remedy the neglect he seems to have suffered these past twenty years and more.

Of his twenty-six collages shown at the Pinacotheca eleven date from between 1920 and 1928, one from 1946, and the rest

from 1947. What is equivocal about Schwitters, as about his fellow-ex-Dadaist, Hans Arp, is the single-mindedness with which, all outer appearances to the contrary notwithstanding, he has striven for a strict internal aesthetic logic. It is not what one would expect from an artist who received his first fruitful impulse from a movement hostile to all kinds of logic, artistic and otherwise. However, the fact is that Schwitters was already a disciple of cubism in 1918 and that he never shared the anti-art position of the majority of Dada. Instead of going over to surrealism, as did so many other ex-Dadaists, he aligned himself subsequently with Mondrian, Van Doesberg, Gabo, and Lissitzky, and in the 1930's joined the Abstraction-Création group.

On the evidence of the present show it is Schwitters's earlier works, those executed under the more immediate influence of classical cubism, that excel by far. As in Giacometti's case, his most recent work shows a great decline, if not a radical change of direction. Though the shapes employed are still more or less rectangular, the composition is no longer built almost exclusively of rectangles on horizontal bases, and the effort toward greater variety of texture and color grain results in discordances. Though the materials of the earlier collages are as heterogenous as those of the later ones—torn tickets, shreds of cigarette packages, odd bits of cardboard and cloth, and so forth—they assert a superior unity and compactness of surface, texture, and design.

Schwitters's signal contribution was his introduction of bright colors in a medium that when originally developed by the classical cubists was confined to a spectrum of black, white, gray, brown, and dull yellow. Despite their variegated color it is by reason of their purity of style, achieved under difficulties more self-imposed than those the original cubists faced when working in this medium, that Schwitters's little collages take their place among the heroic feats of twentieth-century art. Schwitters also experimented with collage constructions composed of odd pieces of wood, plaster, metal, and glass set inside a deep frame. One successful example of this genre, from 1923, demonstrates, as do Arp's bas-reliefs, how contemporary advanced sculpture was able, via the collage, to attach itself to painting and take its point of departure from that medium rather than from anything antecedent in its own medium. Without this bridge from painting to sculpture provided by the collage and its derivative bas-

208

relief, Giacometti, for instance, would have been unable to embark on his revolutionary path.

The Nation, 7 February 1948

81. Review of Exhibitions of Henri Matisse, Eugène Boudin, John Piper, and Misha Reznikoff

It is no new thing for great masters to let unrealized or perfunctory work get out of their studios. But the practice does seem to have become more habitual since the nineteenth century. Of the pictures we see of such an artist, for instance, as Renoir, although each bears some touch of his genius, only one out of, say, ten really comes off in its own terms and deserves to be hung as a successful work; the other nine fail by their creator's own standards. In more recent days Matisse and Picasso have been even more indiscriminate in what they send to the market. But in so far as Picasso's art has declined during these last two decades, while Matisse's has not—or at least not so grievously— Matisse is more to be blamed.

The innocent spectator should be warned that Matisse is not to be judged by the exhibition of his works—selected from between 1900 and 1930—now running at the Bignou Gallery. It contains only two definitely first-rate paintings: the very small *Place du Château, Nice* of 1919 and the larger *Seated Nude* of 1921, which latter, in the master's more three-dimensional vein, has a beautiful pearly-gray cast. The very large *Artist's Studio* of 1911 is certainly more important than either of these, but it is only the brittle beginning of something in the way of large dramatic decoration that Matisse was to realize more momentously several years later under the influence of cubism—see, for example, the Museum of Modern Art's great *Piano Player*. Also worth mentioning in the present show is the *Carnival of Nice* of 1922, which is perhaps a bit too sketchy, but succinct; in it Matisse demonstrates again, as he does in the *Place du Château*, that he uses black better than anyone else since Manet, not excepting Braque.

An exhibition at Durand-Ruel's of thirteen paintings by

Eugène Boudin, the nineteenth-century French landscapist and forerunner of impressionism, likewise runs the danger of giving a false notion of this artist's stature. Boudin's forte lay in the orchestration of grays, and it would seem almost that he could paint at his best only on an overcast day. Over the last few years Durand-Ruel has from time to time shown in its foyer superb examples of Boudin's "gray" style—small, concentrated pictures in which a leaden sky that overhangs a narrow strip of darker sea and shore is put together with, for that time, audaciously juxtaposed touches of gray ranging from soot to pearl. These canvases are among the most exquisite and subtle of all gems produced by the art of painting, and they place Boudin high among the artists of his wonderful century, however narrow and repetitious he may have been in the choice of his themes. Boudin was not an uneven painter, and every one of the seascapes on view at the Durand-Ruel show reveals the hand of a master: particularly the *Falaises de Villerville* of 1893, *La Plage de Villers* of 1891, *Le Bassin de Fécamp, coucher de soleil* of 1894, and the *Port du Havre* of 1884. But unfortunately there are only one or two genuine examples of his gray style, and we see in the other pictures, almost all of which seem to have been done under sunlight, somewhat too much of that timid blondness, along with dull acid greens and starchy blues, which marked the French academic landscape in the long post-Barbizon period. Here Boudin's crucial shortcoming is made plain, a lack of largeness, breadth, or fundamental boldness that denied to him the first order of greatness. Yet in his gray canvases this is a lack we are grateful for—how else but as the products of a policy of limited objectives could we have got such jewels?

The first American show, at Buchholz's, of John Piper, the British painter of whom we have heard so much lately, reveals another delicate painter. But whereas Boudin's delicacy pointed toward the future and was in many respects bold despite itself, Piper, who used to paint abstractly and now does landscapes and architectural views in a sensitive, lyrical manner compounded of Klee and traditional English landscape painting, goes backward in time and pays for his delicacy by surrendering his ambition to say anything really important. Yet there can be no question about Piper's talent, however limited its application and fragile its results. As it happens, he is a much better artist when using color than when confining himself to black and

white, as he does in the large majority of the gouaches which make up the bulk of this show. It is their exquisite pastel tints that bring off such academic little masterpieces as the gouache *Lewknor* and the oil *Dungeness Beach*. And color also makes felicitous such lesser works as *Irish Country Houses*, a set of four narrow horizontal panels in oil, *Nether Worton Church*, another oil, and *Caernarvon*, a gouache. But, felicity, taste, and all, Piper is not a truly interesting painter, and one feels that on the basis of the evidence here at hand his future can be too easily predicted. About the only thing such good taste can do is repeat itself.

Misha Reznikoff, an American painter whose work is to be seen at Knoedler's, seems also a frail talent. But in his "décollages"—which are large water colors that get their texture and some of their color from the effect left by peeling off various layers of the cardboard on which they are painted and then applying the color—Reznikoff ventures into the more dangerous and exciting territory of the abstract. Again, Reznikoff's talent is indisputable, and it shows to good effect in his two most abstract pictures—*Brown Figure*, which is a work of perfection, and *Dances*. Both of these are almost monotone in color and have a strength that is belied elsewhere in this show. Reznikoff is betrayed too often by a certain literary cuteness and a kind of virtuosity that brings him close to prettiness, operating in his off-shade color just as much as in his drawing. His other pictures, though they seem so various among themselves in conception and design, are almost uniformly spoiled—some of them, like *Party in the Evening* and the Picassoid *Masks*, are just barely spoiled—by a decorative and faintly academic slickness and syrupy grace which in many cases ruin works that appear initially to have been well felt out. It is probable, however, that Reznikoff has it in him to say much more than he does in this show, and I look forward to his next.

The Nation, 21 February 1948

82. The Decline of Cubism

As more and more of the recent work of the masters of the School of Paris reaches this country after the six years' interruption

between 1939 and 1945, any remaining doubt vanishes as to the continuing fact of the decline of art that set in in Paris in the early thirties. Picasso, Braque, Arp, Miró, Giacometti, Schwitters—exhibitions, samples, and reproductions would indicate exhaustion on the part of those who in the first three decades of the century created what is now known as modern art. This impression is supported by the repetitious or retrograde tendencies of the work of the notable School of Paris artists who spent the war years here: Léger, Chagall, Lipchitz. And there is also the weakening Mondrian's art suffered between 1937 and his death in 1944 (in this country). On the other hand, Matisse, the late Bonnard, and even the late Vuillard seem to have been spared by the general debility, going on in the thirties and forties to deliver themselves of some of their supreme statements: in the usual way of painters, who, unlike most poets, get better as they grow older.

The problem for criticism is to explain why the cubist generation and its immediate successors have, contrary to artists' precedent, fallen off in middle and old age, and why belated impressionists like Bonnard and Vuillard could maintain a higher consistency of performance during the last fifteen years; why even the German expressionist, Max Beckmann, so inferior to Picasso in native gifts, should paint better today than he does. And why, finally, Matisse, with his magnificent but transitional style, which does not compare with cubism for historical importance, is able to rest so securely in his position as the greatest master of the twentieth century, a position Picasso is further than ever from threatening.

At first glance we realize that we are faced with the debacle of the age of "experiment," of the Apollinairian and cubist mission and its hope, coincident with that of Marxism and the whole matured tradition of Enlightenment, of humanizing the world. In the plastic arts cubism, and nothing else, is the age of "experiment." Whatever feats fauvism in the hands of Matisse, and late impressionism in those of Bonnard and Vuillard, have been capable of, cubism remains the great phenomenon, the epoch-making feat of twentieth-century art, a style that has changed and determined the complexion of Western art as radically as Renaissance naturalism once did. And the main factor in the recent decline of art in Europe is the disorientation of cubist style, which is involved in a crisis that—by a seeming quirk—spares

the surviving members of the generation of artists preceding it in point of historical development.

Yet it does not matter who is exempted from this crisis, so long as cubism is not. For cubism is still the only vital style of our time, the one best able to convey contemporary feeling, and the only one capable of supporting a tradition which will survive into the future and form new artists. The surviving masters of impressionism, fauvism, and expressionism can still deliver splendid performances, and they can influence young artists fruitfully—but they cannot *form* them. Cubism is now the only school. But why, then, if cubism is the only style adequate to contemporary feeling, should it have shown itself, in the persons of its masters, less able to withstand the tests of the last twenty years? The answer is subtle but not far-fetched.

The great art style of any period is that which relates itself to the true insights of its time. But an age may repudiate its real insights, retreat to the insights of the past—which, though not its own, seem safer to act upon—and accept only an art that corresponds to this repudiation; in which case the age will go without great art, to which truth of feeling is essential. In a time of disasters the less radical artists, like the less radical politicians, will perform better since, being familiar with the expected consequences of what they do, they need less nerve to keep to their course. But the more radical artists, like the more radical politicians, become demoralized because they need so much more nerve than the conservatives in order to keep to a course that, guided by the real insights of the age, leads into unknown territory. Yet if the radical artist's loss of nerve becomes permanent, then art declines as a whole, for the conservative artist rides only on momentum and eventually loses touch with the insights of his time—by which all genuine artists are nourished. Or else society may refuse to have any new insights, refuse to make new responses—but in that case it would be better not to talk about art at all.

Cubism originated not only from the art that preceded it, but also from a complex of attitudes that embodied the optimism, boldness, and self-confidence of the highest stage of industrial capitalism, of a period in which the scientific outlook had at last won a confirmation that only some literary men quarreled with seriously, and in which society seemed to have demonstrated its complete capacity to solve its most serious internal as well as

environmental problems. Cubism, by its rejection of illusionist effects in painting or sculpture and its insistence on the physical nature of the two-dimensional picture plane—which it made prominent again in a way quite different from that in which Oriental, medieval, or barbaric art did—expressed the positivist or empirical state of mind with its refusal to refer to anything outside the concrete experience of the particular discipline, field, or medium in which one worked; and it also expressed the empiricist's faith in the supreme reality of concrete experience. Along with this—regardless of whether the individual cubist happened to believe in God, David Hume, or Hermes Trismegistus, for it was a question of a state of mind, not of a reasoned, consistent philosophical position—went an all-pervasive conviction that the world would inevitably go on improving, so that no matter what chances one took with the new, the unknown, or the unforeseeable, there was no risk of getting anything inferior or more dangerous than what one already had.

Cubism reached its height during the First World War and, though the optimism on which it unconsciously floated was draining away fast, during the twenties it was still capable, not only of masterpieces from the hands of Picasso, Braque, Léger, but also of sending forth such bold innovators as Arp, Mondrian, and Giacometti, not to mention Miró. But in the early thirties, by which time both Picasso's and Braque's art had entered upon a crisis from which neither artist has since shown any signs of recovering, the social, emotional, and intellectual substructure of cubism began crumbling fast. Even Klee fell off after 1930. Surrealism and neo-romanticism, with their rejuvenated academicism, sprang up to compete for attention, and Bonnard, painting better and better within a discipline and frame of mind established as long ago as 1905 and for that reason, apparently, more impervious to the prevalent malaise, began to be talked about as the greatest French painter of his time, notwithstanding the presence of Matisse to whom Bonnard himself owed so much.

After 1939 the cubist heritage entered what would seem the final stage of its decline in Europe. True, Dubuffet, a cubist at heart, has appeared since then, and the best of the younger generation of French artists—Tal Coat, Kermadec, Manessier, Le Moal, Pignon, Tailleux, etc., etc.—work within cubism; but so far they have added nothing but refinements. None of them,

except Dubuffet, is truly original. It is no wonder that the death of abstract art, which, even in its Kandinsky and Klee variants, is still essentially cubist, has been announced so often during the last ten years. In a world filled with nostalgia and too profoundly frightened by what has just happened to dare hope that the future contains anything better than the past, how can art be expected to hold on to advanced positions? The masters of cubism, formed by the insights of a more progressive age, had advanced too far, and when history began going backwards they had to retreat, in confusion, from positions that were more exposed because they were more advanced. The metaphor, I feel, is exact.

Obviously, the present situation of art contains many paradoxes and contradictions that only time will resolve. Prominent among them is the situation of art in this country. If artists as great as Picasso, Braque, and Léger have declined so grievously, it can only be because the general social premises that used to guarantee their functioning have disappeared in Europe. And when one sees, on the other hand, how much the level of American Art has risen in the last five years, with the emergence of new talents so full of energy and content as Arshile Gorky,[1] Jackson Pollock, David Smith—and also when one realizes how consistently John Marin has maintained a high standard, whatever the narrowness of his art—then the conclusion forces itself, much to our own surprise, that the main premises of Western art have at last migrated to the United States, along with the center of gravity of industrial production and political power.

Not all the premises have reached this shore—not by a long shot; but enough of them are here and enough of them have abandoned Paris to permit us to abandon our chronic, and hitherto justified, pessimism about the prospects of American art, and hope for much more than we dared hope for in the past. It is not beyond possibility that the cubist tradition may enjoy a new efflorescence in this country. Meanwhile the fact remains that it is in decline at the moment.

Partisan Review, March 1948

1. This essay was accompanied by illustrations of two paintings by Gorky: *The Betrothal I* (1947) and *Agony* (1947). [Editor's note]

83. Review of an Exhibition of Mordecai Ardon-Bronstein and a Discussion of the Reaction in America to Abstract Art

The Palestinian painter, the fifty-eight-year-old Mordecai Ardon-Bronstein, whose work is introduced to us by a retrospective show at the Jewish Museum, impresses this writer at first glance as one of the strongest painters of his generation. It is a welcome surprise to see such high and relevant art come out of a country most of whose cultural products are unavoidably tinged with that provincialism which marks almost all new national self-consciousness.

As is the case with most contemporary Jewish painters, Bronstein's chief direction is expressionist, and in his smaller and lesser canvases there are many reminders of Soutine. However, his best work—especially the apocalyptic and monumental landscapes *Mount of Olives* (1938), which is the finest picture here, *Kidron Valley* (1939), *Bethlehem* (1943), and the smaller *Anatot* (1937)—displays an expressionism modified by cubism. These paintings are brought to the verge of the abstract by their texture, which consists of a multiplicity of cross-hatched little brushstrokes that create a surface in which shapes dissolve, and underneath whose seeming monotony rhythmic variations of hue and value work powerfully. I can think of only one other artist of whom Bronstein's landscapes remind me—the late Arnold Friedman, an American and, again, a Jew, who in the last years of his life approached the abstract by a similar path.

While Bronstein's figure pieces and still lifes seem to me largely unsuccessful because frozen inside expressionist formulas and devoid of the boldness and license with which his landscapes are handled, some of his small later landscapes attain to a flat nakedness and pungency of color that takes them beyond expressionism—I think particularly of the *Yellow Landscape* (1946). But these smaller canvases still fall short of the level of the apocalyptic landscapes. Perhaps no one has answered the sameness of the Palestinian landscape with such pictorial success as Bronstein has in these latter. Far be it from me to see an eternal Jewish soul any more than an eternal Anglo-Saxon one, but there does seem to be some relation between Bronstein's Palestinian pictures and the Old Testament: there is the same hallu-

cinatory monotony, the same intensity applied to broad effects, the same accumulation of parallel or equivalent details around a single obsessively extended theme.

"Equivalent" happens to be the important word here. Mondrian, I believe, was the first to use it with respect to modern painting, and his own art offers perhaps the clearest anticipation of the terminus toward which several of the most important threads in contemporary painting now converge: the even, all-over, "polyphonic" picture in which every square inch is rendered with equal emphasis and there are no longer centers of interest, highlights, or dominating forms, every part of the canvas being equivalent in stress to every other part. Texture and surface carry everything, and the picture becomes reversible, so to speak—with beginning, middle, and end made interchangeable. That such pictures should escape collapsing into decoration, mere wallpaper patterns, is one of the miracles of art in our age, as well as a paradox that has become necessary to the age's greatest painting.

The spreading recognition in this country of the fact that its most significant art is tending to become more and more exclusively abstract—a recognition embodied in this year's Whitney Annual and the recent large-scale Chicago Institute show—has begun to provoke a determined counter-reaction. First there was the murmuring of the newspaper critics against the new acquisitions shown by the Museum of Modern Art; then came an editorial in *Art Digest* (a magazine I recommend as an unconscious cultural document) to swell the murmur to an outcry; then Aline Louchheim's hopeful remark in the *New York Times* about abstract art's having been pocketed off by now in a few "specialized" galleries and a little magazine or two in England and this country; and finally the announcement by the Institute of Modern Art in Boston that it was changing its name to the Institute of Contemporary Art because of the "widespread and injurious misunderstandings which surround the term 'modern.'" The Institute's statement claims, among other things, that by now "'modern art' describes a style which is taken for granted; it has had time to run its course and, in the pattern of all historic styles, has become dated and academic." The Institute also advertises its intention "to distinguish the good art from the bad, the sincere from the sham, the perceptive from the obtuse. It

must also proclaim standards of excellence which the public may comprehend."

It should be explained first of all that no genuine partisan of "modern" or "radical" or advanced art would in his right mind ask for a blanket acceptance of advanced art, though he would argue, and rightly, that art can stay alive only by advancing, "experimenting," and venturing ever and again into what Miss Louchheim calls "extremism." Meanwhile it is up to the critic, the museum director, and the connoisseur to tell the good from the bad, no matter what the school or style. It is just as easy to detect a charlatan when he paints like Mondrian as when he paints like Delacroix. What seems to bother the people at the Boston Institute, Miss Louchheim, and the editor of the *Art Digest* is an unconscious lack of confidence in their own capacity to tell the good from the bad in general; and it is my opinion that, without their art histories at hand, they would feel this lack at the Metropolitan almost as much as at the Museum of Modern Art.

As for the datedness of "modern art"—what, exactly, has come along to supplant it and render it dated? For nothing can be either dated or academic unless something else has appeared to supersede it and make it seem so by contrast. Where, in other words, is the new contemporary art that has made the Institute of Contemporary Art change its name?

As for the public—*which* public? The millions who, as the Institute says, find "modern art" something unintelligible and even meaningless? Those same millions also prefer Norman Rockwell to Courbet, and neither the Institute of Contemporary Art nor any other institute will in our day and age ever persuade them to comprehend the standards that make Courbet the one to be preferred.

The Nation, 6 March 1948

84. Review of an Exhibition of Arshile Gorky

Art is, of course, a reading of experience, but until about eighty years ago it seemed to be unable to register its own proper

experience: I mean that part of experience which has to do with the making of art itself. Even now, though we are relatively well accustomed to poems about the making of poetry (Rimbaud, Mallarmé, Valéry, Stevens) and novels about the problems of novel-writing (Gide and Joyce), we still find music (like Schoenberg's) about composing and pictures about painting (like cubism) rebarbative; and we complain about the over-intellectuality, aridity, abstruseness, lack of humanity, in these works. Only philistines talk about the lack of "humanity" in art—as if anything worthy of being considered a work of art could be un-human; yet when it comes to contemporary painting—and music—a good many otherwise enlightened people do become philistines, alas. And many may even complain about "un-human" abstruseness in connection with Arshile Gorky's newest paintings now on show at Julien Levy's.

What is new about these paintings is the unproblematic voluptuousness with which they celebrate and display the processes of painting for their own sake. With this sensuous richness, which is a refined product of assimilated French tradition, and his own personality as an artist, with all its strengths and weaknesses, Gorky at last arrives at himself and takes his place— awaiting him now for almost twenty years—among the very few contemporary American painters whose work is of more than national importance. Gorky has been for a long time one of the best brush-handlers alive, but he was unable until recently to find enough for his brush to say. Now he seems to have found that in celebrating the elements of the art he practices and in proclaiming his mastery over them. Unlike the classical cubists, Mondrian, or even Miró, he does not seek out problems of painting for his matter. Nor does he comment on the spirit of the times, answering its agitation with his own. On the face of it, Gorky is a complete hedonist, deeper in his hedonism than almost any French painter, and he has begun to paint with consistent success and largeness only after reconciling himself to the fact that his primary impulse to paint lies in the enjoyment of art itself. His art is not incisive—and I am afraid many will misunderstand it for this reason—but it is some of the most luscious, elegant, and mellifluous grand-style painting I have seen, and mixes a certain strength with all its softness and grace. If it still lacks fulness of body, it does not lack solidity and coher-

ence. If certain canvases appear loose or thin, others attain real sonority and resonance and become monumental.

Gorky owes something to Matta's drawing, but he has exalted this ingredient, developing it with a plenitude of painterly qualities such as Matta himself appears incapable of. And he also owes something to Miró—but why not? Gorky's method is what the French call *tachisme*—"spotting," the adjustment of spots or isolated areas of color, usually against a more or less uniform background. Matisse is a *tachiste*, and so was Bonnard to some extent, but the source of the method as Gorky practices it is Miró, and it is because Miró is still so relatively new that Gorky appears to imitate him; in time the impression will fade. In one direction, I feel, Gorky himself has gone beyond Miró by identifying his background more closely with the picture's surface, the immediate, non-fictive plane on which the spots are placed. He does this by scumbling or washing in his pigment transparently over large areas, or by varying color in narrow gradations from one area to another, all of which brings the canvas forward by compelling us to notice its saturation, physical complexion, and flatness. Thus the "spots," which strike us first, seem indissolubly welded to the background on one and the same plane, instead of floating over it.

Gorky's forte is his draftsmanship, and his color is rather confined in its range and effect. Usually he keeps to one of two scales—black, blue, gray, white; or vermilion, red, rose, tan, ocher. In his two strongest pictures—*The Calendars* and *Agony*—the hotter scale is largely relied upon; in another, *Soft Night*, which is perhaps the most interesting and promising if not quite the best picture present, the register is black, gray, and white. But yellow is predominant in the excellent *Pastoral*, which is washed in like a water color; and an untitled small canvas in Mr. Levy's office, slightly timid but perfect within its timidity, is in blue, rose, black. Also to be noticed is the orange and tan *Plow and the Song*. Gorky tends to favor horizontal or square formats, but he changes to the vertical in two impressive but uneven pictures, *Betrothal I* and *Betrothal II*, which are similar in their general tonality and linearism. The second of these is marred by the surface-cutting sharpness and evenness with which its major forms are outlined; without that the picture would have had much greater firmness.

The weakness that accounts for Gorky's unsuccessful works is isolated and emphasized in an enormous drawing, also in Mr. Levy's office, in which we see how the artist's manual inspiration—that is, his really astounding gift as an automatic draftsman—will sometimes run away with the picture for lack of a central impulse or idea that would order the calligraphic details into a whole. Then the result will be a collection of inorganic and, often, repetitious details. Gorky should rely more on the movement of his whole arm rather than on that of his wrist or elbow alone.

But this is carping. The presence of six pictures as excellent as those named above in a show comprising some fifteen or sixteen items in all declares a remarkable rate of performance, especially in view of the very high level the artist sets himself. And Gorky, in my opinion, has still to paint his greatest pictures. Meanwhile he is already the equal of any painter of his own generation anywhere.

The Nation, 20 March 1948

85. The Crisis of the Easel Picture

The easel or cabinet picture—the movable picture hung on a wall—is a unique product of Western culture and has few counterparts elsewhere. The form of the easel picture is conditioned by its social function—that is, to hang on a wall—and to realize this we have only to compare its principles of unity with those of the Persian miniature or Chinese hanging painting, neither of which seems to isolate itself quite as much as the easel picture does from its architectural surroundings. Nor does either show so much independence of the demands of decoration. Traditionally, the Western easel painting subordinates decorative to dramatic effect, cutting the illusion of a boxlike cavity into the wall behind it and organizing within this cavity the illusion of forms, light, and space, all more or less according to the current rules of verisimilitude. When, as Manet and the impressionists began doing, the artist flattens this cavity out for the sake of decorative structure and organizes its elements in terms of flat-

ness and frontality, the easel picture begins to feel itself compromised in its very nature.

The evolution of modern painting from Manet on has subjected the traditional cabinet picture to an uninterrupted process of attrition.[1] Monet and Pissarro in particular, though less revolutionary in other respects, attacked the easel picture's essence by the consistency with which they applied their method of the divided tone, whose operation had to remain the same throughout the picture, requiring every part of the canvas to be treated with the same emphasis of touch. The product of this was a tightly covered, evenly and heavily textured rectangle of paint that muffled contrasts and tended—but only tended—to reduce the picture to a relatively undifferentiated surface.

The tendency initiated by Pissarro and Monet did not work itself out coherently in time. Seurat pushed divisionism to its logical conclusion and applied the divided tone much more inflexibly and mechanically than they, but his concern with clarity of design and contrasts of light and dark sent him in the opposite direction, and while he made the picture shallower, he did not erase or dissolve its dominant forms. Cézanne, Van Gogh, Gauguin, Matisse, and the fauves all contributed to the reduction of the easel picture's fictive depth, but none of them arrived at anything quite so radical in its violation of the traditional laws of composition as Monet and Pissarro had. No matter how much the picture is flattened, as long as its forms are sufficiently differentiated and kept in dramatic imbalance it will remain an easel picture definitely enough. But Monet and Pissarro anticipated at long remove a mode of painting, now practiced by some of our most "advanced" artists, that threatens the identity of the easel picture at precisely these points: the "decentralized," "polyphonic," all-over picture which, with a surface knit together of a multiplicity of identical or similar elements, repeats itself without strong variation from one end of the canvas to the other and dispenses, apparently, with beginning, middle, and ending. Although it still remains easel painting somehow, at least when successful, and will still hang

1. This essay was accompanied by an illustration of a painting, not referred to in the text, by Willem de Kooning. Three other paintings by de Kooning were illustrated in the same issue of *Partisan Review*. [Editor's note]

dramatically on a wall, this sort of painting comes closest of all to decoration—to wallpaper patterns capable of being extended indefinitely—and in so far as it still remains easel painting it infects the whole notion of this form with ambiguity.

I am not thinking of Mondrian in particular at this moment, although his attack on the easel picture is in many respects the most radical of all. Mondrian took his point of departure from that stage of analytical cubism at which Picasso and Braque had arrived around 1912, when their cubes had flattened into little rectangles and half-circles that merged more and more with the background, and the picture was put together of little distinct touches of neutral color—a kind of pointillism—that emphasized the surface by loosening it. (It is significant that the most radical steps taken in painting since Manet's time have in almost every case been accompanied by the tendency to atomize the picture surface into separate brush-strokes.) Mondrian noticed that the cubism of this period depended largely on the motif of the vertical and the horizontal line, and it was from this observation that he seems to have drawn the conclusion he put into such consistent practice. The pictures that resulted constitute the flattest of all easel painting, but strong, dominating forms, as provided by intersecting straight lines and blocks of color, are still insisted upon, and the canvas, as simplified and balanced as it is, still presents itself as the *scene* of forms rather than as one single, indivisible piece of texture. The new "polyphonic" kind of painting that I refer to uses less explicit oppositions, and it is more nearly anticipated by Picasso's and Braque's analytical cubism and by Klee than by Mondrian himself.

Yet, whatever the distinctions made in tracing its origins, the fact is that a number of surprisingly different tendencies in modern art converge toward this new kind of painting, from expressionism, cubism, and Klee as well as from late impressionism, so that what we have to do with here is an important new phase in the history of painting, not an eccentric phenomenon. In France, Dubuffet embodies the tendency toward "polyphonic" painting to some extent in his larger works; there are also his fellow-painters at the Galerie Drouin; the excellent Uruguayan painter, Joaquín Torres García, is another of its exponents; here in America it is practiced by artists so various in their provenance and capacities as Mark Tobey, Jackson Pollock,

the late Arnold Friedman, Rudolf Ray, Ralph Rosenborg, Janet Sobel. Mordecai Ardon-Bronstein, the Palestinian painter whose work was seen here for the first time last month, works in the same direction in his larger landscapes. And I am sure we shall find still others contributing to this vein in the near future.

To characterize what I mean I have advisedly borrowed the term "polyphonic," from Messrs. Kurt List and René Leibowitz. For the resemblance in aesthetic method between this new category of easel painting and Schönberg's principles of composition is striking. Daniel-Henry Kahnweiler, in his extremely important book on Gris, has already sought to establish a parallel between cubism and twelve-tone music, but what he says in this respect is so general as to be beside the point: he makes it a matter simply of restoring order or "architecture" to arts threatened by formlessness. The correspondence I have in mind is more specific and illuminating. Mondrian's term, "equivalent," is important here. Just as Schönberg makes every element, every voice and note in the composition of equal importance—different but equivalent—so these painters render every element, every part of the canvas equivalent; and they likewise weave the work of art into a tight mesh whose principle of formal unity is contained and recapitulated in each thread, so that we find the essence of the whole work in every one of its parts. (See *Finnegans Wake* and Gertrude Stein for the parallel to this in literature.) But these painters go even beyond Schönberg by making their variations upon equivalence so subtle that at first glance we might see in their pictures, not equivalences, but an hallucinated uniformity.

Uniformity—the notion is antiaesthetic. And yet the pictures of many of the painters named above get away with this uniformity, however meaningless or repellent the uninitiated may find it. This very uniformity, this dissolution of the picture into sheer texture, sheer sensation, into the accumulation of similar units of sensation, seems to answer something deep-seated in contemporary sensibility. It corresponds perhaps to the feeling that all hierarchical distinctions have been exhausted, that no area or order of experience is either intrinsically or relatively superior to any other. It may speak for a monist naturalism that takes all the world for granted and for which there are no longer either first or last things, the only valid distinction

being that between the more and the less immediate. Or maybe it means something else—I cannot tell. What, at least, it does mean for the discipline of painting is that the future of the easel picture as the vehicle of ambitious art has become very problematical; for in using the easel picture as they do—and cannot help doing—these artists are destroying it.

Partisan Review, April 1948; A&C (revised).

86. Review of a Joint Exhibition of Antoine Pevsner and Naum Gabo

Two of the more important artists of our time are now having a joint retrospective show at the Museum of Modern Art. Whatever the final intrinsic value of their art, the Russian-born Antoine Pevsner and his younger brother, Naum Gabo, have already won themselves a focal place in the history of modern art by the new perspectives they have opened up to what used to be sculpture. They were the first to draw some of the most radical conclusions from cubism, not only in three-dimensional media, but also, in a sense, in painting. For their constructions, whose elements are confined exclusively to the curve and straight line, anticipated Mondrian's even narrower canon of forms. Nor does it take away from their achievement as pioneers that, working in sculpture, they were helped in the stride they took so swiftly and so far by the fact that sculpture in our society had by their time already become so much less burdened with tradition than painting, which the glorious accomplishments of a nearer past tended to make more conservative and mindful of precedent. Arduous enough was the task these brothers undertook in breaking with the millennia-old Western tradition of "torso," monolithic sculpture by following out their own deductions from cubism, unaided by the inspiration of barbaric and primitive art that stood Brancusi, Lipchitz, Gonzalez, and Giacometti in such good stead. But they broke away also with a cleanness that took them more quickly to the linear, open-work, pictorial, three-dimensional object in metal, plastic, or wood that is now supplanting the statue.

Pevsner and Gabo, it would appear, began "experimenting" some time between 1914 and 1918, but did not go ahead fast until the early twenties. The earliest work at the Museum of Modern Art is a *Plastic Bust* by Gabo dating from 1916, a fairly representational piece of statuary made up of little plastic flanges uniformly rectangular or semi-circular in shape that reproduce the configurations of a very early cubist painting by Picasso or Braque. The only real originality here is the pictorial, wicker-worklike openness of what is still basically a traditionally conceived piece.

The twenties saw, however, a more or less complete departure from representation and tradition, as the brothers produced works that established an altogether new genre in visual art—the abstract "construction," whose world of forms is closer to that of nature, and whose constituent elements are restricted to the straight line and plotted curve of geometry. Gradually, all traces of representation are eliminated. Yet neither the absence of representation nor the geometrical forms are of the essence of this new genre; for subsequently, works of art that can be called nothing else but constructions have been produced by Giacometti, Gonzalez, Arp, David Smith, and others—which are to some extent representation and incorporate non-geometrical, "organic" forms. What is of the essence is that the construction is no longer a statue, but rather a picture in three-dimensional space, and that the sculptor in the round is liberated from the necessity of observing the habits of gravity and mass, being free now to react to landscapes, panoramas, and architecture instead of to somatic forms alone. Thus sculpture, which in the Western Europe of antiquity and of the Middle Ages was the first to teach painting how to adhere to natural appearances, is now being taught by painting how to take liberties with appearances.

The restriction to geometrical forms has not cramped the art of the brothers Gabo and Pevsner as much as might have been anticipated. The differences of style and temperament between the two are immense. While Gabo confines himself largely to plastics, glass, and stone, his brother prefers metals and conceives on a greater scale—and is, in my opinion, much superior as an artist if not as an innovator. Gabo's objects, small in format and excessively limited by the notion of neatness entailed by the constructive aesthetic, exhaust themselves too often in the point

they make of symmetry; and their lightness, fragility, and transparence tend to be mechanical rather than felt out, the automatic results of an aesthetic code that precipitates itself in repetitious arabesques akin to those of penmanship exercises. These weaknesses, the weaknesses of decoration, are made very evident in some small paintings by Gabo shown here.

Of course, I may be reacting to the shortcomings of Gabo's constructions simply because of the novelty of the idiom. In any case, one must look long at this new art and wait patiently for it to speak before venturing to render judgment. And indeed, several of Gabo's pieces do impress one better as time passes: particularly, the plastic-on-wood *Circular Relief* of 1925; the plastic and alabaster *Construction with Alabaster Carving* of 1938; and the plastic and cork *Construction in a Niche* of 1930. It may be that I liked these pieces especially because of their frontality, their affinity with the easel picture, which makes them easy to see from a single point of view. But I doubt it.

Though radical enough, Pevsner's idiom is less purist than his brother's—his genre is not so much the free-standing object as it is wall sculpture, bas-relief, most of his pieces being designed to hang on a wall and be looked at as a picture is. If Gabo's can be called rococo, Pevsner's far more passionate and ambitious art is Jacobean baroque, evolving in broad curves within a massive, square-set, rather monumental framework. Unlike his brother, Pevsner has developed and changed his style almost radically since the twenties: whereas Gabo has continued to work in terms of the measured cubist restraint and clarity from which both originally started, Pevsner has in the course of time become more emphatically expressive, and he now rolls and turns his sheets of metal into bristling and spiky shapes whose symmetry does not prevent them from achieving a contorted, un-constructivist violence. Unhappily, this violence frequently goes out of control and, except for the *Projection into Space* in tin and oxidized brass on plastic of 1938, nothing in the later work quite matches the perfection of the celluloid-on-zinc *Portrait of Marcel Duchamp* of 1926—no little of whose quality is owed to its cubist color harmony in reddish black, brown, and tan—and the celluloid and metal *Bust* of 1923–24. Already present in these works are Pevsner's great force, his ability to use color, and his unwillingness to content himself with the miniature felicities among

which his brother has dallied. The fulness of Pevsner's force, if also its reluctance to be disciplined, is seen in the tin and brass *Fresco* of 1943–44, which is a masterpiece of *grande envergure*, overpowering in the way it captures its section of the wall and makes it bulge and open toward the spectator. I would also single out for praise the oxydized-tin, silver, ivory, and plastic *Construction* of 1935; the *Construction* in brass, oxydized tin, and baccarat crystal on a plastic base of 1933; the *Construction* in oxydized brass on plastic of 1935; and the *Spiral Construction* of 1944.

Pevsner's art becomes, the longer we gaze, a challenge in its totality—not only in its aesthetic, but also in what it says. The term "heroic" seems very applicable when we see how greatly this artist risks being misunderstood in his passionate and rigorous endeavor to persuade us to change the world so that it will correspond to our true and not our rationalized desires.

The Nation, 17 April 1948

87. Review of an Exhibition of Willem de Kooning

Decidedly, the past year has been a remarkably good one for American art. Now, as if suddenly, we are introduced by Willem de Kooning's first show, at the Egan Gallery, to one of the four or five most important painters in the country, and find it hard to believe that work of such distinction should come to our notice without having given preliminary signs of itself long before. The fact is that de Kooning has been painting almost all his life, but only recently to his own satisfaction. He has saved one the trouble of repeating "promising." Having chosen at last, in his early forties, to show his work, he comes before us in his maturity, in possession of himself, with his means under control, and with enough knowledge of himself and of painting in general to exclude all irrelevancies.

De Kooning is an outright "abstract" painter, and there does not seem to be an identifiable image in any of the ten pictures in his show—all of which, incidentally, were done within the last year. A draftsman of the highest order, in using black, gray, tan, and white preponderantly he manages to exploit to the maxi-

mum his lesser gift as a colorist. For de Kooning black becomes a color—not the indifferent schema of drawing, but a hue with all the resonance, ambiguity, and variability of the prismatic scale. Spread smoothly in heavy somatic shapes on an uncrowded canvas, this black identifies the physical picture plane with an emphasis other painters achieve only by clotted pigment. De Kooning's insistence on a smooth, thin surface is a concomitant of his desire for purity, for an art that makes demands only on the optical imagination.

Just as the cubists and their more important contemporaries renounced a good part of the spectrum in order to push farther the radical renovation of painting that the fauves had begun (and as Manet had similarly excluded the full color shade in the eighteen sixties, when he did his most revolutionary work), so de Kooning, along with Gorky, Gottlieb, Pollock, and several other contemporaries, has refined himself down to black in an effort to change the composition and design of post-cubist painting and introduce more open forms, now that the closed-form canon—the canon of the profiled, circumscribed shape—as established by Matisse, Picasso, Mondrian, and Miró seems less and less able to incorporate contemporary feeling. This canon has not been broken with altogether, but it would seem that the possibility of originality and greatness for the generation of artists now under fifty depends on such a break. By excluding the full range of color—for the essence of the problem does not lie there—and concentrating on black and white and their derivatives, the most ambitious members of this generation hope to solve, or at least clarify, the problems involved. And in any case black and white seem to answer a more advanced phase of sensibility at the moment.

De Kooning, like Gorky, lacks a final incisiveness of composition, which may in his case, too, be the paradoxical result of the very plenitude of his draftsman's gift. Emotion that demands singular, original expression tends to be censored out by a really great facility, for facility has a stubbornness of its own and is loath to abandon easy satisfactions. The indeterminateness or ambiguity that characterizes some of de Kooning's pictures is caused, I believe, by his effort to suppress his facility. There is a deliberate renunciation of will in so far as it makes itself felt as skill, and there is also a refusal to work with ideas that are too

clear. But at the same time this demands a considerable exertion of the will in a different context and a heightening of consciousness so that the artist will know when he is being truly spontaneous and when he is working only mechanically. Of course, the same problem comes up for every painter, but I have never seen it exposed as clearly as in de Kooning's case.

Without the force of Pollock or the sensuousness of Gorky, more enmeshed in contradictions than either, de Kooning has it in him to attain to a more clarified art and to provide more viable solutions to the current problems of painting. As it is, these very contradictions are the source of the largeness and seriousness we recognize in this magnificent first show.

The Nation, 24 April 1948

88. Irrelevance versus Irresponsibility

The most recent questioning of the validity of modern painting in this, its post-cubist stage—as we see such questioning, for instance, in Geoffrey Grigson's article, "Authentic and False in the New 'Romanticism'," in the March *Horizon* and in the remarks quoted indirectly therein from Gide and the late Coomaraswamy—reflects again the fallacies to which any criticism of a non-literary art commits itself when it relies largely on discourse, and when, in addition, the amateur's distance is assumed to be adequate to serious discussion. Once again we hear that by devoting himself to means instead of ends the contemporary advanced artist has reduced himself to a technician, performer, virtuoso, at best a mere exponent of his own sensibility, whose work must lack real "human" import.[1]

Modern art lacks a subject (end), lacks "humanity," etc.— how many cultivated people, literary men in particular, go on complaining this way. Thirty years ago their similars, with an equal incomprehension of the point of modern art, were so excited by the novelty of the phenomenon itself that they were

1. This essay was accompanied by illustrations of two pen and ink drawings, not referred to in the text, by Adolph Gottlieb: *Pictograph* (1948) and *Horned Figure* (1948). [Editor's note]

willing to suspend the traditional demands for subject and form, purpose and treatment, means and ends; whether or not they realized what it was all about, they had a categorical enthusiasm for the "modern" that stilled their qualms. And regardless of the damage this uncritical attitude may have done in some areas, it was on the whole a lucky thing for modern art, for without the busy support of the amateurs of novelty in the teens and twenties it would have had much more difficulty in getting itself accepted. But times have changed again, and modern painting and sculpture have now drifted into one of the most precarious of all positions: that of a familiar phenomenon whose familiarity has not made it any the less baffling, a phenomenon moreover that continues to resist the literary approach. And when one remembers that for the average cultivated person in our society the literary approach is the standard one with respect to all the arts, then the position of modern painting and sculpture is seen to be precarious indeed.

Yet painting and sculpture have always been in a somewhat anomalous position. Whereas the point of music *qua* art is usually unmistakabe enough, in practice if not in theory, that of painting and sculpture is more often than not missed by the very people who sincerely enjoy them. If the relative standings of the artists of the past have been established for the record correctly in the main, the grounds on which this has been done still remain more inaccessible to discourse than those governing the criticism even of music. "*Apprendre à voir*," said the Goncourt brothers, "*est le plus long apprentissage de tous les arts*." Does not even Valéry (in *Choses vues*, a selection from which, translated by William Geoffrey, appears in the spring *Kenyon Review*), complain that the "object of painting is uncertain" and in his further remarks demonstrate how, even in the case of this enthusiast of painting, the literary approach prevented him from fully experiencing this art. And, incidentally, was the literary approach to art in general ever put more succinctly, if unwittingly, than when Valéry writes of music: "I conclude that the real connoisseur in this art is necessarily he to whom it suggests nothing"? As though, when the verb "suggests" takes for its objects the relatively conceptualized images Valéry has in mind, the same does not apply to painting and sculpture.

The French writers of the generation after Valéry who so en-

thusiastically welcomed cubism and its aftermath did so for the most part with a magnificent incomprehension that does not seem to have interfered with their *élan*. But we who write in English lack that uninhibited rhetorical exuberance which permits contemporary Frenchmen to be so irresponsible toward their subject matter whenever it happens to be art—and anyhow we make ourselves ridiculous if we try to imitate it. When we sit down to write about art we apply ourselves with an earnestness that, in the absence of a real familiarity with the medium or of a special interest like iconography, makes us grow querulous in the end. This querulousness is not confined to journalists and the editors of art magazines. A writer as enlightened as Mr. Grigson can feel thwarted enough to reproach modern art for its failure to be affirmative, noble, human, universal, etc. And it is significant that Gide, distinguished among all contemporary French writers by his lack of rhetoric and disdaining the face-saving levity with which most of his colleagues address themselves to art, can utter a similar reproach. Nevertheless, in art irresponsibility is often preferable to irrelevance, and at the moment, Mr. Grigson's or Gide's irrelevance does more harm than, say, Sartre's catalogue blurbs.

"Play-boy of means" is what Mr. Grigson calls the modern artist. "Painters need order; they need subject; which is another way of affirming that they need viable ends." Here in America our familiarity, not to say our obsession, with means teaches us that, though a means may be without an end, it can never be without a result or consequence. And art is essentially a matter of means and results, not of means and ends: for no one has ever been able to point out the ends or purposes of art with the finality any artist would need were he to take Mr. Grigson's advice and go in search of ends. If, however, by ends Mr. Grigson really means content and wants to reproach modern art for lack of it, then he has missed the whole point.

Must one argue this over again? The message of modern art, abstract or not, Matisse's, Picasso's, or Mondrian's, is precisely that means are content. Pigment and its abstract combinations on canvas are as important as delineated forms; matter—colors and the surfaces on which they are placed—is as important as ideas. Human activity embodies its own ends and no longer

makes them transcendental by postponing them to afterlife or old age. All experience is sanctified, all we can know is the best we can know. These may be errors, just as the myths of religion are errors, but they are capable of producing an art just as profound and "human" as that which incorporated the myths of religion.

The inability to perceive "human" content in modern art means ultimately the inability to perceive the point of painting and sculpture in general. Mr. Grigson will allow Auden to say "love" in an oblique way, and not a painter, simply because he can always recognize the word, "love," for what it means, but has trouble deciphering paint. Abstract art is effective on the same basis as all previous art and can convey a content equally important or equally unimportant; there is no difference in principle. On the other hand, it is possible to assert—and the assertion has not been effectively refuted so far—that the great masters of the past achieved their art by virtue of combinations of pigment whose real effectiveness was "abstract," and that their greatness is not owed to the spirituality with which they conceived the things they illustrated so much as it is to the success with which they ennobled raw matter to the point where it could function as art.

Mr. Grigson's call for "viable ends" and common, universal humanity in contemporary painting and sculpture (as if anything worthy of the name of art does not strive necessarily for a maximum of humanity and universality) is echoed in essence if not at all in style by a long article called "Aspects of Two Cultures" appearing in Number 52 of the *VOKS Bulletin*, a cultural magazine published in Moscow in English—among other languages—by the USSR Society for Cultural Relations with Foreign Countries. The author of the article is the magazine's editor, Vladimir Kemenov, whose pen, if not mind, functions in a subcellar of consciousness a Neanderthal man should have shrunk from entering. Mr. Kemenov attacks contemporary "bourgeois" art indiscriminately, sparing neither abstract art nor neo-realism and taking in everything in between (though he is careful never to use the word "academic"). Aside from the unbelievable level of intellectual probity on which it is written, Mr. Kemenov's article is remarkable for its insinuations to the effect that our

country is now the chief promoter of "decadent" art (Dali and Sir Kenneth Clark are called Americans, and it is pointed out that Lipchitz has spent a "long time" in this country).

Mr. Kemenov accuses modern art of trying to convince the working man "that he is no more than a conglomeration of mechanical parts . . . or else a biological creature possessing purely animal instincts and desires." Lipchitz is said to be a "representative of that tendency in modern bourgeois art which utterly perverts the image of man, distorting his body, violating measure and proportion, emphasizing his animal nature." Picasso's art is called "an aesthetic apologetics for capitalism" despite his own "professed sympathy for the struggle of democracy against fascism." The impressionists and Cézanne also get theirs in passing, being accused of one-sided "rationalism."

Mr. Kemenov goes on to say that modern art is pathological, insane, mystical, irrational, escapist, etc. But it is to be noted that throughout the article he, or at least his translator, avoids the term, "degenerate art," perhaps because the Nazis used to apply it so regularly to modern art. This does not, however, prevent him from adding that the latter is a "fantastic mixture of unwholesome fantasy and fraud," "worthless nonsense," "a mixture of pathology and chicanery" tracing its origins to "daubs painted by the donkey's tail." But even our "realistic" art is only "quasi-realistic. . . . Its purpose is to put a veneer on bourgeois reality."

Mr. Kemenov says that the decadence and deterioration of modern bourgeois art (it used to be better in the nineteenth century, he admits, when it was realistic and closer to the people) are such that it is unable to produce good war propaganda; only imported Soviet music, movies, and posters could "spiritually" mobilize people in this country and Britain against Hitler during the war. "As opposed to decadent bourgeois art, divorced from the people, hostile to the interests of the democratic masses, permeated with biological individualism and mysticism, Soviet artists present an art created for the people, inspired by the thoughts, feelings, and achievements of the people, and which in its turn enriches the people with its lofty ideas and noble images." Although Mr. Kemenov does not name a single Soviet painter or sculptor, he also writes: "Young Soviet art has already created works of world-wide significance. . . . Soviet art is ad-

vancing along the true path indicated by the genius of Stalin."
Since it would be hard to say that Mr. Kemenov is irresponsible,
we have to conclude that he, too, is irrelevant.

The truly new horror of our times is not, perhaps, totalitari-
anism as such, but the vulgarity it is able to instill in places of
power—the official vulgarity, the certified vulgarity:

> From low to high doth dissolution climb,
> And sink from high to low. . . .

Partisan Review, May 1948

89. Review of *The History of Impressionism* by John Rewald

This year-by-year history of the impressionist movement in
painting is one of the most useful works of art scholarship ever
published in English. The art critic, the student, and the con-
noisseur cannot be grateful enough for the wealth of fact it
contains and for the chronological vividness with which it is ar-
ranged. Not least among the virtues of the book are its numer-
ous reproductions, which seem to have been chosen with the
special purpose of bringing to our attention works which are not
widely reproduced or seen.

One could ask the author for a little more understanding of
the technical procedures of the painters he writes about, and for
a more concrete description of the way in which impressionism
grew out of and then differentiated itself from the art that pre-
ceded it. But Mr. Rewald is an art historian exclusively, not at
all a critic, and he does not claim to be one. In his introduction
he quotes the French historian, Fustel de Coulanges: "History is
not an art; it is a pure science. It does not consist in telling a
pleasant story or in profound philosophizing. Like all science it
consists in stating the facts, in analyzing them, in drawing them
together, and in bringing out their connections. . . ."

I think that Mr. Rewald could still have done a little more to
bring out the "connections" and been a little less literal in his
view of what constitutes a "fact" in art history. The motive that
influences a painter is no less a fact than the one that influences a

statesman or a social class. Let us hope that in the future Mr. Rewald will expand his notion of his subject matter. Meanwhile we are grateful for what he has given us in this present book. Whatever its omissions, it remains a great feat of scholarship.

The Nation, 8 May 1948

90. Painters' Roundup: Review of Three Portfolios of Illustrations

There has been, lately, a certain improvement in standards of reproduction in American art publishing. This is evidenced by the three portfolios at hand. The color reproductions in *Modern Italian Painters* would do credit to a Viennese or Zurich publisher, and it is a pity that hardly more than three or four of the artists included seem to deserve the lavish technique and care spent on their plates. Aside from Modigliani and the early Chirico, modern Italian painting has indeed little to boast of. With the tentative exceptions of Carrà and Campigli, the others whose works are reproduced in this portfolio—Sironi, Garbari, Guidi, Marussig, de Pisis, Morandi—do little more than timidly repeat pre-cubist French painting.

Twenty-four drawings by Ingres, most of them portraits and all in pencil, are excellently reproduced on coated stock in the portfolio issued by Pantheon. The first drawing dates from 1804, when the artist was 24 years old, and the last from 1857, when he was 77, with still ten years to live. The consensus of critical opinion, with which this writer enthusiastically agrees, holds Ingres's portraits, whether drawn or painted, to be far superior to his "subject" pictures—and, indeed, it is my own feeling that the latter represent an aberration on the master's part, imposed by extra-personal considerations, that had little to do with the real nature of either his talent or his insight. Even the five preliminary sketches in this portfolio for details of subject pictures, as exquisite as they are—and granted they were not intended as finished works—fall far short of the sublime clarity and emphatic precision that characterizes every one of the portraits.

The fact of being confronted with a segment of reality that the artist had only to take in and get down on paper—instead of having to idealize, invent, project, and arrange, as was the case with his anecdotal pictures—seems to have induced a complete and unconscious change of attitude. A portrait gave Ingres occasion to interpret only his own experience; and as long as he, like the eminent painters who followed him in his century, stuck to his own immediate experience he could be great. But when, in his mythological, allegorical, historical, and religious canvases, he summoned up visual ideas with which he himself had never had contact, then this great realist fell into affectation and staginess.

What continues to surprise us in Ingres's drawings is their abstractness. In the earlier drawings this demonstrates itself in flat, ornamental patterns full of arabesques and tight flourishes—patterns that make decorative the clothes and furniture of his sitters but exempt their faces. Later on the abstractness becomes broader, more profound and functional, the page more unified; physiognomy is no longer a special chore requiring the artist to interrupt himself, but becomes one with the page and everything else it shows. But in both early and late drawings the penciled line, by the incisiveness of its application and the justness of its placing with relation to the margins of the paper, flattens out the areas it encloses and gives them a life independent of volume, depth, or figuration. The result is some of the greatest draftsmanship of all time. Let me mention here particularly the portraits of Ingres's second father-in-law and second mother-in-law, both done in 1852 and well reproduced in the present portfolio.

Relatively easy as it may be to publish lithographs, Curt Valentin has nevertheless done a specially commendable job in reproducing those of another great draftsman, Joan Miró—whose art, as it happens, can be seen to better advantage these past few years in black and white than in color. About the quality of the forty lithographs at hand, all untitled, there should be no argument; they are as good as anything done in our period and are a match for the black and white drawings of Picasso, whose art, over the last decade and more, has likewise been consistently stronger in this vein than elsewhere. The lithographs at hand evidence a certain enriching of Miró's style: the page is

more crowded and relies more on textural effects; although calligraphy is still Miró's forte, free-floating masses of black and gray are now ranged against each other independently of shape or line. One is also surprised, in view of the past narrowness of Miró's sensibility, to see how much fresh power and invention he shows; the boldness and certainty with which he plays his variations on the single theme of man, woman, animal and bird; the tenacity with which he refuses to be bored by himself.

Michael Leiris's introduction to this portfolio leaves no doubt as to his understanding of Miró's personality, but plenty as to his understanding of painting. One gets more and more tired of what French writers write on art. They seem to regard the subject as an opportunity for taking their prose out for a holiday.

New York Times Book Review, 9 May 1948

91. Review of Exhibitions of Yasuo Kuniyoshi and Arnold Friedman

The Japanese-born Yasuo Kuniyoshi has over the last three decades been one of the most prominent of the American assimilators of French post-impressionist art, especially that phase of it embodied in the painting of Derain, Segonzac, and Vlaminck. This may turn out, however, to be the sole substance of his claim to be remembered. For Kuniyoshi's retrospective show at the Whitney Museum revealed him as a much weaker artist than one had expected—one, certainly, not in the class of such other notable assimilators as Hartley, Maurer, and even Max Weber.

It is true that Kuniyoshi never struck one as an independent force, but it was assumed that he had real personal and painterly qualities and a sure command of his craft. It is exactly in these respects that the present show undeceives us; what we see instead is the pretension to these virtues, the vivid semblance but not the genuine reality of paint quality, sensibility, lyricism. Again and again Kuniyoshi makes mistakes no painter with a true control of his craft could make so often. Muddiness, as the result of the crowding of tones or their insensitive juxtaposition just at the points where the design is most concentrated, ruins

otherwise well-fashioned canvases: thus, for example, the *Accordion and Horse* of 1938, the *Room 110* of 1944, the *Abandoned Treasures* of 1945–46, and the *Headless Horse* of 1945. It is hard to understand how a painter who seems to realize, as Kuniyoshi does, the advantages and disadvantages of working in earth colors can let himself be so sloppy in his handling of dark and light values, which are the all-important consideration in such a style. In many of his still lifes and figure pieces, where a form or a group of forms is dramatically centered against an empty, and usually well-painted, background, the tones clot and become dull and blank exactly inside those forms—and almost nowhere else. It would appear that a lack of genuine assurance, a distrust of his own sensibility, compels the artist to tighten up and press too hard precisely where the success of the picture hangs in the balance.

While it may be that this show was not as well chosen as it could have been, such mistakes and hesitations are too frequent not to be integral to his art. Here, one feels entitled to say, is the price an artist pays who, for all his gifts, lacks enterprise and courage. The very urgency of his own talent frightens Kuniyoshi and, in order to fend off that urgency and stay within the proved public success of his manner, he must freeze up. Kuniyoshi is a success; he is considered one of our most eminent artists; he has received a Whitney show in his own lifetime; he has won a lot of prizes. But because he has played it so safe, because he has denied his own spontaneity, he fails—and fails mechanically—even on his own terms.

Kuniyoshi hardly matters to serious painting in America. Even the nice pictures in this show hardly matter. And there are some nice ones, particularly the *Bouquet and Stove* of 1929 and the *Milk Train* of 1940. And the *Wild Horses* of 1921, the *Flowers in Black Vase* of 1925, the *Picketing a Horse* of 1937, and the *End of Juanita* of 1942 are also nice. But, except perhaps for *Bouquet and Stove*, they are all only nice pictures.

Lloyd Goodrich of the Whitney's staff has written a clear and informative text for the catalogue of the show. I think, however, that he overrates Kuniyoshi's academically facile drawings in relation to his paintings. Facility is not, despite their derivative and ready-made manner, the vice the paintings succumb to.

If the reader is interested in seeing American painting, of ap-

proximately the same "period" as Kuniyoshi's, that matters, I would advise him to visit the late Arnold Friedman's memorial show at the Marquié Gallery. Friedman was a belated impressionist whose absolute sincerity and matter-of-fact courage enabled him to extract a few last important variations from that tradition. These variations matter not only to contemporary American painting but to contemporary painting in general.

The Nation, 15 May 1948

92. Review of Exhibitions of Le Corbusier and Robert Motherwell

The past that rose before us in the exhibition of Le Corbusier's paintings at Rosenberg's was unexpectedly cute: that is, the cubist twenties in the hands of such a lesser light as this seemed naive and sophisticated all in one. And we were not reminded so much of Cocteau, of:

> Muses qui ne songez à plaire ou à déplaire,
> Je sens que vous partez sans même dire adieu.

as of e. e. cummings's:

> what's become of (if you please)
> all the glory that or which was Greece
> all the granja
> that was dada?

The grandeur of cubism is absent from these pictures, but something of its quality remains and a good deal of the spirit of its times. And it remains that Le Corbusier was more than a little competent as a painter, even if his color is brittle and his application of cubism as a unifying style shaky.

Léger taught him to play with the shading of cylindrical volumes and to nail still-life objects to the canvas like heraldic emblems, and he also lent him his brassy color—but color is a department in which Le Corbusier is successful only when, as in some of the earliest pictures shown here (1922–24), he restricts himself to grayish and pinkish whites, grays and diluted earth

colors. This quasi-absence of color was *purisme*, the style and dogma he and Ozenfant developed in the early twenties out of cubism, Léger, and an infatuation with the impersonal, machined objectivity of the industrial product.

Le Corbusier's still lifes are overcrowded and describe too much, but they are not—if the distinction is permitted—overloaded; we are rarely assured of the integrity of the picture plane or of the unity of the design, but a certain unity of feeling does supervene. Under and above the staccato color and the cluttered composition comes a harmony, that of cubist style, which even in the imperfect grasp of this artist was still vital enough at this point in its history to press home its demand for clarity.

As the decade wore along, Le Corbusier's art seems to have gained in ampleness and force. In 1927 we get such a strong picture as the *Syphon et Gants*, and in 1928 the *Deux Bouteilles et Livre*. Far from complete in integration and as lacking as they are in the architectural unity for which they strive, pictures like these demonstrate the continuing energy of the style of their period and swell that stock of good minor painting upon which our eyes will still want to feed for the sake of a delectation that is somehow unobtainable from the impervious works of the greatest masters.

Robert Motherwell's current show at Kootz's is another big step forward on his part and, coming after his last year's show, makes his inclusion among our more important contemporary painters obligatory. Large and middle-sized canvases built on figure motifs and showing flat, uninterrupted expanses of ochreous color realize a monumentality such as is rare in the art of the moment. This painting is founded on roughly geometrical simplifications and the organization of large elementary shapes with heavy but smooth surfaces. It is late cubist in its repertory of form. At the same time it exhibits a personal "handwriting" and can by no means be classified as "intellectual" or altogether studied—though studiousness is a vice from which Motherwell is not entirely free.

The most surprising advance in the show is seen in the collages, one of them, *Elegy*, being the first really successful one by Motherwell that I have seen; and another, *Gray Woman*, just missing fire because of the confusion of dark tones in its upper part. The others, however, still suffer from the weaknesses the

artist has betrayed in this medium in the past: archness, efforts to carry out ideas for which the emotion was lacking to begin with or failed en route.

Motherwell's oils are, once more, a different story. The large *Painter*, whose architectural simplicity conceals toil and care, seems to me the best canvas in the show and attests again to how well this painter works in large format. The smaller *Young Girl*, *The Homely Protestant*, and the *Brown Figure* are other well-rounded and successful canvases. *Man*, a turbid and vehemently brushed picture unlike anything of Motherwell's I have seen before, almost comes off, but not quite; here the inspiration fails in the lower portion, which dissolves into chaos. It if had succeeded, the picture would have been magnificent and perhaps would have opened a new avenue of development for a painter whose persistent and somewhat disingenuous efforts to attain spontaneity have usually collapsed hitherto in the aforesaid archness—an archness like that of the interior decorator who stakes everything on a happy placing to the neglect of everything else. At this stage of his development Motherwell's gifts should put him above such tricks.

The Nation, 29 May 1948

93. Reply to George L. K. Morris

As far as I can tell, Mr. Morris's [1] main complaint is about my taste, and all the rest is *his* taste, about which I myself complain in turn. If I saw eye to eye with Mr. Morris, I do not think he would mind so much that I hand out marks to the class instead of writing appreciative blurbs as they do in France (does he really want that kind of kibitzing?). In arguing differences of taste it is almost impossible to say more than *tu quoque*, and I am given

1. George L. K. Morris, writing in the same issue of *Partisan Review* as this reply by Greenberg, attacked Greenberg as a critic of contemporary art. His article began: "Why is it that America, despite considerable creative vigor and an unusual curiosity about painting, has never produced a reputable art critic?" It may be remarked that Morris, in addition to being an artist, was himself a critic. [Editor's note]

scant opportunity for even that, since Mr. Morris does not mention any of the American artists he—I assume—feels I neglected in my *Horizon* piece,[2] and I am insufficiently acquainted with the Paris painters he lists (though on the basis of the little I have seen of Hartung, Domela, Magnelli, and Lapicque, I would hazard that most of his swans are rather feeble geese).

Nevertheless, Mr. Morris's attack is serious, well written, and sincere, and I must do him the courtesy of answering him, especially since his lecture on the differences between cubism and abstract art embodies a fallacy that may mislead the unwary.

Matisse passed "out of the tournament in love sets around 1917." I feel that anyone with a real "instinct for pictorial structure" would have been unable to write that. This is what happens when literal a priori dogmas about the historically necessary are consulted instead of the pleasure and exaltation to be experienced from painting. Historical necessity does operate, but not with the consistency here expected of it. Matisse's *Woman before an Aquarium* of 1924 and *Lemons on a Pewter Plate* of 1927 (both to be seen at the Philadelphia Museum of Art's recent large retrospective show of Matisse's paintings, drawings, and sculpture)—are painted in a style whose elements were formed by 1907; yet who with a real sensitivity to painting could say they are intrinsically inferior as art to the much more historically important pictures Mondrian and Picasso were turning out around the same time?

"It would have been rewarding if Greenberg had indicated *in what ways* the works of [Picasso, Braque, Arp] . . . have declined since the thirties." Let me be brief, Picasso: insensitive and disruptive color, arbitrary space-handling, literary distortions that lack plastic justification, forced emotion, bombast, attempts (which seem motivated only by a kind of despair) to demonstrate his prowess in all departments of painting (the nerviness shown here is histrionic and old-fashioned). Braque: a growing aimlessness (at least until 1939), repetitiousness and flaccidity of design, virtuosic color, lack of real matter. Arp: chronic poverty of means and ideas (see his monotonous and

2. "The Present Prospects of American Painting and Sculpture," *Horizon*, October 1947. Morris described the article as a "truly disgraceful report." [Editor's note]

243

empty sculpture of the thirties). The trouble with all three artists is that they no longer keep on re-creating the styles they work in: they simply work inside them—something that Matisse even at his most perfunctory does not do, though he does, I will admit, tend to relax his ambition dangerously. All this is not to say that Picasso and Braque still do not produce very good pictures from time to time; it is to say, however, that the general level of their performances has declined below that of Matisse's.

But aesthetic judgments cannot be probatively demonstrated in words, and I beg to be excused from the rest of this futile chore.

The difference between cubism and abstract art is another matter, one of description rather than judgment, and I find Mr. Morris's description superficial in its failure to make distinctions within cubism itself. "Even in the flattest cubist paintings, the image . . . is 'behind the frame'." It was of the essence of cubism after its initial stage to situate the image or rather the pictorial complex, *ambiguously*, leaving the eye to doubt whether it came forward or receded. But the ambiguity itself was weighted, and its inherent, irrevocable (and historical) tendency was to drive the picture plane forward so that it became identical with the physical surface of the canvas itself. This tendency makes itself very evident in Picasso's and Braque's first collages in 1911. By 1913, when Picasso painted his *Card Player* (in the Museum of Modern Art), the "image" had come flush with the frame, where it remained, with a few exceptions, during the rest of classical cubism's life. As a matter of fact, in such a collage as Picasso's oval *Still Life* of 1912 (in the Arensberg Collection) the emphasis with which the central forms are thrust toward the spectator is such that only bas-relief could exceed it. It is rash enough to say that most of Picasso's and Braque's cubist paintings of 1911 and 1912 stay inside the illusion of the third dimension, but it would be downright absurd to say that of all but a few of their cubist pictures in the years immediately after 1913, no matter how well they look in Louis XV frames. As for chiaroscuro—in the later stages of cubism its "symbols" (shading, modeling, dark-markings) are used for the sake of abstract structure and decoration and are so divorced from their native function of depicting volume and depth that it makes no difference whatsoever whether a recognizable object is involved or not.

It belongs to the importance of cubism, to that which makes

244

it the most epochal school of painting since the Renaissance, that it conclusively liquidated the illusion of the third dimension. It did not have to wait for Malevich or Mondrian to do that. Pre-figuring the furthest extremes of abstract art in our time, Picasso as a cubist already contained everything that abstract art has since made obvious. Far from revolting against cubism and its supposed behind-the-frameness, abstract art, in so far as it is successful (and this includes that particularly flat and simplified painting to which Mr. Morris reserves the appellation of abstract art), takes from cubism its cue, inspiration, and total sense of the medium. The main reason why the Kandinsky or "non-objective" school is so lacking in quality is because it is the one section of abstract art that has in fact revolted against cubism and, abandoning the cubist conception of the integrity of the physical picture plane, retreated to a disguised academicism. (Not that there is not something faintly academic about the way in which the abstract art Mr. Morris upholds stays rigidly inside the state of mind of classical cubism. And not that the French painters, aside from Dubuffet, whom I listed originally, and who cling more closely to cubism's canon of forms than do Mr. Morris's friends, are not even more academic. But that, precisely, was one of the implicit points of my article.)

To return in closing to the Matisse-Picasso controversy, I should like to make it clear that I do not consider Matisse as important an innovator as Picasso, but I do think him a better and much more sustained painter. The Philadelphia show, as uneven as it was, made that clear, I believe. (I am told that the Philadelphia Museum was unable to obtain for its show many of the French master's most important works, particularly for the period since 1920.)

P.S. Mr. Morris did have a right to complain, perhaps, about my failure to make sufficiently clear the sense in which I used the term cubism as the name of a tradition. I should have distinguished more explicitly between classical cubism as a specific style and cubism as a tradition. Nevertheless, I believe that in the eyes of the future their differences will seem much less pronounced even than they do now.

Partisan Review, June 1948

The rise of Bonnard's reputation during the last two decades is one of the most spectacular phenomena of the "modern" art market. The evidence represented by the current full-dress show at the Museum of Modern Art justifies this rise and attests to the good judgment of the dealers, collectors, and critics responsible for it. Yet one wonders why, at least in this country and England, Vuillard, whose painting has so much in common with Bonnard's, should still remain more or less overlooked. Whatever the failings of his old age, Vuillard was a master too.

The problem offered by the Bonnard exhibition concerns Vuillard—and Boucher and Fragonard as well. On the evidence presented here Bonnard is almost a major painter, but not quite. Sensuousness, paint quality, color, and an original approach to composition are all present; also taste and erudition. But some final intensity is missing. Bonnard paints more suavely and generously than Matisse or Picasso, but he does not establish the bold, lucid, incandescent structures by which those two masters fix us to the spot, touch new feelings, and expand our consciousness of the possibilities of art. It is all too easy to dispose of the problem by referring to Bonnard's *intimisme*, his motifs, the domestic minutiae, the comforts and discreet pleasures of sedentary bourgeois life; by saying that he is a lesser painter because his aspirations were less "heroic." There is truth in all this, but it does not explain enough. After all, Matisse was something of an *intimiste* too.

The question why an artist who painted as consummately as Bonnard should have failed quite to attain major quality is perhaps best to be explained by a certain aspect of French tradition. France knew for a time other painters of magnificent gifts who seem likewise to have failed to get the most out of themselves. I think of Boucher, Fragonard, and even Greuze. These painters succeeded, they were not *manqués* like Andrea del Sarto or Murillo; they added something, and their handling of paint remains a marvel forever. But one still asks why, given their powers, they did not do more. I believe the answer lies outside the artists themselves. Boucher and Fragonard were reassured and confirmed in their desire to please by the relatively high standards of a cultivated audience that knew and was very much

interested in painting. Any but the most idiosyncratic and visionary painter would have rested content with its approbation. Do we not see how even Chardin, who in the same period painted for a somewhat different audience, less corrupt but also less cultivated, accepted certain restraints that prevented him from taking that place among the greatest painters to which he was entitled by his genius? The case has been similar, I feel, for Bonnard. He too was unable to escape his audience.

There are, of course, great differences. Bonnard did not lack ambition, and he was a perfectionist within his limits; during the last half of his life he strove for a large, monumental kind of decorative painting that involved him in risks and failures. But unlike Matisse, who is cold, undistracted, and full of arrogant purpose, he never managed altogether to transcend the taste of the milieu that sold and bought his work, a milieu that as a whole stood aside from the development of modern art after 1910 and refused to assign itself any more important purpose than the refinement of its daily life. These bourgeois aesthetes knew painting better than anyone else did, and unlike their predecessors in the eighteenth century they did not ask it to satisfy illegitimate demands. Whereas Boucher and Fragonard anthropomorphized the inanimate and rendered it like living flesh to make their pictures even more erotic, Bonnard could render the animate as though it were inanimate, as though it were nothing more than paint on canvas; and his audience was satisfied to have it that way. (Still, it is significant that his nudes, pleasure objects among other pleasure objects, are more erotic somehow than Renoir's.)

But much as Bonnard's audience delighted in the purely culinary pleasures of painting, it did not want him to provide more than was asked for. And it was their taste for decoration and their antipathy for the divergent that Bonnard never outgrew. He experimented within the limits set for him, but he did not try very hard to break through them.

The pictures at the Museum of Modern Art seduce and warm us with their luxury, the paradoxical ease and measure of their shallow and airless depths; but the show does not contain what I would call a supreme masterpiece, nothing that sums itself up and conveys itself so densely and self-evidently as, say, Matisse's *Goldfish* of 1915–16, or one of Picasso's best cubist paintings, or

a good Mondrian. These form the standard by which I find that Bonnard falls slightly short.

But only slightly. There are some superb pictures, and there may be even better ones that are not present; or at least pictures that reveal sides of Bonnard's art which go unrepresented in the present exhibition (a middle-sized, vertical green landscape in the Phillips Memorial Gallery in Washington, rather unlike anything at the Museum of Modern Art, shows Bonnard handling color in shallow depth with a crispness, compactness, and felicity that only Matisse has rivaled). Still, there is enough to feed one's eyes on. Some of Bonnard's still lifes are among the best things ever done in the genre: the *Grapes* of 1928, the *Checkered Tablecloth* of 1936. And again I am sure that pictures equal to these, if not better, have been left out of this show—which, as I have already intimated, could have been better selected.

Bonnard's limp, deliberately "accidental" composition is responsible for some of his best effects, but sometimes it is a way of avoiding the effort, risks, and study involved in the pursuit of intensity. The blues in the *Abduction of Europa* of 1919 build up to an astounding and large magnificence, which is reinforced by what seems the inadvertent simplicity of the composition; yet one can almost see the artist hesitating over the pale creams and pinks in the foreground and refraining from accenting them for fear of losing spontaneity by pushing the problem to the point where it would be necessary to study more carefully the contours that the pale shapes cut against the blues. And in the *Corner of a Table* of 1935 the artist seems to accept the too wide red band made by the table or tablecloth for fear, again, of losing the quality of inadvertence; yet it is obvious to anyone that the excessive size of the band spoils what is otherwise a beautifully painted still life.

The Nation, 12 June 1948

95. The Necessity of the Old Masters

It is assumed that modern literature, whatever its novelties, remains continuous with the past. It is also assumed that anyone

who presumes to write poetry or fiction is not insensible to the virtues of the poetry or fiction of the past, even though he himself may—and should—want to do something different. We would doubt seriously the competence of any poet writing in English who felt that Shakespeare, Spenser, Milton, and Wordsworth were of no concern to him; and if that poet did prove himself competent we would find it a paradox.

The situation, in this country at least, does not seem to be the same in painting. Many young and more or less advanced painters—competent ones—appear to have been left indifferent by the pictures from the Kaiser Friedrich Museum that were shown in Washington and New York recently (and which are to be shown in other American cities through the summer and early fall). Some did not even go to the trouble of seeing them. And also, I know people who, though revealing judgment of a high order when it comes to any painting done since Matisse and Picasso, are insensitive to the merits of even the impressionists.

The explanation of this is not as difficult as it might seem. Since impressionism, painting in western Europe and America has been engaged in unraveling its own tradition and in the process it has been able at moments to accept traditions of art other than those of the West. Literature, being tied to language, cannot maneuver that freely. Language is the product of a certain people, place, and past, and remains bound to that past. The writer who would use his language well is forced to acquire a sense of what has already been done with it. After all, language is *usage*. Painting is not—or not to the same degree. Since it has freed itself from the necessity of representation, painting seems at liberty to reject all but the most recent past; it feels that it has made a new start and created a new instrument for itself.

I myself believe this is an illusion and that the advanced painter cannot withdraw his attention from the past with impunity. Cézanne to the contrary notwithstanding, the moderns are not the primitives of a new tradition, but the liquidators of an old one. Abstract art is still western European art; one still—even if only barely—paints easel pictures; one does not decorate Haida cloths or make sand drawings. An artist working in New York or Paris still cannot introduce Oriental, archaic, or barbaric elements into his work without modifying them radically to fit the terms of easel painting as established by a tradition that goes back to the end of the Middle ages and is not yet dead. The

greater the artist's awareness of those terms, the greater is his power of self-criticism, even if he paints like Mondrian—who was himself by no means indifferent to the old masters. And it is the failure of self-criticism, a failure deriving in part from the inverted historical provincialism of the "modern," that accounts for some of the most serious shortcomings of contemporary advanced American art as a whole.

Whereas in the past we were provincial in our attitude toward the art of other civilizations or cultures, today our best young talent runs the danger of becoming provincial toward the past art of our civilization. Modern art has not in actual practice repudiated that past art as much as many of us think. It is still necessary to be very much aware of it, if only to overcome it. And in so far as we still paint easel pictures to hang on walls, we still have more in common with that past, down at bottom, than with the art of Africa or the South Seas.

The exhibition of the Berlin pictures—which, before fifty-two paintings on wood and metal were subtracted from the lot to be returned to Germany, had the highest frequency of good items I have ever seen in so large a group—demonstrates this indispensability of the past with a certain timeliness. Beginning with the Italian primitives and stopping with Watteau and Tiepolo (except for a magnificent Daumier and a fairly good Manet, both from the Nationalgalerie in Berlin), it affords a succinct and pure impression of the essential character of the Western tradition in painting. We see a world whose depth, resonance, and plenitude are the product of illusion—of perspective, chiaroscuro, underpainting, glazes, scumbles, etc. The single picture is a projection of all reality and makes itself felt as something heavy and full-bodied and inward. These qualities modern painting has sacrificed to intensity. Whereas the Renaissance picture draws you into a statement of a complex of relations between various areas of experience, the post-cubist picture thrusts a sheet of pigment at you with an immediate force proper only to the realm of material sensations.

Modern art, like modern literature and modern life, has lost much. In some directions it has more than compensated for the loss, developing its own complexity and its own—far more subjective—inwardness. But as one brought up on the past (like everyone else), I cannot help regretting what has been lost.

The regret is futile, yet I believe that this nostalgia for the past, responsible though it has been for academicism, has also been a vital ingredient of the greatest advanced art of our times. The artist immune to it has that much less to struggle with, but he is also so much the poorer for his immunity. A certain dosage of nostalgia, a certain twinge of academicism, the very struggle against it seems to me to have been indispensable to both Matisse's and Picasso's greatness and to have contributed to the superior largeness of their art (and I do not mean here Picasso's excursions into Ingres and the antique, but something far subtler and more intimately involved with his temperament). Not that the work of the modern artist must by any means resemble the past; but that he must show some sense of it, a realization of its presence and attraction. Otherwise he dissipates himself in sheer quality and fails to impose that order and shaping which are the indispensable concomitants of high art, and without which the truly cultivated spectator is left thirsty. High art resumes everything that precedes it, otherwise it is less than high.

Among the fifty-two Berlin pictures returned to Germany were some of the strongest of the entire group: particularly Rubens's *Perseus Frees Andromeda*, Bosch's *St. John on Patmos*, Botticelli's *Madonna and Child with Singing Angels*, Dürer's *Portrait of a Young Woman*, Jan van Eyck's *Giovanni Arnolfini*, Gossart's (Mabuse) *Christ in the Garden of Gethsemane*, Holbein's *George Gisze*, Lippo Lippi's *Madonna Adoring the Christ Child*, Simon Marmion's two altar panels, and Antonio Pollaiuolo's *David with the Head of Goliath*.

But enough still remains—or remained at least to be shown at the Metropolitan in New York. I would draw attention especially to Altdorfer's (an ancestor of Klee's painting) *Nativity*, Messina's portrait, the unknown fifteenth-century Austrian master's *Dead Christ*, Giovanni Bellini's *Resurrection* (as poorly unified as this picture is), Bouts's *Madonna in Adoration*, Bronzino's *Portrait of a Young Man*, Castagno's *Assumption of the Virgin*, Cossa's *Harvest Allegory*, Cranach's *Frau Reuss*, Elsheimer's *Noah's Thank Offering* and his landscape, Geertgen Tot Sint Jans's amazingly green *John the Baptist in the Wilderness*, Giorgione's portrait, Giovanni di Paolo's three small panels, Guardi's *Balloon Ascension*, Patinir's *Rest on the Flight to Egypt*, Rembrandt's *Man with*

Golden Helmet and his landscape, Koninck's and Ruysdael's and Rubens's landscapes, Sassetta's St. Francis episode, Ter Borch's *Concert*, Tintoretto's *Man with Long White Beard*, Titian's *Self-Portrait*, Velásquez's portrait, Vermeer's *Pearl Necklace*, all three Watteaus, van der Weyden's two portraits, and Konrad Witz's remarkably delicate yet firm *Crucifixion*.

There are, in addition, some fifty or sixty other very successful pictures present—and I say successful advisedly, for the old masters can be as uneven as the modern ones. In view of the notoriously bad taste usually shown by museum officials in the field of modern art, one is amazed to see how largely right the specialists attached to the Army were in deciding which pictures of the Berlin collections deserved most to be saved from the Russians. Perhaps it was because they were guided by tradition.

While I am on the subject let me advise those still interested in the old masters to pay a visit to the Philadelphia Museum, something I myself had the opportunity to do for the first time only recently—and symptomatically enough, in connection with the Matisse exhibition there. The Johnson, Wilstach, and other collections make the Philadelphia Museum's painting section superior in quality to that of the Metropolitan, and in some respects, particularly the Flemish primitives, it can more than hold its own with the National Gallery in Washington.

Partisan Review, July 1948; *Der Monat*, October 1948 (slightly changed and titled "*Berliner Kunstschätze in den USA*").

96. Valéry, the Littérateur in Essence: Review of *Reflections of the World Today* by Paul Valéry

Paul Valéry was a superb poet, but he was not the "man of mind" he aspired, and his admirers took him, to be. His approach to all things was that of a littérateur, determined by the traditional categories of French rationalism.

The essays and lectures in the present book, with some further material that has been eliminated from the English translation as of too local an interest, appeared in France in their final

form in 1945 shortly before the author's death. The earliest item
dates from 1895 and the book includes, presumably, everything
Valéry thought worth preserving of what he had written on his-
tory, politics and contemporary problems—not his strongest
fields. All in all, the volume is disappointing.

The method—and although Valéry seems conscious at times
of its limitations, he remains imprisoned in them—is that
of the psychological generalization. The world is frozen into
constant types of behavior; everything is made as abstract as pos-
sible; specific circumstances, names, dates, places are tran-
scended. History is reflected in a mind that feels itself above, or
is unconscious of the pressures that produce it, and therefore the
causes of everything men do can be rationalized into such simple
motives as selfishness, stupidity, mimicry and so forth. Valéry
does, it is true, formally acknowledge the importance of other
material factors, but he cannot *think* in terms of them. The hab-
its of French culture weigh too heavily upon him, and all he can
do is psychologize—and moralize.

Much of what Valéry has to say about contemporary events
exhausts itself in banality—sententious, wordy, rarefied banal-
ity. In the preface to a book on Salazar by A. Ferro he writes:
". . . the idea of dictatorship takes shape as soon as the action or
passiveness of those in power appears to the mind inconceivable
and incompatible with the exercise of its reason." Along with
this goes a certain provincialism. In 1931 Valéry discovers with
excitement something that had been a commonplace of Marxist
journalism of thirty years—namely, that the nations had ex-
plored and seized the entire habitable globe, so that there was
now no longer room for either expansion or isolation (except
by violence).

Anyone who in the twentieth century protects his mind as
carefully as Valéry did from Marx has small intellectual right to
express his views on politics in public. Not that one has to be a
Marxist, but that some sense of the role of social forces, of
classes, is indispensable to anyone who wishes to say something
new about politics and that in order to acquire this sense one
must acquaint oneself with Marx—just as it is assumed that the
person who wishes to study philosophy seriously must acquaint
himself with Kant.

Valéry's remarks on the role of Paris in French and European

history and his criticism of the historians for neglecting techniques and habits are another story. But his confirmed inability to carry an idea very far lets these and other flashes of insight sputter out much too soon. We perceive that Valéry is at his best when impressionistic and that he is not as adapt at close analysis or as intellectually athletic as he pretends to be. It is the effort to live up to this pretention that makes his prose so wordy and so empty at times—in this book and elsewhere—and stimulates him to go on endlessly explicating notions that have been common property since he was born. He was not an intellect, he was a sensibility; he was not a philosopher, he was a poet; it is too bad he could not reconcile himself to the difference.

New York Times Book Review, 4 July 1948

97. The State of American Writing, 1948: A Symposium

It seems to me that the most pervasive event in American letters over the last ten years is the stabilization of the avant-garde, accompanied by its growing acceptance by official and commercial culture.[1] It has modified that culture to a limited extent and has in return been granted a recognition and place that do not dissatisfy it. The avant-garde has been professionalized, so to speak, organized into a field for careers; it is no longer the adventure beyond ratified norms, the refusal in the name of truth and excellence to abide by the categories of worldly success and failure. The avant-garde writer *gets ahead* now, and inside established channels: he obtains university or publishing or magazine jobs, finds it relatively easy to be published himself, is asked to lecture, participate in round tables, etc., writes introductions to the classics, and can even win the status of a public figure.

There is nothing inherently wrong in all this (after all, who

1. The editors of *Partisan Review* asked contributors to the symposium to respond to seven questions, one of which was, "What, in your opinion, are the new literary tendencies or figures, if any, that have emerged in the forties?" Other contributors were John Berryman, R. P. Blackmur, Robert Gorham Davis, Leslie A. Fiedler, John Crowe Ransom, Wallace Stevens, Lionel Trilling and H. L. Mencken. [Editor's note]

is best fitted to write introductions to the classics? and why shouldn't serious writers be rewarded with material security?), but so far this accommodation has produced liabilities that outweigh the assets. Whether these liabilities are inevitably connected with social accommodation here and now, I cannot say. The relation of cause and effect is very involved. But it is a fact that there has been a certain regimentation of the avant-garde, a standardization of its attitudes, which—whether the attitude be Henry Miller's or John Crowe Ransom's—threatens to impose a new academicism on us.

Academic because predictable. It has become possible lately to pigeon-hole and predict almost everybody. There is the literary quarterly critic with his "method"; there is the full-time poet; there is the all-around "creative man" or aesthete (interested in the movies, painting, poetry, old almanacs, architecture, etc.); there is the ex- or disabused Marxist (in which category I put myself); there is the "orgast"; there is the neo-saint (socialist, anarchist, or otherwise) with his moral exhibitionism; there is the Hemingway or Western "intellectual"; there is the Kafkan pseudo-philosopher and pseudo-poet; there is the survivor of the Left Bank; there is the man who listens for the latest word from Paris—and so on. Each classification has its sages, managers, and impresarios. Naturally, the lines of separation are not sharply drawn (without simplifying the situation it would be impossible to describe it) and there is considerable overlapping. Yet everybody knows more or less where he belongs, and lines himself up and acts accordingly. What matters is where you wish to place yourself in the struggle for reputation, not what you burn to say.

The avant-garde has been allowed to freeze itself into such a standardized repertory of attitudes because of the absence of new challenges to itself within the field of experience. On the one side it is faced with political crisis, on the other with the increasing aggressiveness and the expansion of middlebrow culture. Both together work to stop the progress of bourgeois culture as a whole toward new experience—one by making its vanguard timid, and the other by forcing it to wait upon backwardness and cultural demagoguery.

Literary rediscovery has always been a part of avant-garde activity, which insists traditionally on making revaluation a

constant and permanent process. That revivals now figure so prominently in publishing only shows the extent to which avant-garde practices have been taken over by official culture. One could say that revivals really began when Stendhal predicted his own discovery (not rediscovery). But didn't Dryden rediscover Chaucer? I feel, however, that the modern precedent was set by the Germans when they rediscovered Hölderlin and Kleist around the turn of the century.

It would appear true that the poetry of the past has a diminishing audience; Spenser, Milton, Wordsworth do not seem to be read by anywhere near as large a proportion of the cultivated public as they used to be. But the popularity of contemporary poetry increases steadily and increases phenomenally, and the successful poet still dominates the literary and academic scene, even if he is not read by as many people as the novelist is. It strikes me as risky to say that poetry has had "an ever diminishing audience" in recent years.

The criticism that concentrates itself on the close analysis of poetry is by and large an American phenomenon and a concomitant, among other things, of the store we set by techniques and of our concern with the statement of procedures. This criticism has illuminated much but it has also darkened much, shutting out both air and light. The detailed analysis of works of art is as much needed as anything in the field of criticism, but we distrust the tendency to make it the only permissible kind of criticism—as we also distrust critics who seem so incapable of independent and fresh insights into the ways in which their subject matter is related to the rest of human activity. Here we feel the breath of provincialism, not to say academicism.

Of course literature would benefit from an equally close examination of prose fiction. But the latter presents much greater difficulties to the analysis of form. The poem can be viewed—and only too often is—as a congeries of details that the critic can attack seriatim, but even the most obtuse of the "new" critics would hesitate to analyze a novel that way. Especially since we have not yet even established satisfactorily what form is in fiction. (Form being just as indispensable to the success of the novel as it is to that of other kinds of art, how then do the novels of supposedly clumsy writers such as Balzac, Dickens, or Dostoyevsky solve the problem of form—for, given their suc-

cess in the reading, we must grant that they do solve that problem?) What, I believe, has made the answer to this question so difficult is the fact that we are still subject, like Flaubert and James, to the illusion that the precepts Aristotle derived for the drama from Aeschylus and Sophocles, and which are exemplified in French classical dramaturgy, govern all literary forms. But economy and unity of action in the narrative are something other than what they are in the drama. It must have been the unconscious realization of this difference—and the inability at the same time to determine exactly what it was—that led Proust and Joyce to borrow, as if in desperation, so many of their "structural" principles from music. And even then they did not escape from drama, for what they borrowed from most was the Wagnerian opera, that *Gesamtkunstwerk*, that work of "total art."

As a person the writer ought indeed to involve himself in the struggle against Stalinism to the "point of commitment." Why should we ask less of him than of any other adult interested in the survival of the common decencies and authentic culture? However, he is under no moral—or aesthetic—obligation whatsoever to involve himself in this struggle as a writer. That he is interested in the struggle as a person does not mean that he is necessarily interested in it *qua* writer. *Qua* writer he is only interested necessarily in what he can write about successfully. I do not mean, however, that the writer does not invest his whole personality in his writing. What I do mean is that his whole personality may not be invested in his interest in the struggle against Stalinism, or, for that matter, in any sort of politics.

It must be obvious to anyone that the volume and social weight of middlebrow culture, borne along as it has been by the great recent increase of the American middle class, have multiplied at least tenfold in the past three decades. This culture presents a more serious threat to the genuine article than the old-time pulp, dime-novel, Tin Pan Alley, *Schund* variety ever has or will. Unlike the latter, which has its social limits clearly marked out for it, middlebrow culture attacks distinctions as such and insinuates itself everywhere, devaluating the precious, infecting the healthy, corrupting the honest, and stultifying the wise. Insidiousness is of its essence, and in recent years its avenues of penetration have become infinitely more difficult to de-

tect and block. In this matter it is necessary for each of us to suspect, and correct, himself. For we are all of us becoming guilty in one way or another. We wouldn't dream of being Edgar Rice Burroughs but anyone of us could all too easily become the equivalent of John Marquand or William Saroyan. Respectable people here and abroad have taken both of the latter for important American writers, a mistake not made so far in the case of Burroughs. (The situation is no better in painting and music.)

Partisan Review, August 1948

98. Review of a Special Issue of *Verve* on Picasso

It is my impression that Picasso is essentially a pastoral, lyric artist, and that the role of epic or tragic master to which he has aspired in the last decade and more, is not a truly congenial one. Support of this impression now comes in the latest double number of *Verve*, which reproduces paintings and drawings done by Picasso in Antibes, in the south of France, during 1946 and 1947, and which also contains short bits of text by the artist himself and his friend, Jaime Sabartès.

Explicitly, literally pastoral and alluding to classical antiquity—their motifs, being fauns, pipes, goats, kids, nymphlike females, and centaurs—these latest works show a certain recovery of effectiveness on Picasso's part. This recovery does not bring him back to the level of 1909–1927, but does take him much beyond the forced and aborted statements of the war years, almost reaching the level of the pen-and-ink drawings of 1938.

To judge from the reproductions in this sumptuous magazine, he has now renounced the brutal demands he once made on color—demands his talent seems forever incapable of satisfying—and has resigned himself to those transparent tints of green, blue, pink, violet, and Naples yellow (reminiscent of his academic Ingresque paintings of the twenties) whose lambency accommodates itself so wel to his subtle draftsmanship. Such color may acknowledge Picasso's weakness as a total orchestrator of paint on the order of the Venetians, Velásquez, Rubens, or Cézanne, but it permits us to see, once more, that he is incon-

testably one of the greatest designers in space and line of all time and all culture.

The fact that many of these cheerfully bucolic oils and drawings are undated and unsigned—for the first time in twenty years—may indicate a change in Picasso's attitude toward himself. It is as if he had stopped, at least for the moment, watching himself in relation to the history of art, had stopped forcing himself to paint for the age and its historians, and had come once more to paint simply for the sake of his joy in it. It is possible that Picasso now has a gentle and elegiac phase in store such as other great artists before him have known in their old age. It may be that he will be able to sum up the pathos of the second quarter of the twentieth century in a way not unworthy of that in which he stated the optimism of its first quarter.

New York Times Book Review, 8 August 1948

99. Review of the Exhibition *Collage*

The reception given by the general run of art reviewers to one of the most important as well as most beautiful shows of modern art ever held in this country—the collage exhibition at the Museum of Modern Art—amounts to a scandal. Like most of the scandals involving modern art, it has passed largely unnoticed so far, which must be attributed to our art public's low state of enlightenment. Here was, in fact, the most concentrated group of masterpieces seen in New York since the paintings from the Berlin museums departed—I mean, specifically, the best collages of Picasso, Braque, Hans Arp, and Kurt Schwitters—and yet all the art journalists of the dailies and weeklies could say was that collage was "dated," that it was a "fad," a "stunt," a "short cut" taken by lazy painters. And no one has risen up to protest.

The collage medium has played a pivotal role in twentieth-century painting and sculpture, and it is the most succinct and direct single clue to the aesthetic of genuinely modern art. Once able to appreciate collage, or *papiers collés*, as practiced by the cubist masters, one is in the position to understand what painting has been about since Manet first laid his shapes in flat. When

Braque, around 1912, glued a piece of imitation wood-grain paper to the surface of a painted canvas, he did not do so for the sake of more varied texture, or of greater expressiveness, or for shock value. As far as I know, Braque has never publicly stated the motive that impelled him to this unexampled step, but it was definitely an integral part of the organic logic of cubism— and at the same time answered something profound in the spirit of the age. For collage was promptly taken up by people outside the cubist movement and applied to a wide variety of uses, many of them popular and few of them with any real relation to the aesthetic of cubism. Yet it is only as part of this aesthetic that collage reveals its true meaning.

Cubism brought about the destruction of the illusionist means and effects that had characterized Western painting since the fifteenth century. The fictive depths of the picture were drained, and its action was brought forward and identified with the immediate, physical surface of the canvas, board, or paper. By pasting a piece of newspaper lettering to the canvas one called attention to the physical reality of the work of art and made that reality the same as the art. The large newspaper type arrested the spectator's eye and prevented it from passing behind the physical surface of the picture into space created by illusion. Painting was no longer a matter of fictive projection or description, and the picture became indissolubly one with the pigment, the texture, and the flat surface that constituted it as an object.

The use of actual elements extraneous to paint pigment was preceded, in both Braque's and Picasso's case, by a short period in which they got a somewhat weaker depth-destroying effect by painting large letters in *trompe-l'oeil* imitation of newspaper type in the foregrounds of their cubist pictures. Once, however, they had begun to use pieces of real newspaper and then "facsimile" wood-grain, labels, swatches of cloth, sand, ashes, and so forth, the next step in the denial of illusion was to lift the extraneous elements above the surface of the picture and secure the effects of depths and volume by bringing this or that part of the picture physically close to the eye, as in bas-relief. In this case three-dimensionality was no longer an effect or illusion but literal reality itself, as in sculpture. By 1912 Picasso was venturing into a kind of bas-relief construction in works that laid the foundation of constructivism, and indeed of all radically modern sculp-

ture since Brancusi and Lipchitz. The picture had now attained to the full and declared three-dimensionality we automatically attribute to the notion, "object," and painting was being transformed, in the course of a strictly coherent process with a logic all its own, into a new kind of sculpture. Thus we see that without collage there would have been no Pevsner, Gonzalez, or Giacometti, no Calder or David Smith.

But the extraneous element, the piece of newspaper or the liquor-bottle label, was not always designed to stop the eye at the surface. It was sometimes used to manipulate or control planes in the picture that were already given as illusions. When one object in a still life was represented in front of another, a piece of opaque textured paper pasted to the representation of the more distant object served to bring it forward, to make the picture generally shallower if not completely flat, and give the artist a fixed point beyond which he could not deepen his illusion of three-dimensional space or volume. At the same time a pleasing ambiguity was created as to which was felt as closest to the eye—the object in front or the real piece of paper pasted to the representation of the object in back.

However, because it generally fixed the eye at the physical surface, collage as employed by the cubists always emphasized the identity of the picture as a flat and more or less abstract pattern rather than as a representation; and it is as a flat pattern that the cubist *papier collé* makes itself primarily felt and enjoyed. (Juan Gris, great cubist master that he was, failed quite to grasp this principle, and that is why three of his four collages in the museum's show are somewhat confused and turgid, however happy they may be in individual details. Until 1916 Gris always hesitated about putting the identity, the gist, of his picture into the surface pattern, instead of the representation, and the resulting ambiguity was usually too uncontrolled to be effective— that is, except in the case of the *Breakfast* of 1914, which succeeds because Gris leaves us in no doubt that the identity of this picture lies in the depiction in conventional depth of a table with a still life on it. Approaching it as a standard cubist collage composition like Picasso's and Braque's, with one's eyes focused primarily on the flat surface pattern, one finds the picture disorganized and congested, but when one shifts focus and views it as a conventional picture it springs instantly into perfection.

Nevertheless, the picture could have been done just as well in paint, for the artist fails entirely to exploit the potentialities exclusive to collage, one of the most important of which is the opacity of textured paper. Gris's *papiers* are transparent and admit light like paint.)

Collage contributed greatly to the geometrical simplification of shapes that cubism undertook after 1912 and anticipated the transition to its "synthetic" phase. Some part in this may have been played by the mechanical difficulties of cutting out complicated forms with scissors, which led perhaps to a preference for large elementary shapes. Here, if ever, the cubists surrendered to the resistance of the medium. Yet in doing so they remained entirely consistent with themselves, for the central premise of painting since Manet, and a great source of its virtues, has been its progressive surrender to, its increasing acknowledgement of, the physical nature of the medium, whether it is oil, water color, charcoal, or pasted papers.

The show at the Museum of Modern Art, splendidly chosen and mounted, offers us the completest survey we have had of the development and elaboration of the collage medium, showing us its abuses as well as its uses. The dadaists and surrealists—except for Arp and Schwitters—saw in it only a means of achieving strange and surprising effects by juxtaposing incongruous images. The result was not works of art—even in Miró's case—but montages, truly stunts: rectangles littered with small pictures connected by no aesthetic necessity, rectangles that do not delight the eye and whose value is wholly exhausted in literary shock effects that have by now become unspeakably stale. Many examples of this staleness are included in the museum's show for the sake, I assume, of their documentary and historical interest.

This exhibition makes it very clear that Picasso and Braque are the great masters of collage proper, followed at a distance by Arp and Schwitters. It also would seem to show that the greatest success in collage so far has been gained through compositions based on a preponderance of rectangular forms whose contours are kept roughly parallel to the edges of the canvas—in other words, repeat the canvas's shape. And this exhibition finally makes it clear, too, that Picasso extracted a much greater variety of effect from the medium and used it with more power than did Braque, while yet fully matching the French painter's purity and

elegance. At this point in his career, and his oils of the same period bear me out, Picasso was the most magnificent artist of the twentieth century.

The Nation, 27 November 1948

100. Review of *Aesthetics and History in the Visual Arts* by Bernard Berenson

Bernard Berenson is one of the greatest, if not the very greatest, of living connoisseurs of Italian Renaissance art, with an erudition and competence that extend far beyond that field. Although he has been handing his verdicts down for almost sixty years now, this book is his first attempt at a coherent explanation of the means by which he arrives at them. Here he talks about art as "life enhancing," about "tactile values" and "movement," defines illustration as opposed to decoration, and so forth, and then goes on to discuss the relation between art history and history in general. Mr. Berenson admits readily that he is no adept of systematic thought. In the words of his own introduction, his book is "a pell mell of stray thoughts, desultory thinking aloud, generalizations, reminiscences, confessions . . . the cross section, as it were, of a mind that for half a century has been dwelling upon art problems of many kinds, not only historical but aesthetical."

But this disarming admission does not make his book any the easier to read. It does not help to resolve or freshen the contradictions and platitudes that sow its first hundred and fifty pages. Nor does Mr. Berenson's tone itself help—his assertiveness, his no-nonsense, over-relaxed and at the same time sententious nineteenth-century man of letters manner, which makes the reader feel that he himself has improved very little since Carlyle and Ruskin first began to scold and Emerson to cajole him.

It goes with such a tone that the writer should have a radical and peevish miscomprehension of the art of his own age. (Whenever will a critic arise able to keep up with the art produced beyond his thirty-fifth year?) Mr. Berenson thinks that modern painting is an affair of chaotic composition and geometrical

forms, which latter, he holds, have always been a symptom of decadence in art. And he writes that cubism, as well as futurism, dadaism and surrealism, are "characterized by jeering at or bluffing over the third dimension and ignoring space relations."

This is, in part, a shrewd observation. But in lumping cubism with surrealism and futurism, and charging it with "ignoring space relations," Mr. Berenson betrays what is fundamentally a high-handed philistinism toward contemporary art.

Yet to judge Mr. Berenson from his attitude toward modern art or his prowess as a thinker would be a great mistake. It remains that within his proper field of competence he owns one of the finest sensibilities ever applied to the systematic study of art—regardless of how unsuccessful he has been as a systematizer. True, it is a sensibility that Italy, become a museum and necropolis, has formed, and which sees all art as culminating in figure compositions and expressive anatomy, and which depreciates color. But Mr. Berenson is quite conscious of his position: "The writer bases his notions, prejudices and discontents on the arts derived from the Greek and always with a turn to the plastic, a preference for the linear, a search for the contour, just as his inspiration flows from pure Hellenism and his words reach toward it."

Obviously, he is proud of his bias, which is a very respectable one. But, fortunately, it is more professed than felt, and when we come to the latter and best part of his book, where he lets his taste roam at large over the art of the past, we notice a catholicity of appreciation that largely belies the profession. There are many things with which I would disagree and because of which I would still accuse the writer of narrowness. But I am compelled always to acknowledge the richness of experience, the authority and the cogency of the sensibility here at work.

Whatever his shortcomings as a writer and thinker, Mr. Berenson has succeeded to a great extent in his endeavor to "make of himself an instrument of precision in the appreciation of works of art." Where he operates as this instrument, where he stops trying to establish his position by answering abstract questions and constructing formulations; where he contents himself instead with throwing off appreciations, locating and defining specific problems—there he explains himself best. And there also he makes his most valuable point, at least as far as

this present book of his is concerned, namely, that the prime consideration of the student of art is not knowledge of his subject so much as experience of it. One wishes that the general run of art writers would take this point more to heart.

New York Times Book Review, 28 November 1948

101. Review of the Whitney Annual

The oils section of this year's Whitney Annual has relapsed into its old mediocrity. Apparently the sudden improvement it showed last year is to remain an isolated phenomenon. And now one wonders more than ever what accounted for the improvement. The present exhibition is, if anything, a bit inferior to those of the three or four preceding last year's, and here again one wonders why. However, what does become plain is that the people who chose the artists and pictures for this year's show were guided by no notion whatsoever of what constitutes valid contemporary painting. I would conclude that reputation or familiarity was the decisive factor in the choice of most of the exhibitors, and the fifteen or twenty new names that do appear are in their majority worse than the old. I feel sure that the Whitney defends its policy, in its annuals and other shows, by claiming the obligation to cover the field of "modern" American painting as a whole and to avoid sectarian emphases. Yet this is no excuse for incompetence of judgment. The museum could have put together a far better show and still have adhered to the same policy. What I complain about is the lack of taste, discrimination, enterprise, discernment—the lack, that is, of ability on the part of the museum's staff to support the responsibility that has fallen to it. Contemporary American painting is by no means as bad as they make it seem to be. All this, aside from the fact that it can be claimed that the obligation to be fair to American painting by concentrating on its most aesthetically valuable aspects overrides the obligation to cover the field statistically.

At the very best the Whitney annuals can be taken as documents of changing trends that are important as signs of the times, if not as art. The most marked and, at first glance, the

most surprising trend which this year's Annual reveals is that toward a neutralized, easy-to-accept abstract art, an ingratiating, pseudo-advanced kind of painting whose color and, to a lesser degree, design are kept academic enough to attract and charm people who do not otherwise take to non-representational art. An artist who has lately jumped into prominence in this new field is Theodoros Stamos, and a place of honor in the first room at the Whitney is given to his sickeningly sweet, inept, and utterly empty painting, *Altar*. Stamos, as it happens, has borrowed most of his style from the lower registers of William Baziotes, a serious and vastly superior artist.

This trend toward an "attractive" abstract art is reinforced by an even more surprising and significant one, this on the part of artists who gained established and prize-winning reputations in the past by staying very close to Cézanne, Beckmann, or the Renaissance and have now suddenly—all within the past year, it seems—gone over into abstract painting in order to prove themselves. Among these new converts are Philip Guston, John Heliker, William Palmer, Rico Lebrun, and Martin Friedman, old stand-bys of "safe" modern art whom the Whitney will invite to its annuals no matter what they do. It is their presence that has increased the proportion of abstract work at the Whitney; and this, ironically enough, is what accounts probably for the exclusion this year of such infinitely stronger artists as Pollock, Motherwell, and Richard Pousette-Dart—for fear no doubt of giving abstract painting a representation larger than that statistically due it. Yet all Guston, Heliker, *et al.* have changed in reality is the superficial aspect of their design, which they borrow in academically modern form from artists like Klee and Léger. Over this they lay color that in its glazed transparency and traditional organization according to darks and lights reminds us of everything painting got used to between Bellini and Delacroix. That the picture looks abstract does not matter so much as the fact that it does not feel any the less academic for that; it has only become, like Rouault, the latest in modern art for those who do not like the latest in modern art.

Guston and Heliker in particular have enough talent to make the formula very effective; they at least—which is more than can be said for Stamos—have always known how to put a picture together. In his *Tormentors*, the painting that greets you as you enter the museum, Guston has put together an abstract picture

so felicitously, and covered up a diversity of influences so skil-
fully, that you are puzzled at not being more moved by it. You
recognize it immediately as academically modern and as saying
nothing new; yet you cannot find a flaw in it. Time, you are sure,
will strip the canvas down to its fundamentally empty facility,
but meanwhile you have to wait. Obviously, Guston will have as
much success as an "advanced" painter as he had when he was
turning out diluted Beckmanns. What, however, is important
in his case and that of the others is not the aesthetic result but
the cultural significance of the felt necessity to prove oneself in
the field of the abstract. It is hard to resist the pressure of the
age, despite worldly success, and especially if you have some real
talent to start with, as most of these expert neophytes have.
Whatever resistance abstract art may meet with from the larger
public, it presents a challenge whose seriousness even these
painters cannot conceal from themselves.

John Marin—to go from the topical to the sublime—is
again represented at the Whitney by a first-class picture, one of
the few in the show. Marin's oils have of late been outdistancing
his reputation, great as that is. But Willem de Kooning's small
whitish and yellow *Mail Box* is the best thing present—and it is
not de Kooning at his strongest either. Among the few other
canvases of any merit to be seen are Charles Seliger's *Earth Crust*
and Ben Shahn's *Allegory*—and this latter picture is sympto-
matic of another recent tendency in evidence at the Whitney;
the easel painting offered as an emblem rather than as, strictly
speaking, a picture. I would also say that Adolph Gottlieb,
Bradley Walker Tomlin, Joseph Hirsch, and Reginald Marsh are
represented by works that rise above the level of their neighbors
on the Whitney's wall—and in the case of the last two I am just
as surprised as anyone else. It only indicates how low the general
level of the present exhibition is.

The presence of the late Arshile Gorky, one of the two or three
genuinely important artists the Whitney showed enough dis-
cernment to invite to its annuals year after year, is greatly missed.
Last year his magnificent *Calendars* practically blotted out the
rest of the show; and, as I have already implied, the competition
was much stiffer then. American art cannot afford Gorky's death,
and it is doubly unfortunate that it came at a time when he was
beginning effectively to realize the fulness of his gifts, giving
promise of a production whose quality would surpass anything

he had done so far. Gorky had already, at the age of forty-five, made himself one of the few, very few, artists qualified to represent American art to the world.

The Nation, 11 December 1948

102. Review of an Exhibition of John Marin

John Marin has the reputation, earned in the course of forty years, of being the greatest living American painter. He is certainly one of the best artists who ever handled a brush in this country. And if it is not beyond all doubt that he is the best painter alive in America at this moment, he assuredly has to be taken into consideration when we ask who is.

At the root of the trouble in answering this and other questions like it lie the kind of art and the kind of personality involved in the highest flights of American art and literature in this century. Who is our greatest poet? If we leave T. S. Eliot to one side as a confirmed Englishman by now, is it Wallace Stevens or Marianne Moore? Aren't both of them too minor really to be great? When we ask who is the greatest we mean "great." And our best poets, painters, and sculptors, not to mention composers, never seem quite to attain that monumentality in single works, or that breadth and completeness in their *oeuvres*, which would justify the appellation. No matter how intense or exquisite their productions, there is something too narrow or partial or one-sided or peripheral about them. "Great" art and literature seem to connote something more—longer-winded or deeper or wider or more complete.

It is hard to think of Marin as a "great" painter—recall only what painting has been done in our time in France and even Germany. How marginal his achievement must appear by comparison. His art does not say enough and what it says is not said with largeness; his shortcomings remain too prominent and are not inclosed and swallowed up by the magnitude of the gift that involves them, that magnitude which—as Balzac, I think, said—sweeps a great artist's faults before it and renders them, so to speak, essential.

And yet—what a good painter Marin is. Just as, when all is said and done, Wallace Stevens and Marianne Moore remain miraculous poets, Marin has taken cubism, married it to fauvist color and a bit of Winslow Homer, and of this made a personal instrument which has been surpassed on the score of sensitivity only by that of Klee among modern painters—an instrument that registers sensations or emotions of an evanescence which has escaped contemporary art elsewhere. And in saying this I am well aware of what such artists as Morris Graves and Mark Tobey have done in more or less the same areas of experience.

Marin came of age as an artist in the decade—between 1910 and 1920—in which Stevens and Moore became poets; and underneath the art-and-America mystique, the art evangelism and rhetoric that, issuing from Alfred Stieglitz's lungs, blew open Marin's bud as it did Marsden Hartley's, there has persisted a rather thin but pungent lyrical current similar to that on which Stevens and Moore have nourished their verse. Confined within limits set by the circumstances of American culture rather than by his native talent, Marin's art has developed and refined itself with originality. This development has not always been even; Marin is not yet rid of the artiness that he, like the rest of Stieglitz's protégés, contracted from that impresario; but he seems to me today to be a stronger painter than he ever was. As we can see at the Whitney annuals, there is still very little in American art that can hold the wall next to him.

Marin's original fame rests on his water colors, and he still handles the lighter medium with more sureness than he does oil. But in the last ten years or more he has turned increasingly toward oil, with results that are already superior to his water colors in terms of substance and scale, however much they retain of water-color technique. In time to come it is possible that his oil paintings will support his fame more securely than anything else. At least his latest exhibition of oils and water colors, at An American Place, would indicate this.

The water colors are as exquisite as ever; the more conventional naturalism that they show this year has not diminished their quality. Those slashes of abstract line by which Marin tries to put architecture into what is really an impressionist perception of atmospheric color are often arbitrary, and a "straight" view of nature from his hand is usually just as organized and

adventurous as anything in his more abstract vein. Of the water colors in the present show I should like to call attention particularly to those done in Maine, and especially the *Sunset Series*.

But the oils are stronger, ampler, more temperamental, and this is not altogether because their medium is heavier; there was a time when Marin's canvases seemed thinner than his papers. The evidence here is that of a greater mastery. The artist still lays his oil pigments on with a good deal of the purity and thinness of water color and, again like a water colorist, uses the bare canvas as another color. But the oil picture has a much more emphatic presence, and Marin's emotion is bodied forth more variously, broadly, and palpably. Moreover, there is none of either the prettiness or the garishness that sometimes afflicts his water colors. In this respect at least he seems to have won greater control over his color precisely because of the greater opacity of oil. But not always a surer sense of design. One notices that Marin paints to best effect when his motif in nature presents a large, distinctly organized form, like a sailing ship for example, or a definitely organized variation of forms, like the alternation of land and sea or even of a group of figures. Then the pure, abstract color by which he is so well able to define the contours of atmosphere fuses with the design. But when this definiteness or distinctness of motif is absent, or when the artist disregards it and throws himself too much upon abstract projections of design, then color wars with design and the picture falls into confusion.

There are, however, some very good canvases in the present show: *Sea in Red—Version No. 2*, *Sea and Figures in Umber and Red—Version No. 1*, and especially *Version No. 2*; also *Sea with Boat in Grays, Greens, and Reds* and *Lake Narraguadis*. There are perhaps other successful pictures, but their idiosyncratic frames, designed by the artist himself and charming enough as objects in themselves, prevent one from getting a sufficiently clear impression of the paintings. In addition, they are hung so close together that they interfere with one another. But these obstacles to enjoyment should not prevent the experienced observer from recognizing what a fine oil painter Marin has become. One looks forward to his annual shows with more and more eagerness every year.

The Nation, 25 December 1948; A&C (substantially changed).

1949

103. The Role of Nature in Modern Painting

"And where there is no concern for reality how can you limit and unite plastic liberties."—Juan Gris in a letter to Daniel-Henry Kahnweiler, quoted in the latter's *Juan Gris: His Life and Work* (translated by Douglas Cooper).

"The difference between expressionism and cubism is that of the painter's object."—Daniel-Henry Kahnweiler, *Ibid.*

One of the important problems of contemporary art criticism is to ascertain how cubism—that purest and most unified of all art styles since Tiepolo and Watteau—arrived at its characteristic form of purity and unity. We know how much French painting of the forty-five years previous to cubism had contributed by its effort towards a more immediate and franker realization of painting as a physical medium, with the new recognition this entailed of the two-dimensionality of the picture plane and of painting's right to be independent of illusion. But this recognition was shared in the twentieth century by the nabis, the fauves, and the French and German expressionists as well as the cubists. The latter, however, established a larger and much more viable style than did the other schools, a style within which at least four artists have produced masterpieces that reach any of the summits of past art, and a style, moreover, to which contemporary visual sensibility refers for its most authoritative standard. And so we ask what it was that enabled cubism to win this supremacy. We remember that Matisse painted his strongest pictures, between 1910 and 1920, while under its influence. And it was cubism's influence that made the difference between promise and realization in Klee's case. Whereas Kandinsky, an artist of genius, never achieved anything even at his best that can stand up to the productions of Picasso, Braque, Gris, and Léger in their prime, precisely because of his failure to make a real contact with cubism.

The decisive difference between cubism and the other movements appears to lie in its relation to nature. The paradox of French painting between Courbet and Cézanne is that, while in effect departing further and further from illusionism, it was driven in its most important manifestations by the conscious desire to give an account of nature that would be more accurate or faithful *in context* than any before. The context was the medium, whose claims—the limitations imposed by the flat surface, the canvas's shape, and the nature of the pigments—had to be accommodated to those of nature. The previous century of painting had erred in not granting the claims of the medium sufficiently and Cézanne, in particular, proposed to remedy this while at the same time giving an even more essentially accurate transcription of nature's appearance. As it turned out, the movement that began with Cézanne eventually culminated in abstract art, which permitted the claims of the medium to override those of nature almost entirely. Yet before that happened, nature did succeed in stamping itself so indelibly on modern painting that its stamp has remained even in an art as abstract as Mondrian's. What was stamped was not the appearance of nature, however, but its logic.

Cubism, which effected the break with the appearance of nature, set itself originally to the task of establishing on a flat surface the completest possible conceptual image of the structure of objects or volumes. While the impressionists had been interested in the purely visual sensations with which nature presented them at the given moment, the cubists were mainly occupied with the generalized forms and relations of the surfaces of volumes, describing and analyzing them in a simplified way that omitted the color and the "accidental" attributes of the objects that served them as models. Taking their cue from Cézanne, they sought for the decisive structure of things that lay permanently under the accidents of momentary appearance, and to do this they were willing to violate the norms of appearance by showing an object from more than one point of view on the same picture plane. But in the end they did not find a completer way of describing the structure of objects on a flat surface— blueprints and engineer's drawings could do that more adequately and had already withdrawn the task from the province of art. Instead, the cubists found the structure of the picture. They

had never forgotten that; in fact, it was their main purpose, and their quest for a better way of transcribing the relations of volumes had been conceived of not as a scientific project but as a quest, ultimately, for a means of creating more firmly organized pictures; this, they had thought, required a truer, completer imitation of nature.

But Picasso and Braque discovered that it was not the essential description of the visible relations of volumes in nature or the more emphatic rendition of their three-dimensionality that could guarantee the organization of a pictorial work of art. On the contrary, to do these things actually disrupted that organization. By dint of their efforts to discover pictorially the structure of objects, of bodies, in nature, Picasso and Braque had come—almost abruptly, it would seem—to a new realization of, and new respect for, the nature of the picture plane itself as a material object; and they came to the further realization that only by transposing the internal logic by which objects are organized in nature could aesthetic form be given to the irreducible flatness which defined the picture plane in its inviolable quality as a material object. This flatness became the final, all-powerful premise of the art of painting, and the experience of nature could be transposed into it only by analogy, not by imitative reproduction.[1] Thus the painter abandoned his interest in the concrete appearance, for example, of a glass and tried instead to approximate by analogy the way in which nature had married the straight contours that defined the glass vertically to the curved ones that defined it laterally. Nature no longer offered appearances to imitate, but principles to parallel.

The Renaissance painter, too, had learned to organize his picture from nature. But for him it was the logic of appearance that mattered rather than the logic of somatic structure. He ordered his illusions by analogy with the Renaissance view of the world as a free space in which separate forms move. The cubists, viewing the world as a continuum, a dense somatic entity (as was dictated by their age), had to strive to organize the picture—

1. The process by which cubism, in pushing naturalism to its ultimate limits and over-emphasizing modeling—which is perhaps the most important means of naturalism in painting—arrived at the antithesis of naturalism, flat abstract art, might be considered a case of "dialectical conversion." [Author's note]

itself an object—by analogy with the single object abstracted from surrounding space and by analogy with the space relations between the different parts of one and the same object. Pictorial space became more cohesive and cramped, not only in depth, but also in relation to the edges of the canvas. (One can, for that matter, already notice in Manet how much more crowded the picture begins to be toward its edges. Think, by contrast, of the immense space in which Rembrandt's figures swim.)

The positivist aesthetic of the twentieth century, which refuses the individual art the right to refer explicitly to anything beyond its own realm of sensations, was driving the cubist painter toward the flat, non-illusionist picture in any case, but it is doubtful whether he would have been able to make such superlative art of it as he did without the guidance of nature. Forced to invent an aesthetic logic *ex nihilo* (which never happens in art anyway), without reference to the logic by which bodies are organized in actual space, the cubists would never have arrived at that sense of the totality, integrity, economy, and indivisibility of the pictorial work of art—an object in its turn too—which governs genuine cubist style. By drawing an analogy with the way in which an object's form and identity possess every grain of the substance of which it is composed, the cubists were able to give their main problem, that of the unity of the flat picture plane, a strict and durable solution.

As the poem, play, or novel depends for its final principle of form on the prevailing conception of the essential structure that integrates an event or cluster of events in actuality, so the form of a picture depends always on a similar conception of the structure that integrates visual experience "in nature." The spontaneous integrity and completeness of the event or thing seen guides the artist in forming the invented event or object that is the work of art. This seems to me to be always true, but it is particularly important to point it out in the case of cubism since cubism has evolved into abstract art, and abstract art seems—but only seems—to conceal its relation to nature.

Picasso, Braque, Gris, Léger, Klee are never able to dispense with the object in nature as a starting point, no matter how far they may go at times toward the abstract. Without the support of nature, Picasso and Braque would not have had the means of organizing their beautiful collages, utterly remote from the

models as they seem, into the intense unities which they are. The integrity, the self-subsistent harmonious fact of mandolin, bottle, or wineglass called up an echo that was largely unrecognizable no doubt, but which became as valid, because of its form, within the order of art as the original perception of the mandolin or bottle was within the order of practical experience.

Other, later masters have been able to do without the object as a starting point. But I feel that outright abstract painting, including Mondrian's, when it is successful, establishes its aesthetic right in the same way, ultimately, as did the masterpieces of cubism—by referring to the integrity of objects in nature. Mondrian's pictures certainly do. It is not because they are abstract that the works of the later Kandinsky and his followers fail to achieve coherence and substantiality, remaining for the most part mere pieces of arbitrary decoration; it is because they lack a sense of style, a feeling for the unity of the picture as an object; that is, they lack almost all reference to the structure of nature. The best modern painting, though it is mostly abstract painting, remains naturalistic in its core, despite all appearances to the contrary. It refers to the structure of the given world both outside and inside human beings. The artist who, like the nabis, the later Kandinsky, and so many of the disciples of the Bauhaus, tries to refer to anything else walks in a void.

Partisan Review, January 1949; A&C (substantially changed).

104. Review of an Exhibition of Gustave Courbet

Bosch, Brueghel, and Courbet are unique in that they are great artists who express what may be called a petty bourgeois attitude. The attitude is different in each case, according to the times, but all three painters agree in criticizing city life from the point of view of the village and in making their criticism on moral grounds. Bosch imagines hell "futuristically" in the form of a megalopolis whose architecture consists of machinery, while he puts paradise out in the fields. Brueghel follows him but exchanges his master's religious revivalism for a fatalism that is combined with a new interest in material reality. Courbet, the

disciple of Proudhon, attacks state institutions in the name of the naked truth, which he sees as *material*, and is the first artist to treat the human form as but one among other objects in nature.

However, Courbet, like his predecessors perhaps, did not let his dissidence isolate him from his age. He put his century into his art so completely that he practically forced his successor, Manet, to turn toward the future before he was quite ready. Who knows but that without Courbet the impressionist movement would have begun a decade or so later than it did—aside from the fact that he himself sowed some of the seeds of that movement? He was a very great artist.

What his painting renders is the nineteenth century's appetite for mass, force, and quantity in their most tangible aspects. At this distance we begin almost to admire the outrightness with which the Victorians indulged their taste for these things. It is upon this that Courbet's quality as a painter depends. Ingres and Delacroix also expressed their age, but their taste was too cultivated to permit them to surrender to it so frankly. It was by his very vulgarity that Courbet was able to attain to a completeness of statement in certain directions that redeemed the vulgarity in part. He might have been a greater artist could he have transcended his age, but some of the enjoyment we get from his art arises precisely from the fact that he did not, that his art is at rest within itself, and lacks many of those tensions we feel elsewhere in the great art of the nineteenth century. Courbet agrees with himself and his time in a way that reminds us of Rubens, Velásquez—of the general climate of art before the French Revolution.

He painted with body color, using very little medium and pressing masses of pigment to the canvas with his palette knife; he emphasized the corporeality of the picture itself as well as that of nature. Especially in his seascapes he indulged himself in pure, frank color such as only Constable before him had dared use, and he relied less than was traditional on chiaroscuro and uniformity of tone as unifying means. One might think that his desire to convey the solidity of nature, and the emphatic modeling this required, would have induced a strong illusion of three-dimensional form, but his simultaneous desire to make the picture itself solid and palpable worked against this in a subtle

way. True, we get a vivid impression of mass and volume from Courbet's art; yet he seems to have wanted to render the palpability of substance and texture even more. Thus in his landscapes and marines he tends to suppress atmospheric recession in order to bring the background forward so that he can make evident the texture—even if it is only the color texture—of cliffs, mountains, water, or sky. The resulting effect sometimes approaches bas-relief, just as in his figure pieces, but his marines also arrive at a clarity of color and a sudden flatness that anticipate the impressionists. We see once again that by driving a tendency to its farthest extreme—in this case the illusion of the third dimension—one finds oneself abruptly going in the opposite direction. Most of the impressionists began painting under the influence of Courbet; yet the art they created dissolves all solidity and undermines the very principle of illusion in painting by returning to two-dimensional optical sensations. Cézanne, in recapitulating Courbet's effort to seize the substantial reality of nature, ended by painting such relatively flat pictures as the Philadelphia Museum's *Mont Sainte-Victoire* in which the seeds of cubism were planted.

Courbet was the first notable French artist since Chardin to become interested in the seventeenth-century Dutch painters, and he was certainly the first to feel the influence of the Spanish. This last is not only clear in the large early compositions which brought him his first fame; it persists later in the broad and simplified modeling that makes for the paradoxical bas-relief effect, if not flatness, of so much of his work. However, it was mostly the Dutch landscapists who furnished an example in the best productions of his later years, which are those astoundingly luminous marines that must have helped awaken the impressionists to the power of unmixed color.

This French master was paradoxical in many ways. He liked size, he used paint in great quantities, and he did big pictures at first; yet in the end it turns out that most of his canvases are only about the same size as the impressionists'—rarely over three and a half feet on any side. He was famous for the rapidity and broadness of his execution, and the coarseness that would appear to be a result of this spoils half his work; yet where he triumphs, later on, it is not by boldness so much as by sensitivity. Once

he had left the great declamatory pictures of his youth behind him, beauty came largely from the nuances of color and plane, nuances he locked under a thick, vitreous surface.

I do not like Courbet's portraits, but they are sensitive in feeling if not in actual painting. His nudes, which I usually like even less, manage however to be less crass and poetic at the same time. Courbet always had trouble in asserting figures in a background, but he achieved some of his greatest triumphs precisely in this matter, and their mood of figure-*cum*-foliage almost redeems some very inanimate nudes. It is the same mood that compensates at times for the vulgarity of Balzac and Berlioz, an operatic romanticism that is still sincere.

Courbet's great fault was his refusal to be cultivated (this does not mean he was not an erudite painter), which was an effect, it seems, of his egotism and self-indulgence. He had small powers of self-criticism, and after reaching artistic maturity in his thirties he stopped developing. As the catalogue for the Courbet exhibition at Wildenstein's says: "From now on his work simply alternated between good and bad. From now on, it was merely a question of landscapes, marines, portraits, nudes—depending upon circumstances." Marx would have said that this was a typical symptom of the petty-bourgeois attitude toward existence, with its reluctance to take risks and its distaste (see Proudhon) for history. I would not dispute this, but I would add that it was also the sign of a temperament that had a great capacity for pleasure and was largely immune to the anxiety which can prevent even the calmest artist from being satisfied with success in the present.

The show at Wildenstein's makes Courbet's unevenness plain. The famous big pictures are mostly still in France, but we can see the Metropolitan's large *Demoiselles du Village*, which despite its coarseness of color would have been an even more astounding work if Corot had not already painted one very much like it (which too, can be seen at the Metropolitan); and the Smith College Museum's *Toilette de la Mariée*, which I would judge to be unfinished, for all its curious but not quite successful strength. The completely satisfying pictures in this show are the seascapes and, to a lesser extent, the landscapes. The artist seems, during the last twenty years of his life, to have been able to handle best what was inanimate and removed somewhat by physical dis-

tance—especially those things one is unable to take between one's fingers, like light, water, and the sky. For all his adoration of the solidity of nature, Courbet came in the end to feel its intangibility with the most truth.

About seven paintings of the forty-three at Wildenstein's there should be no doubt: *The Mediterranean* of 1854–60, *Two Boats on a Beach* of 1865, *Low tide* of 1865–66, *Cliffs at Etretat* of 1867, *The Wave* of 1870, *Seascape* of 1870, and the *Château de Chillon* of 1873.

Mountain Cliffs at Ornans of 1855–60, *The Fringe of the Forest* of 1860, *The Isolated Rock* of 1865–66, *Sea Cliffs* of 1870, and the *Forest* are less complete in their success. Fourteen items out of forty-three may not seem a high score, but each of these fourteen is enough almost of itself to establish Courbet as a master for the ages.

The Nation, 8 January 1949

105. Review of Exhibitions of Thomas Cole and Robert Delaunay

Thomas Cole came to this country from England in 1818, at the age of seventeen, and began his education as a painter in Ohio. By twenty-five he had won the patronage of some of the foremost American collectors of his day, as well as the interest of Fenimore Cooper and William Cullen Bryant. His forte was the romantic grand-style landscape as developed in the England of Turner and Benjamin Haydon under the influence of Claude Lorrain, Salvator Rosa, Ruysdael, and Hobbema. Cole's pictorial imagination, with its leaning toward grandiloquence, became the main immediate influence behind the Hudson River School, whose panoramas, though less explicit literary than his, remained faithful from beginning to end to his conception of landscape painting.

Meeting Cole's pictures from time to time in group shows and museums, one was impressed from the first by his superiority to the other members of the Hudson River School, and saw in him an artist strong enough to be placed on an equal footing

with Eakins, Homer, and Ryder, not to mention Inness and Allston. Viewed in the aggregate, as he is now presented in a comprehensive loan exhibition at the Whitney Museum to commemorate the hundredth anniversary of his death, one may feel compelled to lower this estimate (though it is possible that the fifty oils on hand have been unimaginatively chosen and that a much better case could still be made for him). One or two of Cole's landscapes are indeed among the best things in the romantic-realist vein I have ever seen, and at least ten of the pictures shown at the Whitney come off excellently in their own terms, but there is a great unevenness of level that often compromises these terms. I would surmise that Cole did not adequately understand his own gift, which was great enough but constricted by the influences to which his literary ambitions subjected it—such as that of Claude Lorrain, for instance, a master whose occasional magnificence did not always have a good effect on Turner either. Essentially a realist, Cole produced his best work when he painted with his eye on the visual facts, whose complexity extended his art far more than his literary imagination could. When, on the other hand, he recomposed nature in "ideal" terms, as he did in his more ambitious subject pictures, he would apply a formal rhetoric got from the old masters—or from steel-engraved reproductions of them—that was too heavy, mechanical, and uniform to permit the canvas to breathe. Cole's brush appears for the most part to have had a coarse touch anyway, but where he followed nature in detail his powers as a colorist were called forth and overcame this fault. Elsewhere, beyond the brittle and unfelt paint surfaces, we see only his powers as a draftsman.

Cole died at forty-seven, while still in full development. One can suppose that had he lived longer he would have come to understand himself better; the fashion for "ideal" literature in landscape painting began to die down by the middle of the nineteenth century, and he might then perhaps have put his pictorial imagination to more effective use elsewhere than in allegory or moralism. As it is, the two best paintings at the Whitney are straight landscapes done with topographical and atmospheric fidelity, both in the last ten years of his life: the lovely *The Pass Which Is Called 'the Notch of the White Mountains'*, and the equally lovely *Catskill Mountain House*. In these canvases the autumnal

foliage that was Cole's favorite motif forces him to organize in terms of color, and its variegation, together with the crowded variety of nature itself, offers no room for those dull, dead stretches of mahogany or mauve that weigh down his allegorical paintings. Nature was more rich and subtle pictorially than his own invention, or at least that aspect of it which, in harmony with its age, mistook declamation for imagination.

It remains that Cole was one of the best artists America has produced, and if his talent was aborted in part, that was at least something very typical for American art and literature, then and later. How great Cole's native talent was can be seen from his line drawings, of which there are many at the Whitney show. His draftsmanship has a sensitive precision and an instinct for the unity of the page that enables it to stand comparison with Claude's. One would like to see these drawings reproduced in quantity in a book.

The first one-man show in America—at Sidney Janis's—of the late French artist, Robert Delaunay, who died in 1941, reveals an enterprising painter whose influence is perhaps more important than his art, fine as that is. Delaunay began as a neo-impressionist, was then a fauve, became a cubist by 1910, and was one of the first artists in the world to paint fully abstract easel pictures. The stamp of impressionism, with its preoccupation with chromatic effects, always remained strong in his art; thus he was also among the first, if not the very first, of the followers of cubism to introduce color into that style, which he did while it was still in its "analytic" phase. Delaunay quickly went on from there to a prismatic, curvilinear, abstract kind of painting that became known as "orphism." But he returned to representation from time to time in subsequent years, occasionally working in a manner surprisingly close to Bonnard's, and only in the late thirties—according to this show's evidence—did he become a confirmed abstract artist.

I am told that Delaunay's art, as embodied in such an abstractly cubist yet delicately colored picture as *Les Fenêtres* of 1912, had a stimulating effect on Klee when he visited Paris before the First World War. There is no doubt in my mind that the Delaunay of the same period and a little later had an influence on Chagall, Léger, and especially Kandinsky. Much later on the relation was reversed in the case of the last two, and

Delaunay, whose powers seem to have weakened with age, accepted *their* influence. His affinity with Kandinsky appears always to have been strong; they both retained impressionist color as long as possible, and when Kandinsky went over into abstract geometry in flat high colors, Delaunay followed him—with equally disastrous results, as we can see from his work in the thirties. But Delaunay was a good painter before that, a very good if still a minor one.

The Nation, 22 January 1949

106. Review of an Exhibition of Jean Arp

The Alsatian constructor and sculptor, Jean (or Hans) Arp is at the very least a great minor artist. The future may come, perhaps, to regard him as a major one because of his role as innovator and first master in modern art of the silhouetted shape against a flat background. But if we consider who led the way in modern art and who followed, who produced monumental works and who exquisite ones, who exploited as well as discovered and who only exploited or only discovered, then Arp does not seem quite to deserve being called major. He is, nevertheless, one of the most brilliant items in evidence of contemporary art's enduring vitality.

The influence of cubism brought him out as a collagist, during the 1914–18 war. Previously, at a time when he was still a painter, Kandinsky had introduced him to the possibility of an abstract art. But it was the collage, issuing from the inventive hands of Picasso and Braque, that definitely revealed him to himself. Arp's subsequent development from collage to bas-relief and then to sculpture in the full round is the best example—up to a point—of the way in which modern Western sculpture has succeeded in detaching itself from its own tradition and striking root in cubist painting, where it has found a new source and principle of form. Arp's sculpture, like that of Brancusi and Lipchitz, is at the same time, however, subject to an equivocation that prevents it from being the ideal paradigm of the evolution of that medium in the twentieth century. The

next aesthetically logical step from the bas-relief construction that grew out of the cubist collage was to an entirely new, open, linear, pictorial kind of sculpture whose premise was no longer the natural-hued monolith but the three-dimensional, colored construction in a variety of materials. The work of art here was no longer a *statue*, but an *object*. When Arp in the early thirties, after having practiced bas-relief in wood and other materials, went over into full sculpture, it was not the kind of thing one would have anticipated from his previous development. He returned to the monolithic statue, to a form of carving in stone and modeling in plaster and metal that had little to do with the sharply differentiated planes, the applied colors, and the occasional transparency that had marked—and still mark—his bas-reliefs.

What was modern in this return to the statue—here Brancusi had already shown the way—was the reduction of the monolith to a simple, quasi-geometrical, ovular form, qualified now and then by protuberances and creases, concavities and convolutions that evoke, if not the forms of the human anatomy, then those of the vegetable kingdom. The works that have resulted from this conception have about them something of garden sculpture: a simplicity and purity that demand to be set in isolation among trees, shrubs, and grass. This is a new escape from the city; an escape which seems to me to be the final meaning of the relative academicism of Arp's later work, with its rejection of the object in favor of the statue. Yet most of his later work still has a quiet force and conviction that make it a great deal more than academic. One may not be prepared at first to accept the quality of these little statues, for they do exhibit some of the same "modernistic" streamlining that troubles us in many of Brancusi's best-known works in stone and metal, but a long look at them will usually overcome this hesitation. They are not among the spectacular feats of modern art, but they are the products of one of the most genuine, sensitive, and integrated of living talents.

Arp's first one-man show of sculpture in this country, at the Buchholz Gallery, gives us an opportunity for this long look. Nothing exhibited dates from before 1932, however, and I still prefer his earlier collages and bas-reliefs to his later work in the round—not because they are more advanced, but because they

are more positive and moving, more creative. Arp's first collages, whose elements were exclusively rectangular forms on a horizontal base, will always be landmarks because of their perfection. And he, with Klee, was the first to graft explicit "poetry" to the framework of cubism: the "poetry," in his case, of the curvilinear, "biomorphic" silhouette that calls up organic life. And there was also the "poetry" of the accident. As one of the founders of Dada, Arp was among the very first to use it as a means of plastic invention, and his synthesis of accident and "biomorphic" form did almost as much as cubism to make Miró possible. Arp never used the accident as the orthodox surrealists did, that is, as a result, but always subordinated it to an aesthetic intuition that insisted on working itself out according to its own internal logic, of which the accident itself—the bits of torn paper scattered over a page—served only as the shove that set the process of creation going.

From the days of Dada on, Arp has professed his belief in an anonymous, collective art, and he has therefore at times accepted the collaboration of friends and, especially, of his late wife, the gifted Sophie Taeuber-Arp. In the latter case it was almost always with success—see, for example, plates 20 and 23 in *On My Way*, a book by and about Arp that has recently been published in New York (Wittenborn and Schultz). One cannot be either for or against collective art on principle, but one can still wonder whether Arp's advocacy of it may not be the complement to a certain lack of weight in his art, a certain neutrality, a certain shyness that has made it, alas, only too often overlooked in the histories of modern art. It is not enough to explain Arp by the fact that he is a German romantic in the lyrical *Blaue Blume* tradition. Klee was in that tradition too, and while he may not be an epic artist on the order of Matisse, Picasso, and Léger, he asserted a sharp and definite personality. In my opinion, this is what Arp has failed to do sufficiently.

The Nation, 5 February 1949

Review of Exhibitions of Adolph Gottlieb,
Jackson Pollock, and Josef Albers

Though it contained a high proportion of successful pictures—
and these stronger than any before—Adolph Gottlieb's latest
show, at Jacques Seligmann's, marked only a tentative advance
on his part. He still adheres to the same compositional formula:
the picture space divided into odd-sized rectangles, each filled
with a single pictogram. In my opinion the virtues of Gottlieb's
art deserve even more recognition than they have hitherto re-
ceived; some of the statements he has made in the last two years
are, for all their quietness, among the best painting produced by
younger Americans. Yet it cannot be denied that there is a real
repetitiousness in his design and a narrowness of effect which is
felt particularly in his color. Gottlieb still tends to use color
somewhat academically, in terms of dark and light and varying
degrees of saturation, in order to dissolve surfaces into depth.
Though in several of the more successful canvases in this show—
Totemic Fission, *Ashes of Phoenix*, *Hunter and Hunted*—the artist
begins to use color more boldly and structurally and emphasize
surface design more than before, he still is at his most finished,
as in *Recurrent Apparition*, when he retreats to his old method,
which is that fundamentally of the tinted drawing. It is pre-
sumptuous to urge an artist on, and it is especially so when he is
as talented as Gottlieb; but it is hard not to be impatient with a
painter whose talent contains so much latent and unrealized
force. I feel that Gottlieb should make the fact of his power
much more obvious.

Jackson Pollock's show this year at Betty Parsons's continued
his astounding progress. His confidence in his gift appears to be
almost enough of itself to cancel out or suppress his limita-
tions—which, especially in regard to color, are certainly there.
One large picture, *Number One*, which carries the idea of last
year's brilliant *Cathedral* more than a few steps farther, quieted
any doubts this reviewer may have felt—and he does not in all
honesty remember having felt many—as to the justness of the
superlatives with which he has praised Pollock's art in the past. I
do not know of any other painting by an American that I could
safely put next to this huge baroque scrawl in aluminum, black,
white, madder, and blue. Beneath the apparent monotony of its

surface composition it reveals a sumptuous variety of design and incident, and as a whole it is as well contained in its canvas as anything by a Quattrocento master. Pollock has had the tendency lately to exaggerate the verticality or horizontality, as the case might be, of his pictures, but this one avoids any connotation of a frieze or hanging scroll and presents an almost square surface that belongs very much to easel painting. There were no other things in the show—which manifested in general a greater openness of design than before—that came off quite as conclusively as *Number One*, but the general quality that emerged from such pictures as the one with the black cut-out shapes—*Number Two*—that hung next to it, and from nuEers *Six*, *Seven*, *Eighteen*, and especially *Nineteen*, seemed more than enough to justify the claim that Pollock is one of the major painters of our time.

The strictly rectilinear art of Josef Albers, which was given a large-scale presentation in early February at the Egan and Janis galleries, provides an ever-recurring frustration. As that part of his work shown at Janis's made clear, he is a sensuous, even original colorist, but there seems to be no relation whatsoever between this and his composition, which adheres to the dogma of the straight line. Consequently his pictures are more successful when they do not go beyond black and white, and that section of the exhibition which was installed at Egan's, confined exclusively to pictures in black, gray, and white, became much the more important one—though this may also have been because it included a good deal of Albers's earlier as well as recent work. At Janis's, the color, however interesting as pure chromatic effect, simply interfered with anything that may have been generated by the drawing. Alas, Albers must be accounted another victim of Bauhaus modernism, with its doctrinairism, its inability to rise above merely decorative motifs. It is a shame, for an original gift is present in this case that is much superior to all that. One has to regret that Albers has so rarely allowed the warmth and true plastic feeling we see in his color to dissolve the ruled rectangles in which all these potential virtues are imprisoned.

The Nation, 19 February 1949

There is, in my opinion, a definitely American trend in contemporary art, one that promises to become an original contribution to the mainstream and not merely a local inflection of something developed abroad.[1] I would define it as the continuation in abstract painting and sculpture of the line laid down by cubism and broadened subsequently by Klee, Arp, Miró, Giacometti and the example of the early Kandinsky, all of whose influences have acted to modulate and loosen forms dictated by Matisse, Picasso and Léger. An expressionist ingredient is usually present that relates more to German than to French art, and cubist discipline is used as an armature upon which to body forth emotions whose extremes threaten either to pulverize or dissolve plastic structure. The trend is broad and deep enough to embrace artists as divergent in feeling and means as the late Arshile Gorky, Jackson Pollock, Willem de Kooning, David Smith, Theodore Roszak, Adolph Gottlieb, Robert Motherwell, Robert De Niro and Seymour Lipton—all of whom are under forty-five. Most of these individuals must still waste valuable energy in the effort to survive as working artists in the face of a public whose indifference consigns them to neglect and poverty. Yet I would say that three or four of them are able to match anything being done by artists of the same generation elsewhere in the world. I would even hazard the opinion that they are actually ahead of the French artists who are their contemporaries in age.

I believe that the evidence upon which Herbert Read rests his suggestion that abstract and naturalistic art are compatible in the same age and even in the same person is illusory. The naturalistic art of our time is unredeemable, as it requires only taste to discover; and the sheer multitude of those who still practice it does not make it any more valid. Moreover, the whole bother about eclecticism serves only to conceal the true situation in art

1. Robert Goldwater, editor of the *Magazine of Art*, posed the questions for the symposium. Including Greenberg, there were sixteen contributors: Walter Abell, Alfred H. Barr, Jr., Jacques Barzun, John I. H. Baur, Holger Cahill, Alfred Frankenstein, Lloyd Goodrich, George Heard Hamilton, Douglas MacAgy, H. W. Janson, Daniel Cotton Rich, James Thrall Soby, Lionel Trilling, John Devoluy, and Patrick Heron. [Editor's note]

today. On one side we have cubism, cubist-derived abstract art and expressionism; on the other we have surrealism, even futurism, neo-romanticism, *Neue Sachlichkeit*, magic realism, etc. The first is advanced, creative, evolving, since it corresponds to the truth of contemporary life; the second has simply found new pretexts, all of them literary or journalistic, to reintroduce what is essentially academic naturalism. How well these pretexts have worked in the eyes of the public is shown by the fact that museums like the Museum of Modern Art, professedly committed to genuinely modern art, devote more funds and wall space to this spurious kind of modern art than to the real thing; a policy they justify by the claim that it is their proper function to give a fair representation to the *whole* field of modern art. We see, also, that this questionnaire has to pay heed to the same sort of claim. Under the guise of an originality altogether literary, academicism has managed, almost unnoticed, to steal its way into the *avant-garde* and there to acquire a new respectability to replace the old-fashioned one it lost thirty years ago.

At the same time we should not let the apparent diversity of styles within genuinely advanced art impress us too much. As time passes, the "stylistic" differences between a flower piece by Matisse and one by Soutine fade surprisingly, even as those between Ingres and Delacroix have done (which Matisse himself has noticed).

Public taste seems eclectic because it now contains strata of varying degrees of cultivation and because there has been a breakdown of cultural authority. Socially and culturally unified in former times, the art public since the nineteenth century has been expanded to receive a middle class that becomes less and less willing to abide by the judgment of connoisseurs. People are no longer so ashamed as they used to be of bad taste; rather, without going to the trouble to improve it, they now defend it aggressively.

Too many of those who now have a say in art—critics, journalists, dealers, curators, collectors—would in former times have been excluded from communication with the public by their own sense of inadequacy, if not by the resistance of the cultivated public itself. Today the art public asks expressly not to be made conscious of its own inadequacy. The new social areas that have been opened up for art consumption are able to make

288

their wishes felt through such vessels of expression as *Life*, *Art News*, *Art Digest*, *Harper's* and *Atlantic Monthly*. The philistinism that feels itself confirmed by this sort of art journalism is, I am afraid, more dangerous to culture than is generally realized.

Magazine of Art, March 1949

109. Jean Dubuffet and "Art Brut"

Jean Dubuffet is perhaps the one new painter of real importance to have appeared on the scene in Paris in the last decade. Though himself an erudite and sophisticated artist, he professes to despise cultivation, tradition, professional skill—all that which makes art "fine"—and to see genuine value only in the rawest forms of pictorial representation: graffiti, scrawlings on walls and sidewalks by untrained or impatient hands, the drawings of very young or untalented children, mudpies; *"art brut,"* "raw" art, art in its first and most rudimentary and least conscious stages. This is not at all the same thing as what is called "primitive" or naive art (Rousseau *le Douanier*, Alfred Wallis, Bombois, Vivin, Kane, Pickett, Bauchant, *et al*.), which is a relatively recent phenomenon and is in almost every case the result more or less of an untutored or visually innocent or only half-talented person's attempt to approximate traditional easel painting. The "primitives" do not appear in force until the popular diffusion of museum art is made possible by reproductions and journeyman copies. *Art brut*, however, does not depend on history or culture as much as that. It is found essentially the same in all times and places, wherever anyone without training, interest, or artistic aspirations tries to communicate something graphically.

Dubuffet discovered *art brut* at a time when many advanced writers in France were beginning to question the premises of literature itself as a cultivated discipline and some among them were attempting—as they still are—to bring the novel and short story closer to actual contemporary experience by stripping the narrative of its acquired conventions and modelling their prose on colloquial, popular usage, as Hemingway has

done. Like these writers, Dubuffet is reacting against a tradition so rich, mature, and recent that it still dominates the scene of its triumphs. Even though it is no longer adequately relevant to contemporary experience, the splendor and abundance of its achievements seem to threaten the originality of those who wish to make a fresh response to a fresh reality. In the face of such a situation, one is apt to decide that nothing less in principle than a radical rejection of the past will be enough to win the artist or writer his freedom. But a rejection of this sort is impossible in practice, however much it may be proclaimed in theory. It is not only that one cannot deliberately discard habits of culture instilled since childhood. Even if one could, the supposedly greater immediacy of the work of art or literature would be bought at the price of an even greater aesthetic impoverishment. New experience demands increased, not lessened, consciousness, and the anti-artistic artist or anti-literary writer can succeed only by transcending or suppressing the past, never by rejecting it. If he does so, he does so falsely, and the result is false. What, after all, is more false than the deliberately primitive?

Despite the appearance of his pictures, Dubuffet has not thrown off the past as he seems to think; he has, on the contrary, extended it by treating it selectively. To be sure, he has saved himself from the oppressive influence of Picasso and Matisse, which in its direct form paralyzes so many of the painters of his own generation in Paris. But he has not passed beyond culture and discipline and his art is not the raw, immediate expression that he himself advertises it as. What Dubuffet has actually done is to exchange one part of the modern tradition for another. Instead of Picasso and Matisse, he has chosen Klee. But Klee is not altogether the spontaneous, "state-of-nature" artist he is taken for. Like Dubuffet, he was stimulated by *art brut*, but he assimilated cubism first and took from the "raw" art of children and adults only what cubist discipline would permit. In effect, Dubuffet has absorbed cubism through Klee. (Aside from the fact that he probably also absorbed a good deal of it directly, for he first started out as a painter, back in the twenties, under the influence of Picasso, and it was only when he returned to painting at the time of the Occupation, after a long absence, that he appears to have oriented his art toward Klee's.)

Dubuffet borrowed from Klee the key with which to unlock the spontaneity in himself—Klee who by no means repudiated

tradition and wanted only to create an ampler one for modern art and was able to do so only under the guidance of cubism. Dubuffet has shown the highest sophistication in using Klee's influence as he has, making it the foundation of an art more monumental than that of any other of the Swiss master's disciples. But in order to do this he had to possess the whole extant culture of painting and all that French art, in particular, had to give in the way of a sensuous and knowing manipulation of paint. I believe that this erudition is self-evident in Dubuffet's art, as is also his very acute and civilized perception of what is and is not relevant to ambitious art in our time. Next to this his talk about *art brut* only confuses the issue.

Dubuffet's case demonstrates once again that the "primitivism" of which modern art is so frequently accused is in reality something quite different from what it seems. Instead of being a return to a primitive state of mind (whatever that may be), it represents a new evaluation and opening up of the past such as only erudite artists are capable of. The whole surviving past of art, rather than that of Western Europe and classical antiquity alone, has now been made available to contemporary artists. As our painting and sculpture abandon naturalism they find more and more stimulating precedents outside the historical and social orbit of Western culture. They find these in Africa, Asia, Oceania—and here at home and in the present as well: in the impromptu, rudimentary art of novices, amateurs, children, and lunatics.

Dubuffet's and Klee's art crosses social and status lines as high art never did before. It exposes, for the first time to our respectful view, the spontaneous graphic effusions, the *lumpen* art, of the urban lower classes, which Klee and Dubuffet have discovered and given an aesthetic role as Marx discovered and gave the proletariat a political role. And in a way not unlike Marx's, Dubuffet exaggerates the subversiveness of what he has discovered. It is true that most of the art we see scrawled on sidewalks is jeering and that the obscenity of what gets scribbled on lavoratory walls is rather "anti-social." But the beauty these things acquire at Dubuffet's transfiguring hands is so social that they become eligible for the museums, than which there is, of course, nothing less subversive.

Partisan Review, March 1949

The supremacy of Matisse among living painters is a consolation, but it also offers a peculiar problem. Picasso and Braque painted in the decade 1909–1920 what I think are by and large the most important pictures so far of our century. Yet neither appears to be the complete painter by instinct or accomplishment that Matisse is—the brush-wielder and paint-manipulator *par excellence*, the quiet, deliberate, self-assured master who can no more help painting well than breathing. Matisse may at times execute superficial work, he may do so for years, but he will never lack sensuous certainty. I do not think we can say the same of Picasso or Braque. Picasso, the very type of genius in the twentieth century, paints, if anything, less well than Braque while yet twice the artist. This paradox, like that of Matisse's preeminence, only the future, I feel, will be able to resolve.

It is held by some people of informed taste in modern art that Matisse's contribution was exhausted by at least 1920 (see George L. K. Morris in *Partisan Review* for June, 1948). Though I could not agree that exhaustion was the term to apply to an artist capable of the still lifes Matisse turned out in the twenties, it did seem until recently that his ambition had slackened in the last three decades and that, if he still handled paint as paint better than Picasso did, his art had become far less relevant than Picasso's, or even than Miró's, to the highest aims of painting. However genuine the pleasure received from Matisse's later canvases, it had to be conceded that this pleasure had begun to thin out and that the emotion which had moved us in his masterpieces of the years before 1920 was being replaced by virtuosity. Yet it was always to be expected that some glorious final statement, such as those Titian, Renoir, Beethoven, Milton had issued, would come from him—all the more insofar as his art, pre-cubist in essence if not in inflection, seemed less involved in the crisis that had overtaken post-cubism in the early thirties and better able, precisely because of its greater conservatism, to produce a second flowering.

This expectation has not been disappointed. The examples of Matisse's latest work shown at the comprehensive Philadelphia Museum exhibition last spring were, as we now see, shockingly unrepresentative, or at least they revealed very little of what the artist was about to do. The present show at Pierre Matisse's

of paintings done in 1947 and 1948 and of drawings and paper cut-outs done since 1945 offers a most effective refutation of those who may still doubt that Matisse is the greatest living painter.

Let us not speak of color at first. One does best to begin with the drawings, large affairs executed with brush and black ink (and, I am told, with the paper flat on the floor). I have never before particularly admired Matisse in black and white, but these drawings, which are so tightly packed into their vertical rectangles and have learned so much from cubism, justify everything that has been said in praise of the master's draftsmanship in the past. Matisse was always capable of monumentality, but this is the first time I have seen it in his drawings.

In my opinion the highest praise an artist can be given is to say that, even when many of his individual works are not completely achieved in their own terms, their general, "floating" quality is so strong and ample that it serves to move the spectator as effectively as only the masterpieces of other artists can do. This was true of Cézanne's painting toward the end of his life, and it now seems true of Matisse's. The best picture on hand, and the only one felt through as completely in design as in color, is the *Large Interior in Red* of 1948—a masterpiece, incidentally, that demonstrates once more how much greater Matisse's chances of complete success are when he stays away from the human figure. There is no other single thing in the exhibition to equal this item; yet were it omitted, the exhibition would still make its point, namely, that Matisse is at the present moment painting as well as he ever has painted before, and, in some respects perhaps, even better.

The art public is aware of the importance of Matisse's color, but I think a little too much has been said about his reliance in the use of it upon the decorative precedents furnished by Near Eastern art. It is true that from time to time he has built pictures by "spotting" the color all over the picture surface, as in a Persian miniature, so that the color takes charge of design and design itself inheres in rhythm and repetition rather than in architectonic structure. And it is also true that the paper cut-outs in the present show depend too much on the sheer quality of color and have an elemental and static simplicity of design that makes them pieces of decoration rather than pictures. But in Matisse's most important works of the past—those larger can-

vases painted between 1911 and 1918—and now in these of 1947 and 1948, he puts his picture together in accordance with the implicit rule of easel painting and arrives at a massive simplicity that pertains more to the Italian Renaissance and classical antiquity than to the Orient. In the *Large Interior in Red* a few rather simple rectangular forms are played against a few somewhat more complicated ovals, all these imbedded in an intensely red background that swallows both floor and wall in the same abstract space. Though this red background is the most emphatic feature of the picture, the picture itself remains easel painting in the fullest sense, and anyone who in the face of it still talks about Matisse's "Oriental decorativeness" as if that were the most important thing to say about his art is a victim of journalism.

One is naturally surprised and pleased to see that a man of eighty can still turn out such great and vigorous art. But I have been even more surprised, at various times in the past, to discover Matisse's variety: surprised, for instance, to discover that by 1910 he had made himself one of the best landscapists in the history of painting—and done this, so to speak, almost incidentally, while seeming to be preoccupied with other things.

We complain—and with a good deal of reason—about the age we live in, but I feel that we ought also to rejoice occasionally that we live in the same one as Matisse, and that we have been able, as his contemporaries, to watch his development on the spot. The old masters still give an American who has not had much chance to visit the museums of Europe some wonderful surprises, but I have had none superior to that provided by this first glimpse, in New York, of Matisse's latest work.

The Nation, 5 March 1949

111. Review of Exhibitions of Isamu Noguchi and American Paintings from the Collection of the Museum of Modern Art

To what extent do taste and talent help and to what extent do they interfere with each other? This question, as far as American

art is concerned, has been raised most conspicuously lately in sculpture, first by Alexander Calder and now by the accomplished and perhaps more serious Isamu Noguchi, who is having his first show in many years at the Egan Gallery. The artist who deals with three dimensions is more easily hypnotized, it would seem, by his own facility than is the one confined to a flat surface—where that repetitiousness of rhythm which so often goes with excessive taste tends to be quicker to declare itself as the surrender to decorativeness that it usually is. Symmetry is not as disturbing in sculpture as it is in painting, and the object, symmetrical or not, does not lose itself in the décor as readily in the picture—which, on the other hand, has the advantage of not becoming confused with the furniture. The element of tangibility also plays a part here. The eye, seeing a piece of sculpture, enjoys the triumph of human intention over resistant matter with more immediacy, and the artist is more tempted to rejoice in that triumph for its own sake alone.

In the case both of Calder and Noguchi the "modern" is treated as a convention with a closed canon of forms, derived in the main from Miró and Arp, the two School of Paris artists who have done most to rescue the emphasized contour from cubism. Noguchi's variations on the curved and straight line stay closer to traditional sculpture than does Calder's less somatic art, and his affinity is with Brancusi rather than the constructivists; he works with the remnants of volumes as well as with lines and planes, and in the more traditional material of stone. It is for this reason perhaps that Noguchi's taste makes itself even more noticeable—or, let me say, intrusive—than Calder's.

Noguchi machines and bevels his marble or slate into clean-shaped, glass-smooth plates, rods, and cusps which he fits together into compositions that adhere most often to the vertical scheme of the human figure. There is in general a geometric regularity in the exactness of shape and in the repetition of a limited set of ovals, curves, and straight lines. Sometimes, however, he works in bas-relief and manipulates his forms against the naked wall as a background—as in the black-slate *Open Window*, one of the finest pieces of the show; or he inserts knobs and rods into a flat slab of wood placed on the wall like a picture. Whatever affiliations some of Noguchi's pieces may still have with the statue, his art is, as we can see, fully in the midst of the adventure in genres that is modern advanced sculpture.

Several things in this show are exquisite—even when they measure five feet or more in height. But Noguchi's ability to achieve miniature grace on a large scale is the source precisely of some of the reservations this writer feels with respect to his art. Where is strength? Where are profundity and originality? Noguchi is an ambitious artist who asks to be judged on these terms. Few living artists, here or abroad, are capable of an equal felicity of effect; and given the ends he sets himself, he sometimes comes close to perfection. But these ends are not high enough, they are set within the reach of taste but require too little exertion on the part of talent; Noguchi reaches them by what seems too often a display merely of facility—a facility few can match, but facility none the less.

The stone Noguchi favors for his most ambitious efforts strikes me, also, as being inappropriate to his ideas, most of which seem to demand metal or wood. I would take as proof of this the greater success in this show of his one large piece in wood, the balsa *Cronos*, which moved me as nothing else did, despite—or exactly because of—a lack of clarity in the relations of the horns and cusps that hang high up inside its arch. Another strength of *Cronos* is the rough finish of its surface, which adds force to its contours. It is what I feel to be an excessive polish and smoothness of surface, an excessive clarity and precision of drawing, that weakens so much of Noguchi's other work. One wishes he had left most of his pieces half finished, and had the courage to stand on his conceptions as conceptions, and had abstained from executing them completely.

Noguchi is one of the most important American sculptors of the period, but his taste and the obsessive concern with finish through which it makes itself felt still prevent him from realizing powers that should deserve a term of praise more conclusive than "important."

The exhibition of American work from the Museum of Modern Art's permanent collection of paintings was, as could be expected, vastly disappointing. The only section that provided any real interest, as a section, was the room devoted to our younger abstract artists. And the surprise here was how scandalously few were represented. One sees how remiss the museum has been lately in its duty to encourage modern American art. How little, how woefully little the museum has to show for

the expenditure of so much money, space, time, energy, and—at least on the part of some—devotion.

The Nation, 19 March 1949

112. Review of an Exhibition of Picasso

Perhaps the most important symptom of the crisis in which, in my opinion, Picasso's painting has been involved since the end of the twenties is his endeavor to paint "French." As a symptom it strikes me as even more crucial than the more obvious and extravagant expressiveness of his art since that time. To paint "French" is to use color and paint-surface as positive structural elements of the picture rather than as mere reinforcements of its design. Not all great French painters have worked this way, but it is what French painting at its typical best has come to mean since Delacroix, Courbet, Manet, the impressionists, Cézanne, Bonnard, Matisse, and even Braque; the full and harmonious exploitation of the physical or sensuous properties of pigment— the properties of the medium, that is, as distinct from the resources of the tradition. The picture is to be a delectable object as well as a statement, with color as a major factor, color as a principle of design and not merely its accentuation.

Picasso's strength lies in a different quarter; if French painting, with its cuisine, is related to Venetian, his is related to Florentine. He is a very great draftsman, and he thinks instinctively in terms of dark and light; when he sets those flat decorated planes of his edge to edge he conceives of their contrasts as those of different degrees of light saturation rather than as the contrasts of native, idiosyncratic, particular colors. His cubism showed this no less than did his Blue and Rose periods. But Picasso's ambition to be a "complete" artist, combined with the influence of the French art he went to school with and the French scene in which he has spent most of his life, has for a long time now not permitted him to acknowledge his characteristic limitations. Thus in the early thirties, when the original impulse of cubism had finally faded, he embarked upon a competition with Matisse in the matter of color and sheer paint-handling in which

he imitated as well as emulated the older artist. Since then his successful canvases have been few and far between, and the general level of his painting has run much below the level he set for himself while a cubist.

But this applies only to Picasso's oil painting. His work in black and white, his pen-and-ink drawings, etchings, and lithographs, have not suffered the same decline. As a draftsman pure and simple he remains in close touch with his native self and keeps, therefore, his old mastery of contour and space-division, while continuing to show a fertility of invention that subdues more and more experience to art. The color in his oils may mistake garishness for force and disrupt the composition, the paint itself may be applied with an unduly coarse touch, but in his black and white work we find nothing but grace, justness, energy; all this with an originality of conception in the details that is still beyond the powers of the best of his contemporaries. And as long as Picasso only tints his drawings and uses color thinly and lightly as a reinforcement of line, and not as a primary factor, he succeeds as a colorist too.

The show at Buchholz's of a selection of the smaller-sized oils and of the water colors, ink drawings, crayons and lithographs that Picasso did in 1946, with a few additions from 1947 and 1948, offers a perfect demonstration of the unequal distributions of his gifts. The oils, which show a most outspoken effort to paint "French"—and are not too different in spirit from Braque's recent return to French tradition as before cubism—are lamentably inferior to the graphic work. The latter reveals a consistency of success as one goes from picture to picture such as Picasso last knew under classical cubism, of which these drawings may indeed represent the late remote fruits and final statement. For the feeling with which he refines the human figure into a flat scheme of straight lines and circles and organizes it on the page belongs preponderantly to that earlier period. The spaces inclosed by the lines or circles are most often left to the white of the paper; sometimes, however, they are lightly tinted, sometimes filled in decoratively with solid color, dots, or stripes. It is all easy, cheerful, surehanded—"classical."

So pat and inevitable is the success of these drawings that they become almost academic. But it is an academicism to which, this once, the artist is entitled; the material he conventionalizes

is what he has discovered for himself, and he conventionalizes so perfectly, summing up everything that the second-hand Picassos have been trying so vainly to do these past thirty years, that the results are made useless to any except the most abject of his followers.

In these and other works of Picasso's that one has seen since 1945 is evidence of the beginning of a new and mellower period. The limpid, pastel colors that make even the oils cheerful, the classic pastoral motifs, the increasing resignation to his own limitations—these may be signs of old age's new youth. The reckless triviality of the ceramics (which I find rather pleasing) and of the dozen and a half bronze figurines (which I find nothing but trivial) that are also shown at Buchholz's adds to this impression. But the drawings do even more: for they give us better grounds than anything Picasso has done since his neo-cubist drawings of 1938 to anticipate the resolution of the crisis that has affected his painting in oil during the last twenty years. It is conceivable that he will, at least for a while, regain on canvas that consistency of success and that authenticity which he seems never to have lost on paper.

The Nation, 2 April 1949

113. Review of Exhibitions of Ben Nicholson and Larry Rivers

Prettiness has been the besetting sin of English pictorial art—some Englishmen say since Anglo-Saxon times. To my knowledge, Ben Nicholson is the first English artist to have put it to a truly virtuous use and to have detached it from the picturesque; and this he has done by imprisoning his native aptitude for the pretty in a canon of abstract forms that derives largely from Mondrian and—in so far as it permits only hair-thin lines—is even narrower. Working exclusively, until recent years, with ruled and horizontally based rectangles and exactly plotted circles, Nicholson has subjected himself to a discipline whose penalty for error is so severe that the artist can leave absolutely nothing to chance, and therefore the discipline exerts a pressure

calculated to extract from prettiness only its positive values. We have but to look at Nicholson's pictures to discover that prettiness actually does have these. And we also discover that Nicholson, for all his anemia and repetitiousness, is one of the best, albeit minor, painters alive at the moment. His first American show, at Durlacher Brothers, reveals this to our startled eyes. I had admired single paintings of his before, but I must say that I did not expect such consistency of success in a relatively large number of works. There are twenty-eight items in the exhibition, which covers the artist's career from 1932 to the spring of last year. (Nicholson is, I believe, in his forties.)

It is true that this painter tends to academicize his art somewhat by confining it within a style established in its essentials by other artists, and by subjecting it to the primacy of taste— taste over strength, taste over boldness, richness, originality. Here he is not unlike other contemporary British artists and, especially, the sculptor Henry Moore. But he is different from them in that his work has freshness and the felicity of his taste is so intense and is applied to a mode so difficult that it becomes practically equivalent to originality. And all this without a trace of that inappropriate pretentiousness which mars the products of Moore's equally tasteful hand. Nicholson has a sense of placement and of space-division and shows a tact in the use of color— which he applies in thin and pure tints taken from the lighter end of the chromatic scale—that would deserve to be called much more than taste were these capacities accompanied by greater inventiveness. Even so, he is more enterprising than he might seem. Many of his paintings, those in monochrome particularly, are actually painted reliefs in wood, in which planes are raised and lowered as physical facts, not as illusions. The suggestion to be taken from some of Picasso's and Arp's early work, that painting in the twentieth century strives toward the condition of sculpture, has not been lost on Nicholson. And the success and vitality of his bas-reliefs demonstrate that he plays some real part in the adventure of contemporary art.

One could go into the reservations that would have to be made in any large and conclusive estimate of Nicholson's painting—and they would be very definite—but at the present moment I think it rather unnecessary. Let us make the most for the time being of our discovery of him in this country—and let us

hope that his partial return to nature in the last four or five years will not continue to thwart his talent as it now does.

Judging superficially, one is liable to say that everything Larry Rivers displayed in his first show at the Jane Street Gallery is taken from Bonnard. There is the same niggling, broken touch, the same conception of the illusion of three-dimensional space, the same color often, a similar approach to composition, similar subjects. The similarity is real and conscious, but it accounts really for little in the superb end-effect of Rivers's painting, which has a plenitude and sensuousness all its own. Rivers is a better designer than colorist—or rather, more obviously a designer than a colorist; for his color does everything he asks it to within the relatively narrow range he sets for it; and part of the artist's originality comes from the way in which he accommodates earth tones, ochers, umbers, etc., to the brushstroke and flat design of full-color impressionism. Eventually Rivers may acquire a lusciousness of color and surface more traditionally appropriate to the vein he paints in, but I for one would rather see this amazing beginner remain with his present approach and exploit further a native force that is already quite apparent in his art. That force, so unlike anything in late impressionism, he owes entirely to himself, and it has already made him a better composer of pictures than was Bonnard himself in many instances.

The Nation, 16 April 1949

114. Review of an Exhibition of Edgar Degas

Degas's pastels and later oils, hung together in any number, have a wonderful, glowing effect, as can be seen in the room to the left as one gets off the elevator at the big Degas exhibition at Wildenstein's. But this breaks down under closer examination: it is discovered to be a decorative, ensemble effect, and not that of a mustering of pictures which are masterpieces in their individual right. The explanation of this discrepancy between the whole and its parts lies, I think, in the powerful general quality of color Degas achieved after the late eighteen-seventies, but

this was something he was unable to marry successfully to his drawing or design, and thus unable to organize as an integral element of the picture.

Insofar as Degas followed each step in the evolution of impressionism, he did a certain amount of violence to both his strengths and limitations as a colorist. He proclaimed his lack of interest in color repeatedly, but here deceived himself as much as he did others. And he seems to have deceived himself equally about his relation to impressionism as a formal movement. In spite of his violent disclaimers of membership, his independent personal behavior, and his continuing emphasis on draftsmanship, he remained among its most faithful adherents, participating in all but one of the impressionist group shows. In the earlier stages of impressionism—while Manet was the leading influence—Degas was a very great painter. Manet's tendency to work in large and abruptly opposed areas of dark and light, the flattened, simplified, and relatively few planes with which he secured the illusion of depth, his hard and decisive silhouetting, his fondness for blacks and whites and tube color—all this Degas found congenial to his own gift as a draftsman, and during the time he followed Manet's lead he painted most of his greatest pictures. And he did more than follow. He may have lacked something of his mentor's force, but he surpassed him in many ways as a picture-composer and altogether as a colorist: his browns, yellows, tans, grays, and blues have a cool radiance beside which Manet's palette seems dry. The direct brilliance, moreover, of the reds reflected in the mirror behind the figure in the superb little *Man in a Blouse* of 1874 anticipates the extremest freedom of color in twentieth-century art.

The apparently unfinished *Lady with Umbrella* of 1877 that hangs next to the *Man in a Blouse* at Wildenstein's gives us the other pole of Degas's talent: the head is Ingresque but more intensely naturalistic, brushed in with a swift yet precise delicacy that reminds one of Goya—to whom Degas must have gone as directly as did Manet.

Degas had a real capacity for color, but it was thwarted by his adoption of the divided-tone technique that Monet and Renoir introduced into impressionism in the late seventies. It was unfortunate for him that he did not part company with the movement as soon as divisionism became its hallmark. The fact is,

302

however, that he could not bear to separate himself from the school that had helped make him the artist he was and that, for all his pretensions to the status of a lone wolf, he could not be unaffected by the development of the only contemporary artists in whose work he was genuinely interested. So he followed and competed with Monet, Renoir, Pissarro, Sisley in their quest of light and evanescent color. Yet at the same time he refused to paint outdoors and continued to insist on the primacy of line and contour—elements manifestly made discordant, not to say supererogatory, by the impressionist aesthetic of the interwoven passage. And while he strove, succeeding in his pastels at least, to make his color even more prismatic and overpowering in its luminosity than Renoir's or Monet's, he did not at all relax his emphasis on drawing. The result was to set up two competing systems inside the single picture: composition by masses of color and composition by tensions of line. The color remains unprecipitated, so to speak, something that shifts away from the contour-embraced forms and asserts a structure at variance with theirs. Usually, in the pastels, the pigment is applied with a coruscating intensity which is too even and complete and which, because it is not modulated in accordance with the drama of the linear design, seems superimposed. One's eyes become surfeited and bored. And sometimes Degas resolved the conflict between impressionist color and emphatic drawing by retreating toward the picturesque, muting his color but not muting it enough, so that the result became pretty and little else. See, for example, the *Race Horses* of 1884 at Wildenstein's, or some of the smaller ballet pictures.

But how well Degas could still handle color when he abandoned the impressionist method of divided tones is shown later on by his portrait of Henri Rouart and his son Alexis, which he painted in 1895, and which the Wildenstein catalogue—an excellent one—says was his last finished portrait. Why he suddenly changed his style at this point I do not know, but can only hazard that he may have been influenced at the moment by his juniors, Gauguin and Van Gogh, or even by the earlier Cézanne. Here, at any rate, he builds his picture out of a few summarily outlined areas of flat, unbroken high color, laying the paint on with a little medium and obtaining thereby a simple, intense strength that makes the pastels look meretricious by compari-

son. The success is owed to the harmony between drawing and color, and this is achieved because the latter reflects Degas's temperament and not merely his adherence to impressionism and his competition with his fellow-impressionists. The color is positive and literal, as suited Degas's design, not diffused and generalized as under the impressionist method.

Perhaps the representation of Degas's later period could have been much better chosen for the show at Wildenstein's. Certainly, there could have been more monochrome drawings, a medium in which the artist was always successful, even in old age. But bad judgment can do only so much harm. Despite the portrait of Henri Rouart and his son, one is forced to conclude that Degas was a truly great painter only up to the eighteen-eighties.

The Nation, 30 April 1949

115. The Question of the Pound Award

I agree with Mr. Barrett.[1] The Fellows in American Letters should have said more—that is, if they had more to say, and they should have had. As a Jew, I myself cannot help being offended by the matter of Pound's latest poetry; and since 1943 things like that make me feel *physically* afraid too.

I do not quarrel here with the Fellows' aesthetic verdict, but I question its primacy in the affair at hand, a primacy that hints at an absolute acceptance of the autonomy not only of art but of every separate field of human activity. Does no hierarchy of value obtain among them? Would Mr. Eliot, for instance, approve of this for his "Christian society"?

Life includes and is more important than art, and it judges things by their consequences. I am not against the publication of *The Pisan Cantos*, even though they offend me; my perhaps

1. William Barrett had written an editorial in *Partisan Review* (April 1949) criticizing the awarding of the 1948 Bollingen Prize for Poetry to Ezra Pound for *The Pisan Cantos*. *Partisan Review* asked Greenberg, W. H. Auden, Robert Gorham Davis, Irving Howe, George Orwell, Karl Shapiro, Allen Tate and, once again, William Barrett, to respond to the editorial and to the continuing controversy caused by the award. [Editor's note]

irrational sensitivity as a Jew cedes to my fear of censorship in general, and to the anticipation of the pleasure to be gotten from reading poetry, and I have to swallow that consequence. But I wish the Fellows had been, or shown themselves, more aware of the additional consequence when they awarded their Bollingen Prize. They could have taken greater trouble to explain their decision and thereby spared me, and a good many Jews like me, additional offense. (This does not mean, necessarily, that I am against the award itself.)

In any case, I am sick of the art-adoration that prevails among cultured people, more in our time than in any other: that art silliness which condones almost any moral or intellectual failing on the artist's part as long as he is or seems a successful artist. It is still justifiable to demand that he be a successful human being before anything else, even if at the cost of his art. As it is, psychopathy has become endemic among artists and writers, in whose company the moral idiot is tolerated as perhaps nowhere else in society.

Although it is irrelevant to the discussion, I must not let fall the opportunity to say at this point that, long before I heard of Pound's fascist sympathies, I was struck by his chronic failure to apprehend the substance, the concrete reality, of the things he talked about or did. I feel this failure in his poetry just as much as in what he wrote about painting and music. As a poet he seems to me to have always been more virtuoso than artist and to have seldom grasped the reality of the poem as a whole, as something with a beginning, middle, and ending. Thus, usually, any line or group of lines of a poem by Pound impresses me as superior to the whole of which it is part. (I would, however, except the *Mauberley* poems and several others of the same period from this stricture.)

Partisan Review, May 1949

116. Braque Spread Large

It does not seem to have been made quite clear yet as to whose was the decisive initiative, Picasso's or Braque's, in the first years

of cubism. The artists themselves are not too reliable in dating many of the works they did at that time. Braque would appear to have been the first to introduce *trompe-l'oeil* effects, to mix sand with his paint, and to create a collage, but Picasso led the way apparently in matters of fundamental approach, though not always. By 1913 anyhow Braque, I have the impression, was beginning to lose that plastic certainly which (despite, in his own case, a tendency to over-crowd canvases with detail) had enabled both artists to turn out an almost uninterrupted succession of masterpieces in oil and especially collage between the latter part of 1910 and the middle of 1913. Picasso, more sure-handed than Braque to start with, kept this certainty a bit longer and continued to be enterprising, as he showed in his bas-relief constructions and in works that go to the brink of abstraction. It was only with his first brightly colored and more naturalistic cubist still lifes, painted in the summer of 1914, that Picasso's sureness wavered and these are, almost for the first time, inferior to Braque's production of the same period. The French artist had stayed closer meanwhile to the modes of cubism already established by the end of 1912 and, though he too began to put some franker color into his paintings, he moved more cautiously and did not return as far to the integrity of the object.

Picasso says that when Braque and Derain went off to the war in August, 1914, his relations with them changed. But we hear also that he and Braque had had a quarrel shortly before that; certainly they have been cool to each other ever since then. Braque was wounded in the head in May, 1915, and over a year later was mustered out of the army. He began to paint again, but he was no longer a leader of cubism now and had to readjust himself at first by accepting the influence of Juan Gris, whom he himself had led, and at a great advance, before the war. Meanwhile Picasso, who had continued to paint in Paris in 1915 and 1916, had executed some of his strongest and most original cubist works—pictures with full color in a more simplifiedly geometric style.

Perhaps the war made no really radical difference in Braque's career. We shall never be able to tell. But it is a fact that his inventiveness abandoned him, and in the years since 1917 he seems to have followed Picasso's lead consistently and without ever regaining the initiative. When Picasso began doing still

lifes in a more naturalistic manner Braque did them that way too; when Picasso drew some schematized and rather expressionistic nudes Braque followed suit again; and when, after 1930, Picasso went in for sumptuous color and baroque design Braque once more followed. I do not mean that he followed abjectly; his sensibility, aside from the fact that it functions better with regard to color and the mechanics of oil pigment than Picasso's, has always been independent enough to convert to itself whatever it touched; but he became dependent on Picasso for his cues. And he has since 1917 fallen far short of the Spanish artist, if not in felicity, then in originality, plastic sense, power, and breadth.

All this the big Braque exhibition at the Museum of Modern Art—the most comprehensive one ever held—makes plainer than ever. It is a little sad to see, in spite of its splendor. From three ravishing vertical paintings, as great as anything ever put on canvas—*Still Life with Violin and Pitcher* of 1909–10 and the *Portuguese* and *Man with Guitar* of 1911 (in the last two of which, touches of gray heightened with silvery white achieve the perfection of that lyrical quality which is Braque's particular forte)—from these and from the very strict, pure, and elegant collages of 1912, 1913, and 1914, there is almost a steady decline (smallish still lifes all in browns, olive greens, blacks, and oyster whites) until 1928, when Braque makes a pronounced recovery in a series of more highly keyed large still lifes, of great magnificence, that take off from an idea originally Picasso's. This recovery continues unevenly into the early thirties, after which the decline sets in again and—in my opinion—remains. The falling off, both before and after the recovery, makes itself felt particularly in small but crucial errors of design or proportion and, to a lesser extent, in the distribution, as distinct from specific quality, of color (blacks, for instance, deadening the picture because they are spread over too large areas).

During all these years Braque's preponderant motif, and that by far, is the still life. The relative narrowness of his repertory, in means as well as subject, makes an abrupt contrast to Picasso's. And at the same time he remains more consistently a cubist, seldom attempting to break away from cubism's fundamental conception of the way to equate the two dimensions of the picture plane with nature's three. As Bernard Dorival has pointed

out, the French artist is humbler than Picasso, more aware of his personal limitations, and infinitely less impatient with those imposed by his age. Thus, if Braque has not cut such a figure in the history of art, he has at least been far more loyal to himself.

But has this been enough? Even though we recognize how badly Picasso has served himself during the last twenty years by his refusal to acknowledge his limitations and by his highly arbitrary efforts to show that he can do everything—even then, we cannot excuse Braque. Hasn't he been too comfortable? Could he not have tried to cope with a greater amount of experience than he has? The crisis of cubism as the great art style of our times justifies these questions, as unjust as they may be to the artist himself.

It is true, of course, that enterprise and adventure in art are no longer as much on the order of the day as they were up until the late twenties, and that the historical conditions that made them so possible then have largely disappeared. Picasso, shutting his eyes to this, has tried, however, to continue programmatically that audacity which, because, no doubt, of the "heroic age" atmosphere that formed him before 1914, seems to him the normal mode of the ambitious artist. And we, with our own notions formed in good part by Picasso's example, tend to feel the same. Actually, I think that Picasso is correct—correct in principle, that is, for contemporary art. Whether history now moves faster than it used to is an open question, but it seems that today more than ever art begins to languish the moment it stops assimilating new experience. It is to the operation of this law that Braque has succumbed, so that his art has fallen to a level far below Picasso's, which while it sins in the opposite direction—by trying to assimilate new experience even when the new experience is not there—does at least seek out every challenge the age can offer.

Braque is essentially a hedonist, conscientious about details, annoyed by larger questions. Since the early thirties he has followed the course typical of such an artist in a period of decadence, when talent is no longer borne up, swept along, and extended to its full by collective inspiration: he is content to turn out luxury articles which offer us richness of paint quality and color, but only in isolation, not as integrated parts of a whole. Look at the last room or so of the show at the Museum of

Modern Art. There Braque even abandons cubism and goes back to something not too unlike the late impressionism of Bonnard and Vuillard, in search of a charm not rightly his. There he applies paint with a clumsiness and lack of taste and sincerity such as we would have expected of him least of all. The ornateness of color and paint matter is, even as ornateness, mechanical, manufactured; it is the notion, the advertisement, the intention, not the reality of the quality itself (see, for example, *The Stove* of 1944).

It *is* sad. I become curious as to what Braque thinks of himself now. Is he aware of what has happened to his great gift? What does he feel about his relation to Picasso? Was it the absence from painting which the 1914 war forced on him, his head wound, and his parting with Picasso that made such a difference between the painter of *The Portuguese* and the painter of *The Stove*? Did he need Picasso more than Picasso needed him? Or are his temperament and native capacities, and the turn of the times, the crucial factors—that is, crucial in more than the ordinary sense? Braque's career strikes me as more puzzling even than Léger's (whose importance begins lately to seem even greater than his). How, in the hectic atmosphere of the School of Paris, was he able to avert his glance from so many challenges?

Partisan Review, May 1949; A&C (substantially changed).

117. Review of an Exhibition of George Bellows

George Bellows is one of the most important artists America has produced in this century. This does not mean much to world art perhaps, in view of what is still the rather minor importance to it of American art as a whole. Bellows died in 1925 at the age of forty-two, and for his short lifetime was contemporary with a number of painters in France, and in Germany and England as well, whose contributions swelled and advanced the mainstream of art as his did not. Brought next to Matisse, say, or Soutine or Beckmann or even Walter Sickert, Bellows begins to look provincial.

But something more lies beneath this provinciality, just as it

does in John Sloan's very similar case. Bellows, like Sloan, was a disciple of Robert Henri and his genre realism, and he started out as a painter in the early 1900's in a manner closely resembling Sloan's: with a palette confined to the middle register characteristic of that period, all grays, gray-blacks, gray whites, pale unsaturated yellows, buffs, greens, and pinks. Color was not the main thing, and it was rarely used with any vividness; the picture was organized and accented in terms of dark and light; at the same time chiaroscuro was renounced: like Manet, Bellows modeled his forms broadly, in varying shades of the local color, not in gradual grays or blacks. This style was a continuation, essentially, of Manet's phase of impressionism, but both Bellows and Sloan extracted something sufficiently new from it, something this writer considers to be still a part of the best American art of the twentieth century. A beautiful example of this kind of painting can be seen currently at a small show of Bellows's work at H. V. Allison and Company—*Beach at Coney Island*, done in 1908. And there is also *Blue Morning*, painted in 1907, in which Bellows began to display a capacity for atmospheric color.

Several years later the artist went in for intenser color, and here—although there is much opinion that holds the contrary—I feel he did even better work. As before, the paint is laid on fat, never in impasto but in a thick, viscous film; now, however, this serves to reflect more light and infuse with a curious sultry brilliance the heavy viridian greens and ultramarine blues he sees in foliage and sky. It was such color that Bellows used in his landscapes, especially those square views from the east bank of the Hudson—the pictures by which, in my estimation, he will live longest. There are, however, competent critics who think Bellows weak as a colorist and that this weakness renders his open-air painting inferior to his lithographs during the last part of his life (see Jerome Mellquist in *The Emergence of an American Art*). It is true that Bellows could paint pictures in which he used color very clumsily—see, for example, the *Bull and Cows* of 1918 at Allison's—and that when he reverted to his older, more draftsman's manner, as he would do in his big prize-fight paintings, which are almost monochrome, he could calculate his effects more surely. But an artist is to be judged by his best, not his safest work, and it still seems to me that Bellows was at his best, even if not at his surest, as a colorist and land-

scape painter: then he was more ambitious, more spontaneous, and took more chances.

The exhibition at Allison's hardly represents this side of his talent. On the whole it is not a show Bellows could be safely judged by, although at least three successful pictures are present (there is *In the Woods—Waterfall* of 1909, in addition to the two canvases already mentioned). The Metropolitan Museum gave Bellows a full-scale memorial show in the year of his death, in 1925, and early in 1946 the Chicago Art Institute held an even larger exhibition of his work. It is about time we had another chance to see him spread large, here in New York, if only to remind us, as we so often need to be, of what Americans were capable of in the way of art at a time when its prospects in this country seemed less hopeful than they do now.

The Nation, 14 May 1949

118. Review of Exhibitions of Adaline Kent and
 William Congdon

Sculpture's new vitality is again demonstrated by the first show at Betty Parsons's of the work of Adaline Kent, an artist hitherto unknown to me. Our Western sculpture owes its refluent vitality to the fact that shortly before the 1914–1918 war it broke with its old Graeco-Roman-Renaissance tradition, under the pressure of cubist painting, and entered upon a new development, founded on the imitation of modern painting, that has made it into an art of abstract drawing in three-dimensional space rather than one of carving or modeling. The first radical result of this new development is already seen in the "construction," called so because it is a work of plastic art which is put together, constructed, fabricated, not a statue chiseled out of stone or molded from metal or clay.

Miss Kent is still more sculptor than constructor, but the effect of her art is the product largely of the overtures she has made toward the construction—and of the tensions generated by the problems—of abstract form in a talent that might otherwise have dissipated itself in the decorative. Forms that do not

directly imitate nature will not permit the artist to take the easy way out by relying at any difficult point on associations; she has to deal with plastic relations in all their strict and formidable nakedness. Miss Kent works in hydrocal, a kind of plaster that resembles concrete and—as Stuart Preston points out—lacks particular character, having a grayish-brownish color and a hard surface that absorbs light yet has very little appearance of porousness. The present artist sometimes paints this plaster in different colors, in the way of the new sculptors, who have returned to polychrome for, really, the first time since the Renaissance. But it is in the openness of her work, as well as in its abstractedness, that Miss Kent approaches the construction; she combines rod-like forms and perforates planes with the eye of a painter and is no more afraid of sharp edges or corners than a carpenter or mason. The result has a pleasing pictorial quality, and sometimes even more, as in the pieces *The Gambler* and *Ambush*, which manage to control a greater amount of space than they actually inclose: the former by the galvanic energy in the thrust of its arms, and the latter by the opposite quality of a monumental repose that still embodies a tension.

It is hard to say yet whether Miss Kent has a robust talent. Some of her pieces show poverty of ideas or content; others fail to carry their ideas far enough, and resolve themselves into pat repetition of rhythm. The artist's "carved drawings," gouache on hydrocal, which are hung on the wall like bas-relief pictures, make the strengths and weaknesses of her gift—though I must say they show more of the latter—as clear and distinct as if under a microscope. But these very uneven works constitute nothing which entitle us to judge Miss Kent as an artist. That she is, and more than a promising one.

A painter, William Congdon, is also being shown at Betty Parsons's concurrently with Miss Kent, and his talent is in its most general aspects not too unlike hers. He possesses perhaps even greater felicity and sureness, and something of the same kind of originality, an originality of personal expression that is not backed up as yet by strong force or a radically independent approach. Congdon's subjects are exclusively the townscape and houses, and he owes to the example of Klee his willingness to accept the monotony of design involved by these. But though the design in itself may be monotonous, the effect is not. We have already seen this kind of repetitious, all-over composition,

without beginning, middle, or end, in analytical cubism and in the recent work of such painters as Mark Tobey, Jackson Pollock, Janet Sobel, and Mordecai Ardon-Bronstein. Congdon does not go as far as they in uniformity of surface, especially not in his small gouaches done in Italy—which are of a great felicity in their quick and stripped-down notation of color and form, but perhaps lack ambition. It is in his larger oils, much more abstract and painted after his return to this country, that Congdon shows his true measure. In these, freed largely from the object, he states his sensations with much greater boldness. The original motif in each picture is a row of house fronts and the strip of sky above them, which the artist reduces to two blocked-in areas of more or less uniform color—a large block of deep color for the houses and a rectangular band of lighter hue for the sky. The design, as design, is conceptually like Mondrian's in part, but Congdon works and crosshatches and embroiders his color inside the given area, so that the effect comes closer to Tobey's in the end, and we have the sensation of a continuous surface varied in a uniform rhythm.

One likes Congdon's painting and feels, particularly in its color, the presence of a real painterly emotion. Yet his individual colors have about them a faint tinge of the academic, of something not quite worked into a modern expression and therefore slightly second-hand. Where the emotion is felt most is in the color relations, which have to overcome a brilliance of surface in the individual hue that permits an inappropriate and, so to speak, sentimental connotation of depth. The eye in this context asks for something more paque, more positive.

As in Miss Kent's case, I am eager to see what Congdon does next. My impression is that he is only at the beginning of the evolution that will decide him as a painter.

The Nation, 28 May 1949

119. The New Sculpture

Art and literature seem usually to seek their frames of reference wherever the social mind or sensibility of the given historical moment finds its surest truth. In the Middle Ages this area of

certainty, or rather of plausibility, coincided with religion, in the Renaissance and for some time thereafter with abstract reason. The nineteenth century shifted the area of plausibility to factual, empirical reality, a notion that has undergone considerable change during the last hundred years and always in the direction of a narrower conception of what constitutes an indisputable fact of experience. Our sensibility has shifted similarly, demanding of aesthetic experience an increasingly literal order of effects and becoming more and more reluctant to admit illusion and fiction. Thus it is not only our society's highly developed division of labor that has suggested the greater specialization of the separate arts; it is also our taste for the actual, immediate, first-hand, which desires that painting, sculpture, music, poetry become more concrete by confining themselves strictly to that which is most palpable in them, namely their mediums, and by refraining from treating or imitating what lies outside the province of their exclusive effects. This does not mean what Lessing meant when he protested against the confusion of the arts; Lessing still thought of the arts as imitative of an external reality which was to be incorporated by means of illusion; but modern sensibility asks for the exclusion of all reality external to the medium of the respective art—for the exclusion, that is, of subject matter. Only by reducing themselves to the means by which they attain virtuality as art, to the literal essence of their medium, and only by avoiding as much as possible explicit reference to any form of experience not given immediately through their mediums, can the arts communicate that sense of concretely felt, irreducible experience in which our sensibility finds its fundamental certainty.

This is the complex of factors—by no means stated completely—that I believe responsible for, among other things, such phenomena as "pure" poetry, the "pure" novel, and "pure" or abstract painting and sculpture. Notice, for instance, how emphatically such writers as Mallarmé, Valéry, Joyce, Gertrude Stein, Cummings, Dylan Thomas, Stefan George, and Hart Crane call attention to their medium, which does not disguise or render itself transparent in order to grant us the quickest possible access to their content or subject matter, but becomes itself a large part of the subject matter. I could illustrate this tendency at length in modern literature, but literature is not what I am interested in dealing with here.

However, we should remember that no attempt at a "pure" work of art has ever succeeded in being more than an approximation—least of all in literature, which uses words that signify other things than themselves. The tendency toward "purity" or absolute abstractness exists only as a tendency, an aim, not as a realization. But as a tendency it is sufficient to explain much in the present state, not only of literature, but also of the visual arts, which are driven toward the same sort of insistence on the palpability of their mediums that we see in Mallarmé, Joyce, and Gertrude Stein.

The literal nature of the medium of painting consists in configurations of pigment on a flat surface, just as the essential medium of poetry consists in rhythmic configurations of words arranged according to the rules of a language. Modern painting conforms to our desire for that which is positive and literal by openly declaring itself to be what painting has always been but has for long tried to dissemble: colors placed on a two-dimensional surface. The illusion of the third dimension is renounced, and likewise the fiction of representation, which belongs to the literal part of painting as little as it does to that of music; to transpose the image of a three-dimensional object to a flat surface, even if only schematically, is considered by such a modern painter as the late Mondrian to be a denial and violation of the nature of the medium. Modern sensibility tends to consider it a deception, and therefore shallow, un-moving, without concreteness.

Mondrian has shown that it is still possible to paint authentic easel pictures while conforming to this strict—and more than strict—notion of painting. Nevertheless one begins to see a danger in it for the art of painting as we have known it. Pictorial art of this sort comes very close to decoration. Mondrian's greatness may be said to consist in good measure in having so successfully incorporated the virtues of decoration in easel painting, but this is small guarantee for the future. Painting of a kind that identifies itself exclusively with its surface cannot help developing toward decoration and suffering a certain narrowing of its range of expression. It may compensate for this by a greater intensity and concreteness—contemporary abstract art has done so with signal success—but a loss is still felt in so far as the unity and dynamics of the easel picture are weakened, as they must be by any absolutely flat painting. The fact is, I fear, that easel painting in

the literally two-dimensional mode that our age, with its positiveness, forces upon it may soon be unable to say enough about what we feel to satisfy us quite, and that we shall no longer be able to rely upon painting as largely as we used to for a visual ordering of our experience.

I do not mean to suggest that painting will soon decline as an art; it is not essential to the point I wish to make to claim that. What is to be pointed out is that painting's place as the supreme visual art is now threatened, whether it is in decline or not. And I want also to call attention to sculpture, an art that has been in relative desuetude for several centuries but which has lately undergone a transformation that seems to endow it with a greater range of expression for modern sensibility than painting now has. This transformation, or revolution, is a product of cubism.

Between the Renaissance and Rodin, sculpture suffered as a vehicle of expression because of its adherence to the monolithic, somatic Graeco-Roman tradition of carving and modelling. The ideal subject of this tradition was the human torso and head, and it rejected as inappropriate all that was inanimate and immobile. An art confined to the monolith could say very little for the post-Renaissance man, and painting was therefore able to monopolize subject matter, imagination, and talent in the visual arts, where almost everything that happened between Michelangelo and Rodin happened on canvas. That sculpture was at a lesser remove than any of the other arts from that which it imitated—from its subject matter—and that it required less powers of abstraction to transpose the image, say, of an animal to stone in the round than to a flat surface, or into words—this also counted against it for several centuries. Sculpture was too *literal* a medium.

Rodin was the first sculptor who tried actually to catch up with painting, dissolving stone forms into light and air in search of effects analogous to those of impressionist painting. He was a great artist but he destroyed his tradition and left only ambiguities behind him. Maillol and Lehmbruck were also great sculptors, and it was Rodin perhaps who made them possible, but the first got his inspiration from archaeology and the second from expressionist painting. They mark an end, and their art cleared the way for something radically new to fill the vacuum left by the extinction of the Graeco-Roman-Renaissance tradition.

316

Meanwhile cubism had appeared in painting. Brancusi, under its indirect influence and the more direct one of Negro sculpture, was able to begin the transition from the monolith to a new kind of sculpture derived from modern painting and the wood-carvings of Africa and Oceania: a kind of sculpture entirely new to European civilization, art no longer restricted to the solid mass and to human and animal forms. Brancusi himself does not complete the transition. What he does, at least in his work in stone and metal, is push the monolith to such an extreme, reduce it to such archetypal simplicity, that it is exhausted more or less as a principle of form. The new sculpture really begins with Braque's and Picasso's cubist collages, springing up out of a mode of painting that thrusts forms outward from the picture plane instead of drawing them back into the recessions of illusionary space.[1] Thence the new sculpture grew through the bas-relief constructions that Picasso and then Arp and Schwitters created by raising the collage above the picture plane; and from there Picasso, a magnificent sculptor as well as painter, along with the Russian constructivists Tatlin, Pevsner, and Gabo, and also Archipenko, Duchamp-Villon, Lipchitz, Laurens, and then Giacometti, at last delivered it into the positive truth of free space, altogether away from the picture plane.

This new, pictorial, draftsman's sculpture has more or less abandoned the traditional materials of stone and bronze in favor of ones more flexible under such modern tools as the oxyacetylene torch: steel, iron, alloys, glass, plastics. It has no regard for the unity of its physical medium and will use any number of different materials in the same work and any variety of applied colors—as befits an art that sees in its products almost as much that is pictorial as is sculptural. The sculptor-constructor is, if anything, more drawn to ideas conceived by analogy with landscape than to those derived from single objects.

The new sculpture is also freed, as should be self-evident from what I have said, from the requirements of imitative representation. And it is here precisely that its advantage over mod-

1. There is a curious historical symmetry here. Our Western, naturalistic painting had its own origins in the sculpture of the 12th and 13th centuries, which was 200 years ahead of painting in point of capacity for imitating nature, and which continued to dominate the other arts until the late 15th century. [Author's note]

ern painting, as far as range of expression is concerned, lies. The same evolution in sensibility that denied to painting the illusion of depth and of representation made itself felt in sculpture by tending to deny it the monolith, which in three-dimensional art has too many connotations of representation. Released from mass and solidity, sculpture finds a much larger world before it, and itself in the position to say all that painting can no longer say. The same process that has impoverished painting has enriched sculpture. Sculpture has always been able to create objects that seem to have a denser, more literal reality than those created by painting; this, which used to be its handicap, now constitutes its greater appeal to our newfangled, positivist sensibility, and this also gives it its greater license. It is now free to invent an infinity of new objects and disposes of a potential wealth of forms with which our taste cannot quarrel in principle, since they will all have their self-evident physical reality, as palpable and independent and present as the houses we live in and the furniture we use. Originally the most transparent of all the arts because the closest to the physical nature of its subject matter, sculpture now enjoys the benefit of being the art to which the least connotation of fiction or illusion is attached.

The new sculpture has still another advantage. To painting, no matter how abstract and flat, there still clings something of the past simply because it is painting and painting has such a rich and recent past. This until a short time ago was an asset, but I am afraid that it has begun to shrink. The new sculpture has almost no historical associations whatsoever—at least not with our own civilization's past—which endows it with a virginity that compels the artist's boldness and invites him to tell everything without fear of censorship by tradition.[2] All he need remember of the past is cubist painting, all he need avoid is naturalism.

All this, I believe, explains why the number of promising young sculptors in this country is so much greater, propor-

2. One of the ways in which the new sculpture's advantage over painting is revealed is by our feeling that what we see in the pictures of such painters as Matta, Lam, and sometimes Sutherland—all three of whom owe so much to Picasso—and in a good deal of Picasso's own work, is illegitimate sculpture, illustrations of sculpture or of ideas essentially sculptural. But we never feel that the new sculpture is illegitimate painting. It is too fresh, just as Mantegna's painting, which owed so much to the other art, was too fresh to be called illegitimate sculpture. [Author's note]

tionally, than is that of promising young painters. Of the latter we have four or five who may figure eventually in the history of the art of our times. But we have as many as nine or ten young sculptor-constructors who have a chance, as things look, to contribute something ambitious, serious and original: David Smith, Theodore Roszak, David Hare, Herbert Ferber, Seymour Lipton, Richard Lippold, Peter Grippe, Burgoyne Diller, Adaline Kent, Ibram Lassaw, Noguchi—and still others. Not all these artists are richly gifted and not all of them have broken away from the monolith; their styles are as various as the variety of sculpture since 1905. But unequal as they are in talent, they all show freshness, inventiveness, and positive taste, qualities they owe, I feel, to the fact that their medium is so new and so cogent that it produces interesting work almost automatically, just as the new naturalistic painting of the fifteenth century in Italy and Flanders extracted masterpieces from even mediocre hands. The same seems to be the case, from what I can gather, with the new sculpture in Paris and London.

As yet not enough attention has been paid to the novelty of the new sculpture. But not enough attention is paid to sculpture in general. For most of us, raised as we are to look only at painting, a piece of sculpture fades too quickly into an indifferent background as a matter-of-fact ornamental object. The new sculpture-construction has to contend with this habit of vision, and it is for this reason, I think, that so few attempts have been made to evaluate it seriously and relate it to the rest of art and to the feeling of our time. Yet this new "genre" is perhaps the most important manifestation of the visual arts since cubist painting, and is at this moment pregnant with more excitement than any other art except music.

Partisan Review June 1949; A&C (substantially changed).

120. The New York Market for American Art

The past season on Fifty-seventh Street has been disappointing, by and large, for American art, particularly so by contrast to the previous one of 1947–48, which saw the introduction of a surprising amount of new talent and, more important even than

that, the beginnings of self-realization by artists already on the scene. It was as if a new current of critical as well as creative activity had emerged, almost suddenly, to raise the collective level of our advanced art to a point of awareness and performance beyond anything it had known before. This was not a phenomenon of merely local reference, nor was it momentary; it had a wide bearing, had been in process of growth for three or four years, and it seemed to make American art for perhaps the first time an equal participant in the dialogue with Europe. I do not think by any means that this current is now exhausted; certainly if a year were enough to do that, it could hardly have the character I claim for it. But it may be subject to ebb and flow, and after its first rising it may have had to contract itself the better to assure and consolidate its reality. There was, in spite of everything, some evidence on Fifty-seventh Street of its continuance and even more evidence in the studios.

Our society does very little overtly to encourage American art in its new advance and a great deal to discourage it. I do not mean only the attacks on abstract art and its related forms that appear in the press—the greater amount of attention paid lately to modern art, even if it is but to complain about it, is in a way a promising sign. The importance of modern art has become such that it is no longer sufficient to oppose it by ignoring its presence; its enemies have to fight it actively, and in doing so they have made painting and sculpture a crucial issue of cultural life—which is to assign them much more relative importance than they ever enjoyed before in this country.

Society more effectively discourages advanced art by simply withholding its money and refusing to buy it or give it honorific publicity. The growth of interest in modern painting and sculpture has not been accompanied by a proportional growth of the market for them. And the present efflorescence of American art, no matter what new and, for the first time, international importance it gives to that art, cannot continue for long without a good deal more financial support than it now receives. What the situation is with respect to this factor we can see from the past season on Fifty-seventh Street. Not that the new enthusiasm flagged in advanced art circles because of lack of sales; it is more likely, I repeat, that it obeyed some inner rhythm of its own. But Fifty-seventh Street, to judge from the way in which it in-

vested its money, did not seem even to be aware of the presence of this enthusiasm or of its already considerable fruits.

The closing of the Kootz Gallery at the end of the 1947–48 season left a big gap. There are only a few places, relatively, that show or are at all interested in advanced painting by Americans, and they play a role disproportionate to their number, their financial strength, and the amount of work they circulate. They are the places in which American art happens today. Samuel Kootz's gallery had made itself the focus, along with Betty Parsons's, of all that was most alive, serious, and adventurous in contemporary American art, and during the four years of its existence it provided such significant young painters as Robert Motherwell and Adolph Gottlieb with the conditions under which they were able to develop their work to its present high level. The uncomfortable vacuum left by Mr. Kootz's departure has not been altogether filled by Sidney Janis's new establishment at the same address, the new Peridot Gallery downtown, the Jane Street Gallery, or by the emergence into prominence as sponsors of the new American abstract art of the excellent Egan Gallery and, to a lesser extent, Jacques Seligmann's.

Despite all the surviving galleries named above, and the Pinacotheca and Marian Willard's and J. B. Neumann's galleries in addition, it remains as difficult as ever for a young American painter or sculptor working in an advanced mode to win real attention in New York. What accounts for this difficulty to some degree is not so much limited gallery space as limited sales outlets. Those galleries which, like the Buchholz, Pierre Matisse's, Paul Rosenberg's, and others, have built themselves prestige and clienteles by importing and exhibiting modern French, German, and British art do in general show inhospitality toward almost everything new or adventurous in the latest American art. Good business sense may justify this policy, but the firms in question cannot boast that they act with full responsibility toward art. There are galleries and dealers that create values, and there are others that exploit values already created. One would like to see more of an overlapping between the two kinds on Fifty-seventh Street. For there is no question that a more open attitude on the part of the second toward advanced American art would help infinitely to maintain its new élan and establish it as the contribution it can be to the international mainstream.

It is possible that the more powerful organs of American public opinion will after a time awake to the fact that our new painting and sculpture constitute the most original and vigorous art in the world today, and that national pride will overcome ingrained philistinism and induce our journalists to boast of what they neither understand nor enjoy. That would still be to the good. Blind recognition is better than none at all. But it would be very embarrassing and not altogether healthy if the Luce magazines, for instance, boarded the train before the powers on Fifty-seventh Street did. That would show bad business policy on the part of those powers, and business policy is the only excuse they can still offer for their obtuseness.

The Nation, 11 June 1949

121. Our Period Style

> Can we not take it then that the recovery of a true style in the visual arts, one in which once again building rules, and painting and sculpture serve, and one in which form is obviously representative of character, indicates the return of unity in society too? Granted that this new style often looks rather forbidding and seems to lack human warmth. But is not the same true of contemporary life? Here, too, amenities to which we have been used are being replaced by something more exacting and more elementary. —Nikolaus Pevsner, *An Outline of European Architecture* (Penguin Books, 1945).

The absence—without precedent, as far as we know—in 19th-century Europe of an independent contemporary style shared in common by sculpture, painting, architecture, decoration and design seems to have been prolonged until our day. Yet the situation is not really what it was. The last forty or fifty years have seen it remedied on the highest levels of our artistic and architectural production, and the artist or designer who works on those levels once again has available a style that encourages him to answer contemporary feeling with independence and at the same time prepares an audience, no matter how small, for his originality. It is perhaps because we accepted eclectic historicism from the first (why, is an interesting question) as the natu-

ral state of things in architecture and design that we do not now sufficiently celebrate the presence of a style that at last satisfies us integrally and comfortably to everything new we have experienced since the 18th century. "International style" architecture, cubist and post-cubist painting and sculpture, "modern" furniture and decoration and design are the manifestations of the new style. Conditioned by industrialism, it is native to our century, owes well-nigh nothing to the past, and the arts and crafts can draw energy from it as from a common fund whereby they fertilize and invigorate each other. Painting plays a curious role in this new style. Not that it is its sole creator—the style arose independently in architecture and would, I feel sure, have come to fruition there without painting's aid. But painting—cubist painting—did serve to reveal the new style in architecture to itself, define some of its plastic ingredients and make their tenor explicit. And it also transmitted the style, single-handedly, to sculpture; as far as sculpture is concerned, the new style was created by painting, and by painting alone. Yet at the same time sculpture demonstrates more clearly than either painting or architecture those essential features of the new style that are shared by all the visual arts in common. This is why it would be best to describe the style through that art.

More directly and less ambiguously than painting and more nakedly than architecture, sculpture realizes the new notion of the work of visual art as an open, more or less transparent object whose effect lies mainly in its total design, its exhibited structure, and which relies relatively little on expressive details. The plastic means are flat planes, lines, and enclosed spaces rather than masses, volumes and modelling. The interest is in lines of force, thrusts, in the "activation" of empty space; there is also a great impulse, as in dancing—and also in modern engineering—to discount the law of gravity, which is done in sculpture by lifting the object from its base on wires or rods. A similar effect is made possible in architecture by the superior tensile strength of the new materials devised by industrial science.

The new sculpture emulates nature by offering a context in which entities are created by positional relations; the old sculpture emulated a nature that seemed to create through weight and solidity alone. The old sculptor, like the old architect, made his work a monolith more or less isolated from the space around

it; the modern sculptor and the modern architect conceive of space more dynamically, as all-pervasive and all embracing. And, as Nikolaus Pevsner puts it, inside and outside are interwoven. The artist no longer seals his figure or construction off from the rest of space behind an impenetrable surface, but instead permits space to enter into its core and the core to reach out into and organize the ambience.

J. M. Richards's and Elizabeth Mock's description of Frank Lloyd Wright's first "prairie houses," in their *Introduction to Modern Architecture* (Penguin Books, 1947), well illustrates the new unity of style among the visual arts; for, *mutatis mutandis*, it can be fittingly applied to the works of the constructivists and other modern sculptors:

> . . . Space took on a life of its own. It became fluid, expansive, continuous from one room to another, and from inside to outside through bands of casement windows or great banks of glass doors. Terraces, porches, and boldly cantilevered roofs all contributed the extraordinary effect of an interpretation of interior and exterior space. Outside, materials were concentrated in large unbroken surfaces and the houses seemed composed of flat, independent planes, some horizontal, some vertical, some intersecting, some floating at different levels. . . . Thus began the process that might be called the dissolution of the wall. The wall is no longer the necessary psychological boundary of a building. It may be merely a transparent, scarcely noticeable transition between inside and outside, giving an illusion of limitless space to even the smallest interior. This breakdown of the Renaissance concept of windows as isolated holes-in-the-wall is an inevitable expression of our twentieth-century consciousness of space as continuous . . . it was encouraged by the development of modern skeleton construction, in which walls support nothing, therefore can be wholly of glass.

The reader will notice that I have been led to use some of the same expressions as Mr. Richards and Mrs. Mock in order to describe modern sculpture.

What most essentially defines the new unity of style in architecture, sculpture and painting is, however, their common tendency to treat all *matter*, as distinguished from *space*, as two-dimensional. Matter is analyzed into points, lines and the surfaces of planes that are meant to be felt as without thickness and possessing the hypothetically absolute two-dimensionality of

demonstrations in plane geometry. It is by virtue of this immateriality, this urge to reduce their plastic elements to the minimum of substance needed to body forth visibility, that modern architecture and sculpture can be with the greatest justice termed "abstract." If painting does not show a corresponding tendency to reduce the thickness of pigment it is because it is still engaged in emphasizing the primacy of the plane surface composed of paint and canvas as against the older conception of painting as an affair of illusion, transparent window effects, and effaced means. And in any case cubist painting was the first to illustrate, if not embody, the new conception of matter as something which must be reduced, for the purposes of plastic art, to two dimensions; it gave us our first clear glimpse of the "open" object permeated by space and permeating space.

Gothic style, too, seemed to strive for immateriality. But where Gothic style "spiritualized" matter by challenging its weight, modern style "scientizes" it by resolving mass and weight into planes or fields of force and into guiding and limiting lines of space (which move horizontally as well as upwards; modern style has in general not too much feeling for the distinction between upwards and downwards: the best skyscrapers would look just as well stood upside down). The affinity between the new style in the visual arts and modern physical science should be obvious from the terms in which I have described the former. But it is not at all a matter of the modern artist being influenced by science and trying to illustrate its new explanation of the nature of matter; the artist works much more empirically than that and, regardless of what goes on in other fields, tries simply to make an aesthetically effective object in compliance with the demands of his own sensibility and that of his audience. His relation with science—or philosophy or religion—is owed to the fact that, in our age as in every other, the highest aesthetic sensibility rests on the same basic assumptions, conscious or unconscious, as to the nature of reality as does the advanced thinking contemporaneous with it. What the mechanism is by which such assumptions penetrate to all departments of culture, almost simultaneously it would seem, has not yet been satisfactorily explained, but that they do is indisputable.

Our period presents a picture of discord, atomization, disintegration, unprincipled eclecticisms, etc., etc. How then does the new unity of style in the visual arts fit into it? I can reply

only by hazarding that the picture may be deceptive because incomplete. Despite all appearances to the contrary, our age may still contain a new principle of unity in itself; I seem to see one being generated empirically out of certain solutions dictated by the novel problems of an industrialized and urbanized society. This principle may not yet have been adequately argued in words, but I feel it to be already confirmed in art and technics—wherever man has to cope with matter. One of the prime causes of the ills of our age is, possibly, that it resists its own principle of unity.

The spirit or style of an age is seen at its most unmistakable in the *new* ways in which it shapes and handles physical substance. If so, the style of ours—and in this I see its principle of unity—is characterized by economy, directness and consistency in the fitting of means to ends: in a word, by the practice of rationalization. Rationalization in the industrial sense, a frightening idea by now, but so only because it has never been put into effect completely and courageously enough: as a method, that is, by which to determine ends as well as means. The new art style breathes rationalization. It makes more explicit and prominent than ever before that economy of means which has always been indispensable to successful works of art. It does not rationalize art—which is impossible—but it produces an art that answers the temper of men who know no better way of attaining an end than by the rationalization of every means thereto. This art is one of the few manifestations of our time uninflated by illegitimate content—no religion or mysticism or political certainties. And in its radical inadaptability to the uses of any interest, ideological or institutional, lies the most certain guarantee of the truth with which it expresses us.

Integral efficiency is as lofty an ideal as any, and perhaps more real than any other. Its unfavorable associations are the vulgar ones. But only in art as yet, because art does not have to determine and can so well refuse to serve ends outside itself, has an appropriate vision of efficiency as an ideal been bodied forth, a vision of that complete and positive rationality which seems to me the only remedy for our present confusions.

Partisan Review, November 1949

Bibliography

Works by Greenberg

UNCOLLECTED WRITINGS, 1939–1949

"An Interview with Ignacio Silone." *Partisan Review* 6 (Fall 1939): 22–30.

With Dwight Macdonald. "10 Propositions on the War." *Partisan Review* 8 (July-August 1941): 271–78.

With Dwight Macdonald. "Reply" (to Philip Rahv, "10 Propositions and 8 Errors," in the same issue). *Partisan Review* 8 (November-December 1941): 506–508.

"L'art américain au XXe siècle." *Les Temps Modernes* 2 (August-September 1946): 340–52.

BOOKS

Joan Miró. New York: Quadrangle Press, 1948.

Matisse. New York: H. N. Abrams, 1953.

Art and Culture: Critical Essays. Boston: Beacon Press, 1961.

Hans Hofmann. Paris: Georges Fall, 1961.

TRANSLATIONS FROM THE GERMAN

The Brown Network: The Activities of the Nazis in Foreign Countries. Introduced by William Francis Hare. New York: Knight Publications, 1936.

With Emma Ashton and Jay Dratler. Manfred Schneider, *Goya: A Portrait of the Artist as a Man*. New York: Knight Publications, 1936.

Franz Kafka. "Josephine, The Songstress: Or, the Mice Nation." *Partisan Review* 9 (May-June 1942): 213–28.

With Willa and Edwin Muir. Franz Kafka, *Parables*. New York: Schocken Books, 1947.

With Willa and Edwin Muir. Franz Kafka, *The Great Wall of China: Stories and Reflections*. New York: Schocken Books, 1948.

Paul Celan. "*Fugue*." *Commentary* 19 (March 1955): 242.

Works on Greenberg

Most of the literature on Greenberg dates from the appearance of *Art and Culture* in 1961. Before then Greenberg's criticism was not subjected to any sustained analysis, at least not in print, although it was referred to with increasing frequency in articles and books. The fullest attention it received was in several reviews that followed the publication of *Joan Miró* in 1948, in George L. K. Morris's article of the same year, and in Alfred H. Barr, Jr.'s book on Matisse in 1951.

Art and Culture thus marked a shift in the kind of critical attention paid to Greenberg's work. The book seems to have clarified the extent to which his writings were informed by a developed theory of modern art and the extent to which he understood the practice of art criticism to be marked by peculiar limits and constraints that reflected the peculiar limits and constraints of its subject. In short, it clarified what he meant by modernism. Since 1961 most of the extensive discourse on Greenberg's critical practice has dealt with the implications of his modernist stance. The following list of selected secondary sources reflects this interest.

Barr, Alfred H., Jr. *Matisse: His Art and His Public*. New York: Museum of Modern Art, 1951.

Brook, D. "Art Criticism: Authority and Argument." *Studio International* 180 (September 1970): 66–69.

Calas, Nicolas. "The Enterprise of Criticism." *Arts Magazine* 42 (September-October 1967): 9.

Carrier, David. "Greenberg, Fried, and Philosophy: American-Type Formalism." In *Aesthetics: A Critical Anthology*. Edited by George Dickie and R. J. Sclafini. New York: St. Martin's Press, 1977.

Cavaliere, Barbara, and Robert C. Hobbs. "Against a Newer Laocoon." *Arts Magazine* 51 (April 1977): 110–17.

Clark, T. J. "Greenberg's Theory of Art." *Critical Inquiry* 9 (September 1982): 139–56.

———. "Arguments About Modernism: A Reply to Michael Fried." In *The Politics of Interpretation*. Edited by W. J. T. Mitchell. Chicago: University of Chicago Press, 1982–1983.

Crow, Thomas. "Modernism and Mass Culture in the Visual Arts." In *Modernism and Modernity*. Edited by Benjamin H. D. Buchloh, Serge Guilbaut, and David Solkin. Halifax, N.S.: Press of the Nova Scotia College of Art and Design, 1983.

Curtin, Deane W. "Varieties of Aesthetic Formalism." *Journal of Aesthetics and Art Criticism* 40 (Spring 1982): 315–26.

Dorfman, Geoffrey and David. "Reaffirming Painting: A Critique of Structuralist Criticism." *Artforum* 16 (October 1977): 59–65.

Foster, Stephen C. *The Critics of Abstract Expressionism*. Ann Arbor, Mich: UMI Research Press, 1980.

Frascina, Francis, ed. *Pollock and After: The Critical Debate*. New York: Harper & Row, 1985.

Fried, Michael. Introduction to *Three American Painters: Kenneth Noland, Jules Olitski, Frank Stella*. Exhibition catalogue. Cambridge, Mass.: Fogg Art Museum, 1965.

—————. "How Modernism Works: A Response to T. J. Clark." *Critical Inquiry* 9 (September 1982): 217–34.

Goldwater, Robert. "The Painting of Miró." Review of *Joan Miró*, by Greenberg. *The Nation* 168 (26 February 1949): 250–51.

Guilbaut, Serge. "The New Adventures of the Avant-Garde in America." *October* 15 (Winter 1980): 61–78.

—————. *How York Stole the Idea of Modern Art: Abstract Expressionism, Freedom and the Cold War*. Chicago: University of Chicago Press, 1983.

Halasz, Piri. "Art Criticism (and Art History) in New York: The 1940s vs. the 1980s; Part Three: Clement Greenberg." *Arts Magazine* 57 (April 1983): 80–9.

Harrison, Charles, and Fred Orton. Introduction to *Modernism, Criticism, Realism: Alternative Contexts for Art*. New York: Harper & Row, 1984.

Hess, Thomas B. "Catalan Grotesque." Review of *Joan Miró*, by Greenberg. *Art News* 47 (February 1949): 9.

Higgens, Andrew. "Clement Greenberg and the Idea of the Avant-Garde." *Studio International* 183 (October 1971): 144–47.

Hoesterey, Von Ingeborg. "Die Moderne am Ende? Zu den ästhetischen Positionen von Jürgen Habermas und Clement Greenberg." *Zeitschrift fur Ästhetik und allgemeine Kunstwissenschaft* 29 (1984): 19–32.

Kees, Weldon. "Miró and Modern Art." Review of *Joan Miró*, by Greenberg. *Partisan Review* XVI (March 1949): 295–97.

Kozloff, Max. "A Letter to the Editor." *Art International* 7 (June 1963): 89–92.

—————. "The Critical Reception of Abstract-Expressionism." *Arts Magazine* 40 (December 1965): 27–33.

Kramer, Hilton. "A Critic on the Side of History: Notes on Clement Greenberg." Review of *Art and Culture*, by Greenberg. *Arts Magazine* 37 (October 1962): 60–63.

Kroll, Jack. "Some Greenberg Circles." Review of *Art and Culture* and *Hans Hofmann*, by Greenberg. *Art News* 61 (March 1962): 35, 48–49.

Kuspit, Donald B. *Clement Greenberg: Art Critic*. Madison, Wis.: University of Wisconsin Press, 1979.

329

————. "The Unhappy Consciousness of Modernism." *Artforum* 19 (January 1981): 53–57.

Morris, George L. K. "On Critics and Greenberg: A Communication." *Partisan Review* XV (June 1948): 681–85.

Natapoff, Flora. "The Abuse of Clemency: Clement Greenberg's Reductive Aesthetic." *Modern Occasions* 1 (Fall 1970): 113–17.

Orton, Fred, and Griselda Pollock. "*Avant-Gardes* and Partisans Reviewed." *Art History* 4 (September 1981): 305–27.

Ratcliff, Carter. "Art Criticism: Other Eyes, Other Minds: Clement Greenberg." *Art International* XVIII (December 1974): 53–57.

Reise, Barbara M. "Greenberg and The Group: A Retrospective View." *Studio International* 175 (May-June 1968): 254–57, 314–16.

Sandler, Irving. *The Triumph of American Painting: A History of Abstract Expressionism.* New York: Praeger, 1970.

Shapiro, David and Cecile. "Abstract Expressionism: The Politics of Apolitical Painting." *Prospects* 3 (1977): 175–214.

Stadler, Ingrid. "The Idea of Art and of Its Criticism: A Rational Reconstruction of a Kantian Doctrine." In *Essays in Kant's Aesthetics.* Edited by Ted Cohen and Paul Guyer. Chicago: University of Chicago Press, 1982.

Steinberg, Leo. *Other Criteria: Confrontations with Twentieth-Century Art.* New York: Oxford University Press, 1972.

Chronology to 1949

1909
January 16. Clement Greenberg born in the Bronx, New York City, oldest of the three sons of Joseph and Dora (Brodwin) Greenberg. His younger brothers are Sol and Martin.

Both parents were born into the Lithuanian Jewish cultural enclave, his father in White Russia in 1881, and his mother in northeastern Poland in 1886. They came to the United States, in their separate ways, in 1900 and 1899, and were married in 1907. In politics they were free-thinking socialists. Their culture included Italian opera and Russian novels; at home they spoke Yiddish for a long while.

1914–1925
In 1914 the family moved from New York City to Norfolk, Virginia, where Joseph Greenberg was a storekeeper (clothing).

In 1920 the family returned to New York City, this time to Brooklyn, where Joseph Greenberg changed occupations to manufacturer (metal goods).

Clement Greenberg attended high school in Brooklyn, first at Erasmus Hall and then at the Marquand School where he combined the last two years in one.

March–May 1925. Enrolled in Richard Lahey's life drawing class at the Art Students League.

1926–1930
Fall 1926. Entered the freshman class at Syracuse University, N.Y., and studied languages and literature. In addition to French and Latin, learned in high school, studied German and Italian.

Spring 1930. Graduated with an A.B.

1931–1932
Worked at home in New York City, continuing to study languages and literature, writing poetry and short stories (unpublished).

1933–1934
Employed by his father in a family venture into the wholesale dry-goods business; worked in St. Louis, Cleveland, San Francisco, and Los Angeles.

30 March 1934. Married Edwina Ewing in San Francisco; in 1935 had a son Daniel; in 1936 was divorced.

1934. Published a magazine adventure story; in 1936 published another story.

1935–1936

For Knight Publications, New York, translated from the German *The Brown Network: The Activities of the Nazis in Foreign Countries*; collaborated on the translation of *Goya: A Portrait of the Artist as a Man*, again from the German.

Beginning of 1936. Became employed as a clerk, first in the United States Civil Service Commission, New York City, then briefly in the Veterans Administration, New York City.

1937–1938

1937. Took a job with the United States Customs Service, Appraiser's Division, in the Port of New York, Department of Wines and Liquors. Remained with the department until late 1942.

Began drawing regularly from live models with Igor Pantukhov (at the time a close friend of Lee Krasner) at a WPA studio in the west Twenties. Attended three lectures by Hans Hofmann at his school (1938–1939 academic year). "Hofmann has not yet published his views [on modern art]," Greenberg wrote, "but they have already directly and indirectly influenced many, including this writer—who owes more to the initial illumination received from Hofmann's lectures than to any other source" (1945).

Introduced by Harold Rosenberg and Lionel Abel to the circle of writers around *Partisan Review*, notably Dwight Macdonald.

1939

Published first article in the winter issue of *Partisan Review*—a review of *A Penny for the Poor* by Bertolt Brecht. Greenberg had encountered Brecht's work in the early 1930s and had written (but not published) on it previously.

April–June. Traveled for the first time to Europe—England, France, Italy and Switzerland. In Paris introduced to Paul Eluard, Jean-Paul Sartre, Georges Hugnet, Virgil Thomson, Jean Arp and his wife Sophie Taeuber, and Hans Bellmer by Sherry Mangan, who was *Time* magazine's correspondent in Paris. In Zurich interviewed Ignacio Silone for the fall *Partisan Review*.

Also in the fall issue of *Partisan Review*, published "Avant-Garde and Kitsch." The essay had been worked on extensively before the trip to Europe; Dwight Macdonald read and commented on a preliminary draft.

1940–1941

January 1940. Became an editor of *Partisan Review*; other editors at that time were F. W. Dupee, Dwight Macdonald, George L. K. Morris, William Phillips, and Philip Rahv. First published in *The Nation* on 19 April 1941—a review of exhibitions of Miró, Léger and Kandinsky.

1942

In 1940 and 1941 published mainly on literature, in 1942 mainly on art. With the March 7 issue of *The Nation* became the magazine's regular art critic, a position held until late 1949.

In May–June issue of *Partisan Review*, published a translation of Kafka's "Josephine, The Songstress: Or, the Mice Nation." Continued to translate Kafka's short stories and essays for publication until 1948.

Late 1942. Resigned from the United States Customs Service and from the editorial board of *Partisan Review*. At about the same time was introduced to Jackson Pollock by Lee Krasner.

1943

February 1943. Joined the U.S. Army Air Force. In September was honorably discharged for medical reasons.

October 1943. Resumed writing for *The Nation*.

1944–1945

Fall 1944. Became managing editor of *Contemporary Jewish Record*, published by the American Jewish Committee. In June 1945 the magazine stopped publishing and was incorporated into *Commentary* (first issue, November 1945). Greenberg became associate editor of *Commentary*, a position he held until fired in 1957.

1946–1947

Fall 1947. Started to write occasional book reviews for the *New York Times Book Review*.

1 December 1947. Ridiculed in *Time* magazine for having declared in the October *Horizon* that Jackson Pollock was "the most powerful painter in America" and that David Smith was the only "major" sculptor in America.

1948–1949

1948. Wrote and published first book, *Joan Miró*, and wrote a series of longer articles for *Partisan Review*. In 1949 continued to concentrate on longer articles for *Partisan Review*.

11 October 1948. Appeared in *Life* as a "distinguished critic" in a round-table discussion on modern art.

25 November 1949. Resigned as regular art critic for *The Nation*. Reflecting on his critical activities in the 1940s, Greenberg wrote that he had had "a belly-full of reviewing in general. . . . Art criticism, I would say, is about the most ungrateful form of 'elevated' writing I know of. It may also be one of the most challenging—if only because so few people have done it well enough to be remembered—but I'm not sure the challenge is worth it" (*Twentieth Century Authors*, 1955).

John O'Brian

Index